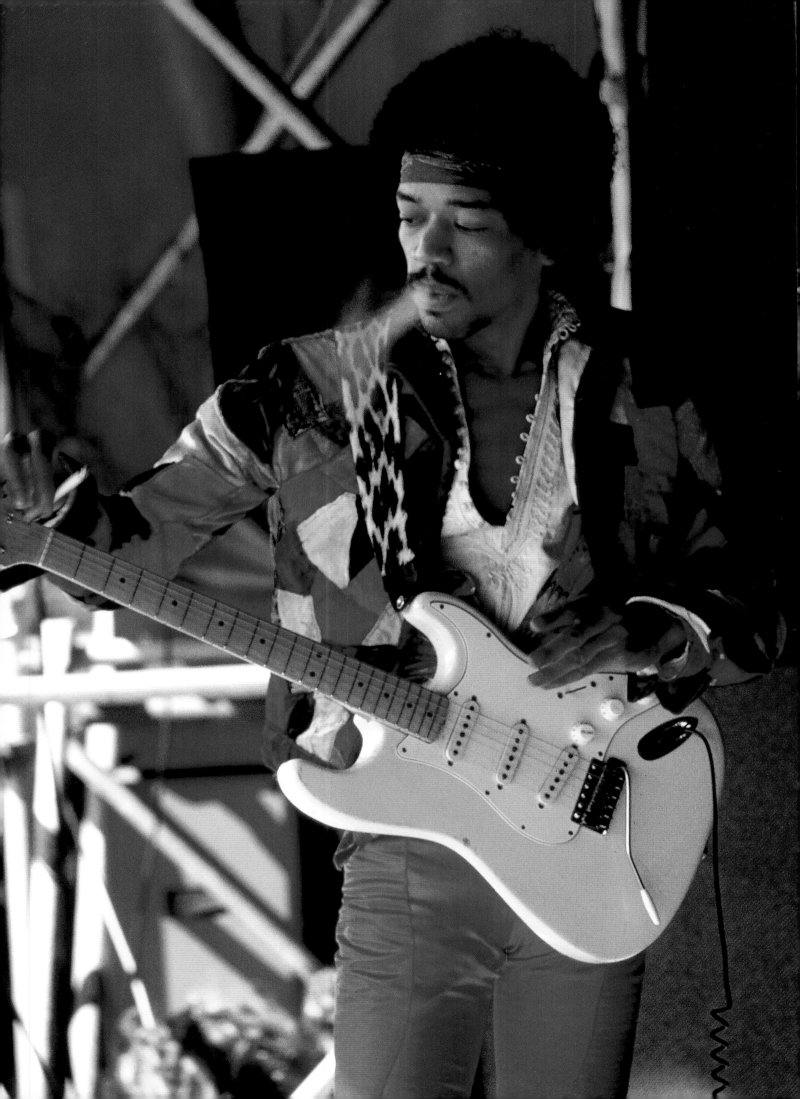

GUITAR HEAVEN

The Most Famous Guitars
To Electrify Our World

Neville Marten

COLLINS|DESIGN

An Imprint of HarperCollins*Publishers*

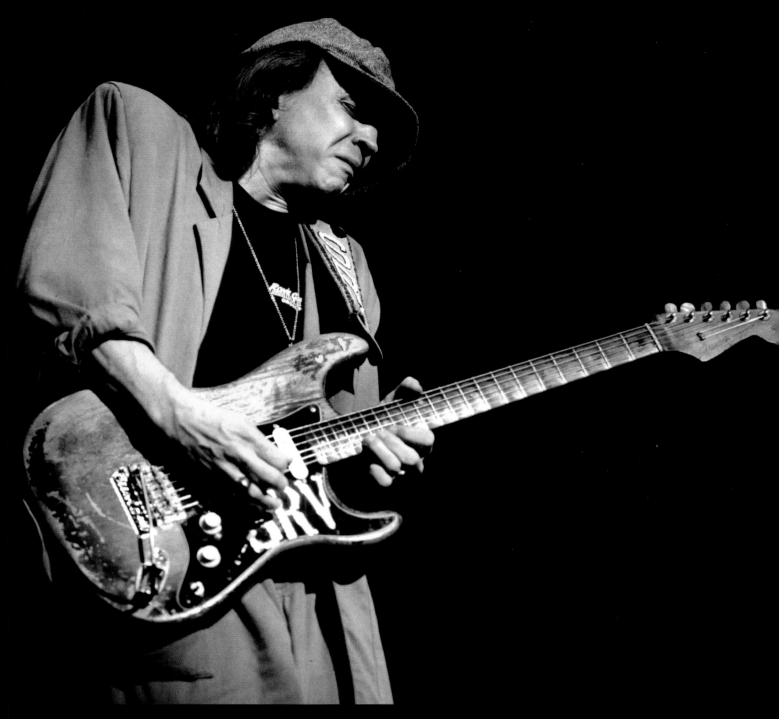

Guitar Heaven

The Most Famous Guitars To Electrify Our World

Copyright © 2007 by Octopus Publishing Group Ltd.

HarperCollins books may be purchased for educational, business, or sales promotional use. For information, please write: Special Markets Department, HarperCollins Publishers 10 East 53rd Street, New York, NY 10022.

First published in North America in 2007 by: Collins Design
An Imprint of HarperCollins*Publishers*
10 East 53rd Street, New York, NY 10022
Tel: (212) 207-7000, Fax: (212) 207-7654
collinsdesign@harpercollins.com www.harpercollins.com

Distributed throughout North America by:
HarperCollins*Publishers,* 10 East 53rd Street
New York, NY 10022, Fax: (212) 207-7654

Library of Congress Control Number: 2007930326

ISBN: 978-0-06-135944-6
ISBN-10: 0-06-135944-0

Printed and bound by Toppan Printing Company in China

First Printing, 2007

Above Stevie Ray Vaughan **Previous page** Jimi Hendrix

Back cover: tl – Jimi Hendrix (Redferns/Jorgen Angel);
tr – Pete Townshend (Redferns/Jan Persson); c – Bob Marley
(Redferns/David Corio); bl – Eric Clapton (Redferns/Susie
McDonald); br – Bob Dylan (Getty/Michael Ochs Archive).

Contents

Foreword

I played a lot of instruments when I was a kid: piano, harmonica, drums, you name it. But the minute I picked up the guitar, I fell in love. I knew that I would play it for the rest of my life. The only problem with it was that it wasn't loud enough. Back then, PA systems were nonexistent, so whenever I played live, the weakest voice in the band was always the guitar player.

I remember playing at a barbecue stand halfway between Waukesha and Milwaukee and this fellow in the rumble seat of a car wrote a note to the carhop for me that said, "Your voice and harmonica are fine, but your guitar's not loud enough." That fellow was right and I thought I should do something about it. I kept thinking, what would I want out of a guitar?

I conducted two experiments at the same time: I took a piece from the railroad track and attached a string to it, and then I did the same thing with a piece of pinewood. I put the earpiece of my mother's telephone, which consisted of a magnet and a coil of wire, under the string on the railroad track, and then I ran the sound through my mother's radio. I yelled to my mother, "I found it! The electric guitar!" And my mother asked, "Well, what is it?" I said, "It's a piece of railroad," and she said, "The day you see a cowboy playing guitar with a piece railroad track...." It didn't take me long to get off the railroad track. Today, my guitar designs are a bit more sophisticated.

When I design an instrument, I take into account all the different aspects of the instrument as well as the musician's needs. What's good for one kind of musician, such as a bluegrass guitar player, may not work for a guy playing rock. A jazz player wants something else altogether. One musician may want coloration, for instance, while another won't. Today, too, there's a whole new generation of musicians who play with a different set of styles and technological know-how. In the beginning, there were classical rules about how you were supposed to play the instrument. I've always been astonished by musicians who say, "You can't do that" or "You have to use your fingers. You can't use a pick." As time went by, the rules were broken. The design of today's guitars has evolved to fit these new needs and sounds.

What links every guitar player to each other is the love of the instrument. When I originally started tinkering with the guitar, I wanted it to be as loud as a railroad track but beautiful and loveable so the person playing it would have an honest and emotional connection to it. A guitar is something that you can hold and love and it's never going to bug you.

But, here's the secret about the guitar: It's defiant. It will never let you conquer it. The more that you get involved with it, the more you realize how little you know. I've never given up the fight of trying to figure it out, which is why I'm still playing. There is something about this particular instrument that makes you want to engage in the challenge. The musicians in this book have risen to the challenge, pairing their skill level, attitude, and creativity with some of the finest guitars ever made. For every kind of musical style or personality – studied, eclectic, or outrageous – there is the perfect guitar, one that inspires you to keep the fight alive and helps get your message out, loud and clear. I hope you enjoy the battle as much as I do.

– Les Paul, March 2007

Introduction

Like many 12-year-old boys in 1962, I caught a song being played on BBC radio the like of which I had never heard before. It was raw and earthy with unusual two-part vocal harmony sung in fifths – I did not know they were fifths then, of course, but I was a musical kid and could tell they were different to the sweeter harmonies I had heard in tracks by Neil Sedaka or The Everly Brothers. It had a quality I would later recognize as "bluesiness", but which at the time simply connected with me on a visceral level. The track was "Love Me Do" and it was by a group named The Beatles. When I finally saw this quartet on our black-and-white television, their look captivated me as much as their sound. A drummer sat at the back and wiggled his head, while three lads at the front played electric guitars, one with his instrument's neck facing the opposite way to the others.

Of course I had seen electric guitars before. I loved Elvis Presley, and his guitarist Scotty Moore had one. It looked like a huge violin and was a Gibson Super 400, an arch-top instrument with f-holes, played mainly by jazz musicians. Yet, while I loved the music, that guitar did nothing to waken my passion. I had also avidly watched British rock and roll television programmes such as "Six-Five Special" and "Oh Boy!". I had seen The Shadows with their matching pink Stratocasters, but even The Shads had not connected with me like this new band did. I adored those vocal harmonies and weirdly – I say weirdly because I must have been the only kid on the planet who did – preferred the look of their conventional but slightly quirky guitars to that of Hank Marvin's and Bruce Welch's futuristic Strats. Of course, I did not know they were Strats and I certainly did not know that George Harrison and John Lennon – when I discovered these Beatles' names – were playing Rickenbacker and Gretsch.

Bisons and Rapiers

The Shadows had, however, awakened me to the delights of guitars. Because of them, the British guitar industry (such as it was) sprang into life, and companies such as Watkins started making their own Strat-alike, called the Rapier. Burns – true innovators among the copyists – reputedly made the greatest electric guitar in the world, the Black Bison. Even the names of the guitars were exciting. Black Bison, Rapier – remember that these were the days of cowboy television programmes and Errol Flynn action movies and the connection was not lost even on a lad of my age. Kelloggs Corn Flakes actually ran a competition to win a Black Bison – I did enter, but never received my Burns.

A friend down the road had been taking classical guitar lessons – a sort of punishment back then, it seemed to me. But he had an ear and had managed to work out the three chords to "Love Me Do". He later worked out "Sweets For My Sweet" by The Searchers and I used to join him on falsetto harmony as we "entertained" our families with squeaky renditions of our two-hit repertoire. Along with other kids whose fathers had been in the

armed forces, mine thought the new long-haired groups were an affront to music, to our country, and to almost everything else. Therefore my mother's requests to let me have a guitar for my birthday fell on deaf ears. She was a musician, had won a scholarship to the Royal Academy at just nine years old, and at that tender age had played hymns in school assembly – by ear! – if the music teacher was ill. Perhaps that is where my own feel for music was born.

Move on a couple of years and we had relocated to the north of England and I had a new set of friends. The Beatles had cracked the United States, the airwaves were awash with new music, and every teenager wanted to play guitar. The Fab Four were still my favourites, but The Rolling Stones were now on the scene, as well as The Hollies, The Byrds, The Kinks, The Monkees, and many others. My friends and I started to notice the different guitars they were playing. I remember dashing to school and saying: "Did you see Ricky Nelson on television last night? The guy was playing a homemade guitar!" My more knowledgeable classmates shouted me down with howls of derision: "You idiot, it was a Fender Telecaster!" The guitarist was the great James Burton who went on to play with Elvis Presley on his 1968 Comeback Special.

At last, a guitar of my own

One of my mates had a German Hofner Club 40 and the other a British Burns Sonic. They used to let me play on them for a few minutes until they could take my atonal fumblings no more. These instruments played much better than mine. My dad had relented, on condition that I got myself a job and contributed half of the guitar's massive £8 price tag. My keenness both surprised and impressed him, and so I now owned the instrument that many British players of note would start on, the Rosetti Lucky 7, which was made in eastern Europe.

My fellow guitarist neophytes and I kept our eagle eyes on the television and spotted Gibson Firebirds and Vox Phantoms in the hands of

Below A silk-suited Hank Marvin of The Shadows playing Britain's first Fender Stratocaster; and "mop-tops" Paul McCartney, George Harrison, and John Lennon with their quirky Hofner, Gretsch, and Rickenbacker guitars.

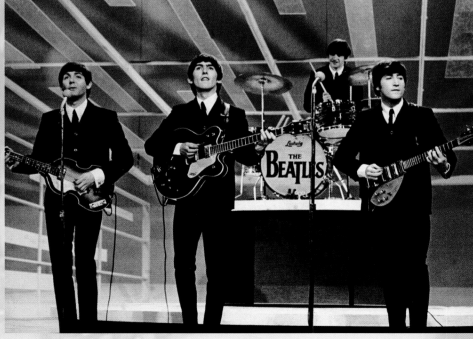

The Stones, an ES-355 played by the great B.B. King, The Kinks' Dave Davies playing a Flying V (wow!), and another Telecaster hung around the neck of the guitarist in The Yardbirds. I later spotted the same guy playing in a band called The Bluesbreakers, using a Les Paul. His name was Eric Clapton. Eric, along with all the great American bluesmen both black and white, was to be a huge influence on my playing. Jimi Hendrix, with his upside-down Stratocaster, hit the scene in 1967. I saw Jimi's first performance on British television and was amazed.

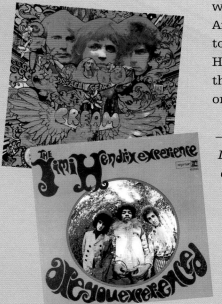

I was so lucky to be brought up in that era – I was 17 when the albums *Sergeant Pepper*, *Disraeli Gears*, and *Are You Experienced* came out, and I witnessed these musical milestones as they happened. What started to dawn on me in my mid to late teens was that different groups used different guitars and they made different sounds. Cream and The Jimi Hendrix Experience were both three-piece blues-rock bands but, whereas Clapton with his Gibson SG or ES-335 made huge, dark, distorted tones, Hendrix's Strat was generally cleaner and sweeter. So I came to recognize the relationship between a guitar's looks and its sound – and began to spot why individual guitarists had chosen their particular instrument. As often as not, it was as much for the statement it made visually as for its inherent tone – but usually it was a combination of the two.

I really came to love guitars and I recall as though it were yesterday buying my first proper electric – a 1967 Fender Telecaster – from Guitar Village in Shaftesbury Avenue, London, in 1970. It cost me £105. My next purchase was a white Strat, which, in hindsight, was almost certainly a Hendrix reject: it had a second strap button on the lower horn, the nut had been turned round and was loose in its slot, and it was made up of a 1959 neck, early 1960s scratchplate, and pickups with a 1967 body and serial number plate. Who else, in 1970, played a Strat that way round and could afford to buy at least three, make up a great one, and discard the others? Mine turned out to be the runt of the litter and I eventually sold it for the same amount I paid for it – £115.

Working with guitars – a dream come true

I began pulling my guitars to pieces to see how they were built, learning about what made them tick and setting mine up so that they played better. When in 1972 I bought a red 1967 Gibson ES-335 – the Clapton influence was at work – I had it playing so well that all my friends started asking me to set their guitars up like mine. So a little sideline was born.

In 1976, I answered an advert in the paper for a guitar technician working for Gibson importer Henri Selmer, and essentially bluffed my way into the job. I loved working there. We were the British repair centre for Gibson and we had to repair new instruments that were faulty – and in 1976 there were a lot of faulty Gibsons being produced – as well as taking on customer repairs that included many major Gibson players of the day. I

have had my hands on many iconic Gibbos, but discretion prevents me from spilling the beans. I then went on to do the same for Fender – when, among other things, I set up Hendrix's white Woodstock Strat when his drummer Mitch Mitchell brought it out of mothballs and decided to sell it. As was the norm, I cut the strings off and threw them away, not realizing that the guitar would sell for almost £200,000. Had I kept them, and been able to prove the master had played on them, they would probably be worth a king's ransom today. Another Hendrix-related gaffe!

Mixing words and guitars...

When *Guitarist* magazine was launched in Britain in 1984, I immediately became interested in writing articles for them. I had fancied it for a while, and when the opportunity arose to interview Hank Marvin – he was coming to see me to try out some new reissue Strats at my Fender workshop – I offered the interview to them and it was accepted. I started doing regular reviews for the magazine, and then a job came up and I applied for it. I began as staff writer, then became features editor, and eventually took over the editor's chair. I ended up editing *Guitarist* for around 15 years during several stints – the magazine is now 23 and still doing very well. In that time, I have seen and played thousands of guitars, either as a reviewer or simply as an interested party. I still love them. I continue to buy them and, although I have not amassed a huge collection, have a few nice pieces that continually make me grin every time I open their musty old cases to have a play, get the pots working again, clean up the frets, and replace the tarnished strings. I still gig up and down Britain

Below What 14-year-old guitar freak could not be bowled over by seeing The Kinks on television? Here Dave Davies is playing his original Gibson Flying V, brother Ray sports a sensible Fender Tele, and Pete Quaife plays a Ricky bass – but not a single Kink is plugged in.

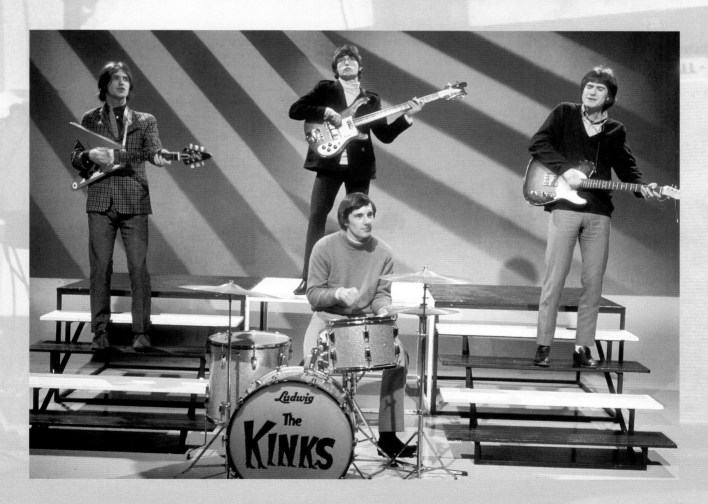

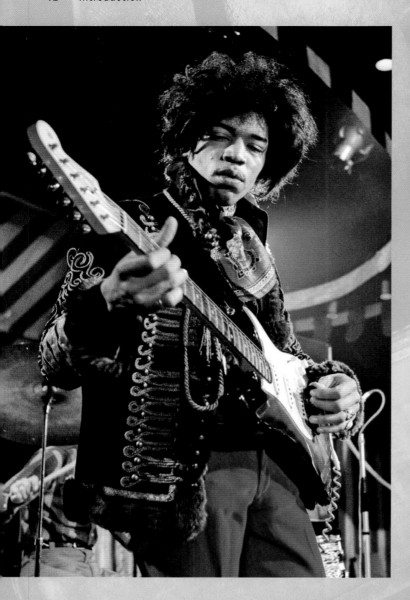

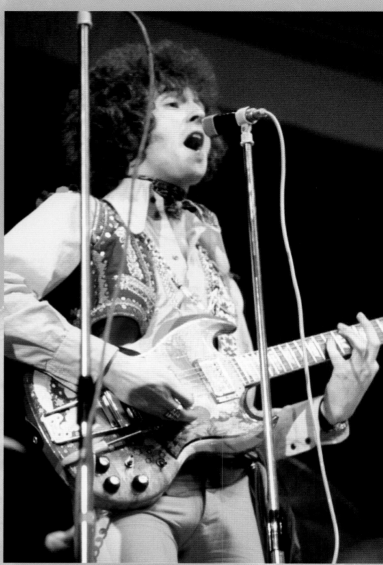

in Brit rock and roll star Marty Wilde's band The Wildcats – using a new and brilliant Gibson 1963 block-inlay ES-335 reissue – and write and play my monthly "Blues Headlines" column for *Guitarist*. I am also editor of a great tuition magazine – *Guitarist*'s sister publication *Guitar Techniques* – and operate as editor at large on these magazines, as well as our other title, *Total Guitar*.

Above After The Beatles and the mid-1960s beat boom, the next big things to hit the guitar world were psychedelic blues-rockers Jimi Hendrix and Eric Clapton. Here are Jimi (above left) and Eric (above right).

Choosing the guitars for this book

When I was asked to write *Guitar Heaven*, I had a dilemma. Given the thousands of great guitars out there, the different styles of music played, and people's huge range of tastes, how would it be possible to fit all this information in one book? Instead of opting for the encylcopedic approach, this is my personal "take" on things. Apart from the instruments in the book being those that I find personally satisfying or inspirational, the vast majority have either had an influence on music – as the choice of great players – or have helped move the guitar maker's art forward through innovation or simply great design.

Electric basses, acoustics, and archtop jazz guitars have been omitted. Basses and acoustics are a world unto themselves and deserve greater

level of coverage than could have been given here. Jazz guitars, too, are something of a breed apart and deserve more depth than could have been provided. As this book comes from my perspective as a pop/blues/rock kind of fellow, it seemed the logical thing to do. However, there are a few jazz-style instruments included – the redoubtable Gibson ES-175, for instance, choice of many a jazz great, including the renowned Joe Pass – but those featured are also found in rock and pop.

The guitar, the musician, and the music

I also felt it was important to put the guitars into musical context and not just have a dry textbook-style layout. The instruments had to be beautifully shot, too. Although it was vital to include historical information and relevant construction detail in the text, the truth is that a Gretsch 6120 in the hands of Brian Setzer, a Strat being played by Stevie Ray Vaughan, or Freddie King with a Gibson ES-345 says so much more about each instrument's purpose in life than any number of words could.

Yet even that raises as many questions as it provides answers. The manufacturer or designer cannot always be sure who will play his guitars, even if a specific style of music was envisaged at an instrument's conception. Once it is out in the big wide world it is anybody's guess as to who is going to pick it up. Take the Gretsch 6120: it was designed with country and western music in mind, but has since become the number one six-string icon of rock and roll. Eddie Cochran chose one and his influence over a young Brian Setzer was immense; today you can check out almost any group playing rockabilly and a Gretsch will almost certainly feature. Another good example is Fender's Jazzmaster. Leo Fender so wanted to produce an instrument that would be taken seriously by the jazz fraternity – who thought he made disposable guitars for disposable music. But not a single jazz musician of note took up his new design. The guitar would have sunk into total obscurity had it not been for surf music and garage punk bands – the latter purchased them when they were so out of fashion that they sported extremely low price tags.

The classic vintage models

Guitar Heaven was not written to concentrate on valuable vintage guitars, to the exclusion of the many fine modern guitars still made by all the great manufacturers. The very scarcity of some old instruments – mainly Gibsons, Fenders, and Gretsches from the 1950s – has sent their value skyrocketing and the vintage market is now a worldwide multi-billion-dollar industry. Often today's instruments are better and more consistently built because of computerized machinery that can shape necks to within fractions of a millimetre, or create pickups with the exact number of windings on each coil.

Old guitars, while often beautiful in looks, sound, and playability, vary greatly from one to the next. Two very rarely sound identical, since the pickups could have 500 turns, more or less, of copper wire wrapped around their bobbins due to operatives nattering to one another or simply losing count. Necks vary from guitar to guitar depending on who did the final shaping. It is the same with Fender bodies – some Strats' belly and forearm contours are deep and radical while others have the minimum of wood removed to do the job. A modern factory can turn out incredibly

consistent products, but what is so great about the guitar is that a good technician can set up yours so that it plays exactly as *you* like – a tweak of the truss rod here, a file of a nut slot there, or a raising or lowering of the bridge can all entirely change the way it feels. So, although we all love vintage guitars, realistically so few of us can afford them and afford to use them for fear of theft or damage that *Guitar Heaven* is as happy to picture a new Flying V from Gibson's standard range as to ply you with a shot of something that would fetch the price of a reasonable yacht!

Advances in techonology

Along with new production techniques such as CNC routers, laser inlay-cutting equipment, and lacquers that are cured by ultraviolet light in 30 seconds, there has come the "boutique" guitar. Started by Hamer and Schecter in the '70s, Paul Reed Smith picked up the baton the following decade, in a movement to create flawless pieces of guitar engineering that continues to this day. Other makers like Tom Anderson and John Suhr combine the best of the technological advances with the finest luthiery in the world to create stunning instruments. However, these gorgeous pieces tend to be played by well-heeled lovers of guitar art, or by professional players who simply require the best-playing, best-sounding tool for the job. The really big names and the cool young guns alike seem to stick with their Fenders and Gibsons, or Ibanezes and Jacksons – hence there are no sections in this book for these and other stunning makes.

Although B.C. Rich and Dean are not in the main body of the book – they are not my personal cup of tea as a player – I have always had a soft spot for B.C. Rich's outlandish designs and I know that they are the beloved marque of young rockers – so accept this great photo of Slash playing one as my nod toward Bernie Rico and his team. Likewise with Dean: I reviewed a pair of American-made guitars from Dean Zelinsky's range and they were stunningly built instruments. I love the Explorer-style Z models and the Explorer-meets-V design of the ML, and the Dean Hardtail in my review almost out-PRSed PRS! Check out the picture of Dimebag playing his favourite Dean.

From Clapton to The Killers – the players' influence

Many of the guitars we see today as icons are in that position because of patronage. For instance, the Gibson ES-330 and Epiphone Casino are to all intents and purposes the same instrument. They were made side by side in the Gibson factory and yet the poor old 330 languishes as an almost forgotten model, whereas the Casino reigns glorious owing to its use by three Liverpool lads named Harrison, McCartney, and Lennon. Of course, the major influences on younger generations of players are still the iconic musicians who picked up these instruments when they were a relatively new phenomenon and made the greatest impact on music using them – the aforementioned Beatles, Hendrix, Stones, Kinks, and Clapton, for instance.

The same happens when every new guitar star comes along. Slash of Guns N' Roses brought the very out-of-fashion Les Paul back into the limelight when the band released *Appetite For Destruction* in 1987. Also in the 1980s, a new style of

Below Among the "boutique" builders of the world, no one makes a finer guitar than California's Tom Anderson. His client roster reads like an A-list session guitar players' directory.

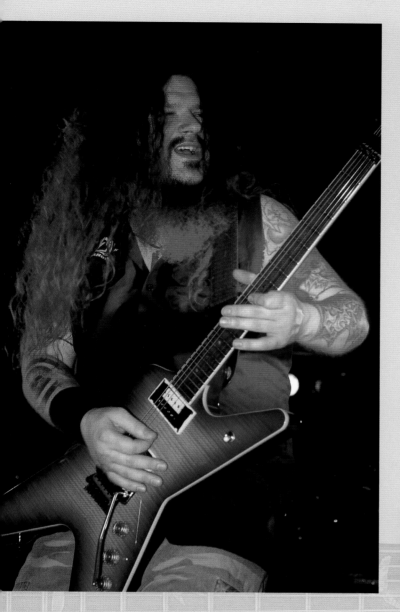

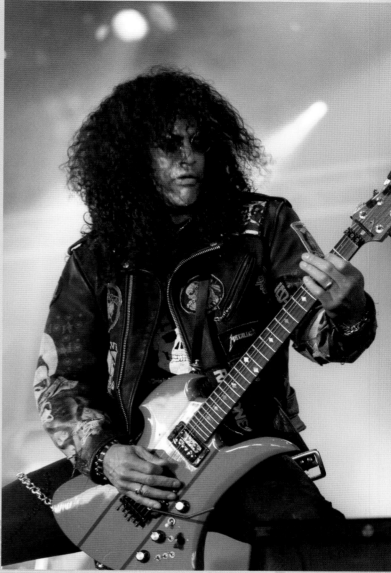

music emerged that saw young virtuoso players climbing on the shoulders of giants like Eddie Van Halen and forging even more amazing techniques. Younger electric guitar companies such as Ibanez and Jackson leapt on these musicians – Steve Vai, Joe Satriani, and others – as they needed people to be the "face" of their products, just as Fender, Gibson, Gretsch, and Rickenbacker had before them. Today's influences on even younger generations are likely to be Pearl Jam, Kaiser Chiefs, or The Killers, and so it goes on.

It is this combination of instrument and player – as a look and as a sound – that makes the guitar so iconic. Would Brian May of Queen look right with anything but his homemade Red Special slung around his neck? It is the same with John Lennon's blonde Epiphone Casino and Hendrix's upside-down Strat. Then you hear them play and the effect on your ears simply underlines what your eyes have already told you.

I hope *Guitar Heaven* is as enjoyable for you to read as it was for me to write. And I hope it manages to convey that the player is nothing without the guitar, and the guitar is just a plank of wood with strings if no one picks it up and rocks!

Above Among the most influential modern guitarists are the late Dimebag Darrell of Pantera and Damageplan, and the mighty Slash of Guns N' Roses. Here are Dime with his favourite Dean ML (above left), and Slash playing a B.C. Rich Mockingbird (above right).

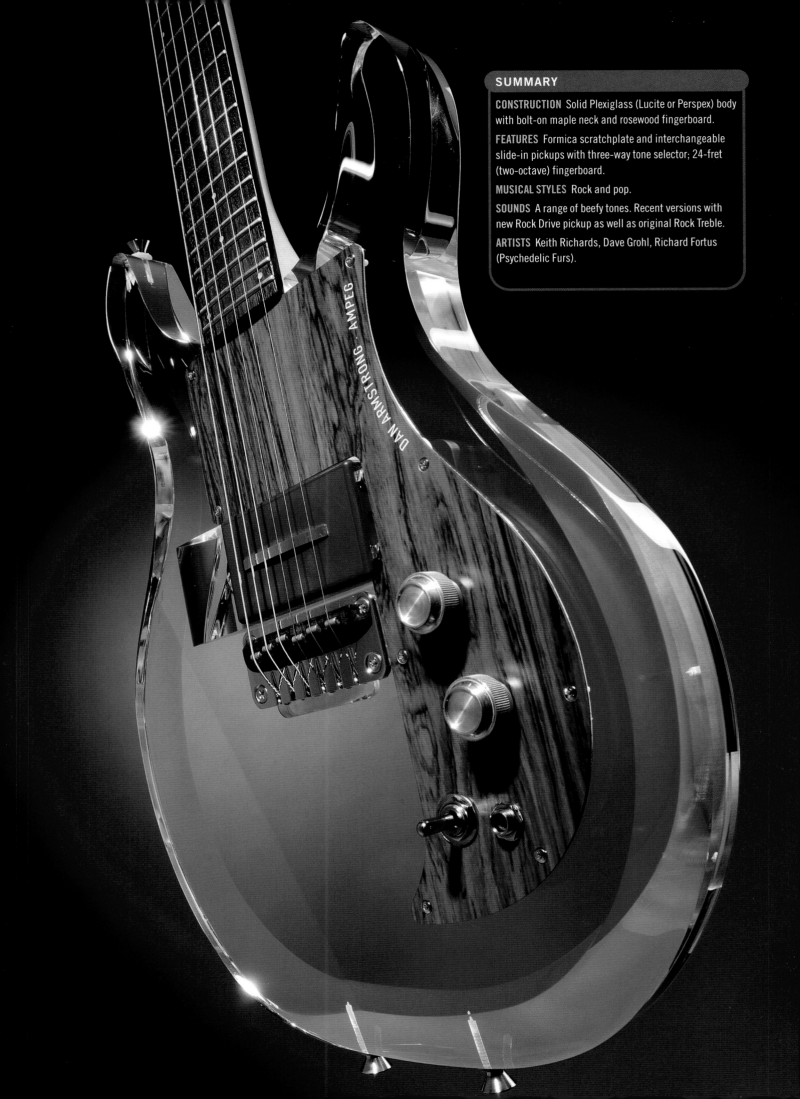

SUMMARY

CONSTRUCTION Solid Plexiglass (Lucite or Perspex) body with bolt-on maple neck and rosewood fingerboard.

FEATURES Formica scratchplate and interchangeable slide-in pickups with three-way tone selector; 24-fret (two-octave) fingerboard.

MUSICAL STYLES Rock and pop.

SOUNDS A range of beefy tones. Recent versions with new Rock Drive pickup as well as original Rock Treble.

ARTISTS Keith Richards, Dave Grohl, Richard Fortus (Psychedelic Furs).

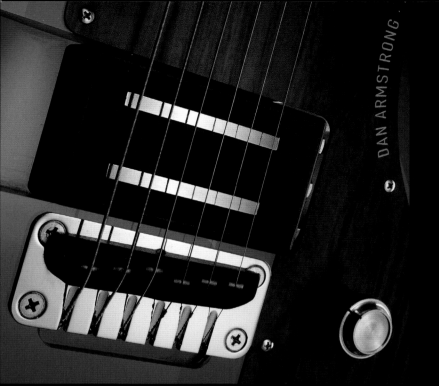

Ampeg Dan Armstrong Plexiglass

Although the "See-Through" guitar was designed before the 1960s were out, the late Dan Armstrong's Plexiglass baby is back with a bang, with slide-in pickups and Formica scratchplate – just like the original.

Keith Richards of The Rolling Stones has always had an eye for a cool guitar. He was playing Gibson Les Pauls before Eric Clapton and Led Zeppelin's Jimmy Page, was an early champion of Music Man's elegant Silhouette, and, at the turn of the 1970s was often seen with a transparent six-string. This was the Dan Armstrong "See-Through" or "Plexiglass".

The guitar world is peppered with great innovators – far-sighted individuals who combine aesthetic taste with ergonomic sense and engineering brilliance. One of these was Dan Armstrong of Ampeg, without whom the electric guitar could not have advanced to the position it holds today. Ampeg made guitar and bass amplifiers in Linden, New Jersey, and in the late 1960s approached technician Armstrong to see if he could come up with a modernistic guitar and bass that would put the company in contention with Fender's and Gibson's potent designs. Armstrong went away and dreamed up an instrument built from transparent acrylic known as Plexiglass, Lucite, or Perspex. The "Plexi", as it became known, offered a host of other innovations that would set 1969's guitar world alight. The idea behind the plastic body was that it would be so dense that it would have virtually no acoustic properties at all – even solid-wood guitars resonate and have some acoustic volume – so all the listener heard was the electronic sound of the pickups and amp.

Opposite and above
Dan Armstrong designed the Ampeg using Plexiglass not only to look fabulous but also to produce an instrument with a body that did not resonate like a wooden one and therefore affect its sound. Tone should come from the pickups and controls alone.

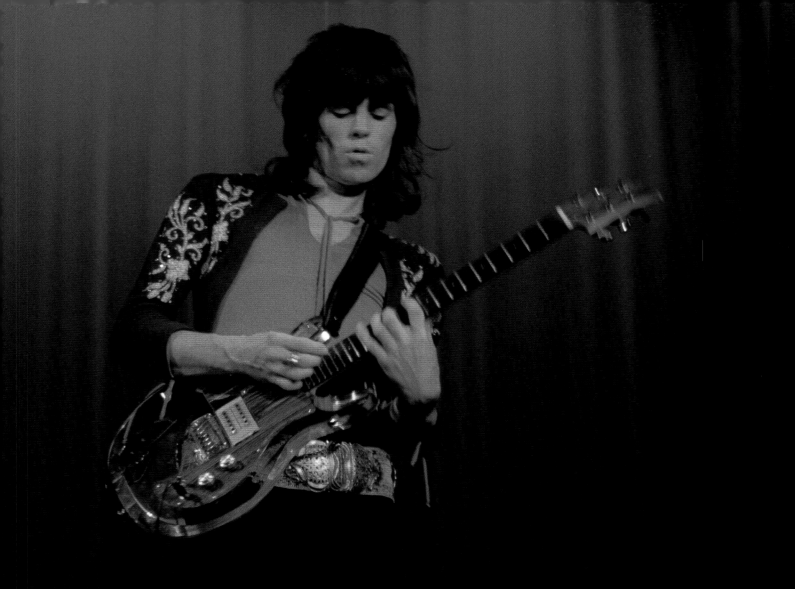

As well as a fantastic-looking transparent body, chamfered around its edges like a Gibson SG, the Plexi featured a set of interchangeable slide-in pickups, a clever tone-switching system that offered a variety of great sounds, and a Formica scratchplate. It was also the first production guitar to have 24 frets, or two full octaves, clear of the body.

The Plexi was an instant hit and was immediately picked up by The Stones' guitarist, who loved its looks and aggressive tones and used his from 1969 to 1971. Although a particularly weighty guitar, the Plexi's acrylic body and huge pickups – developed by electronics guru Bill Lawrence – lent it a unique tone, while its innovative 24-fret neck provided playability that was years ahead of its time. Today's users include The Foo Fighters' Dave Grohl and Justin Hawkins of The Darkness – players whose music is hard-edged and uncompromising.

Despite its initial popularity (at the guitar's height in 1970 Ampeg were reportedly making 600 a month), owing to production problems and issues between Armstrong and Ampeg, by 1971 the instruments were no longer being made. Although the original had tuning problems because of its rather "Heath Robinson" rosewood bridge and haphazard string saddle arrangement, these have been all but eradicated in Ampeg's 2006 reissue, a guitar that looks set to rekindle the excitement of the year that gave us Woodstock, "Honky Tonk Women", and a man on the moon. Dan Armstrong died in 2004, at the age of 70.

Above Keith Richards of The Rolling Stones was the first major player to use Ampeg's Plexiglass – his undeniable coolness added iconic status to an already groovy guitar.

"I really liked it but it was a prototype and somebody stole it. I tried more of them but the quality [of the replacements] wasn't there."
Keith Richards

Burns Marvin

Although they were both best known for their use of Fender Stratocasters, for a while during the 1960s The Shadows' Hank Marvin and Bruce Welch were seldom seen without their matching Burns guitars.

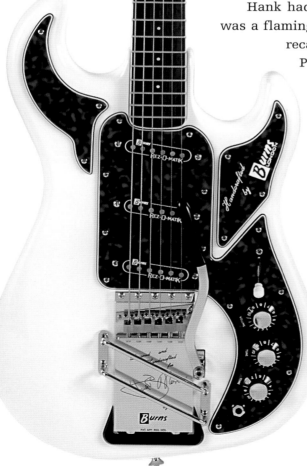

The music of The Shadows was characterized by strong melodies and clean guitar tones. Lead guitarist Hank Marvin and dedicated rhythm player Bruce Welch were the perfect team. Hank supplied the tunes – aided and abetted by lashings of echo and use of his guitar's vibrato arm – and Bruce played perfectly intoned and beautifully timed accompaniment. The band featured on dozens of U.K. chart hits for over three decades from the late 1950s onward – with and without teen idol singer Cliff Richard.

Welch was a perfectionist when it came to music, and his perfectionism would cause a switch in the instruments used by The Shadows between 1964 and 1970.

Hank had famously received Britain's first Fender Stratocaster – "It was a flamingo pink one and Cliff ordered it from the Fender catalogue", recalls Marvin – and the rest of the band, including Jet Harris on Precision bass, followed suit with Fender.

In the studio, Welch usually preferred to play acoustic for his rhythm tracks. Playing live, it was his own Stratocaster, but Bruce became increasingly obsessed by tuning problems and in 1963 the band spoke to Burns about designing a "Shadows" guitar with many of the Fender's sonic characteristics but with a vibrato system that held its tuning to Bruce's satisfaction.

The Marvin, as it became known, was indeed a Fender-like instrument but Burns cleverly disguised its body shape by using multiple mock-tortoiseshell body plates. Hank came up with the idea of a violin-style "scroll" headstock and the instrument was born. It is certainly a striking guitar – especially in the white finish chosen by the band (green sunburst was another option but this lacked the impact of white).

Left Like Fender, Gibson, and Gretsch, Burns was bought by a large corporation and suffered as a result. Baldwin purchased it in 1965, but quality diminished and it closed in 1970.

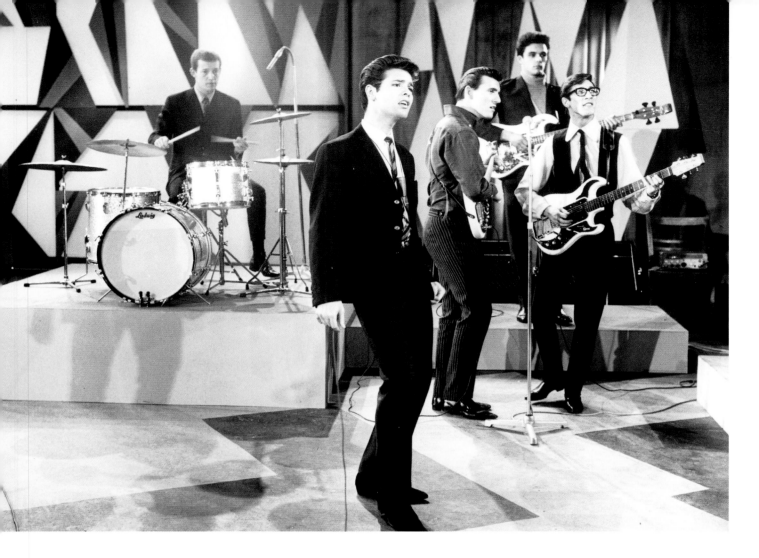

Above For the second half of the 1960s, British instrumental band The Shadows ditched their Stratocasters and were seen almost exclusively with Burns guitars – a massive boost for the company but still not enough for financial success.

SUMMARY

CONSTRUCTION Solid American alder body with bolt-on maple neck and rosewood fingerboard (new guitars are also available with maple 'boards).

FEATURES Three Rez-O-Matic single-coil pickups with alnico magnets; multiple "jigsaw" body plates in tortoiseshell (or mint green on new models); Rez-O-Tube vibrato system; volume, tone, and pickup selector.

MUSICAL STYLES Instrumental pop.

SOUNDS From the outset Burns and Marvin were after the plummy but clean sound so perfectly delivered by Fender's Stratocaster, but the British guitar's tone was if anything fatter – think of "The Rise And Fall Of Flingal Bunt" by The Shadows.

ARTISTS Hank Marvin and Bruce Welch (The Shadows).

The Shadows' use of the Marvin guitars proved to be a great boost to the fortunes of Burns. Born in 1925, James Ormston Burns came from County Durham in England's north-east and was an engineer, carpenter, and paint sprayer by trade. While serving in the RAF, he built his own guitar from scraps, and on leaving the service he set up his own business in the Midlands, soon moving to Romford, which is near London. He was also a successful lap-steel guitarist in his own right.

Burns, whose skills as a designer and engineer outweighed his business acumen, brought out a variety of models before the Marvin, including the Sonic range and his giant horned beast, the Bison. The original Bison was simply not cost-effective and only 49 were made – apparently number 50 became a coffee table! In 1962, Burns released a simplified version.

In 1965, owing to being heavily in debt to his suppliers, Burns sold the company to the American piano and organ manufacturer Baldwin in a move that echoed Leo Fender's sale of his company to CBS. Indeed, many similarities existed between the two men – both

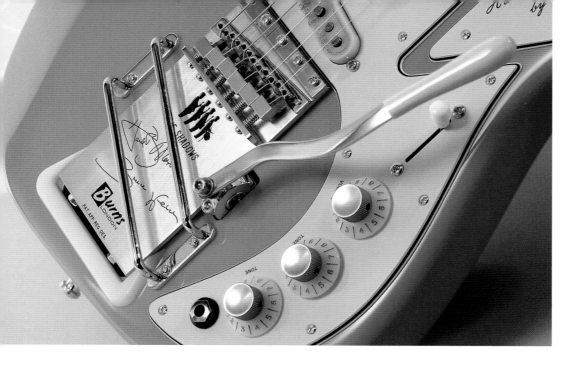

were insatiable workers full of ideas, able to crack engineering and playability problems and make the musician's dream a reality.

The Baldwin era was not an auspicious one for Burns. Output increased but the quality of the instruments suffered. As a consequence, when in 1970 The Shadows' instruments were stolen, they decided to return their allegiance to Fender. Jim Burns made several comeback attempts in the 1970s but by then unfortunately he was out of step with the guitar-playing public.

In 1992, he became consultant to a newly formed company, Burns London, but died in 1999. Today, Marvin-style models are still made – probably better than they ever were – and bought by legions of fans still true to the music of The Shadows.

Burns Bison

The culmination of Burns design was this impressive monster of a guitar. With its twin body horns pointing both inward and upward, jazz guitarist and Burns user Ike Isaacs said "It looks like a bloody bison" and the name stuck. The first version debuted in 1961 as a glued-in neck guitar boasting an array of four Ultra Sonic pickups, a vibrato system with over 30 moving parts, and the ingenious "cigar", a metal cover that masked the tuner posts and ugly string windings. It also employed a radical truss rod system designed by Burns using a "gearbox" mechanism to adjust it – when Baldwin bought Burns and Gretsch later in the 1960s, the American instruments adopted the Burns idea. Sonically the Bison was extravagant too and over the years has included "split sound" and "wild dog" circuitry that offered various pickup combinations and tone selections. Due to their scarcity original Bisons are extremely collectable, fetching premium prices for a British guitar. Today a version of the simpler three-pickup model is available – still a handsome beast – but built in the Far East.

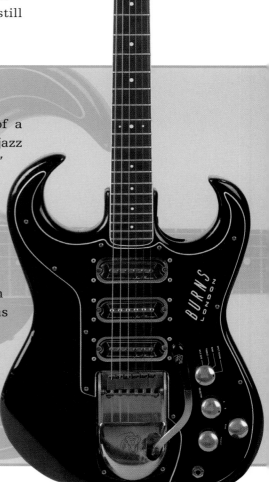

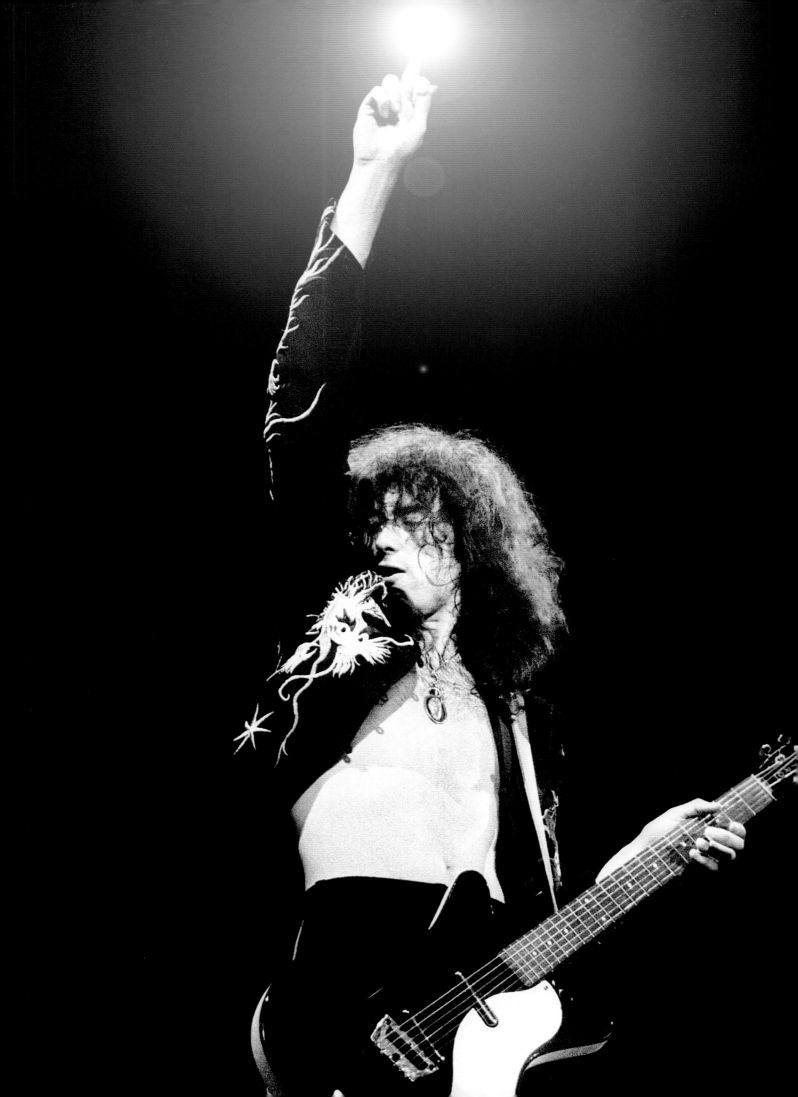

Danelectro Shorthorn Standard

Would you believe that a stapled-together beginner's guitar like those made for mail-order catalogues was often the instrument of choice for the guitarist in the world's greatest rock band?

Opposite and below When Led Zeppelin performed at London's Earls Court in May 1975 at the height of their worldwide fame (left), Jimmy Page could afford any guitar he desired. Yet he still chose to play the lowly Danelectro on "Babe I'm Gonna Leave You" and other songs.

When Led Zeppelin's Jimmy Page – who had the choice of any guitar in the world to play – needed a certain sound, a sound that no other guitar could give him, he turned to a "catalogue special" designed by Nathan Daniel.

Daniel had no pretensions when it came to building electric guitars. "Make 'em cheap and sell 'em cheap" might well have been his motto. Having worked for Epiphone as an amplifier designer from 1935 to 1946, he set up his own firm the following year and soon began making instruments for sale through Sears Roebuck under the Silvertone brand. He also produced guitars with the Danelectro badge that were sold through other intermediaries to the budget market. Until 1956 these were made using conventional solid-body construction.

At this time Daniel, probably believing that student electric guitars and the rock and roll music they were being used to play were more or less disposable, decided to build them that way. The trouble was that not

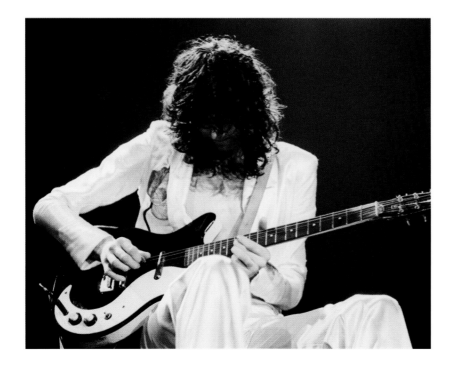

"I used the Danelectro in the latter days [of The Yardbirds]. I used it on stage for 'White Summer'. I used a special tuning on that – a sitar tuning, in fact ... It's taken a bit of a battering, the Danelectro guitar, I'm afraid." Jimmy Page

only did they not fall to pieces, but they also happened to sound extremely good.

Made from a stapled-together poplar wood frame with Masonite (hardboard) front and back, off-white vinyl stuck around the edges to conceal the cheap construction, and pickups whose electronics were housed in cast-off lipstick tubes, Danelectro guitars somehow managed to look cool. A huge range of models was produced, including the single-cutaway U model – in one- and two-pickup format – and the aptly named Longhorn, which, in bass guitar form, John Entwistle used for his thunderous solo on The Who's "My Generation". The double-cutaway Standard later became known as the "Shorthorn" for obvious reasons.

Over the years, by comparison to expensive vintage guitars or even new Gibsons, Gretsches, or Fenders, the Danelectro's cheapness and disposability has made it attractive both to beginners and to the rich and famous, who are not only looking for individual tone but perhaps revelling in a kind of inverted snobbery as well. Jimmy Page, who bought his Danelectro Standard while with The Yardbirds, sits alongside players such as Aerosmith's Joe Perry, Beck, and Jimi Hendrix, who used a Shorthorn while serving in the U.S. Army. His Danelectro student guitar served Jimi well, since he was to go on to become the greatest electric guitarist ever.

SUMMARY

CONSTRUCTION Poplar wood frame with Masonite (hardboard) top and back with vinyl around the edges to mask construction technique; bolt-on maple neck with rosewood fingerboard.

FEATURES Two "lipstick tube" pickups with three-way selector; dual concentric knobs for volume and tone on each pickup; simple bridge with wooden saddle; 21-fret neck with "Coke bottle" headstock.

MUSICAL STYLES Rock and blues.

SOUNDS Raunchy and earthy single-coil tones have more "grit" than Fenders – think of live versions of "Kashmir", "Babe I'm Gonna Leave You", and "Black Mountain Side".

ARTISTS Jimmy Page, Eric Clapton (Blind Faith), Beck, Syd Barrett (Pink Floyd).

Opposite You may not have seen one, but you will have heard a Coral Sitar on hundreds of records including Stevie Wonder's "Signed, Sealed, Delivered", "Have You Seen Her" by The Stylistics, and Joe South's hit "Games People Play".

Coral Electric Sitar

The Coral Electric sitar was designed for session guitarist Vinnie Bell, who required an instrument that could produce the Indian sitar sounds prevalent in late 1960s psychedelic music but without the years of practice normally required to master the instrument. Danelectro's answer was a burgundy "crackle finished" instrument, vaguely gourdlike in shape with a handy session player's knee cut-out and built from solid poplar with built-in chambers. Vinnie Bell's name was visible under a clear scratchplate.

The instrument boasted 13 drone strings that resonated in sympathy with whatever was being played on the instrument's regular tuned six guitar strings. A special "buzz" bridge created the characteristic "miaow" sound and the result was a convincing effect. Chords could also be played on it, unlike with

genuine sitars that are built specifically for single-note playing.

If you think you have not heard a Coral sitar, think again. It was the staple sound of many Motown tracks, including Stevie Wonder's "Signed, Sealed, Delivered"; The Stylistics used it on numbers such as "Have You Seen Her", and Vinnie Bell himself played the memorable hook lines from Freda Payne's "Band Of Gold" and The Lemon Pipers' "Green Tambourine". It also played the main riff in The Box Tops' 1960s hit "I Cry Like A Baby" and Joe South's "The Games People Play".

The Coral electric sitar is a must-have in any session guitarist's equipment, and manufacturers such as Jerry Jones make high-quality reissues. You can hear electric sitar (pioneered by Danelectro/Silvertone/Coral) on songs from The Supremes to Metallica!

Duesenberg Starplayer TV and Special

This German builder has been crafting fantastic retro guitars for the past decade or so and has rapidly made an impact with blues and rock guitarists around the world.

Opposite The two models pictured are: the 49er with DP90 and Grand Vintage humbucker combination; and the Starplayer TV Outlaw in black Tolex with Super Tremola vibrato.

Dieter Gölsdorf has been in the music industry since the 1970s when he began making kit guitars under the Rockinger name. In 1980, he produced the world's first fine-tuning vibrato system, the Rockinger Tru Tune Tremolo. A collector of Gibson guitars featuring his favourite P-90 pickup, Gölsdorf started to experiment with building his own, initially as direct replacements but finally made to fit the ubiquitous humbucker-size cover. The Duesenberg name was first used in 1986 on a range of futuristic designs, but since the mid-1990s has been mainly applied to some eye-catching retro models. It is the detail that makes Duesenberg so attractive – Art Deco-style scratchplates, tuner buttons, and knobs; sparkly plastics, metal truss rod cover, and a stylized metal "D" logo on the body all add to the feeling that these guitars come from former times. Weird and wonderful finishes include green pearl, blue sparkle, and even black "croc" Tolex vinyl. But the attention to manufacturing detail, playability, and sound makes these guitars more than quirky video props.

Central to the range are the solid-body Starplayer Special and semi-solid Starplayer TV. Using laminated construction – spruce for the top and maple for the back and rims – the Starplayer TV features a Gibson 335-style solid centre block and a single f-hole. Pickups are Duesenberg's own Domino single-coil (P-90 style pickup in humbucker housing) at the neck and Grand Vintage humbucker at the bridge. It also has Gölsdorf's much-improved Bigsby-type tailpiece. The all-solid Starplayer Special follows the same single-cutaway design, but this time the maple neck is attached to the body so it looks glued but is in fact held in place by two large machine bolts. The Special's maple-capped body is made of alder, giving a lighter, more dynamic response. This time pickups are both humbucking, a Grand Vintage at the neck and Crunchbucker at the bridge. Electrics on both models are simple, with just master volume and tone, plus three-way pickup selector. The TV's DP90 and Grand Vintage combination offers a great balance of blues to rock tones: the "both pickups on" position elicits a funky "hollow" sound all its own, while the Special's double-bucker formula provides a rockier, more robust tonality.

SUMMARY

CONSTRUCTION Single-cutaway bodies – solid alder and maple on Starplayer Special and laminated maple on semisolid TV; glued maple neck on TV and bolt-on maple for Special.

FEATURES Duesenberg DP90 and Grand Vintage pickups on TV, Grand Vintage and Crunchbucker on Special; master volume and tone plus three-way selector switch. Tremola vibrato on TV, stud tailpiece and tune-o-matic bridge on Special; metal "D" plate on body with three-step Art Deco scratchplate.

MUSICAL STYLES Blues and rock.

SOUNDS Thick and gutsy – semisolid TV more dynamic; in-between sound on DP90/Grand Vintage combination hollow and "spanky".

ARTISTS Ron Wood, Mike Campbell, ZZ Top, Mike McCready (Pearl Jam), Davey Johnstone (Elton John band), Elvis Costello.

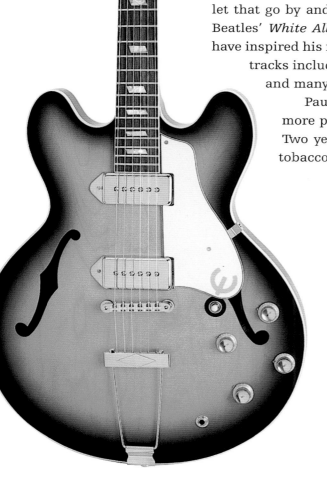

Epiphone Casino

In the "Swinging Sixties", Gibson launched a sister brand to its own successful line of thinline f-hole guitars. The Epiphone brand developed a following of its own, including three famous Liverpool lads.

Looking at Epiphone's elegant Casino, with its obvious visual connections to the company's jazz guitars of the 1930s and 40s, it is perhaps hard to picture it as purveyor of heavy rock. But in the hands of Paul McCartney it helped to create some of the hottest tones ever in modern music.

"I heard Pete Townshend being interviewed about a song they had that he reckoned was the heaviest thing anyone had ever done", said the ex-Beatle, alluding to The Who's "I Can See For Miles". "Well, I wasn't going to let that go by and so I came up with 'Helter Skelter'." The song from The Beatles' *White Album* was said by hippy cult leader Charles Manson to have inspired his murderous antics, but other equally heavy Casino-driven tracks included "Paperback Writer" (Paul played the song's meaty riff) and many of the sounds found on the *Revolver* album onward.

Paul had bought the guitar in 1964 and it had been used on more poppy tracks such as "Another Girl" and "Ticket To Ride". Two years later, both other guitar-playing Beatles also bought tobacco-sunburst-coloured Casinos, but John Lennon had his

SUMMARY

CONSTRUCTION Slimline semi-acoustic body made from laminated maple – hollow, with no centre block; glued-in mahogany neck with rosewood fingerboard and single parallelogram position markers (earliest model had pearloid dots); neck joins body at 16th fret.

FEATURES Twin P-90 pickups (earliest had a single P-90 mounted in the middle); black plastic covers changing to nickel in 1963; two volumes and two tones with three-way selector switch; white pickguard with "E" logo (earliest model's was tortoiseshell).

MUSICAL STYLES Pop and pop-rock.

SOUNDS Fat and naturally overdriving. Earthy and basic, the guitar is perfect for riffing or for lower end of the neck solos.

ARTISTS Beatles Paul, George, and John; Paul Weller.

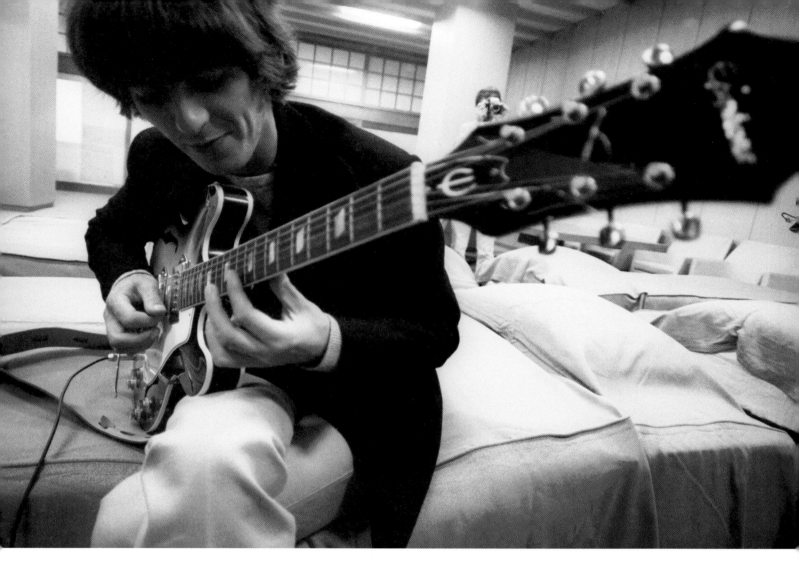

Above All three guitar-playing Beatles had Casinos. Paul acquired his in 1964 and used it on many early tracks, including "Ticket To Ride", "Another Girl" (*Help!*), and later numbers on which he played electric guitar, such as "Paperback Writer", "Taxman" (*Revolver*) and "Good Morning" (*Sergeant Pepper*). Harrison (above) and Lennon bought their Epiphones as a direct result of McCartney's success with the instrument.

"If I had to choose one electric guitar it would be this."
Paul McCartney

stripped and lightly lacquered to leave it natural. This was the guitar he played on the roof of the Apple building on 30 January 1969 – the group's final live performance together. Featuring two f-holes and slimline, all-hollow construction, the instrument's front, back, and sides were made of thin laminates, steam-pressed to form their arched, cellolike appearance. The Casino also carried a pair of Gibson P-90 pickups. Known for their powerful output, in the semi-acoustic setting this was highlighted with extra bass and the possibility of feedback typical of hollow-body guitars.

Gibson had bought the Epiphone company in 1957, and designed the Casino and its sister guitar the Riviera to build alongside its existing ES-335 and ES-330 models; the Casino's designation was in fact ES-230. But why produce two such similar guitar lines? Gibson's U.S. dealers had agreements whereby rival stores in the same city were not allowed to stock Gibson products, so the Epiphone brand was a clever marketing ploy that gave the manufacturer double coverage compared to other manufacturers.

While today Epiphone is seen as Gibson's poor relation – most instruments are made in East Asia – up until 1969 they were built in the same factory and were similarly priced. Some guitarists preferred the less ostentatious sister brand. While the Casino was a fine instrument in its own right, its Beatle influence cannot be overstated. Noel Gallagher of Oasis and Paul Weller, both avowed fans of the "Fab Four", adopted Epiphone semis, while other groups whose music can be traced back to 1960s sounds and fashion are often fans of Epiphone's classy Casino.

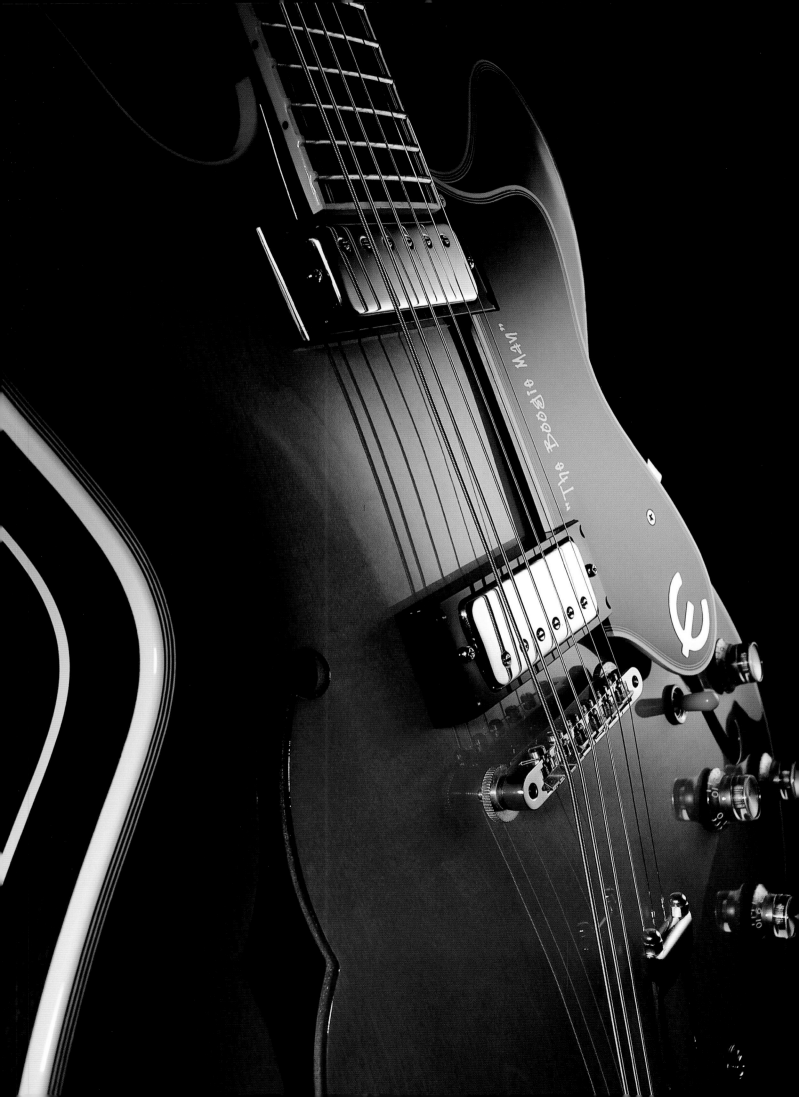

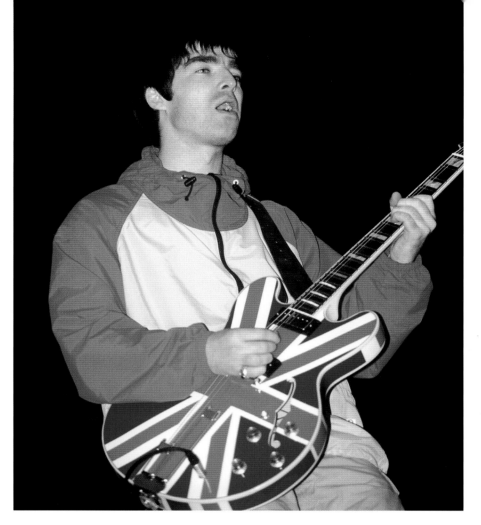

"Before we became very wealthy young men, I used to use Epiphone guitars. But they're really a poor man's Gibson, which is what I now use. I don't have a deal with them, as I don't go in for that sort of thing. But I did design a guitar for Epiphone once."
Noel Gallagher

Epiphone Sheraton

Where Gibson had its ES-335/345/355 line of sensational semisolids, sister brand Epiphone – made in the same factory from 1958 onward – made a somewhat lower-key entrance.

Opposite and above John Lee Hooker preferred Epiphone Sheratons to the Gibson semis of blues musicians B.B. and Freddie King. Epiphone made him the "Boogie Man" guitar (left).

One particular thinline Epiphone guitar was the choice of both a Mississippi blues giant and a writer of pop anthems from the north-west of England. John Lee Hooker had been associated with the brand since father of electric blues T-Bone Walker gave him his first electric – an Epiphone – when the two met in Detroit in the early 1950s. Oasis guitarist Noel Gallagher's use of an Epiphone semi is traceable back to three mop-top lads from up the road in Liverpool.

There is little doubt that Epiphone's slimline but all-hollow Casino would have been consigned to "also-ran" status, like its Gibson ES-330 relation, had it not been for the use of the guitar by George Harrison, John Lennon, and Paul McCartney. The Beatles drew attention to a marque that otherwise lived in the shadow of its superstar sister Gibson. And, while the Casino's sibling the Riviera should have registered higher on the playing public's radar, its chances were destroyed by tiny, inappropriate-looking New York single-coil pickups (replaced by similar-looking Gibson mini-humbuckers in 1961) and an ugly Frequensator tailpiece.

SUMMARY

CONSTRUCTION Laminated arched maple top and back, solid maple centre block; mahogany neck and rosewood fingerboard; "fern" headstock inlay and "V" block markers in pearl and abalone.

FEATURES Early models had Epiphone New York single-coil pickups, replaced with Gibson mini-humbuckers.

MUSICAL STYLES Blues and pop-rock.

SOUNDS Tough and edgy when distorted, warm and mellow when clean – think of "Live Forever" by Oasis.

ARTISTS Noel Gallagher (Oasis), John Lee Hooker.

Another semi in the Epiphone stable fared slightly better than the Riviera, however. This was the top-line Sheraton, whose combination of gold-plated parts, flashier bindings, and the lovely "fern" headstock inlay (seen on the company's pre-Gibson Emperor model of the 1950s) visually made sense. This was John Lee Hooker's Epiphone of choice and – in 1980s Japanese guise – the one on which Oasis' Noel Gallagher's fortune was forged. It was the Sheraton he had painted in Union Jack fashion and which later formed the basis for the Supernova model (visually more like a Casino/ES-345 cross!) that was available in similar finish – as well as in the blue of Manchester City football club.

The Sheraton was the most upmarket of Epi's thinline semis, built alongside the Gibson ES-355 and its equivalent for levels of equipment and flash. Its multiple body, headstock, and scratchplate binding, snazzy "fern" inlay, and "V-block" markers on an ebony fingerboard lent the kind of elegance that harked back to Epiphone's glory days, the jazz years of the 1930s and 40s. It was a gorgeous package that should have done better. But its indifferent Epiphone New York pickups did not do the guitar justice. Although a Bigsby vibrato was available on the Sheraton's launch, the quirky unit that became standard after 1961 (along with much-improved Gibson mini-humbuckers) was a poor substitute.

As collectors' instruments, Sheratons (and Rivieras) hardly figure on the same scale as their Gibson equivalents (or that of the Beatle-biased Casino), and, while the original Riviera still looks uncomfortable in its own skin, the more elegant Sheraton strikes an elegant pose whether kicking out John Lee Hooker's "Boom Boom" or "Live Forever" by Oasis.

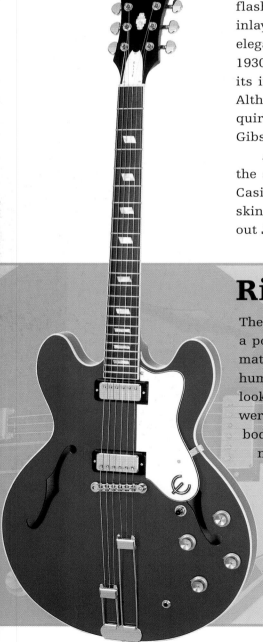

Riviera

The least successful of Epiphone's thinline semis, the Riviera was a poor substitute for its sister guitar the Gibson ES-335 and no match for its stablemate the Casino. With its powerful large humbucking pickups, the Gibson not only sounded huge but looked great, too. By comparison, the Riviera's mini-humbuckers were too thin-sounding and looked too small for the guitar's large body. The Casino, while limited in playability due to its 16th-fret neck join compared to the Riviera's more accessible 19 frets clear of the body, sounded so much better with its hot P-90 pickups. The fact that The Beatles ignored the Riviera in favour of the Casino also lent it no credibility. A white scratchplate and truss rod cover added a certain elegance to the guitar's appearance, but its Frequensator tailpiece smacked of fussiness. So this otherwise almost great guitar was consigned to also-ran status.

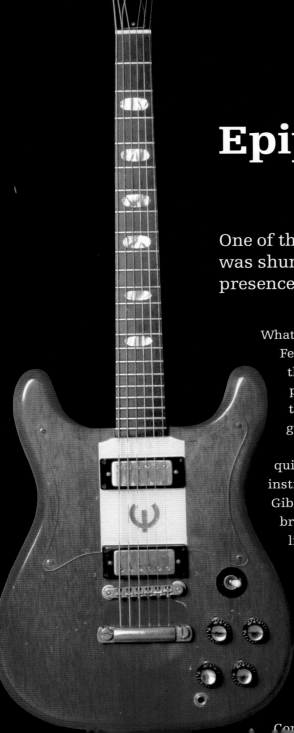

Epiphone Coronet & Crestwood

One of the prettiest solid-body electric guitars of all was shunned on its 1958 debut, but is finally making its presence felt almost 50 years on.

What do Babyshambles' Pete Doherty and Nick McCarthy of Franz Ferdinand know that so many guitarists don't? Well, among other things, the fact that back in 1958, before Epiphone began producing East Asian copies of famous Gibson models such as the Les Paul, SG, and Firebird, some of the company's electric guitar designs were delightfully unique.

Gibson had bought the ailing firm just a year earlier, but quickly adopted Epiphone as a sister brand to its own line of instruments. It would appear that some designs, already on the Gibson drawing board but deemed unsuitable for the parent brand, might better suit the Epi line. So it was with the pretty little Coronet. Along with its big sisters, the more lavishly equipped Crestwood and Wilshire, the Coronet cleverly amalgamated elements from a variety of sources. Fender's Telecaster formed the original blueprint and, with a bit of scaling down, the addition of a top horn and more rounded edges on a mahogany rather than ash or poplar body, the guitar took on its own identity. Its styling borrowed from Gibson's own double-cutaway Les Paul Junior and probably also went on to influence its replacement the SG.

Designed as a beginner or "junior" instrument, the first Coronet featured a single Epiphone New York pickup. This mini

humbucker would form the basis for Gibson's 1963 Firebird power plant and also equip the Les Paul Deluxe that would come a decade later. The guitar also came with a metal-plate Epiphone logo on its three-a-side headstock and an asymmetrical white scratchplate. But within a year the pickup had become Gibson's ubiquitous P-90 single-coil and the plate took on the larger and more elegant double-sized look that now characterizes the model. By 1961 the metal logo had become pearl and a couple of years later the transformation was complete with a slightly elongated upper horn and the six-a-side "batwing" peghead that suits the design so well.

It is the Coronet's elegant simplicity that makes it so appealing. Its all-mahogany construction (save for the dotted rosewood fingerboard), with glued-in neck and finished in see-through cherry lacquer, removes it from Fender territory, although the influences are plain. Its barking, resonant tones make it ideal for punk-laced pop, and, with bands such as Babyshambles and Franz Ferdinand playing them, Coronets are becoming sought after. The fully formed later design – batwing headstock, longer top horn, and symmetrical scratchplate – is the most collectable. The Coronet was discontinued in 1970 and, although some Korean reissues were made in the late 1990s, these were a far cry from the simple beauty of the originals. So perhaps now is the time for an up-to-date remake.

SUMMARY

CONSTRUCTION Slim mahogany body with glued-in mahogany neck; early model featured three-a-side headstock while later version sported the famous "batwing" design.

FEATURES Single Epiphone New York pickup on earliest version, quickly changed to Gibson P90; wrapover combination bridge/ tailpiece; lop-sided early scratchplate switched to later symmetrical style with "E" (known as "slash C") logo.

MUSICAL STYLES Punk pop.

SOUNDS Ringing and fat distorted chords and riffs.

ARTISTS The Coronet, like Fender's Telecaster Deluxe, is the choice of cool, punk-inspired pop bands such as Franz Ferdinand and Babyshambles.

Above Two later Epiphone solid-bodies: the single-pickup Coronet carries the optional vibrato, while the overlaid instrument is the 1963–9 Crestwood Deluxe with pearl inlaid ebony fingerboard and three mini-humbuckers

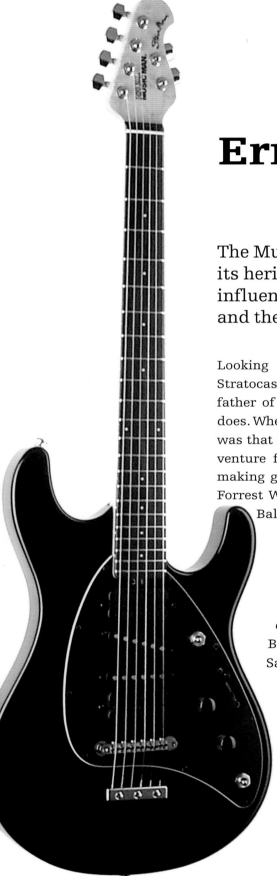

"When I'm on tour I bring the Music Man. When something works you don't change it. I've been with her I think 11 years – we're a couple, her and me."
Steve Morse

Ernie Ball Music Man Silhouette

The Music Man Silhouette is a guitar that owes its heritage to two of the United States' most influential designers: the string giant Ernie Ball and the irrepressible Leo Fender.

Looking at Music Man's elegant Silhouette, the DNA of Fender's Stratocaster is hard to miss. Yet, while the guitar's design has no link to the father of bolt-on-necked mass-production guitars, the Music Man name does. When Fender sold out to CBS in 1965 for $13,000,000, part of the deal was that Leo would not become involved in any guitar or amplifier-related venture for 10 years. So it was not until 1976 that Music Man began making guitars, basses, and amps, with Leo joining ex-Fender employees Forrest White and Tom Walker on the board. String manufacturer Ernie Ball had helped design the company's innovative bass the StingRay, while his son Sterling also worked for the company.

At the beginning of the 1980s, owing to poor sales of certain Music Man products and deteriorating relations between Leo and his partners, Fender quit Music Man, joining his old pal George Fullerton to form G&L. The old Music Man closed its doors in 1984 but was soon in the hands of Ernie and Sterling Ball, with production shifting to Ernie's old Earthwood factory at San Luis Obispo on the Californian coast.

The Silhouette was the new company's first six-string and it was an instant hit. Continuing Leo's four-plus-two tuner arrangement from earlier Music Man models the StingRay and Sabre, the Silhouette was a beautifully built instrument, light in weight and vibrant of tone. It was a far cry from the hefty lumps being built by Gibson and Fender at the time.

Left The Silhouette was Ernie Ball Music Man's first guitar. Launched in 1986, its trademarked "four and two" tuner arrangement set it apart from any other electric on the market.

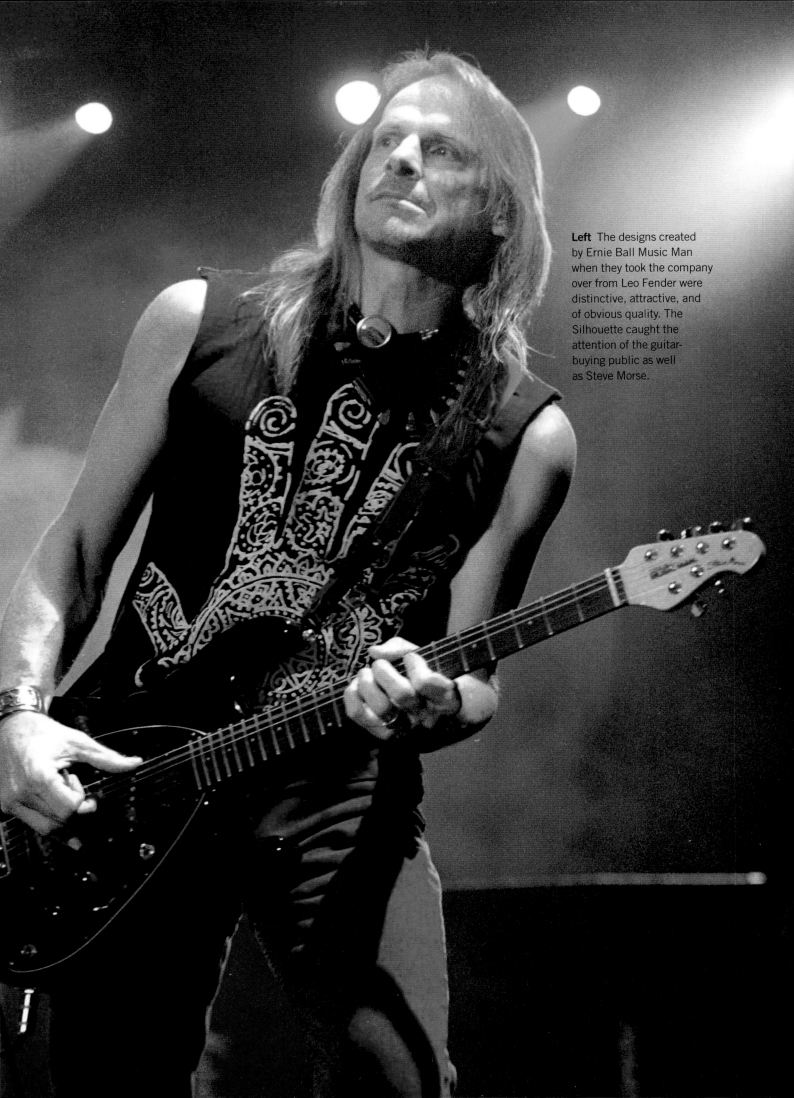

Left The designs created by Ernie Ball Music Man when they took the company over from Leo Fender were distinctive, attractive, and of obvious quality. The Silhouette caught the attention of the guitar-buying public as well as Steve Morse.

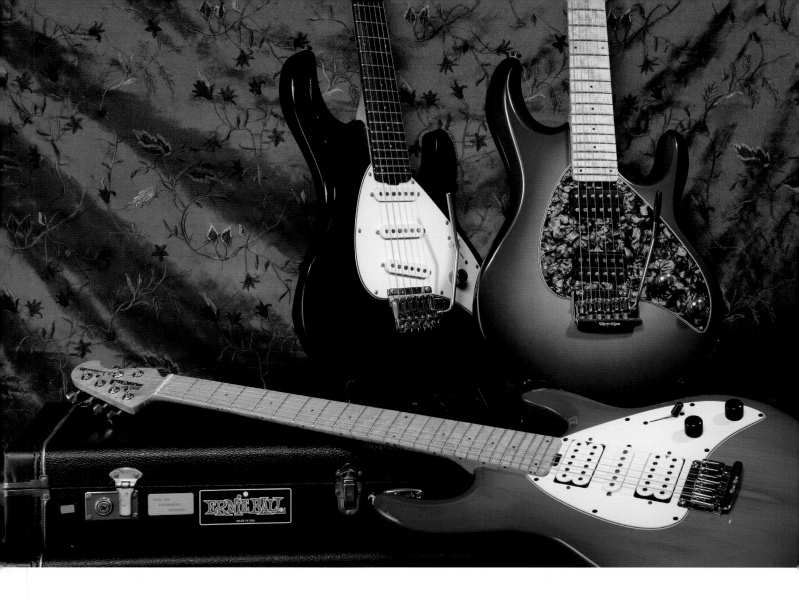

Music Man necks were slim and easy to play, finished in gunstock oil for a natural touch that made them feel played-in and organic. Necks were held in place with five, not four, bolts on a longer-than-usual heel that guaranteed there was no slippage or poor string alignment. Usability was further aided by the inclusion of a simple truss rod adjustment mechanism that did not require removal of the neck or strings. It was as if guitar design had moved on 50 years in just 12 months. Some high-profile players quickly adopted the Silhouette as their choice of instrument on stage, including Keith Richards and Ronnie Wood of The Rolling Stones. Such endorsement secured Music Man's position among the world's top guitar constructors.

Today's Silhouette is available with or without vibrato unit, or with a piezo bridge for pseudo-acoustic tones. It is a more rock-orientated instrument than the earlier Strat-style model, with either two humbuckers and middle single-coil (Silhouette) or two singles with bridge humbucker (Silhouette Special).

Although these instruments are made in tiny numbers, this has helped Sterling Ball and his forward-thinking company maintain boutique-style quality and attract endorsers.

Above The Silhouette is available with a variety of pickup combinations – three single-coils, two humbuckers, two humbuckers and a single-coil, and even Fishman's excellent Power Bridge for creating "acoustic" sounds.

SUMMARY

CONSTRUCTION Solid ash double-cutaway body with bolt-on maple neck – five bolts with deep-set heel.

FEATURES Earlier models had three single-coil pickups; options now available include H/S/H and S/S/H arrangements, vibratos, and piezo bridges; famous "four and two" tuner layout.

MUSICAL STYLES Light rock, country, and blues.

SOUNDS Twangy and bright.

ARTISTS Keith Richards, Ronnie Wood, Steve Morse.

> "Sterling Ball said to me one day, 'I think I have a guitar with your name on it' ... I've been using the model ever since ... " Albert Lee

Ernie Ball Music Man Albert Lee

This quirky-looking instrument is the main six-string of a British musician who has made his name as the foremost exponent of American hot country guitar.

Albert Lee's signature Music Man guitar is the result of the guitarist's evolution in playing and an association with a range of instruments during his illustrious career. Albert was brought up on the quick-fire licks of Gene Vincent's guitarist Cliff Gallup and, having mistaken Buddy Holly's Stratocaster for one, flirted with a Grazzioso Strat copy before settling on a three-pickup Gibson Les Paul Custom. He then became fascinated by the sound of Speedy West's guitarist Jimmy Bryant and Elvis Presley's 1970s sidekick James Burton, and discovered that they played Telecasters. In Britain at this time, the Tele was deemed a "rhythm" guitar, since The Shadows' ace strummer Bruce Welch was pictured on the group's debut album holding one – next to Hank Marvin's "lead" Strat. Undeterred, Albert bought his first Tele and loved its twangy sound. Using a Tele, he was to gain fame alongside his hero James Burton in Emmylou Harris's Hot Band and use it on stage to play his lightning-fast signature tune "Country Boy".

Move on some years and Albert is playing Tele-style guitars built by Phil Kubicki – Lee was often photographed using one of these during his five-year

stint playing with Eric Clapton. They featured three single-coil pickups and Albert got used to the combinations that were available using bridge and middle and, in particular, neck and bridge units.

When Sterling Ball introduced the company's excellent Silhouette model – another "three single-coils" guitar – he gave several of them to Albert, because the guitarist had offered advice on the guitar's features and design. Albert played them while backing The Everly Brothers and had one particular favourite. The instrument that eventually became the Albert Lee Model had "been kicking around for a couple of years", according to Albert, before Ball showed him the guitar, believing that it might suit his requirements.

Indeed the two seemed made for each other, the instrument's curious angular design somehow echoing the guitarist's facial features. Albert and his main see-through pink Music Man have been almost inseparable since that time, although the instrument's original maple body has been switched to the lighter weight and more dynamic-sounding ash.

Albert's long-time friend and pickup guru Seymour Duncan has also created special design single-coils for the instrument. Very Stratlike in tone, Albert's death-defying licks sound clean and mean on his signature guitar, whether he is touring Europe with his band Hogan's Heroes, performing with country superstars in the United States, or appearing as guest lead guitarist in Bill Wyman's boogie band The Rhythm Kings.

Rarely has a guitar's look and sound so perfectly complemented its player as the Music Man that was made for Albert Lee.

SUMMARY

CONSTRUCTION Asymmetrical ash body (early models maple) with deep-set five-bolt bird's-eye maple neck.

FEATURES Three Seymour Duncan special-design single-coil pickups; pink-burst finish.

MUSICAL STYLES Country and rock and roll.

SOUNDS Smooth fat Strat-type tones, especially with neck and middle pickups together.

ARTISTS George Harrison, Elvis Presley.

Ernie Ball Music Man Van Halen

When in 1991 Ernie Ball Music Man gained the mighty Eddie Van Halen as its star player, things could not have looked better.

When the album *Van Halen* hit the streets in 1978, shock waves coursed through the guitar community. No one since Hendrix or Clapton had induced such passion in the instrument and Van Halen's playing style formed the basis of rock guitar technique for the next decade.

Van Halen's early successes came on a "homemade" guitar dubbed the "Franken-

strat". He later switched to a Kramer guitar with a similar paint job and handmade vibe.

In 1991, an instrument appeared that fulfilled Eddie's wish for the perfect guitar. After collaborating with Sterling Ball, the EVH was released. Featuring a basswood body with striking flamed maple top and a gunstock oiled neck shaped exactly to the wear of Eddie's favourite Frankenstrat, the EVH boasted two custom DiMarzio pickups and Floyd Rose licensed vibrato. It also had a single volume knob and a three-way pickup selector on the lower horn. A "four and two" headstock with pearl-buttoned Schaller tuners completed the picture.

Van Halen was known for his self-styled "brown" sound, a menacing tone that contained less distortion than expected. The vintage-voiced specially designed DiMarzio humbuckers were screwed directly to the guitar's body, allowing more of the body's vibrations to be transmitted to the guitar. The basswood body timber, too, is known for its lack of influence over the tone. His Floyd Rose vibrato was set so

that it only lowered the strings' pitch – standard setup raises it as well.

The EVH went straight into the big league of "most wanted" guitars. When Eddie was lured to the giant Peavey Corporation, players thought they might lose it completely. But Sterling Ball and his team tweaked it and renamed it the Axis. The Axis Sport is also available.

SUMMARY

CONSTRUCTION Solid basswood body with quilted maple cap; deep-set five-bolt neck custom-shaped to Eddie's specification.

FEATURES Twin DiMarzio special-design pickups; Floyd Rose licensed vibrato (operates down only); volume knob marked "Tone".

MUSICAL STYLES U.S. rock.

SOUNDS Dark but smooth "brown" sound.

ARTISTS Eddie Van Halen.

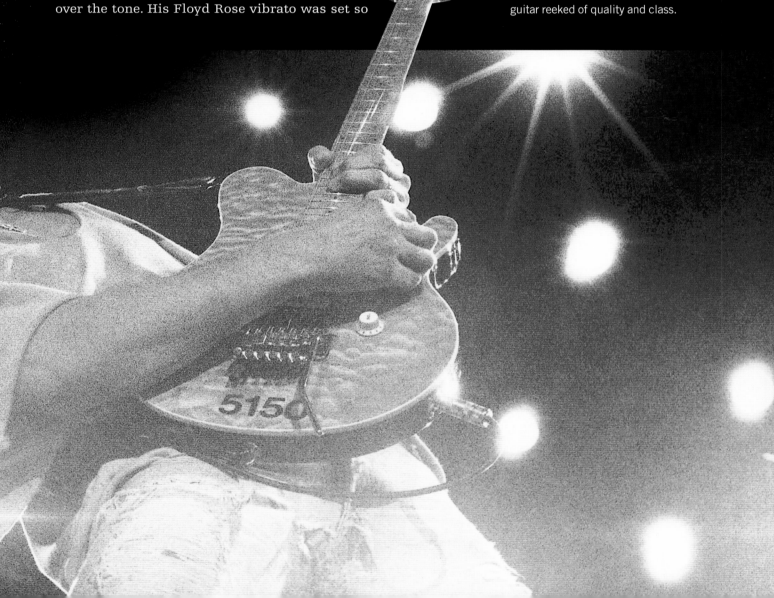

Below The Van Halen model EVH was big news for Music Man and for Eddie Van Halen. The fabulous guitar reeked of quality and class.

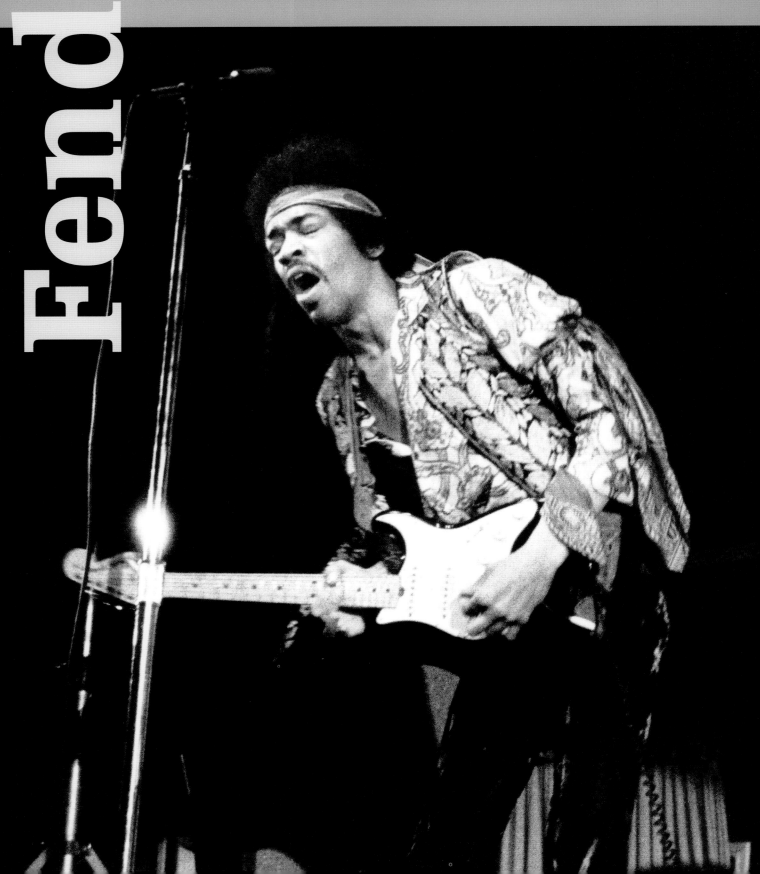

Fender

"The time I burned my guitar it was like a sacrifice. You sacrifice the things you love. I love my guitar." Jimi Hendrix

Fender Stratocaster

The most recognizable and copied of all electric guitars, Fender's Stratocaster is revered – along with the Coca-Cola bottle and the Volkswagen Beetle – as one of the most evocative icons of modern design.

Elegant, sexy, mean, and brooding, one look at the Fender Stratocaster's sleek lines and sweeping curves tells you it is a classic. Designed when pink Chevvys with whitewall tyres and chrome bumpers ruled southern California's ocean boulevards, the Strat echoed the United States' post-war obsession with outer space and rode the same wave of optimistic youth culture that was to bring rock and roll into the world.

While the Telecaster had broken the mould four years earlier with its modular, solid-body design, even Leo Fender's own milestone looked Neolithic by comparison. While the Tele's body was a simple slab of ash, its younger, prettier sibling boasted twin body horns, rounded edges, and contours that made it hug the player's body with unheard-of intimacy. Although the earliest Strats were two-tone brown and yellow sunburst, soon they were being offered in a range of "custom colours" – the same Du Pont finishes that were used by the American auto industry – meaning that early Fender catalogues taunted us with names such as Fiesta Red, Lake Placid Blue, and Sea Foam Green.

With characteristic clarity of vision, Leo Fender realized that musical instruments needed to be usable, not just beautiful. So, as well as the Stratocaster's lightweight "custom contoured body", he included three pickups for unprecedented tonal variation, controls that operated intuitively, and his masterstroke – a built-in vibrato system that stayed in tune. This was not form over function; it was form and function in absolute harmony.

Every guitarist seeing a Strat for the first time coveted it. In Britain, the first real exposure to the instrument was with Buddy Holly's album *The*

Left So simple, elegant, and practical was Fender's 1954 Stratocaster that its basic design elements haven't been altered for over 50 years.

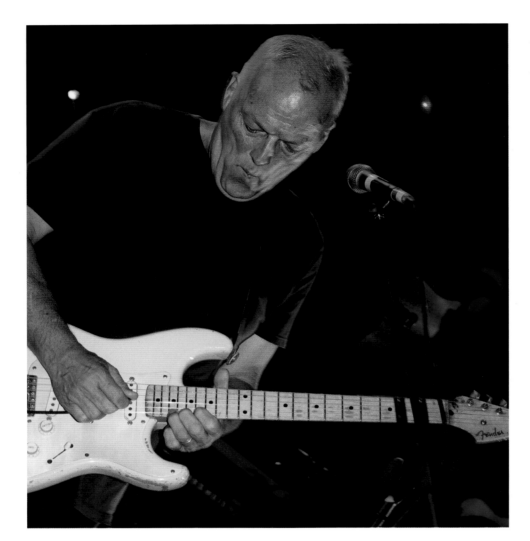

Left David Gilmour has been voted the most influential Stratocaster player of all time by guitar magazines. His melodic style with long, soaring solos relied heavily on the Stratocaster's cutting single-coil sound, helping to make Pink Floyd one of the highest selling rock bands of all time.

Opposite Leo Fender's futuristic design could have come off the drawing board in the 21st century. The fact that it was conceived in the early 1950s and launched the year before rock and roll took off with Bill Haley's "Rock Around The Clock" (1954) is testament to Fender's practicality and engineering genius. Think of an electric guitar and, more than 50 years later, you still imagine a Fender Stratocaster.

"Chirping" Crickets, on which the bespectacled star was plainly sporting one. The Shadows' Hank Marvin saw it and adopted not only the guitar – the first one in Britain, in Fiesta Red – but also the horn-rimmed glasses. Mark Knopfler of Dire Straits, whose own hero was Marvin, admitted: "A Strat was a thing of wonder. When I was 14 or 15 The Shadows were a big influence, and they had the first Strat that came to England – Hank Marvin played Strat lead and Bruce Welch played Tele rhythm."

The Strat's early popularity with players such as Marvin ensured its temporary fall from favour when The Beatles exploded onto the scene. Deliberately eschewing Fenders "because The Shadows used them", George and John opted for Gretsch, Rickenbacker, and Epiphone models – as did most who followed them. When the British blues boom hit in 1966, players such as Eric Clapton, Peter Green, Jeff Beck, and Jimmy Page preferred Gibson Les Pauls for their power and and their ability to sustain (although the Strat's charms would eventually seduce all but Page).

In 1967, Jimi Hendrix wowed the world with his far-out looks, psychedelic songs, and extraordinary guitar-playing. Although not the first to use wah-wah, fuzz, and feedback effects, they became his trademark. He also played a Fender Stratocaster – upside down! A left-hander, Jimi flipped his Strat over but restrung it conventionally (the thinnest string nearest the ground), because he preferred the controls and vibrato bar in this position.

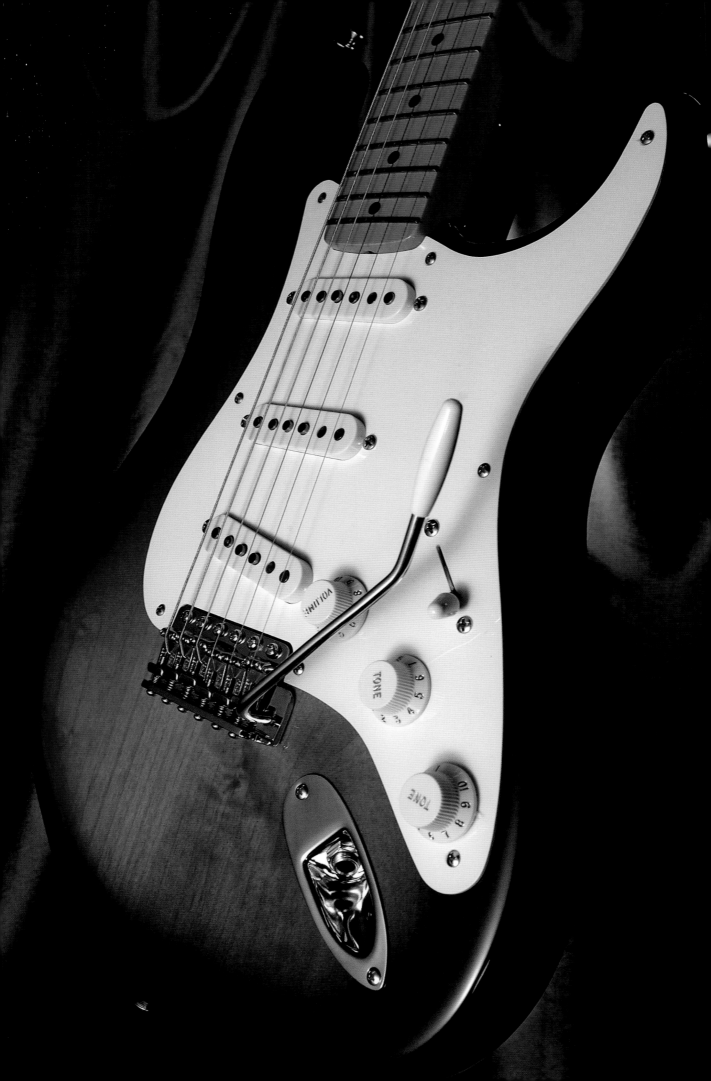

Hendrix's influence was unprecedented. He single-handedly made the Stratocaster cool again, and many red ones that had been bought to play Shadows numbers were refinished in white to echo Jimi's favourite colour.

Today the Fender Stratocaster is the world's number one electric guitar. It has been used to play almost every kind of music. In the hands of blues players such as Stevie Ray Vaughan, Eric Clapton, and Robert Cray it has been perhaps at its most vocal, but even today it is the main choice of Zutons' guitarists David McCabe and Boyan Chowdhury, as well as the multi-platinum-selling Red Hot Chili Peppers.

Below The Stratocaster has been the instrument of choice for many of the world's top players, and today Fender makes "signature" models for its most famous users. Below we see (left) the Jeff Beck Strat with noiseless pickups and modern floating vibrato, (centre) the Rory Gallagher Strat, a faithful reproduction of the late Irishman's beaten-up 1961 guitar, and (right) the Eric Clapton Strat that features a special booster circuit, V-shaped neck, and disabled vibrato system.

SUMMARY

CONSTRUCTION Solid ash or alder body with screwed-in maple neck – rosewood fingerboards were introduced in 1959 and both options remain; six-a-side headstock with Fender transfer logo.

FEATURES Three single-coil pickups mounted on a single-ply white or white-black-white laminated scratchplate; single volume and two tone knobs; 21 frets on vintage models and 22 on later U.S. versions; synchronized vibrato system with screw-in arm.

MUSICAL STYLES Primarily the instrument of blues and rock. Its clean clear tones made it the favourite of rock and rollers such as Buddy Holly, and instrumental guitar bands like The Shadows. In the hands of Eric Clapton and Stevie Ray Vaughan it is perhaps the ultimate blues guitar, while Mark Knopfler and David Gilmour favour it for its clarity of voice in Album Oriented Rock (AOR) music.

SOUNDS The Stratocaster is capable of everything from a piercing treble pickup sound – Buddy Holly's "Peggy Sue" – to a warm neck pickup tone – "The Wind Cries Mary" by Jimi Hendrix – and a wiry, hollow voice – Dire Straits' "Sultans Of Swing".

ARTISTS The list includes Eric Clapton, Jimi Hendrix, David Gilmour, John Frusciante (Red Hot Chili Peppers), Chris Rea, The Killers, Buddy Holly, The Shadows, Rory Gallagher, Ron Wood (The Rolling Stones), Jeff Beck, Stevie Ray Vaughan.

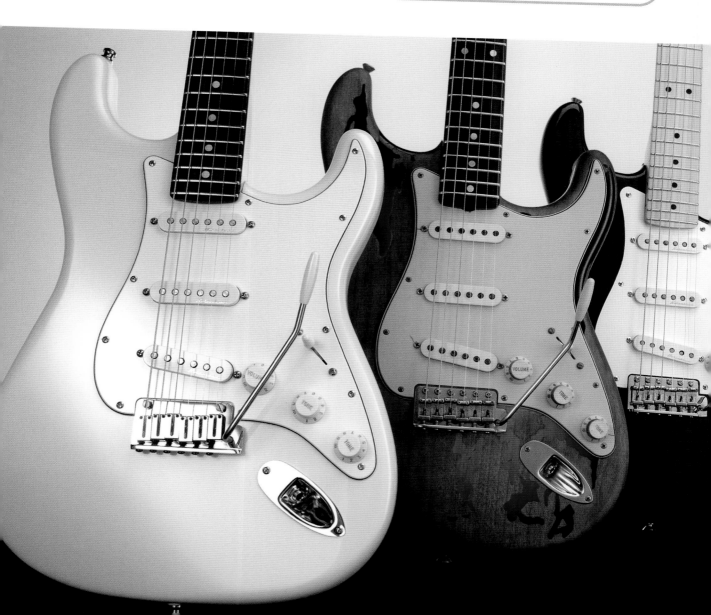

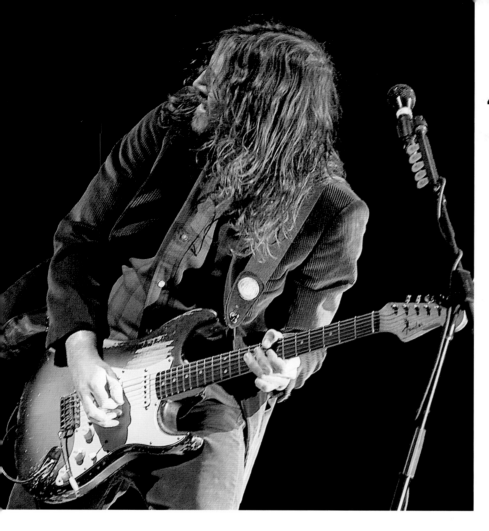

"When the guys asked me to rejoin the band I said I really need a Stratocaster. So Anthony [Kiedis, vocals] lent me the money and we went to Guitar Center and I got the one with the rosewood neck. It's a '62 and I used that on virtually every track on *By The Way*."
John Frusciante

Fender VG Strat

More than 50 years after Fender set the world alight with its groundbreaking Stratocaster, the company has teamed up with synthesizer giant Roland to try to do it all over again.

The VG Strat uses Roland's patented COSM technology to "model" the sounds of several different guitars, including Fender's Telecaster, Gibson-style humbucking tones, and even acoustic guitars. On top of that there are five alternative tunings – normal, drop D, DADGAD, baritone, open G, and 12-string. The sounds are digitally recreated with Roland's onboard electronics, with each string's vibrations individually captured by the Roland GK "hex" pickup mounted in front of the bridge.

Master volume and tone controls operate in standard fashion and the Strat's five-way selector switch offers its usual fare – so you can use the VG as a straightforward Stratocaster, too. But two extra knobs provide the model selections and tuning options; it is here that the guitar's versatility shines through – flip from Strat to Tele to Les Paul to 12-string acoustic in an instant. Or play in open G for the verses and switch to standard tuning for the solo.

Fender was not the first with a modelling guitar: Californian company Line 6 beat them with its innovative Variax range. Yet no other instrument has the Strat's sex appeal and sheer desirability, so, despite the VG's relatively limited palette and its inability to store its users' own sounds, the Roland/Fender collaboration looks like it is set for success – and who knows what further enhancements could be waiting just around the corner?

Buddy Holly was the first Stratocaster superstar. His picture on the front of *The "Chirping" Crickets* album inspired legions of guitarists to become Fender fans. His catchy guitar style employed all three Strat pickups and made use of its revolutionary vibrato system.

Hank Marvin entreated singer Cliff Richard to order him a Fiesta Red Strat with gold-plated parts – then the most expensive model in the Fender catalogue. For British guitar fans it was the ultimate electric guitar, and most Strats imported to Britain were in this colour.

Jeff Beck has been associated with various makes of instrument, but in recent years the Strat has become indispensable to his music. Beck milks every tone available from the guitar and his use of the vibrato system is beyond anything Leo could possibly have imagined.

Stevie Ray Vaughan took the influences of Jimi Hendrix and Albert King and turned them into something wholly new and exciting. His style was a high-octane blend of traditional blues and modern rock that inspired an entire generation of soundalikes.

Ritchie Blackmore took influences from rock and roll and classical music to invent neo-classical rock. Blackmore "scalloped" his Strats' fingerboards, removing wood from between the frets for easier string-bending. His abuse of the instrument's vibrato bar is legendary!

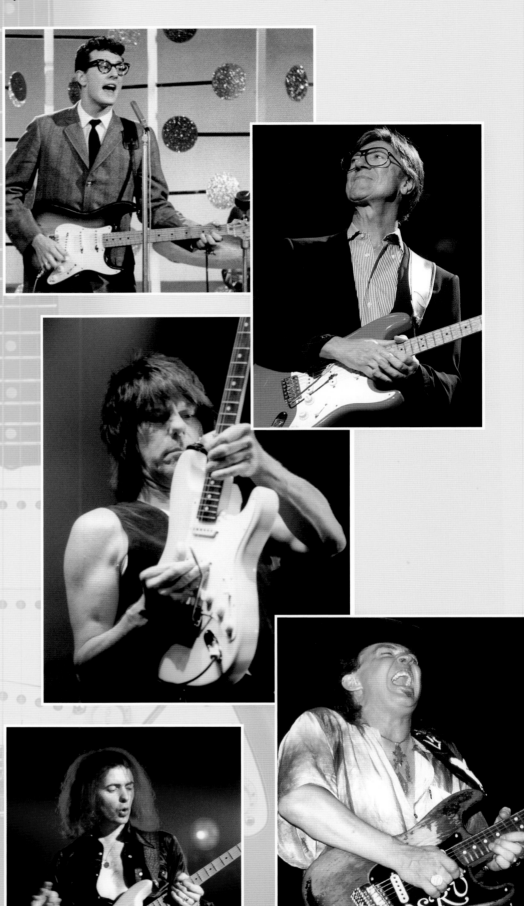

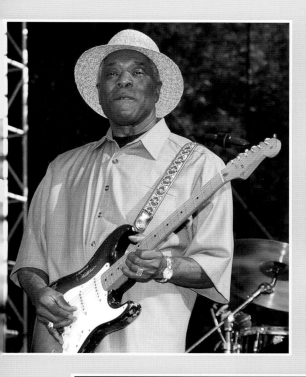

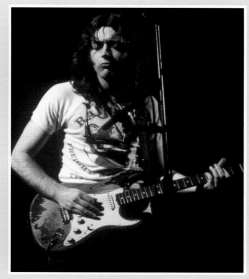

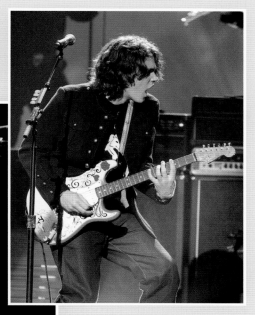

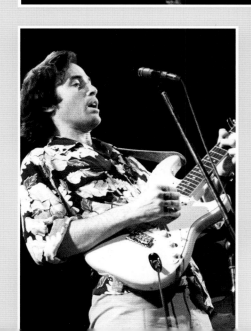

Rory Gallagher bought the first Stratocaster in Ireland and it was his primary instrument until his death in 1995. Rory's was one of the hardest-working Strats ever, and the finish of his famous three-tone sunburst guitar became totally worn away.

Buddy Guy converted to Strats from the more conventional thinline semi, and was one of the few black blues players to do so. Commonly seen with his signature "polka-dot" Strat, in recent years Buddy has reverted to a classic 1950s sunburst model.

John Mayer is a multi-Grammy-winner, and he has his own "signature" model Stratocaster. Mayer is widely regarded as one of the most important guitarist-singer-songwriters of the new millennium, having moved from acoustic-based music to blues-tinged pop with the John Mayer Trio.

Eric Clapton came to fame as a Gibson player, adopting the Les Paul, SG, and ES-335. After Hendrix's death he switched to the Strat almost exclusively, his famous "Blackie" and "Brownie" becoming the most expensive instruments ever sold at auction.

Yngwie Malmsteen hit the scene in the early 1980s as a young Swedish guitarist following in the footsteps of Ritchie Blackmore. He melded classical influences with rock techniques.

Ry Cooder and his beautiful bottleneck guitar playing – as heard in the soundtrack to the 1984 film *Paris, Texas* – influenced others such as Bonnie Raitt and Chris Rea to take up slide guitar and to use the Fender Stratocaster.

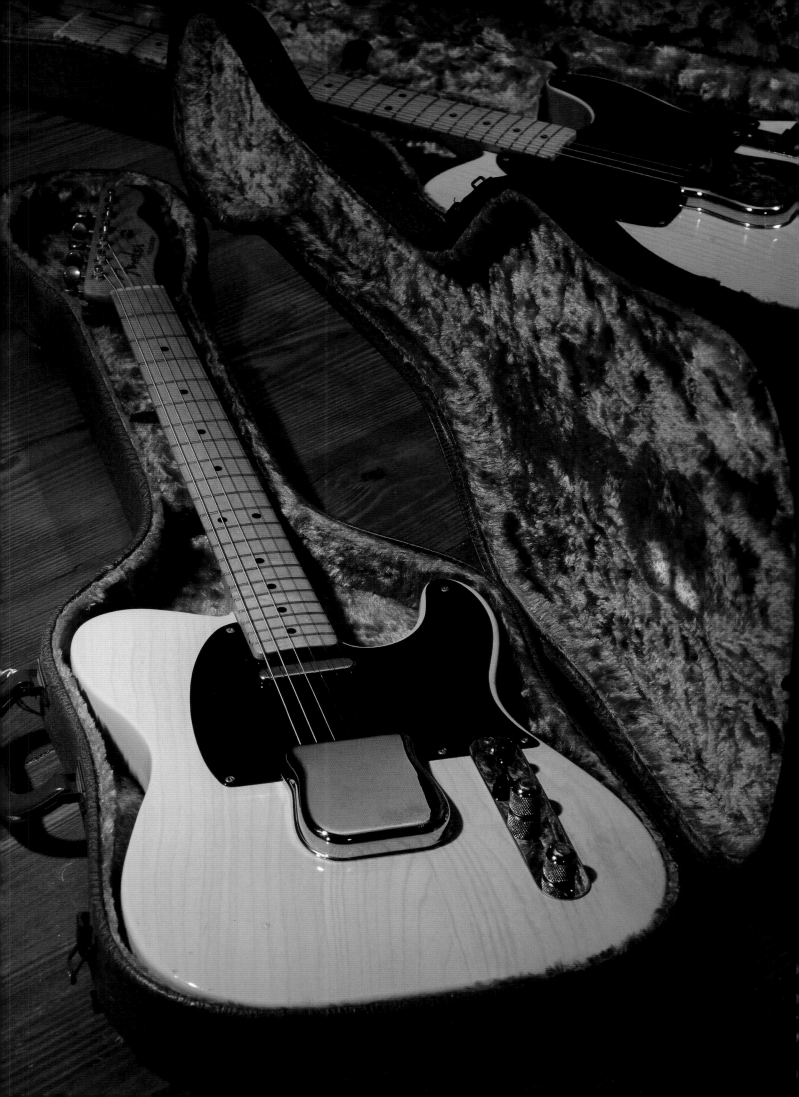

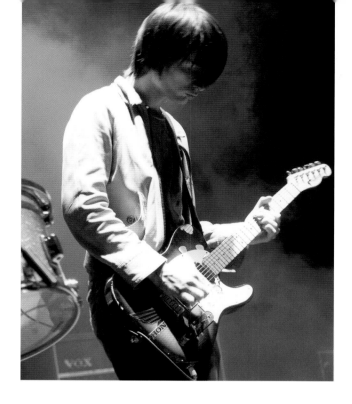

"My first Telecaster was stolen so I had to get a new one. The good thing about getting new equipment is that it comes straight from the shop and is not worn out after 40 or 50 years of practice."
Jonny Greenwood

Fender Telecaster

In many ways, the guitar that kicked off the 1950s also triggered the search for a new sound and led the way to rock and roll and the rise of the pop group.

Opposite The first production solid-body electric and still in many people's eyes the best of them all, the Tele is simplicity itself in every department but can take any style of music and any level of player in its stride.

When examined alongside many of the guitar designs available today, it is easy to view Leo Fender's 1950 Telecaster as a bit of a "plain Jane". It is simple enough when compared to its own stablemates the Stratocaster, the Jazzmaster, and the Jaguar, but positively austere when put alongside flamed maple, gold-plated, and pearl-inlaid offerings from the likes of Paul Reed Smith and Gibson. Yet the Tele, as it is affectionately known, is not only one of the greatest electric guitars ever made, but its historical significance is monumental.

Although innovators such as Merle Travis, Paul Bigsby, and Les Paul had been experimenting with solid-bodies for years, Fender's brilliance – inspired by his engineer's logic and sense of practicality – was to create the first production guitar built from a solid plank. Whether it was he who initially came up with the idea of a detachable one-piece neck for ease of manufacture and repair, a simple adjustable bridge, or pickups that provided a modern, twangy tone, it does not really matter. That he put all these ideas into cogent musical form in his Orange County, California, factory was enough to earn the tag of genius.

In continuous production since the day it was launched, the Tele simply worked. At less than 5cm (2in) thick, it was a mere sliver compared to the jazz guitars that had gone before. Each of its 21 frets was accessible thanks to a generous cutaway in the body. Its twin pickups – made with a single coil of wire and six magnets – provided a tone so crisp and vibrant that its appeal to younger players was all but assured. Initially finished in butterscotch-coloured lacquer with white maple neck and fingerboard, at

its launch the Tele's "vanilla" looks caused nothing but amusement from rival guitar companies. Derided as the "plank" by top manufacturer Gibson and given no chance of success, just two years later the market leader had been panicked into creating its own solid-body guitar (with a little help from Les Paul). Despite jumping on the solid-body bandwagon, the Fender twang still eluded the competition – Gibson in particular – and in no time Leo was the one to beat in the electric guitar market. Improved guitar amplification, mainly from Fender's own products, assisted the solid-body guitar's rise in popularity and its relatively cheap price compared to traditional instruments meant that the Tele could not fail.

The guitar's list of players is seemingly endless. The Tele is the instrument of masters – Jeff Beck and Eric Clapton both cut their teeth on

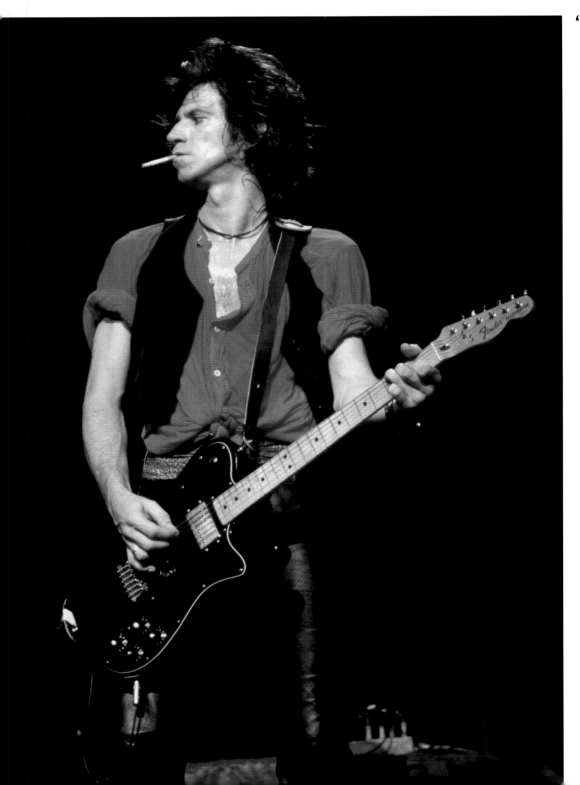

"Keith Richards uses a Telecaster, but he takes the sixth string off and tunes it to G. That's what The Rolling Stones use all the time."
Ike Turner

Left and opposite Its simplicity of design made the Tele ripe for experimentation. Many players beefed it up by installing a humbucking pickup in the neck position. Fender caught on and offered the Custom (left), sporting this modification, and the Deluxe with two humbuckers designed by Seth Lover of Gibson fame. Solid rosewood, paisley finish, and f-hole thinline (pictured right with sunburst Tele Custom) variations have all proven popular.

it. It is the guitar of cool – The Stones' Keith Richards, Bruce Springsteen, Blur's Graham Coxon, Jonny Greenwood of Radiohead, Bob Dylan, and Coldplay's Jonny Buckland all swear by it. It is the instrument of the blues – Muddy Waters and Albert Collins used it exclusively. It is a real rock and roller – Status Quo have made a career out of it. It is also the females' favourite – Sheryl Crow, The Pretenders' Chrissie Hynde, and bluesgirl Susan Tedeschi all adore its non-macho nature.

Most of all, though, the Telecaster is the guitar of country music. Watch any CMA award show and Teles are everywhere – check out veterans Merle Travis, Johnny Cash's guitarist Luther Perkins, and Buck Owens; watch the brilliant Marty Stuart or Vince Gill; and marvel at the incredible Brad Paisley or the late, great Roy Buchanan and Danny Gatton.

As a final footnote to the Tele's superb versatility, Led Zeppelin's beefiest riff (the one in "Whole Lotta Love") and the solo that has been voted "best of all time" (in "Stairway To Heaven") were both played by Jimmy Page on Leo Fender's "plank" – which is not a bad endorsement for the homely old Telecaster.

SUMMARY

CONSTRUCTION Solid ash or alder, but various other timbers have been used, such as rosewood; and there are semisolid versions with f-holes; maple neck with either rosewood or integral maple fingerboard; six-a-side headstock.

FEATURES Regular Tele has two single-coil pickups, volume and tone controls with three-way selector; other versions have two Seth Lover-designed humbuckers or one humbucker and one single-coil; simple three-saddle bridge on classic Tele but six-way bridges available on some modern versions.

MUSICAL STYLES Telecasters can be used in any style, from rock and pop to jazz, but country has become the instrument's best-known genre with the Tele the staple instrument to be seen with.

SOUNDS Anything from warm jazz to dirty blues, searing country and heavy rock – think of "Whole Lotta Love" by Led Zeppelin, or anything by Mike Stern (jazz fusion), Muddy Waters (blues), and Brad Paisley (country).

ARTISTS More or less everyone, but Bruce Springsteen, Jimmy Page, Keith Richards, Muddy Waters, Albert Collins, Brad Paisley, Jonny Greenwood (Radiohead), Graham Coxon (Blur), and Mike Stern have all made important statements with the Telecaster.

Next page Keith Richards loves the wiry Telecaster sound but often brings extra power to the guitar with the addition of a neck humbucker. Ronnie Wood usually prefers a Strat.

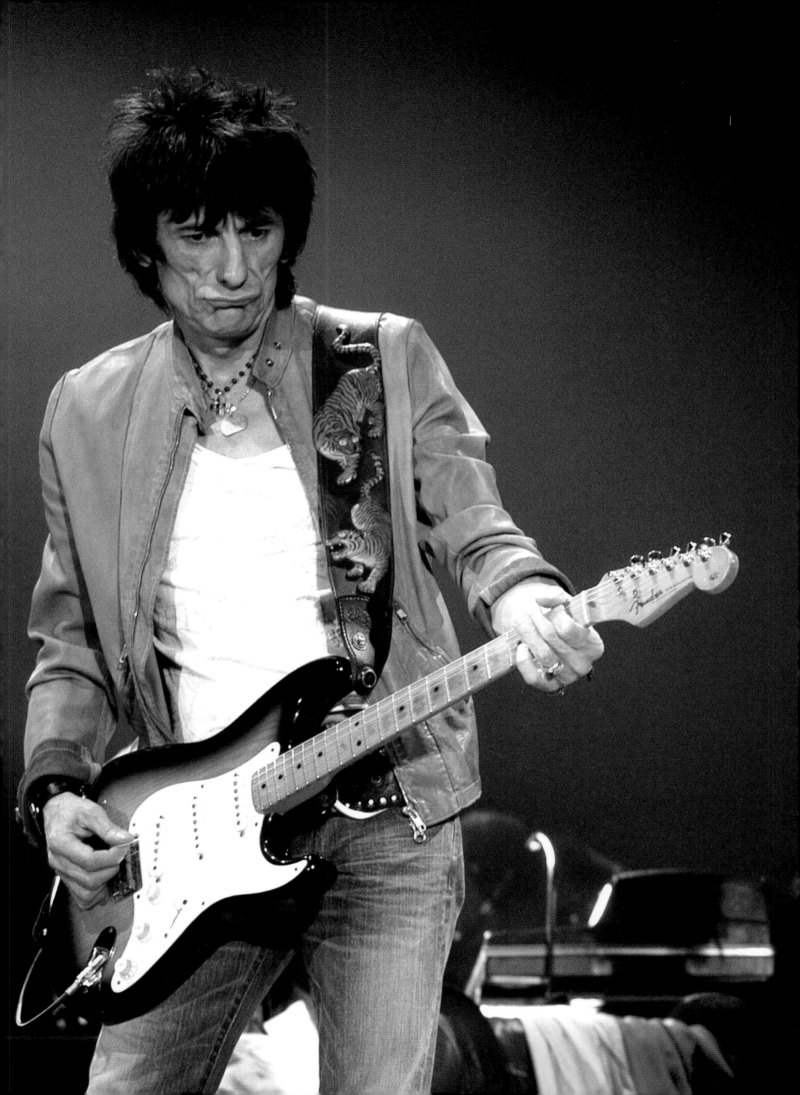

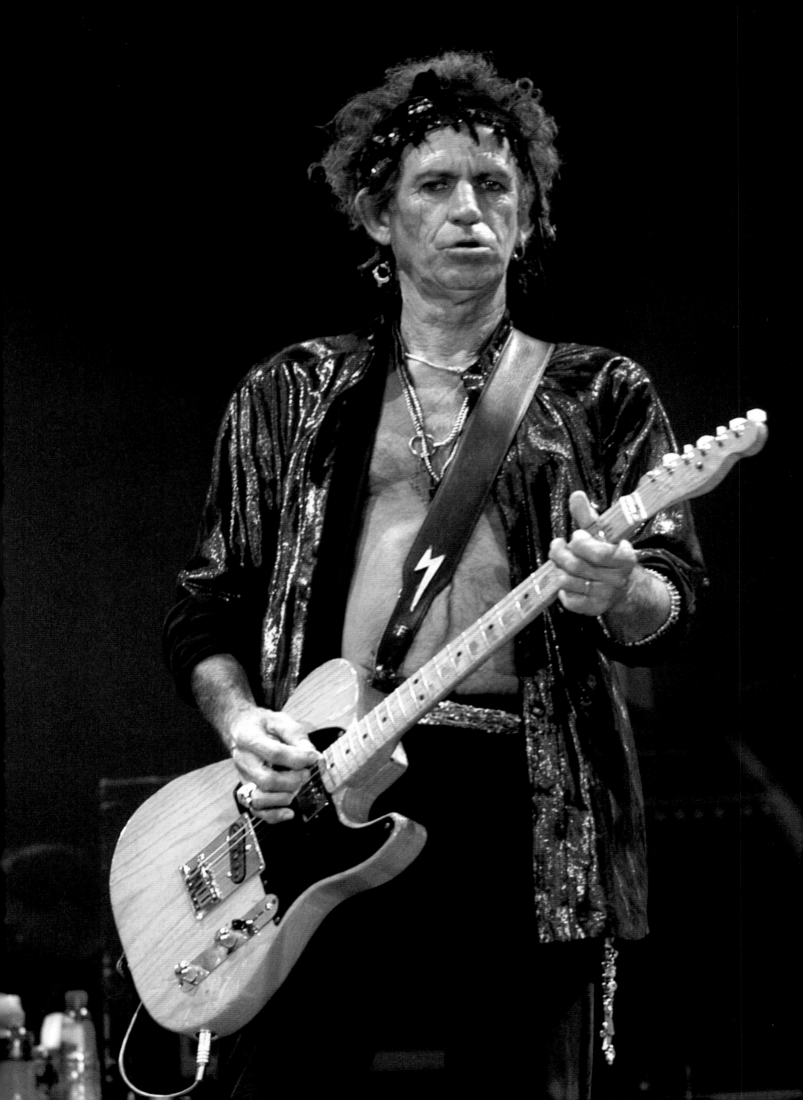

James Burton came to fame as the precocious talent in Ricky Nelson's band, playing country-tinged rock and roll licks on tracks such as "Traveling Man" and "Hello Mary Lou". He was Elvis Presley's "Las Vegas years" guitarist and the lynchpin in Emmylou Harris' Hot Band.

Steve Cropper's minimalist playing on hundreds of Stax sessions and with Booker T and the MG's was all done with his Fender Telecaster. Tracks such as Otis Reading's "Sittin' On The Dock Of The Bay" and Booker T's "Green Onions" display its dry, gutsy tone.

Brad Paisley possesses film-star good looks and a guitar technique so astounding as to beggar belief. He plays the Telecaster that seems made for him – the paisley!

Roy Buchanan is one of country blues' most gifted players. His soaring notes and quick-fire bursts influenced many other great Tele connoisseurs such as Johnny Hiland and the late Danny Gatton. Sadly, he was found hanged in police custody in 1988.

Bruce Springsteen is rarely seen without an early 1950s "butterscotch" Tele with black pickguard. His use of the Telecaster underlines his and the instrument's "blue collar" image – if under-statement is your thing, there is no better choice.

Chrissie Hynde the Pretenders' voice and rhythm guitarist shows off the Telecaster as the female player's perfect choice. With none of the high-testosterone image of rock guitars – even the Stratocaster – the Tele is favoured by many women guitarists.

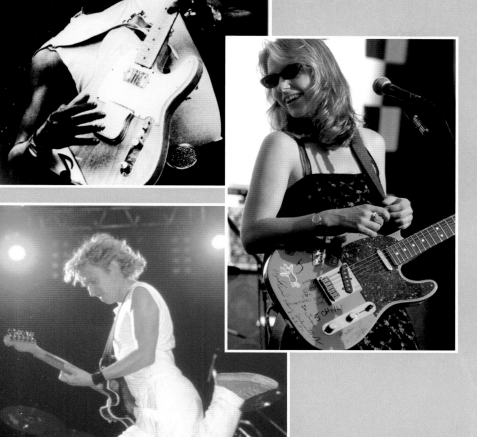

Albert Collins was known as "The Iceman" for his powerful cutting tones, and the late bluesman was never seen without his Telecaster. With it tuned to F minor, Collins employed a capo to change key yet wrenched incredible licks from his Tele, usually with a Gibson humbucker at the neck.

Susan Tedeschi is one of a host of female blues guitarists to adopt the Tele for its breadth of tone and "softer" look. Tedeschi, along with players such as Sue Foley and Deborah Coleman, highlights it as a great choice for women bluesers.

Andy Summers' use of part chords, complex riffs, and a distinctive "chorused" effect formed the signature sound of The Police. His main guitar was a bound-bodied Custom Tele with a Gibson humbucker at the neck.

Graham Coxon is one of Britrock's most influential figures. The former Blur guitarist plays creatively and with intelligence. Rarely seen without his black Telecaster, Coxon continues a successful solo career after leaving the band in 2002.

Tom Morello is a Harvard graduate who came to prominence in Rage Against The Machine and now plays in Audioslave and as solo artist The Nightwatchman. A brilliant stylist with a unique approach, Morello's Tele is covered in stickers and usually in drop D tuning.

"I never liked mellow sounding guitars. I bought a Fender Jazzmaster in New York, which in those days was $95 because nobody wanted 'em. Now they're up to $400, probably because Elvis Costello had his picture taken with 'em so many times." Tom Verlaine

Fender Jazzmaster

Jazz players wanted big hollow-body guitars with traditional looks and craftsmanship, as well as fat-sounding humbucking pickups. So what on earth was Leo Fender thinking about in 1958 with his Jazzmaster?

The most successful electric guitars in any genre are those with simple and intuitive operation. A quick glance and you should know what everything does; reach for a switch or a control knob and it is where you expect it to be, and it does exactly what you expect it to do.

Leo Fender got so much right with his Telecaster and Stratocaster, as they conformed exactly to these principles. But he missed the mark in many respects with the Jazzmaster's concept – jazz players were never going to use it, for all the above reasons. Yet in a twist of fate Fender fluked a design that became the darling of garage bands, new wave, and grunge acts.

On its launch in 1958, the Jazzmaster cost $50 more than a Strat and was the first Fender to use a rosewood fingerboard. This, along with the company's new three-tone sunburst finish and a red tortoiseshell scratchplate, certainly created a different look.

The Jazz's design was aimed at those players whom Leo judged as credible. Even though rock'n'roll was paying his bills and making his name, he was not interested in this music and its players and wanted something that would appeal to the guitar-playing elite – the jazzers. Using a cleverly conceived offset body, designed to suit the sitting guitarist but equally at home on a strap, Leo also added larger pickups and a sophisticated switching system with slider control that allowed preset sounds to be dialled in. But the single-coil pickups were unshielded, so stage lights and amp transformers induced unwanted hum. Leo's floating vibrato system was an elegant piece of work, using a pinpoint rocker

Left Fender's almost forgotten Jazzmaster, the guitar of 1960s surf music, surfaced again when garage, punk, and indie bands took hold the following decade.

SUMMARY

CONSTRUCTION Alder body with bolt-on maple neck; first Fender guitar with rosewood fingerboard.

FEATURES Two oversized single-coil pickups; separate rhythm circuit; floating vibrato with string-lock mechanism and separate bridge; offset body design.

MUSICAL STYLES Surf, punk, garage, new wave, and grunge.

SOUNDS Middly and dull compared to other Fenders – think of "Walk Don't Run" by The Ventures.

ARTISTS The Ventures, Elvis Costello, Tom Verlaine, Thurston Moore (Sonic Youth), J Mascis (Dinosaur Junior), and Thom Yorke (Radiohead) have all made use of the Jazzmaster's quirky looks and great rhythm guitar tone.

mechanism and separate bridge. It also had the ability to lock, so if a string broke the guitar would remain in pitch. But the shallow break angle of the strings across the Jazz's bridge meant that hefty strumming could dislodge one or more. While this and the guitar's huge pickups were designed to produce a more jazzlike sound, it was a flop with the very players he so much wanted to like it. His complicated switching system and less than perfect vibrato alienated the guitar from serious guitar-playing rockers, too – Buddy Holly played a Strat and Ricky Nelson's guitarist James Burton a Tele. The Jazzmaster seemed lost between two worlds.

Enter The Ventures. This guitar instrumental band was selling millions of records at the end of the 1950s and early 60s, so their influence was massive for aspiring players. Guitarists Don Wilson and Bob Bogle had both used Jazzmasters, and a sunburst model was clearly visible on the sleeve of the group's eponymous album.

When surf music died out and British beat, blues, and rock took over, Jazzmasters could be picked up for next to nothing. This made the model attractive to 1970s American punk bands and 1980s British new wave acts, including Television's Tom Verlaine and a young Elvis Costello – ironic, since Fender dropped the model in 1980, the year after Costello's major album *Armed Forces* hit the U.K. charts.

Fender Starcaster

The semisolid Starcaster was conceived as a rival to Gibson's ES-335, but it initially flopped. However, money-strapped players picked up models cheaply and its popularity grew.

Fender, while obviously happy at its company's success in the face of early derision from Gibson and others, still harboured the desire to be mainstream. In 1966, just a year into CBS's ownership, Fender came up with its ES-335-alike, the Coronado, which limped to its demise only six years later. Three years later came the far more radical Starcaster.

There is certainly logic in Fender's thinking with the design of this guitar. This time they opted for a vaguely Strattish look with maple neck and newly designed six-a-side headstock, albeit on a bound semisolid body with f-holes and twin humbucking pickups. The Starcaster's pickups had already been used on the Telecaster Deluxe, Custom, and Thinline and were in fact designed by Seth Lover of Gibson humbucker fame. Intended to sound lighter and more "Fenderish" than Seth's original pickup, the Wide Range had its three bass-side pole-pieces toward the neck side and the three treble ones facing the bridge to visually differentiate it from Gibson.

Below Like so many initial flops, the much-maligned Starcaster has recently received a new lease of life in the hands of Radiohead's Jonny Greenwood and Dave Keuning of The Killers (below). There is even talk of a limited-run reissue.

With less girth in its sound, the Starcaster actually sounded more like a fat Telecaster than an ES-335 and so again missed the mark. It was extremely unpopular at its launch, and by the early 1980s Fender had pulled the plug.

As so often happens if a model initially fails, when discarded Starcasters started becoming available for relative peanuts, struggling young bands that wanted American Fenders but could not afford Strat and Tele prices latched onto them. Today players such as Dave Keuning, Leo Nocentelli, and Jonny Greenwood all love their Starcasters' alternative looks and zestful tones.

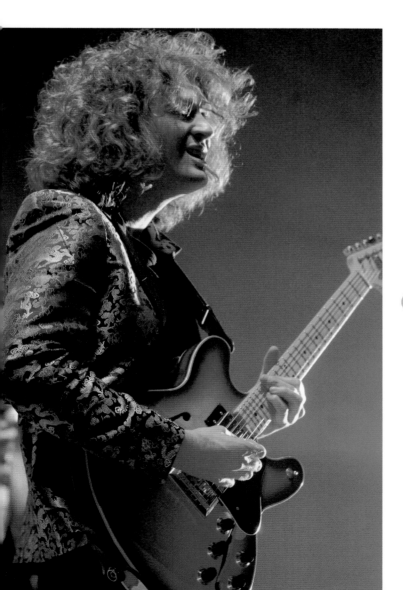

SUMMARY

CONSTRUCTION Hollow maple body with solid centre section.

FEATURES Two Seth Lover-designed Wide Range humbucking pickups; three-bolt neck with tilt system; new design six-a-side headstock; two volumes, two tones and master volume; three-way toggle switch on lower horn; six-way nonvibrato bridge.

MUSICAL STYLES Modern pop and alternative rock.

SOUNDS Like a fat Telecaster, bright but not too cutting.

ARTISTS Leo Nocentelli (The Meters), Jonny Greenwood (Radiohead), Boyan Chowdhury (The Zutons), Dave Keuning (The Killers).

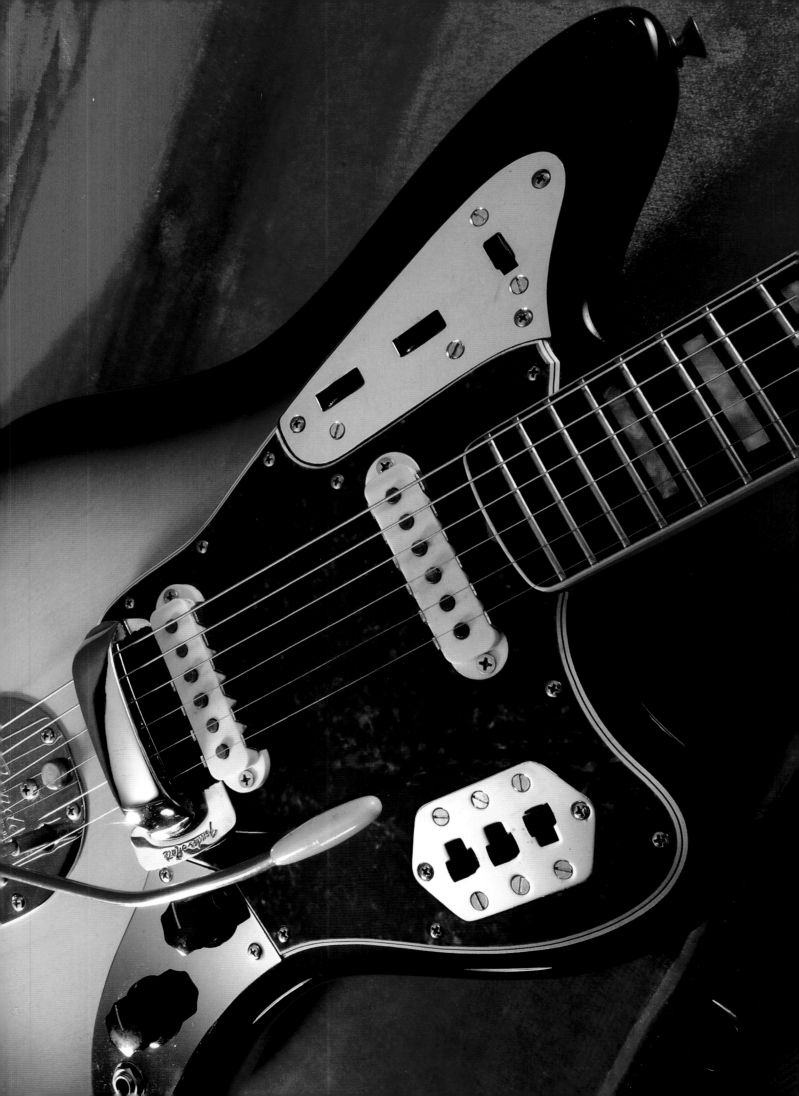

Fender Jaguar

Four years after the Jazzmaster came the Jaguar,
which was an even more complex guitar and another
intended by Leo to woo Gibson players over to his
ever-growing stable of instruments.

Left The short-scale Jaguar was Fender's attempt to go upmarket and perhaps attract those who still preferred Gibson, Gretsch, or Rickenbacker. But its complex array of switches alienated it from Gibson players, who were used to simple and intuitive controls. The Jag's "surf" looks were lost on country-loving Gretsch users, and Ricky fans stayed loyal to their own quirky brand.

It is ironic that by 1962 Gibson was doing everything in its power to emulate Fender's precocious success, having released instruments such as the Explorer, Flying V, and SG. At precisely the same time, Leo was in his workshop devising models aimed directly at the old master's market.

While the Jazzmaster had failed to hit its intended target – the jazz guitarist – its sales had been good owing to its adoption by surf and garage bands, or by those who simply wanted a Fender and opted for the top model. So Leo was probably unaware that his complex switching system and user-unfriendly vibrato were destined to render the instrument a flop when beat, blues, and rock music came on the scene. So the Jaguar continued where the Jazzmaster had left off.

Using the same body but employing a short 60cm (24in) scale length and 22 frets in the hope of attracting Gibson fans, the Jaguar maintained the Jazz's separate bridge and distant vibrato tailpiece with its low break angle and attendant string-popping problem. But it also added a string

Right Just like her partner Thurston Moore in Sonic Youth, Kim Gordon's candy apple red Jaguar is bashed up and beaten, its finish is falling off at the edges, and the bridge single-coil has been replaced by a more powerful humbucker.

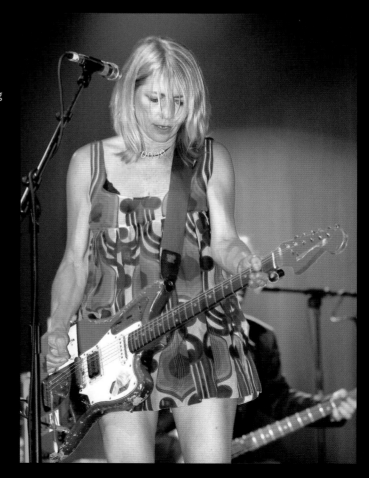

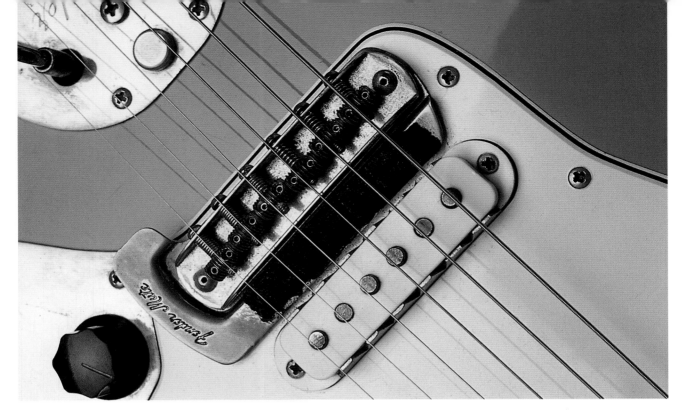

Above and left The strings' shallow break angle over the Jaguar's bridge means that aggressive strumming or bending can knock them out of their saddles; this and the guitar's complicated controls system made it unpopular with intuitive blues and rock players.

damper. This was intended as a labour-saving device – why should players bother to use their hands to damp the strings when they could press a lever and a rubber pad would pop up and do it for them? A nonplayer, Leo did not realize, however, that this was exactly what they did not want – real guitarists liked to use their guitars intuitively and right-hand damping was a technique integral to all styles.

Fender also failed to grasp the fact that the Jaguar's complex switching system – spread across three chrome plates neatly blended into the instrument's main scratchplate – was another off-putting factor. A tone switch and two pickup on/off switches on the hexagonal chrome plate were just the start of it. A Jazzmaster-style rhythm circuit on the upper plate carried a selector switch plus roller volume and tone pots, while the lead circuit's own controls were found in the usual place, by the jack socket. It looked great on paper, but guitarists felt like they needed a degree in electronics to use it.

The pickups, however, were great. Looking like Strat single-coils, they sat in chrome surrounds that shielded them from Jazzmaster-style hum. They were hotter than Strat pickups as well, but unfortunately their potential was destroyed by the guitar's awkward electrics and fussy vibrato.

The Jaguar failed to win over Gibson players and it joined the Jaguar initially as a surf guitar – The Beach Boys' Carl Wilson played one – and resurfaced in the 1990s with alternative rock bands such as Sonic Youth and Placebo and in the hands of the late king of grunge Kurt Cobain. Today, Red Hot Chili Peppers' John Frusciante is perhaps its most high-profile user.

Although the Jaguar – which at the time of its launch was Fender's most expensive guitar – was dropped in 1975, currently it is being built alongside the Jazzmaster in Fender's factory in Corona, California, and also as a more affordable version in Japan.

SUMMARY

CONSTRUCTION Alder body and bolt-on maple neck with rosewood fingerboard.

FEATURES Special-design single-coil pickups set in shielding surrounds; offset body design, pickup on/off switches, and separate rhythm and lead circuits and controls; floating vibrato with string damping mechanism.

MUSICAL STYLES Surf, alternative rock, and grunge.

SOUNDS Hard and metallic when played dirty, but with a sweet side when played clean.

ARTISTS John Frusciante, Kurt Cobain, Brian Molko (Placebo), Boyan Chowdhury (The Zutons), Graham Coxon (Blur), and Jonny Buckland (Coldplay) all use a Jaguar as an alternative to their other Fender guitars.

Fender Electric XII

The mid-1960s were a time of jangling pop music, when the sound of electric 12-string guitar tones abounded. Where The Beatles had led the way with "A Hard Day's Night" and "Ticket To Ride", The Byrds followed suit with "Mr Tambourine Man" and "Turn! Turn! Turn!", and many other British Invasion acts jumped on the bandwagon. Unfortunately for Fender, most bands copied George Harrison and Roger McGuinn and chose Rickenbacker instruments, although Tony Hicks of The Hollies preferred his Vox. Never one to miss a marketing trick, Leo responded with his own take on such things, and in 1965 the Electric XII hit the stores. Based around the Jaguar/Jazzmaster body shape, the model used two split-coil pickups and an elongated headstock that became known as the "hockey stick".

The Electric XII was commonly seen in Du Pont automotive finishes and was a handsome instrument. Yet while it was hailed as a great 12-string to play – the neck was wider than that of the Rickenbacker whose string pairs were so close together as to prove awkward – the Fender never made it to icon status like its rival. Roy Wood of British band The Move was one of the few high-profile players to use it in anger.

Fender Mustang

Launched as a student model, the short-scale Mustang of 1964 was in fact a rather sophisticated instrument, even worthy of a rock superstar's patronage.

Many guitar companies have realized the importance of appealing to younger players. The theory is simple: capture allegiance to the brand during formative playing years and retain it later on. With this in mind, Fender introduced a range of quality student guitars – just as Gibson had always done – and leader of the bunch was the Mustang, introduced in 1964.

In reality a rather professional instrument, the Mustang's main tip of the hat to the younger player was its shorter scale. Offered in two lengths, both were considerably less than Fender's standard 65cm (25½in) from nut to bridge. The regular Mustang measured 60cm (24in) and the shorter-scale model was just 57cm (22½in). The theory was that smaller hands would

Left The Mustang was never quite sure of its status: was it a short-scale instrument for grown-ups or a junior guitar for the more discerning young player? Kurt Cobain of Nirvana obviously felt it was the former.

"There's a difficulty in finding reasonably priced, high-quality left-handed guitars." Kurt Cobain

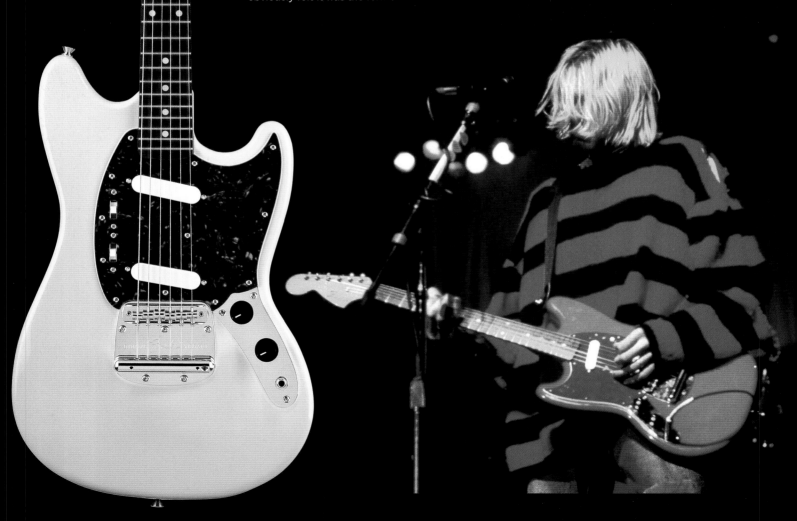

find this size more comfortable, but in reality few shorter-scale Mustangs were made.

Emanating from the Jaguar/Jazzmaster side of the Fender family, the Mustang offered a quality vibrato with smooth action over a floating bridge. Its body came initially in slab form like its more junior siblings the Duo-Sonic and Musicmaster, but all models soon gained the contouring of more grown-up Fenders and the offset waist of the Jag/Jazz. Classy pearloid or mock-tortoiseshell pickguards carried two pickups with a three-position switch for each – on/off and two tone presets. Master volume and tone controls were sited on a metal pickguard extension that also housed the jack socket.

SUMMARY

CONSTRUCTION Early models had slab bodies but soon changed to contoured design with Jaguar/Jazzmaster-style offset waist; maple neck with rosewood fingerboard, later offered as all maple.

FEATURES Two plastic-covered single-coil pickups without visible pole-pieces; two pickup on/off and tone slider switches; master volume and tone controls; Easy Action vibrato with floating bridge; large headstock with plastic-buttoned Kluson tuners.

MUSICAL STYLES All student styles and grunge!

SOUNDS Typical Fender tones – bright bridge pickup and mellower "flutey" neck single-coil; hollow mixed pickup tones courtesy of tone switch combinations.

ARTISTS Kurt Cobain (Nirvana).

Although the standard Mustang finish was sunburst, it was also available in custom colours (red and blue were most popular) and later versions received double "competition stripes" over the forearm contour, lending support to the belief that Leo saw this as something more than a beginner's guitar. With an selection of typical bright Fender tones, the Mustang's switching system lent it some interesting "hollow" sounds and, although never as versatile or intuitive to use as a Strat owing to its fiddly slider controls, the model did receive the patronage of some professional players, the most famous being Nirvana's Kurt Cobain. Dropped by Fender in 1981 in favour of the Bullet – a far more cheaply produced and less satisfactory design – Mustangs have been built by Fender Japan since 1986. The Jag-Stang, designed by Kurt Cobain to be half Jaguar and half Mustang, was introduced the year after the guitarist's death in April 1994.

Next page Kurt Cobain's left-handed Jaguar has had both pickups replaced with high output DiMarzio pickups; there's a Schaller bridge in place of the original Fender and the pickup on/off switches taped over.

Fender Duo-Sonic

Fender's student models, with smaller bodies and shorter necks, were designed as playable instruments that would inspire young musicians to continue with the guitar, eventually buying the company's more serious, costly fare. Although affordable due to their stripped-down nature, only cosmetic corners were cut; these were well-made guitars that looked and sounded like real Fenders. The Mustang was Fender's top student guitar, with twin pickups and vibrato, but two simpler versions built around the same body design had preceded it. The most basic of these was the Musicmaster, an alder-bodied, maple-necked instrument with a Strat-style headstock. The Musicmaster's "big brother" was the two-pickup Duo-Sonic, identical apart from the second pickup. The Duo-Sonic's most famous user was Jimi Hendrix, who played the model as a teenager before graduating to his signature Fender, the Stratocaster.

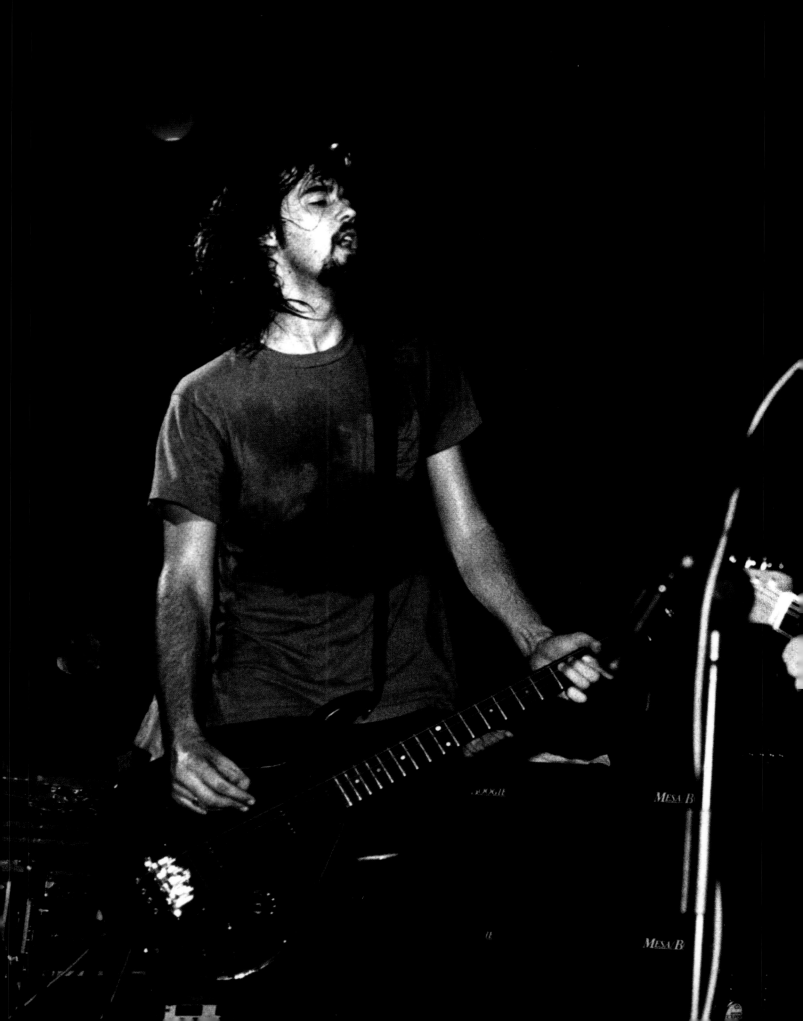

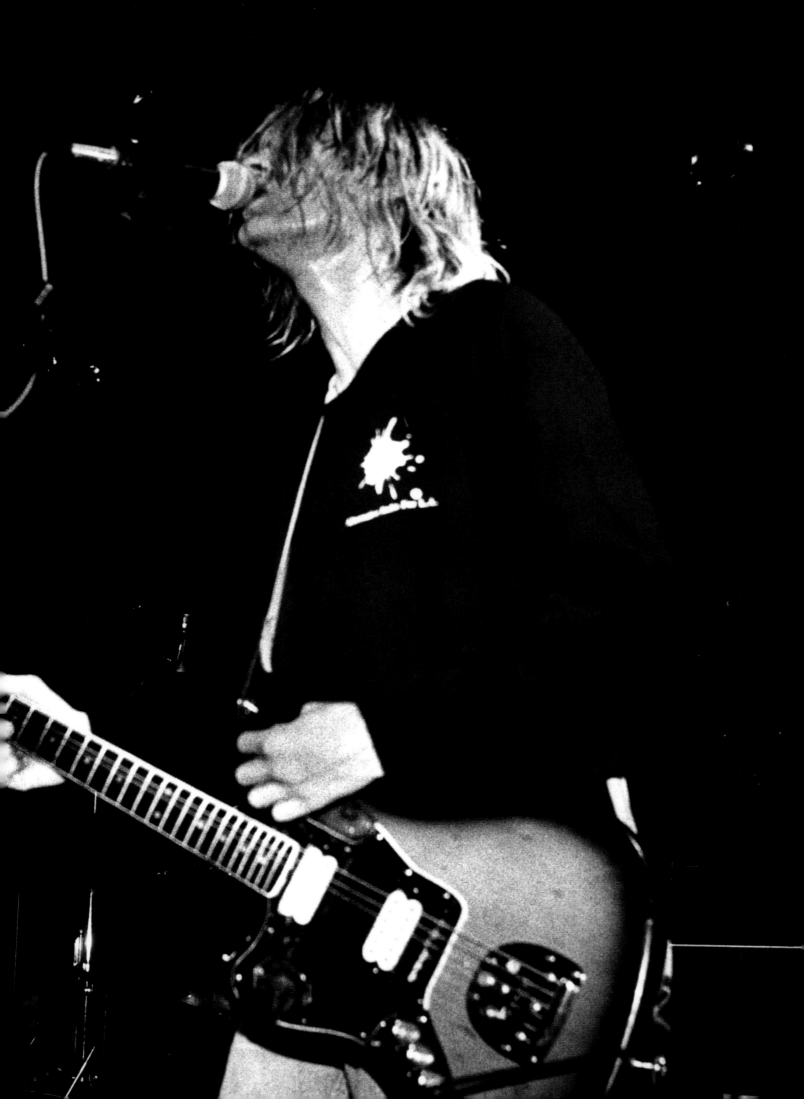

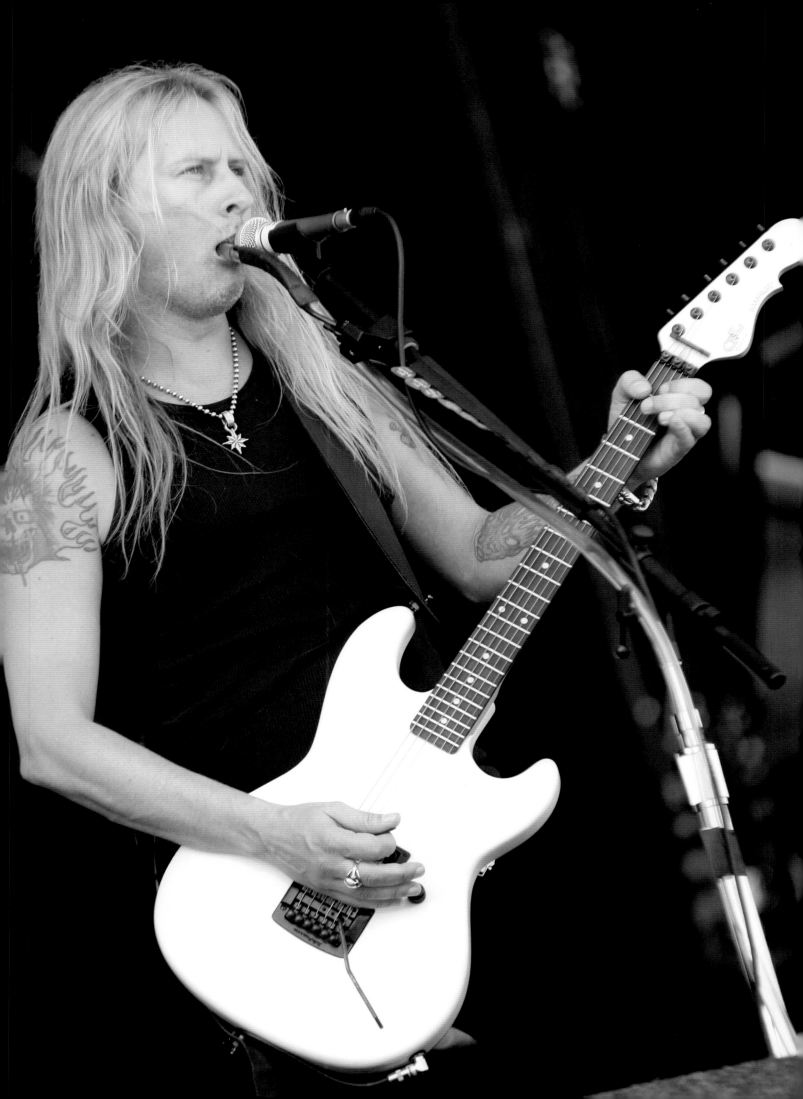

Left Jerry Cantrell of Alice In Chains (left) took a liking to the simple design of G&L's 1980s Rampage, with its one humbucking pickup and Kahler vibrato system, which some players favoured because of its simple operation and loose feel.

SUMMARY

CONSTRUCTION Solid alder or ash body with two-piece maple neck and glued-on maple or rosewood fingerboard; six-a-side headstock.

FEATURES Range of single-coil pickups; Saddle Lock bridge; tone, volume, and three-way selector.

MUSICAL STYLES Blues, rock, pop, and country.

SOUNDS Anything from country twang to raw blues and fat rock.

ARTISTS Art Alexakis (Everclear), Deano Brown (Tim McGraw band), Jerry Cantrell (Alice In Chains), Iris DeMent, Andrew and Tim Farris (INXS), Probyn Gregory (Brian Wilson band), among others.

G&L ASAT & Rampage

After Leo Fender sold his company to CBS in 1965, his next venture was with Music Man. After disagreements within that company, in 1979 Leo formed G&L with George Fullerton.

G&L wanted to design and produce guitars "just like in the old days". Leo set up shop in Fender Avenue, Fullerton. Quality was to be uppermost and Leo introduced typical Fender-type innovations. Not all his ideas met with market success, but he was clearly as innovative and driven as ever.

Leo said that ASAT stood for "Another Strat, Another Tele", alluding to the fact that he could not escape from the models that made his name. It is hard to deny the similarities between his post-Fender/Music Man products and those illustrious forebears, and today's G&L range is built mainly around those two designs. The ASAT (perhaps the model best received by the public) is created in the image of Leo's 1950 body shape but is the platform for a host of different timber choices, constructional ideas – including bound or semihollow bodies – and a range of pickup and hardware configurations. The ASAT Special (pictured) features a pair of high-output Magnetic Field single-coil pickups and Leo's improved Saddle Lock bridge, and comes in standard or premier finishes on alder or swamp ash.

The Rampage model was a simplified S-style design with one humbucking pickup and Kahler vibrato system. Kahler had lost out to Floyd Rose in the race to create the locking vibrato the public would want – it was said to rob guitars of sustain, but some players preferred it. The Rampage was discontinued in 1991, but several limited-edition runs have been made and more are likely in the future.

Left When Leo Fender started G&L Guitars he called his T-style model the ASAT because it seemed to him that all anyone wanted from him was "Another Strat, Another Tele".

Gibson

Gibson Les Paul Goldtop

'Lester Polfus was a brilliant young man. The importance of his contributions to music in general and the electric guitar in particular cannot be overestimated. Now in his 90s, all his faculties are intact and he is still playing.

Polfus, who had success as guitarist Rhubarb Red and later with Mary Ford under the name Les Paul, had become disenchanted with the available electric guitars as early as the 1930s. At that time, they were simply acoustic "jazz-" or "cello-" style instruments with pickups attached. Even though companies such as Gibson and Epiphone soon started incorporating electrics into the design, at heart they were still acoustics with a pickup and a couple of controls tagged on.

Les believed that an electric guitar did not need to be hollow at all, since the sound was no longer coming from the acoustic soundboard; instead, he reasoned, it should be solid, to improve sustain and rid the instrument of unwanted overtones and the feedback that dogged amplified guitars. After experimenting with his own Gibson arch-top by slicing off its sides, building in a 10cm (4in) square solid centre block, and then gluing the "wings" back on – Epiphone allowed his Frankenstein-like escapades space in their New York factory – Les came up with the "Log". In 1941, it was the nearest thing yet to a purpose-built solid-body electric guitar. Convinced that he was onto something, Les took his Log to Gibson when guitar manufacturing recommenced after World War II, explaining the theory behind his experiments and suggesting they build a solid-body to his design. Sadly Gibson, notoriously myopic at times, dismissed his idea.

Move on to 1952 and Gibson found itself lagging behind: Fender's ridiculed Telecaster had become a runaway success and, according to Paul, "They remembered the funny guy with the broomstick" and invited him back to talk. The upshot of these meetings was that Gibson would produce a twin-pickup solid-body guitar bearing Les's name. The company had not been entirely idle, however, and a design was more or less complete – a small-bodied, elegant guitar with a 13mm (½in) maple cap glued to a thick mahogany base and fitted with a brace of the company's powerful P-90 pickups. Gibson gave the Les Paul model a carved front because they knew Fender lacked the machinery to do likewise. The top was finished in metallic gold since, according to Paul, "It looked

"Leo's beliefs and my beliefs were terribly similar. We just had different ideas about the sounds we wanted to create." Les Paul

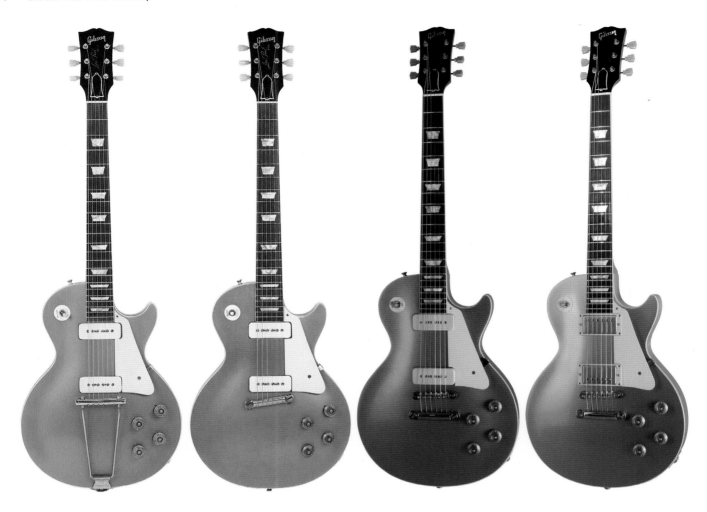

expensive", while the back, sides, and neck were left natural mahogany. This led to the instrument's nickname of "Goldtop", a moniker that stuck and that now even Gibson uses to describe this version of the guitar. Early instruments featured a wrapunder trapeze-style bridge/tailpiece that guitarists did not like, because it precluded damping of the strings with the picking hand. This was changed to a wrapover bar tailpiece in late 1953 and then a separate bridge and tailpiece arrangement a couple of years later.

Goldtops first appeared in 1952 and a host of other models bearing the guitarist's name came and went during that decade as Gibson tried to thwart guitarists' indifference to the instrument. Although the Les Paul initially sold well, players and the public had got used to Fender's modern, slicing tone, and the fat, sustaining sound of the Gibson was not *de rigeur*. In 1957, the P-90 pickups were switched to Walt Fuller's and Seth Lover's new hum-cancelling (or "humbucking") pickups, and these instruments command the highest Goldtop prices today.

One more change – the removal of the gold finish, to be replaced by a sunburst-flamed maple cap – was to create the most sought-after player's guitar ever – the Les Paul Standard.

Above Four Goldtops (from left): the trapeze tailpiece and P-90 pickup original (1952); with stop tailpiece (1953); with stop tailpiece and tune-o-matic (1956); with twin humbucker (1957).

SUMMARY

CONSTRUCTION Solid mahogany body base and glued-in neck, two-piece maple cap bound in cream, bound rosewood fingerboard with pearloid "crown" position markers and 22 frets.

FEATURES Two P-90 single-coil pickups (replaced in 1957 by humbuckers), twin volume and tone controls with three-way pickup selector. Gold finish to top (some early models had all-over gold finish).

MUSICAL STYLES The Goldtop is a favourite of blues players, especially those who like to sound authentic and not too rocky.

SOUNDS Thick, rich, and sustaining – think "Another Brick In The Wall" by Pink Floyd, or the instrumental "Jessica" by The Allman Brothers.

ARTISTS Freddie King, Michael Bloomfield, and Howlin' Wolf's guitarist Hubert Sumlin all play or played P-90 versions; Snowy White and The Allman Brothers' Dickey Betts prefer humbuckers. Pink Floyd's David Gilmour and Steve Hackett of Genesis have also used Goldtops.

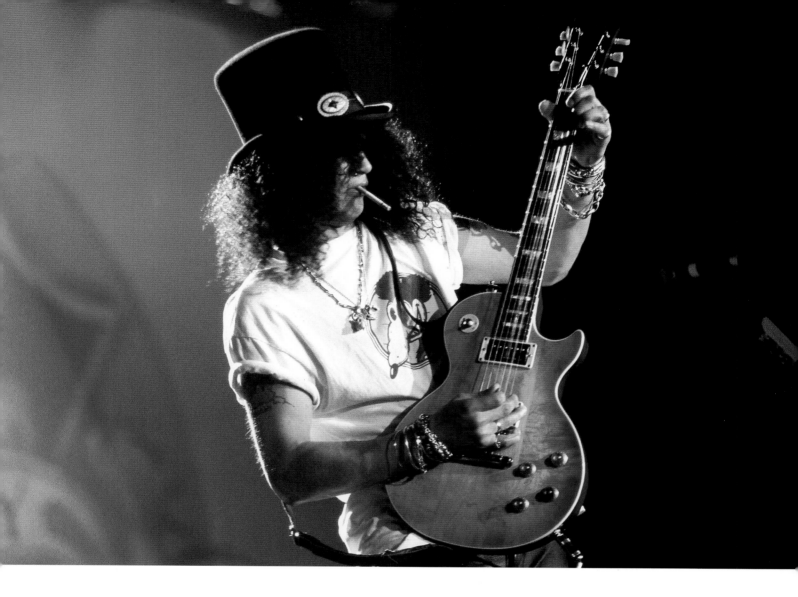

Gibson Les Paul Standard

Above At the end of the 1980s, the Les Paul had fallen from favour with pointy headstocked rock axes and the ubiquitous Stratocaster ruling the roost – that is until guitarist Slash and his band Guns N' Roses released the devastating album *Appetite For Destruction* when the band's popularity, and that of Gibson's most famous solid-body, skyrocketed.

Next page Like British bluesman Gary Moore, Guns N' Roses guitarist Slash likes to remove the raised finger-rest from his Les Pauls because he finds it gets in the way of his picking hand.

By 1958, while sales of Fender's Tele and Strat were sky-high, Gibson was struggling with its Les Paul model. Beside the curvy double-horned Strat, it looked decidedly old-fashioned. Enter the Les Paul Standard.

By 1958, rock and roll was well under way, with artists such as Buddy Holly preferring to be seen with a sunburst maple-necked Strat on the cover of *The "Chirping" Crickets* album. The sound of the day was Fender's single-coil twang, too, not the woolly jazz tone of Gibson; and, while the humbucking pickup was a landmark in guitar electronics, its tone had even more girth than its P-90 predecessor.

Gibson knew it had a great guitar in the Les Paul and was not ready to throw in the towel. So a last-ditch attempt was made to create the most desirable Gibson solid-body yet. It was simple: remove the gold finish, fit a two-piece flamed maple cap, spray it a fetching cherry sunburst, and there you have it – one of the most beautiful electric guitars ever built. The subtle sunburst over its shimmering "dished" maple cap worked perfectly against its cream-bound body, while its large "crown" fingerboard inlays

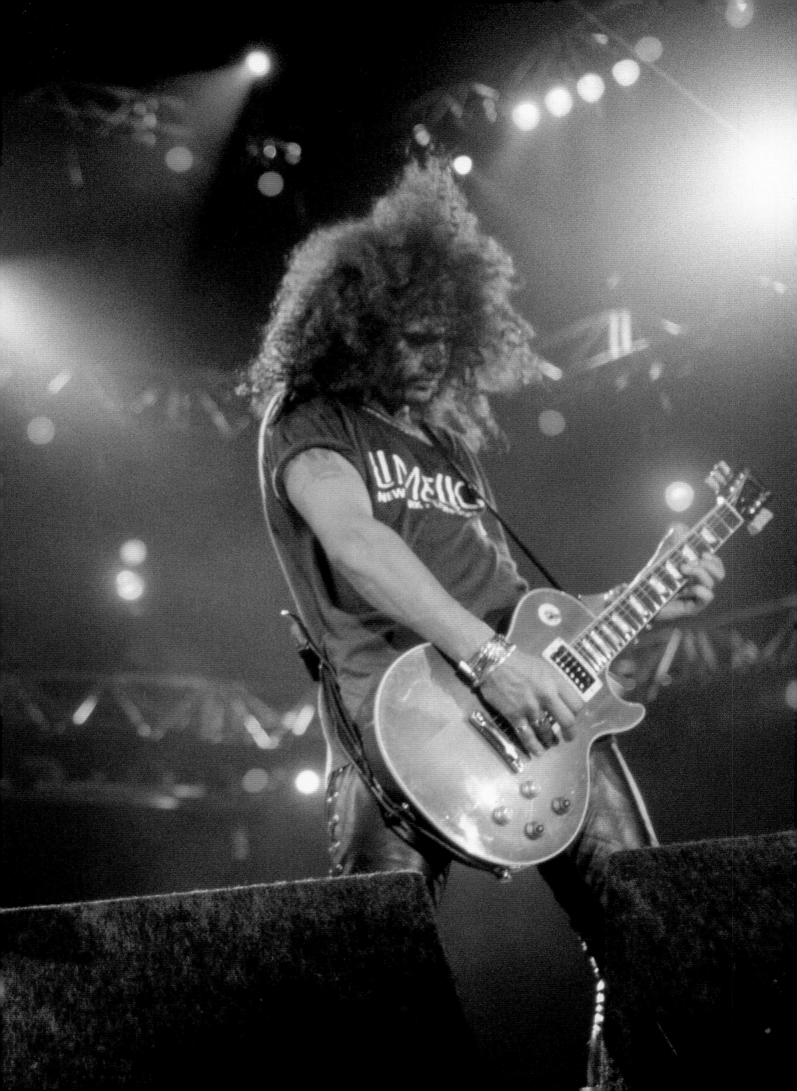

added to this powerful visual statement. The Les Paul had come of age. The problem was that guitar players did not know it yet. This gorgeous, perfectly proportioned hunk of mahogany and maple still did not cut it in the twangy world of rock and roll. Not only did it sound huge, but its neck was the size of a baseball bat compared to the Strat's slender handful. By 1959, Gibson had slimmed it down somewhat, and by the following year it had lost even more girth. But the die was cast for the poor old Les Paul. In the three years since the flame-top's introduction, only 1,700 or so had been made, and in 1960 Gibson pulled the plug.

Six years later, John Mayall released his landmark album *Bluesbreakers With Eric Clapton*. The young Clapton had recently ditched his Fender Telecaster for a 1960 Les Paul; he had also bought a new Marshall amplifier and, in his quest for the biggest, baddest sound with the most sustain, found this a heaven-sent combination. The Les Paul's powerful pickups drove the Marshall's 50-watt power stage into beautiful, natural distortion. Notes sang out and sustained long and loud, or shot up unexpectedly to spine-tingling harmonics. Gibson had fitted bigger frets to the Standard in 1959, too, and these hefty wires suited Clapton's

blues bending and vibrato perfectly. At the same time in the United States, Paul Butterfield's guitarist Michael Bloomfield noticed the same phenomenon, although his Fender amp produced a sweeter, less distorted sound. The success of the Mayall album and the notoriety gained by Clapton's heart-felt, virtuosic displays – which prompted the graffito "Clapton is God" to be scrawled on a wall at Islington tube station in London – made other blues guitarists seek out this now rare guitar. Jeff Beck, Jimmy Page, and Peter Green all followed Clapton in choosing Les Pauls, and it was then the turn of the weak, single-coil Fenders to take a back seat.

Such was the scarcity of Standards in London in the late 1960s that guitar shops began charging £400 for used examples – more than double their brand-new price seven or so years earlier. Players began searching out other Les Pauls such as the Goldtop and Custom, and then any Gibsons sporting similar electrics, such as SGs and ES-335s. Thus the early vintage guitar market was born.

By 1968, Gibson had reintroduced the Les Paul. A few P-90-equipped examples – probably made from leftover 1950s parts – made their way onto the market, along with black Customs and a new model, the Deluxe – essentially a Standard with small humbucking pickups fitted into cut-out cream P-90 covers. Now Gibson's biggest seller, the Les Paul has been in continuous production since 1968, replicas of the 1958–60 version by far the most sought-after in the company's range. Eric Clapton said: "The one I had with John Mayall was a regular sunburst Les Paul that I bought in one of the shops in London after seeing Freddie King's album cover of *Let's Hide Away And Dance*. It was almost brand new – original case with that lovely purple velvet lining, just magnificent."

SUMMARY

CONSTRUCTION Solid mahogany body base and neck with book-matched two-piece flame maple cap; body's tope edge bound in cream plastic; rosewood fingerboard with pearloid "crown" position markers and 22 frets.

FEATURES Two humbucking pickups, twin volume and tone controls with three-way pickup selector. Original models came in cherry sunburst but over the years a variety of colours has been offered, including black, red, and tobacco sunburst.

MUSICAL STYLES Blues, blues-rock, and classic rock.

SOUNDS Dark but sweet, with singing sustain.

ARTISTS Eric Clapton, Jimmy Page, Peter Green, Noel Gallagher, Neil Young, Paul Kossoff (Free), Gary Moore, Slash (Guns N' Roses), Scott Gorham (Thin Lizzy), Billy Gibbons (ZZ Top), Joe Walsh, and Don Felder (The Eagles).

Junior and Special

Years before Fender took up the idea, Gibson had been making models for younger players. These "junior" instruments appealed both to learner guitarists and up-and-coming artists with little money. The Les Paul had its own student models in the form of the Junior and the Special, released in 1954 and 1955. Without the expensive arched maple top, these two guitars featured P-90 pickups (one for the Junior and two for the Special) and a simple wrapover bridge/tailpiece. Gibson cut many cosmetic corners, but did not stint on quality of materials, playability, and tone. Many say that these simpler guitars sound better. Early Juniors and Specials did follow the single-cutaway Les Paul design, but around 1958 switched to an elegant double-cutaway design. Debate still rages as to which model is better.

Gibson Les Paul Custom

Where Gibson has always scored over other major guitar manufacturers – perhaps with the exception of Gretsch – is in understanding the importance of looks in a guitar's desirability. The Goldtop Les Paul was a fine-looking instrument, but in 1954 Gibson, used to creating extra-special versions of many of its models, gave the Les Paul the Custom treatment.

This premium model came in black, with gold-plated hardware and an ebony fingerboard. To underline its status, large mother-of-pearl position markers replaced the celluloid inlays of the Goldtop, and the "split H" inlay from the company's flagship model, the Super 400 jazz guitar, was used on the guitar's slightly widened headstock. Multiple black and white binding was added around the body's top and back, and it received Ted McCarty's new tune-o-matic bridge that allowed both string height and intonation adjustment. Pickup-wise it was slightly different, too, the neck position P-90 being replaced with a new pickup with rectangular Alnico magnets. This gave a brighter tone akin to the neck pickup on a Fender Stratocaster. Frets were fine-gauge wire dressed almost flat – great for smooth jazz but less appropriate for bluesy string-bending styles. A Custom found its way into the hands of Franny Beecher, who replaced the late Danny Cedrone in Bill Haley's Comets and who inherited the latter's speedy solo in the group's 1955 hit "Rock Around The Clock", for which it proved perfect. One constructional difference was the omission of the thick maple cap; instead the entire body was solid mahogany, which gave a slightly warmer overall tone. In 1957, the humbucking pickup became available and, as befitted the Custom's image, it received three of these powerful new twin-coils – the middle one wired out of phase with the bridge unit for a distinctive "honky" tone. This version was immortalized in the film *This Is Spinal Tap* as the "none more black, Custom three-pickup".

Many guitarists rate the Les Paul Custom as the greatest-looking electric guitar of all, and it was nicknamed "Black Beauty" and "Fretless Wonder" (owing to those low-profile frets). When the Les Paul was reinstated in 1968, the Custom came back in two-humbucker format with maple cap reinstated. It is this incarnation that most guitarists find the most successful.

SUMMARY

CONSTRUCTION Early model was all solid mahogany, while later versions have the Les Paul's usual two-piece maple cap; customs are multiple bound front and back in black and white, with a bound ebony fingerboard with mother-of-pearl block markers and 22 frets.

FEATURES Early models had one P-90 and one Alnico single-coil pickup (replaced in 1957 by three humbuckers); twin volume and tone controls with three-way pickup selector; black finish, but later versions came in an array of Gibson colours, including wine red, cherry sunburst, and white.

MUSICAL STYLES Blues, blues-rock, and classic rock.

SOUNDS Dark and aggressive but cutting, with singing sustain.

ARTISTS Keith Richards, Eric Clapton, Jimmy Page, Steve Jones (The Sex Pistols), Peter Frampton, Billy Duffy (The Cult), Neal Schon (Journey), Edge (U2), Robert Fripp (King Crimson), Lindsey Buckingham (Fleetwood Mac), Frank Zappa, Brian Robertson (Thin Lizzy), Huey Morgan (Fun Lovin' Criminals), Jan Akkerman, James Dean Bradfield (The Manic Street Preachers), Justin Hawkins (The Darkness).

Above and opposite As if the Les Paul Custom wasn't eye-catching enough (see LP Black Beauty above), Ozzy Ozbourne and Black Label Society guitarist Zakk Wylde has his painted in a cream and black bull's eye finish!

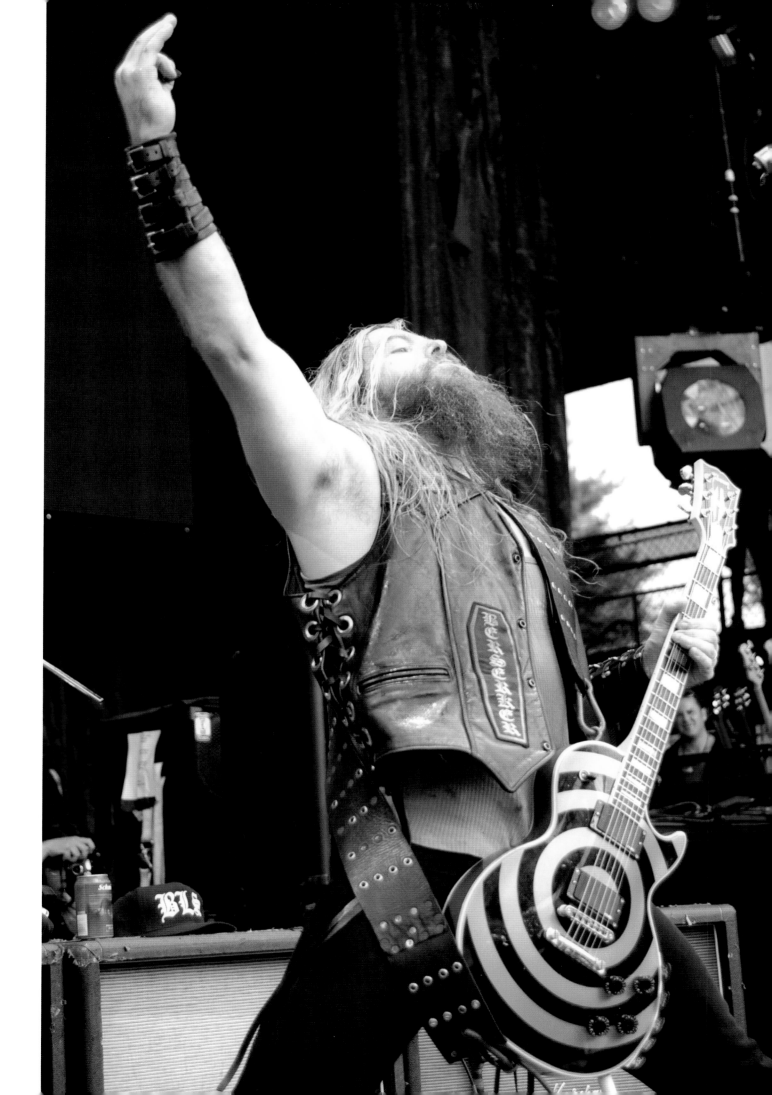

Marc Bolan melded the rock and roll sound with psychedelic lyrics and great looks to create glam rock. When his Les Paul Standard's neck broke, he had it replaced with one from a flashier-looking Custom.

Freddie King played Les Pauls before he discovered Gibson semis. When Eric Clapton saw Freddie with a Les Paul on the cover of his album *Let's Hide Away And Dance*, the young Brit went out and bought one – and changed rock and roll history.

Jimmy Page is for some the archetypal Les Paul player – guitar slung low, heavy riffs, and dirty leads spewing forth. Jimmy's main Les Paul Standard is fitted with a clever switching system to give him more sonic options.

Robert Fripp has been a fan of the Les Paul Custom since the early days of King Crimson. His astounding technique and pioneering work in progressive music makes him one of the most important figures in rock.

Peter Green replaced Eric Clapton in John Mayall's Bluesbreakers. It was a daunting task but he pulled it off. In hindsight some say the guitarist, who went on to found Fleetwood Mac, was the more naturally gifted of the two bluesmen.

Mick Ronson made his name as David Bowie's guitarist and musical arranger and contributed to Bowie's success in the early 1970s.

Paul Kossoff was one of rock's early casualties and one of its most formidable talents. His powerful blues style was full of passion. Kossoff played a 1959 Les Paul Standard on "All Right Now" and "The Hunter".

Bob Marley was reggae's biggest artist and its greatest ambassador. His dreadlocks and stripped-bodied Les Paul Special were both integral to his image. Marley so loved the guitar that it now lies with him in his grave.

Neil Young plays earthy, raunchy solos on his Les Paul Goldtop with Bigsby vibrato. Those to whom flawless technique is king criticize Young's soloing style, but these critics seem to be missing the fire and intensity in his playing.

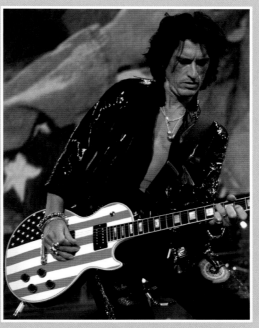

Jeff Beck was an early convert to the Les Paul sound, using his black Standard on the 1967 hit "Hi Ho Silver Lining" and on his groundbreaking instrumental album *Blow By Blow*, the cover of which featured a painting of him with the guitar.

Joe Perry is a huge Jimmy Page fan – note the guitar slung low around his knees – and so the Les Paul is an obvious choice. Although here he is playing a Custom painted in Stars and Stripes finish, he also has a Gibson signature model to his name.

Gary Moore spearheaded the Les Paul's comeback in Britain with his 1990 album *Still Got The Blues*, on which his extraordinary feel and technique were unleashed. Until 2006, Gary owned the 1958 Standard that originally belonged to Peter Green from Fleetwood Mac.

Duane Allman's work in The Allman Brothers Band, especially when playing harmony leads with fellow Les Paul cohort Dickey Betts, is among the greatest white blues of all time. Duane also contributed the slide guitar parts on Eric Clapton's "Layla".

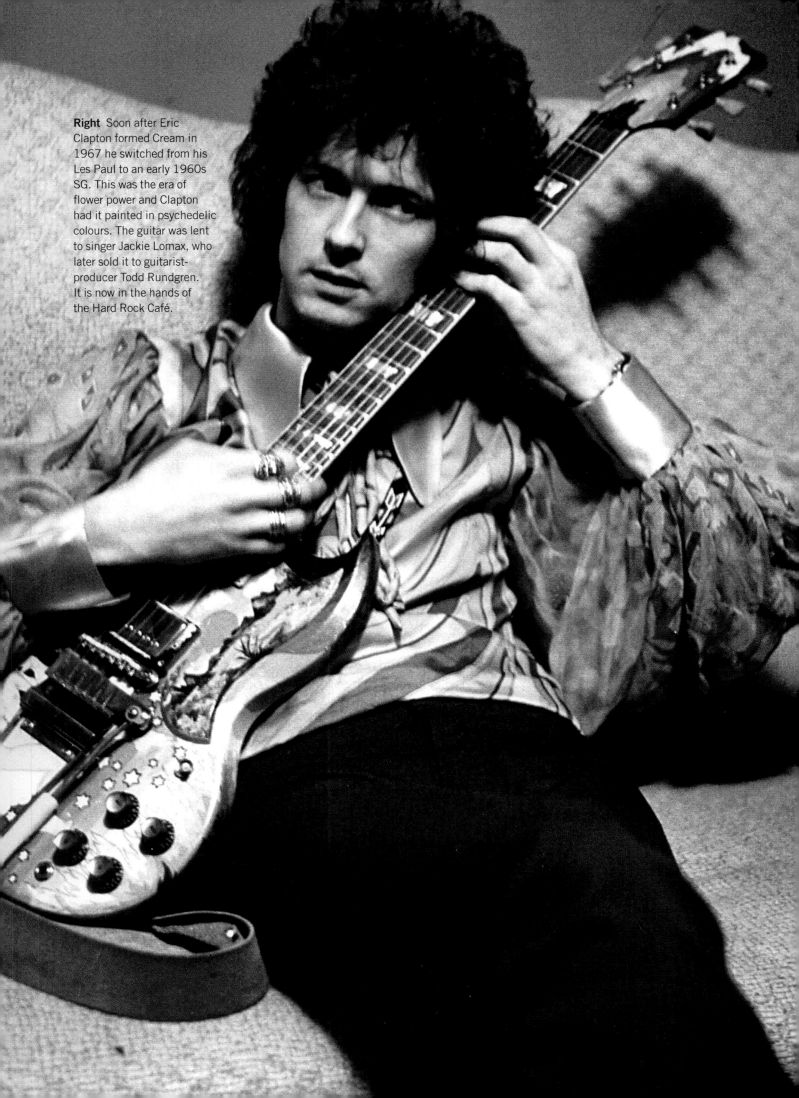

Right Soon after Eric Clapton formed Cream in 1967 he switched from his Les Paul to an early 1960s SG. This was the era of flower power and Clapton had it painted in psychedelic colours. The guitar was lent to singer Jackie Lomax, who later sold it to guitarist-producer Todd Rundgren. It is now in the hands of the Hard Rock Café.

"That SG was a very, very powerful and comfortable instrument because of its lightness and the width and the flatness of the neck. It had everything I wanted at that point." Eric Clapton

Gibson SG Standard

With its bisonlike horns, slender chamfered body, and cherry red finish, Gibson's SG looks like no other guitar. Although it has been around since 1961, the SG is more popular now than ever before.

Anyone who has seen or heard Aussie rockers AC/DC has witnessed the unique looks and mighty sound of Gibson's SG. This was one of the great guitar designs of the golden era.

By the end of the 1950s, Gibson's fight to get in on Fender's solid-body act was proving futile. Guitarists did not want Les Pauls because they were heavy and sounded thick and nasal compared to Fender's bright, modern twang. So, in 1960, Gibson halted production of the single-cutaway dodo, replacing it with a leaner, meaner machine. Initially still carrying the Les Paul moniker, the guitar was soon renamed SG – short for Solid Guitar – since the guitarist disliked almost everything about the design and chose not be associated with it.

Made from a single mahogany plank, the SG's looks were honed to perfection by the addition of chamfering around its perimeter and inside its two asymmetrical pointed horns. With a neck that joined the body at the last of its 22 frets, it was a player's dream, its thin but wide fingerboard offering total access. Electrics were the same as those of its predecessor, with twin volume and tone controls and a three-way selector switch governing a pair of humbucking pickups. The guitar sounded and felt lighter than its predecessor.

Although a reasonable seller on its release – unlike the Les Paul it sold enough to keep it in production – it was not until the blues and rock booms of the mid and late 1960s that the SG's merits were understood. When

Left Its pointed horns and chamfered body make Gibson's SG visually distinctive. Designed to replace the failed Les Paul model, early examples are now known as "Les Paul SGs".

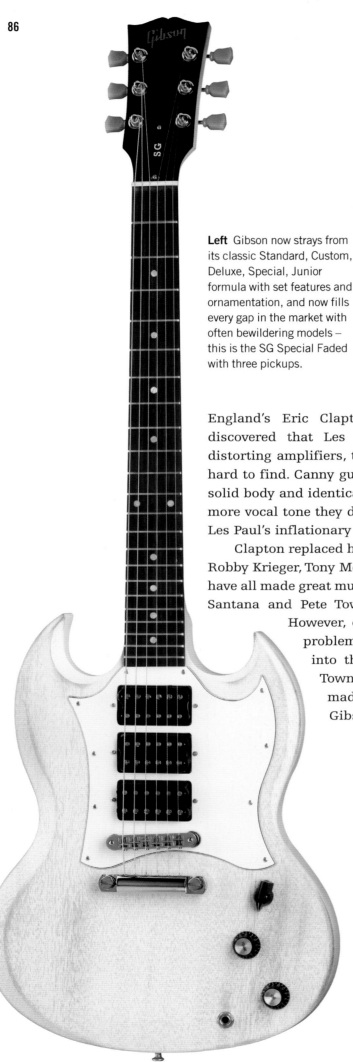

Left Gibson now strays from its classic Standard, Custom, Deluxe, Special, Junior formula with set features and ornamentation, and now fills every gap in the market with often bewildering models – this is the SG Special Faded with three pickups.

SUMMARY

CONSTRUCTION Thin solid-body in mahogany with chamfered edges and double pointed, almost symmetrical horns; mahogany neck glued in at 20th fret for total fingerboard access. Standard has rosewood fingerboard with crown inlays, Special and Junior have pearloid dots, Custom is ebony with pearl blocks.

FEATURES Most SGs feature twin humbuckers (Custom has three while other models have P-90s), two volumes and tones and three-way selector. Usually tune-o-matic bridge and stud tailpiece are used but sideways-operating Maestro, long and short Vibrolo, and sometimes Bigsby vibratos have been fitted.

MUSICAL STYLES Blues, rock, and pop.

SOUNDS Eric Clapton found his "woman tone" on an SG – thick and fat – but Angus Young prefers its naturally biting but driving sound.

ARTISTS Eric Clapton, Angus Young, Paul Weller, Frank Zappa, Robby Krieger, Glen Buxton (Alice Cooper band), Tony McPhee, Jimi Hendrix, George Harrison, Derek Trucks (The Allman Brothers).

England's Eric Clapton and the United States' Michael Bloomfield discovered that Les Pauls sounded great cranked up loud through distorting amplifiers, their newfound notoriety made them expensive and hard to find. Canny guitarists soon realized that the SG, with its similarly solid body and identical equipment did the same thing. It was a smoother, more vocal tone they discovered and, as SGs were as yet unaffected by the Les Paul's inflationary prices, blues and rock players snapped them up.

Clapton replaced his Les Paul with an SG in Cream, while Frank Zappa, Robby Krieger, Tony McPhee, Paul Weller, and the slide player Derek Trucks have all made great music with one. Even Elvis Presley played an SG! Carlos Santana and Pete Townshend both played SGs at Woodstock in 1969. However, only one of the guitars survived. "I never had any problem smashing SGs", said Townshend, who pole-axed his into the Woodstock stage. "They were like balsa wood." Townshend destroyed dozens, but his flamboyant antics made the SG even more desirable. Ironically, in 2000 Gibson produced a Pete Townshend Signature SG model!

"My style changed partly because of the equipment I was using. I'd been playing a Les Paul Goldtop or ES-5 through a Fender or Acoustic amp. But by the 1970s I was playing the SG through Marshall amps." Frank Zappa

Opposite Although it had Gibson on the headstock, Frank Zappa's SG is a handmade copy "built by a guy in Phoenix". It has 23 frets, an onboard preamp, and phase switches.

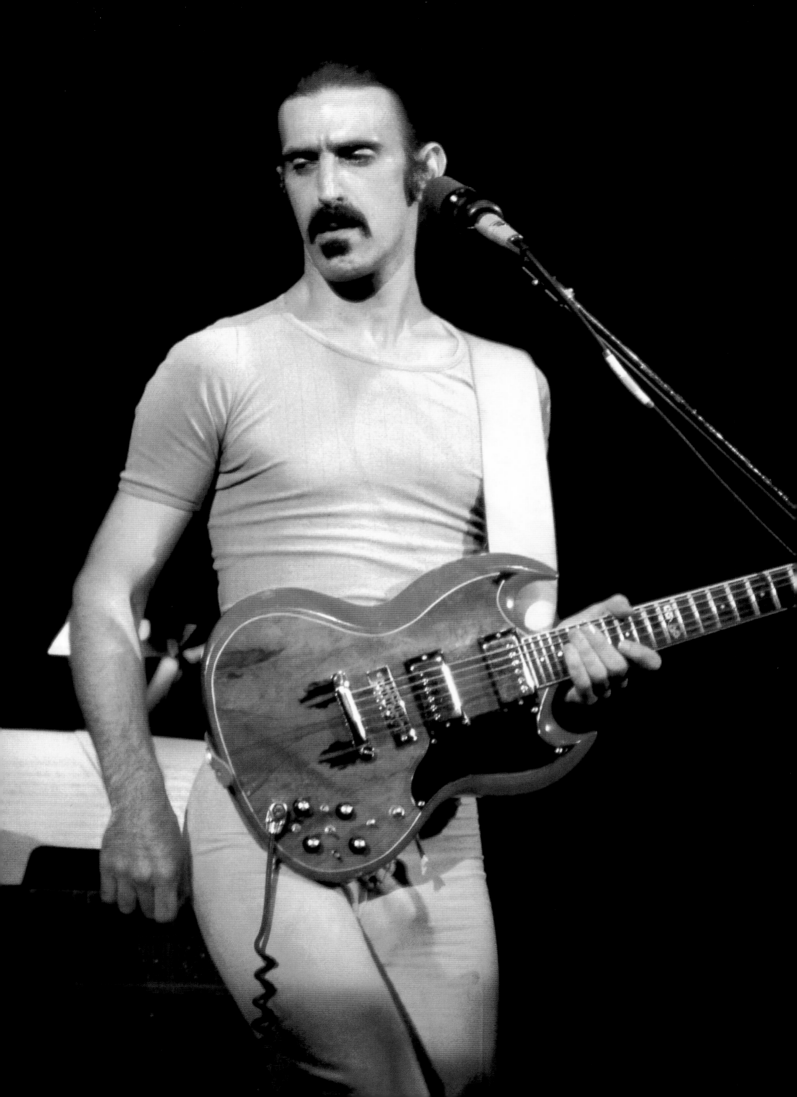

Angus Young – AC/DC's school-uniformed boy wonder – is a terror of the Gibson SG. His speedy and aggressive playing perfectly suits the instrument's tone and looks, with powerful solos perfectly crafted to excite and amaze.

George Harrison played his cherry-red SG Standard on The Beatles' album *Revolver*. The thick sounds of Paul's Epiphone Casino and George's SG are all over tracks such as "Doctor Robert", "And Your Bird Can Sing", and "Taxman".

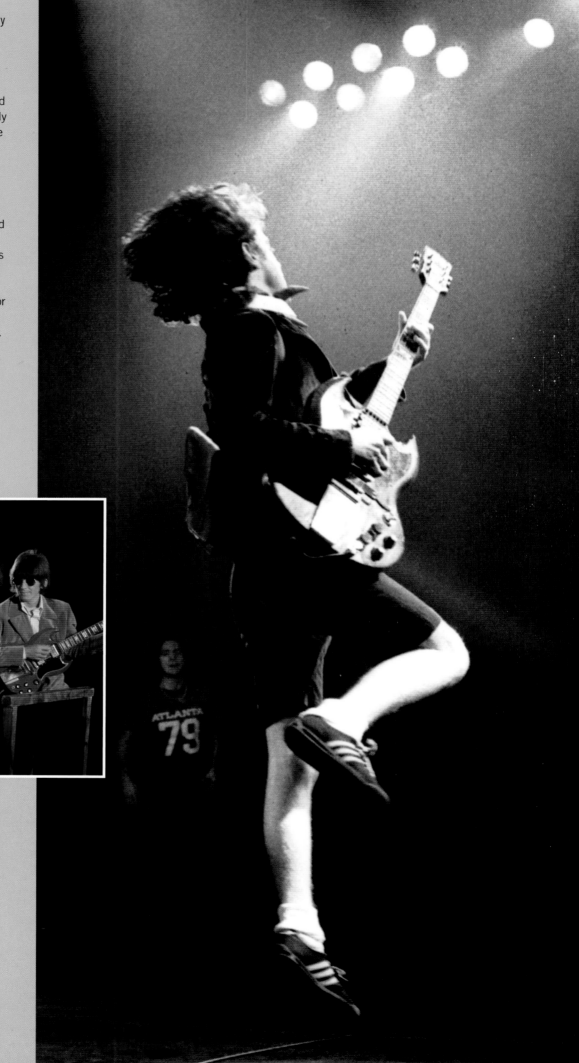

Derek Trucks is a staggering young guitarist who not only fronts his own band but is also the "new Duane Allman" in The Allman Brothers Band. His unbelievable slide playing has also attracted the attention of Eric Clapton, who invited him into his 2006/7 touring line-up.

Robby Krieger of The Doors – the United States' most prominent group of the flower-power era, whose charismatic front man Jim Morrison succumbed to drugs – was seldom seen without a cherry Standard or Special (as shown here).

Tony Iommi has been an SG player since the start of Black Sabbath's incredible career. The left-handed father of heavy metal has played British-made John Birch SG replicas but now has his own signature Gibson model.

Jerry Garcia was a talented multi-instrumentalist who occupies a special place in the hearts of American music fans. While Jerry, The Grateful Dead's main guitarist, played many instruments during his lifetime, he would often revert to this Bigsby-equipped SG.

Pete Townshend chose cherry-red SG Specials, both to play and to smash to smithereens – as famously filmed at 1969's Woodstock festival – when, after The Who's mid-1960s mod phase, he and the band turned toward rock.

Gibson EDS-1275

Some guitars become synonymous with a single player,
yet many guitarists other than Led Zeppelin's Jimmy Page
adopted the "double-neck SG" built by Gibson in 1962.

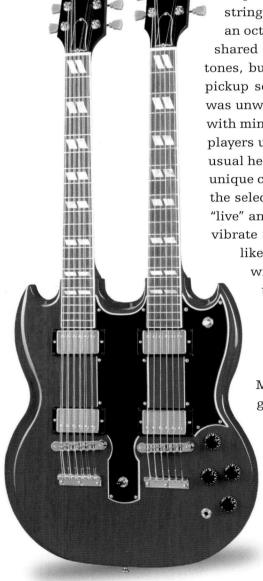

Twin-neck electrics date back to 1952 when vibrato tailpiece designer and pedal steel guitar maker Paul Bigsby built one for country star Joe Maphis. Gibson entered the twin-neck market in 1958 with a special order six- and 12-string model and the much scarcer six-string and mandolin. These were hollow-body instruments with pointed "Florentine" cutaways.

In 1961, Gibson launched the SG range, and from the following year its double-necks became based around this design – albeit with foreshortened horns and less drastic chamfering around the body's edges. Essentially two conjoined SG bodies, the EDS-1275 used a complex scratchplate system to conceal the wiring that linked the two halves and on which a selector switch for each side, or both, was mounted. Although they employed the company's traditional tune-o-matic bridge, both sets of strings – the 12-string's top two pairs in unison and the remaining four an octave apart – were attached by simple hook-in anchors. Both halves shared the standard Gibson control layout of two volumes and two tones, but room around the control area was limited, so the three-way pickup selector was put on the lower horn. All-mahogany, the EDS-1275 was unwieldy, but it did allow guitarists to play both styles of instrument with minimum inconvenience. The 12-string neck was mounted on top and players usually wore the guitar with the lower, six-string positioned at its usual height and the double-course neck sitting higher on their chest. One unique characteristic of the EDS-1275 was due to its unusual wiring. With the selector switch in the middle position, both halves of the guitar were "live" and while playing the six-string neck the strings of the 12 would vibrate in sympathy, lending an eerie, ethereal sound. John McLaughlin liked the effect so much he even had a series of acoustic guitars built with similar sympathetic "drone" strings across the body. Despite the guitar's neck-heaviness, several EDS-1275 players changed the Kluson tuners to the better-quality but weightier Grovers.

The double-neck's most famous user was Jimmy Page, who lent it immortality on Led Zeppelin's epic masterpiece "Stairway To Heaven", which boasted distinct six- and 12-string passages. Multineck guitars are now must-have accessories for showman guitarists – Steve Vai has used a triple-necked Ibanez, Bon Jovi's Richie Sambora has a 6, 12, and mandolin acoustic Ovation, while bassist Roger Newell had a three-necked Wal instrument built, with six-string guitar plus fretted and fretless basses!

Left Which guitar has 40 frets, four humbucking pickups, 18 strings, and 18 tuners? Why, Gibson's EDS-1275 double-neck, of course!

Opposite The sight of Jimmy Page on stage with Led Zeppelin playing his cherry double-neck (*see also* next page) typifies the Gibson EDS-1275.

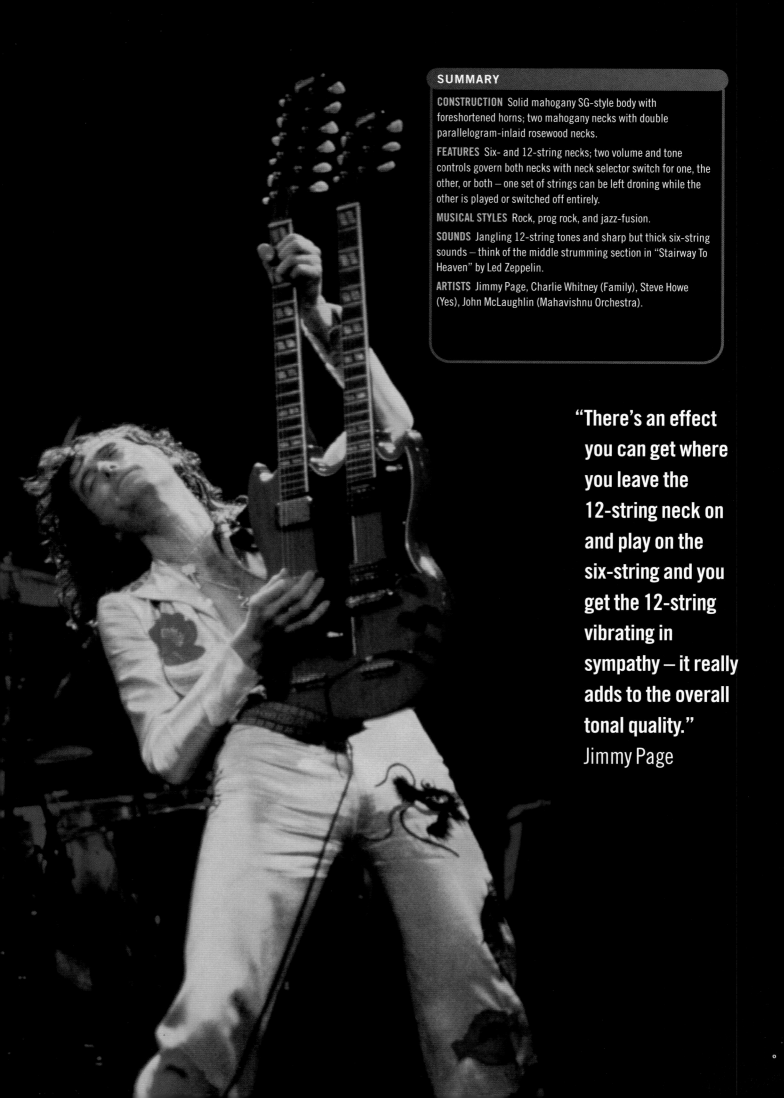

SUMMARY

CONSTRUCTION Solid mahogany SG-style body with foreshortened horns; two mahogany necks with double parallelogram-inlaid rosewood necks.

FEATURES Six- and 12-string necks; two volume and tone controls govern both necks with neck selector switch for one, the other, or both — one set of strings can be left droning while the other is played or switched off entirely.

MUSICAL STYLES Rock, prog rock, and jazz-fusion.

SOUNDS Jangling 12-string tones and sharp but thick six-string sounds — think of the middle strumming section in "Stairway To Heaven" by Led Zeppelin.

ARTISTS Jimmy Page, Charlie Whitney (Family), Steve Howe (Yes), John McLaughlin (Mahavishnu Orchestra).

"There's an effect you can get where you leave the 12-string neck on and play on the six-string and you get the 12-string vibrating in sympathy — it really adds to the overall tonal quality."
Jimmy Page

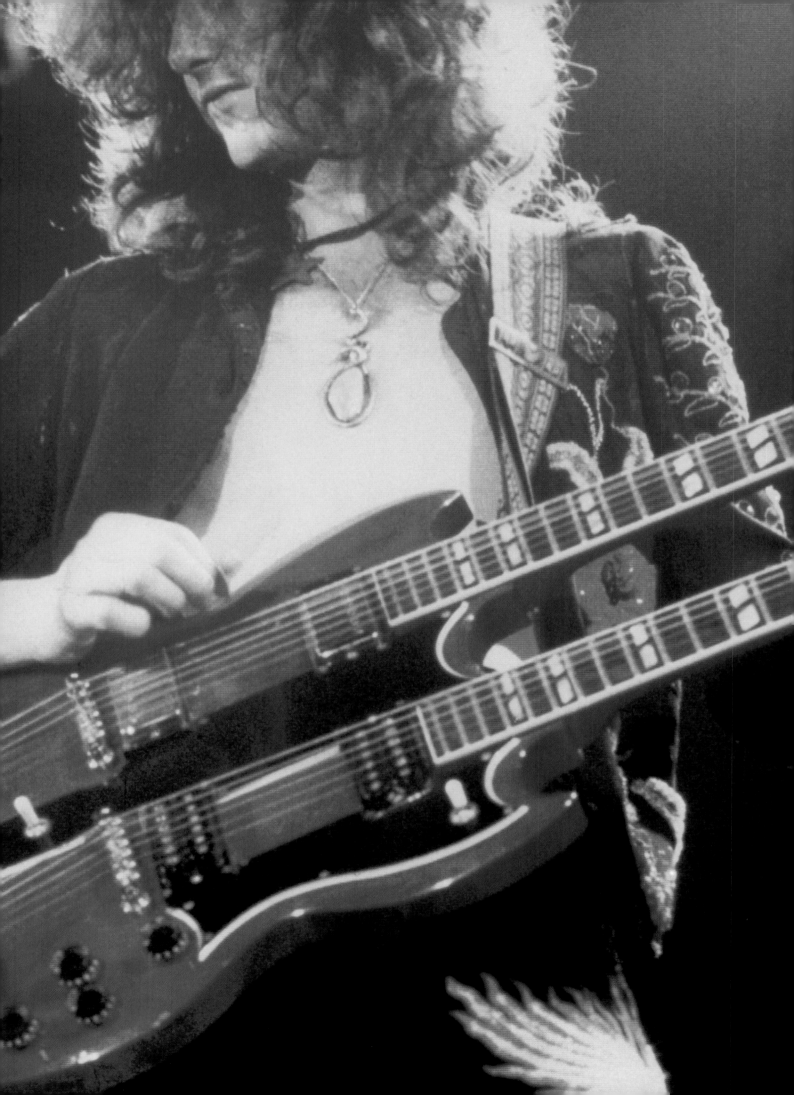

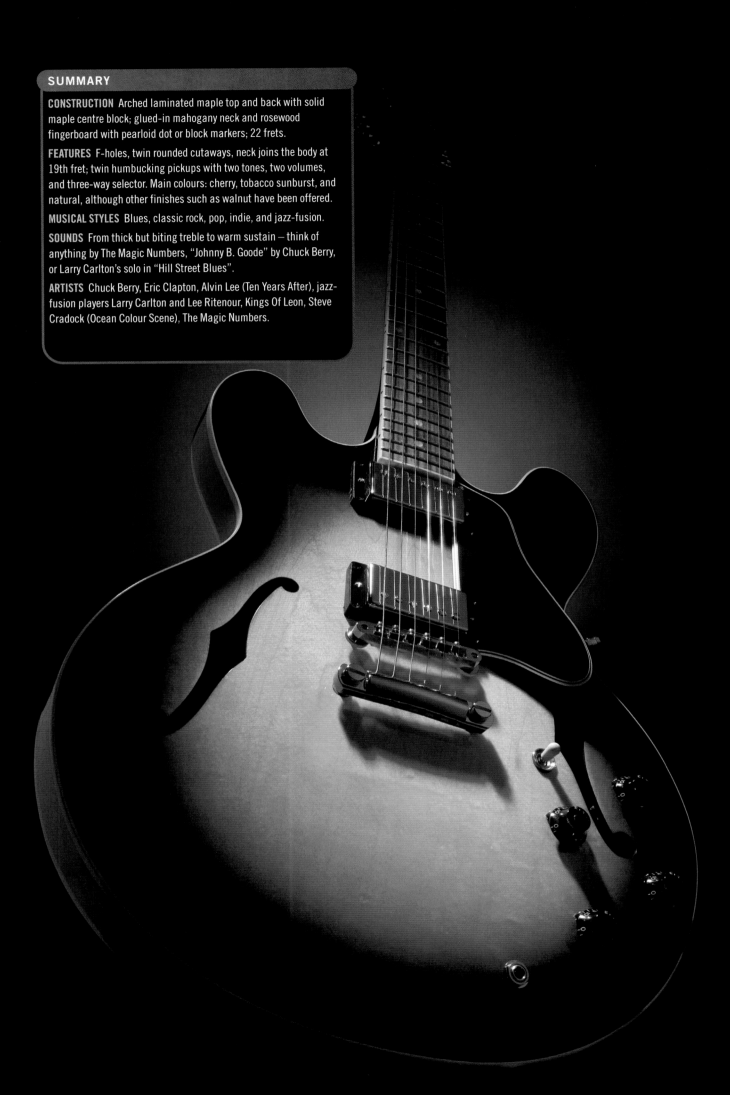

SUMMARY

CONSTRUCTION Arched laminated maple top and back with solid maple centre block; glued-in mahogany neck and rosewood fingerboard with pearloid dot or block markers; 22 frets.

FEATURES F-holes, twin rounded cutaways, neck joins the body at 19th fret; twin humbucking pickups with two tones, two volumes, and three-way selector. Main colours: cherry, tobacco sunburst, and natural, although other finishes such as walnut have been offered.

MUSICAL STYLES Blues, classic rock, pop, indie, and jazz-fusion.

SOUNDS From thick but biting treble to warm sustain — think of anything by The Magic Numbers, "Johnny B. Goode" by Chuck Berry, or Larry Carlton's solo in "Hill Street Blues".

ARTISTS Chuck Berry, Eric Clapton, Alvin Lee (Ten Years After), jazz-fusion players Larry Carlton and Lee Ritenour, Kings Of Leon, Steve Cradock (Ocean Colour Scene), The Magic Numbers.

> "I wanted a guitar that was coming from the ES-175 jazz side but which was more contemporary sounding, more versatile, and more comfortable for me to play on, and the 335 was perfect." Larry Carlton

Gibson ES-335

When a guitar finds itself as the perfect choice for players in any style from pop to rock or blues and jazz, then you know its designer has got things right.

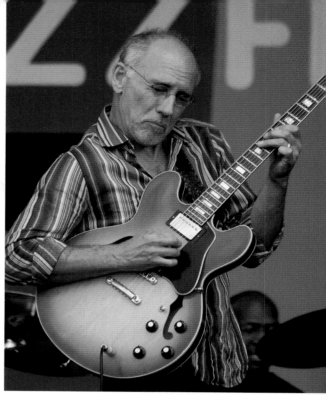

In the late 1950s, Gibson wanted something that bridged the gap, both musically and stylistically, between its f-hole jazz-style instruments and the solid-body Les Paul that was still struggling. Gibson's ace designer Ted McCarty and his team set out on a quest that would produce one of the company's, and indeed the world's, best-loved electric guitars.

Ironically, McCarty harked back to Les Paul's "Log" for the new design, the cello guitar with a solid centre block that he had made in 1941 and which Gibson had summarily rejected. The company already had a range of thinline semis, including the Byrdland and ES-350T (Chuck Berry's early favourite), but these were all-hollow affairs that did not address the problem of acoustic feedback or "hollow-body howl" that afflicted such instruments as amplification became more powerful and stage volume increased. McCarty designed an all-new shape with symmetrical rounded horns, f-holes, and a neck that joined the body at the 19th fret for almost total fingerboard access. It was to be a player's guitar indeed!

The top and back were made of laminated maple, pressed into the gentle arch that characterizes the thinline semi. This arch made it tricky to fit an internal block, so McCarty had strips of spruce cut, which plugged the gaps between the flat maple centre section and curved top and back. The result was an instrument that sounded "solid" but that retained the dynamics and more vocal character of a hollow-body. Gibson's standard set-up of dual humbucking pickups and twin volume and tone controls made it instantly familiar, despite it being an all-new concept.

From the outset, the ES-335 (which stood for Electric Spanish guitar costing $335) was a runaway success. It is even said that it contributed to the temporary demise of its stablemate, the Les Paul model. Early 335s had pearloid position marker dots but these were upgraded in 1962 with rectangular blocks – hence the distinction between "dot" and "block" marker models. Available in natural and tobacco sunburst, the ES-335 came in see-through cherry and it was this finish that captured the imagination of most fans – even though the comparative scarcity of, in particular, the natural version has made it the most valuable on the collector's market.

Above One of the most technically able and musical guitarists of all is Larry Carlton. His work with Steely Dan, Joni Mitchell, and solo is among the finest playing anywhere. Gibson produces a replica of his 1968 guitar. Larry is known as "Mr. 335".

Opposite One of the all-time classic designs, Gibson's original ES-335 came in see-through cherry red, natural (the rarest and most valuable of the vintage era), and tobacco sunburst, as pictured.

Gibson ES-345

In typical Gibson style, it was not enough to invent the best thinline semisolid guitar the world had ever seen; they felt a couple of upmarket versions might suit, too.

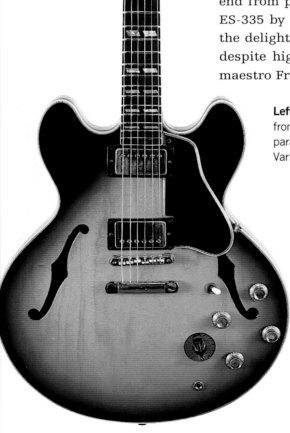

The Gibson ES-335 hit the streets in 1958 to almost universal acclaim. But it came equipped with the company's "standard" level of ornamentation – rosewood fingerboard with dot inlays (small blocks came later), simple body binding, no standard vibrato system, the usual electrics set-up, and of course nickel-plated parts. Gibson could not simply leave it at that. By this time, Gretsch was making a splash with its Chet Atkins line and, while the 335's success probably prompted its switch from single- to double-cutaway design in 1961, it is likely that Gibson took a lead from its rival in the inclusion of more sophisticated electronics. Ironically for Gibson, the failure of Gretsch's complex switching and stereo wiring to catch on would also blight the success of the handsomely upmarket ES-345.

While constructionally the 345 was identical to its lowlier sibling on its release in 1959, Gibson gave it gold-plated hardware, triple cream and black body binding, ES-175-style double parallelogram position markers, and a six-way "chicken head" rotary switch called a Varitone. This offered a range of preset pickup tones via a system of built-in filters. The ES-345 operated in stereo, with each pickup feeding its own amplifier or amp channel via a "Y" cable, but this made things fiddly and potentially expensive. The Varitone, too, which progressively removed the signal's bass end from positions 1 to 6, gave as many ugly tones as usable ones – the ES-335 by comparison was a fabulous-sounding guitar at every turn. So the delightful-looking ES-345 was never the success of its lesser brother, despite high-profile users such as Tony Hicks of The Hollies and blues maestro Freddie King. Discontinued in 1983, the ES-345 is again available.

Left The ES-345 is easy to differentiate from its lowlier 335 sibling due to its double parallelogram position markers, six-way Varitone switch, and gold-plated hardware.

SUMMARY

CONSTRUCTION Arched laminated maple back and top with solid maple centre block and glued-in mahogany neck.

FEATURES Stereo humbucking pickups with six-way Varitone switch – some models featured a variety of vibrato systems, including Bigsby and Maestro; double parallelogram position markers on rosewood fingerboard; gold parts.

MUSICAL STYLES Pop and blues.

SOUNDS Often nasal, but also thin and trebly.

ARTISTS Freddie King, Tony Hicks (The Hollies), Keith Richards (early Rolling Stones), George Harrison.

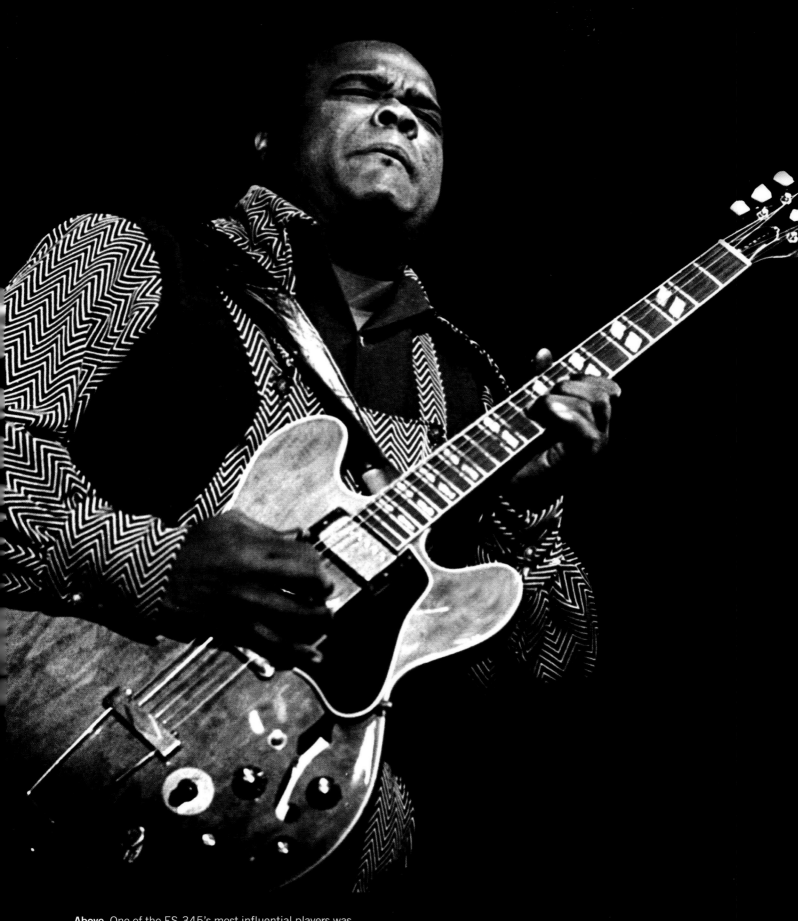

Above One of the ES-345's most influential players was bluesman Freddie King, whose lightning licks influenced every major player of the 1960s era – most notably Eric Clapton, who covered several of the big man's songs including "Hideaway" and "Have You Ever Loved A Woman".

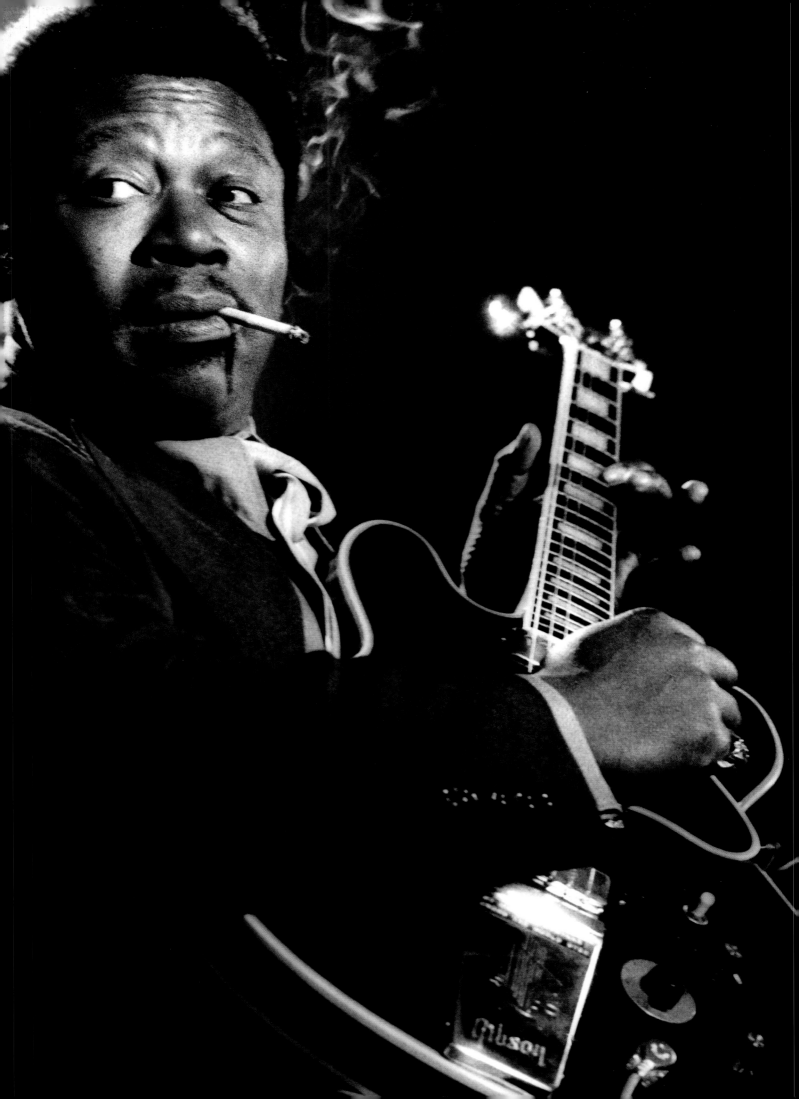

Gibson ES-355

If the 345 was the prettified version of Gibson's fabulous new semi, then the ES-355 was its all-singing, all-dancing big brother – with bells on.

When the King of the Blues wants an instrument befitting his status, and displaying just the right blend of earthiness and flash, there is only one choice – the glorious ES-355. B.B. King has played the Gibson semisolid range almost since the beginning, picking the flashiest model early on and giving it the name associated with all his favourite guitars: Lucille.

Never short of great guitar ideas, Gibson has always cleverly sought to exploit them in as many ways as possible. Just as we have Les Pauls and SGs in Standard, Junior, Special, and Custom guise, so the same is true for the ES-300 semisolid series. The 335 could be viewed as the Standard version, the 345 the Deluxe, and the grand 355 as the Custom. Indeed, regard an ES-355 alongside the Les Paul Custom and the comparisons are obvious: multiple white-black-white body binding and the same on the enlarged headstock with split diamond inlay, ebony fingerboard with large pearl block markers, and of course gold-plated hardware throughout.

Like the ES-345, its snazzier brother is traditionally fitted with the unpopular six-way Varitone switch, but mono versions have been available from early on. Vibrato systems have been a feature on most instruments, be it the early sideways Maestro unit, the long "lyre" style Vibrola, or the ubiquitous Bigsby. The semi also features an upgraded scratchplate – in mock tortoiseshell hand-bound in multiple white and black edging.

Sales of Gibson's "premium" semisolids paled against the popular 335, but lately guitarists such as Oasis' Noel Gallagher have picked up on the 355's merits and beauty. Although officially discontinued in 1982, since then Gibson has produced a Lucille model based around the ES-355. It has no sound-holes but carries Schaller's TP-6 adjustable tailpiece, a brass truss-rod cover, and the guitar's name emblazoned in pearl script down the centre of its headstock. It is still B.B. King's instrument of choice, but a "standard" ES-355 is available once more, built to original specifications.

Left Just as the Les Paul Custom was the top of the line in its range, so the ES-355 topped Gibson's semisolid ES-300 series. Its ebony fingerboard with pearl block inlays, as well as multiple body, headstock, and finger-rest binding, marked it out from the crowd.

SUMMARY

CONSTRUCTION Laminated arched maple back and top with solid maple centre section; glued-in mahogany neck; ebony fingerboard.

FEATURES Stereo humbucking pickups with six-way Varitone switch (no-Varitone model available); multiple bound body and headstock with split diamond inlay; pearl fingerboard markers; gold parts; variety of vibrato options over the years, including sideways Maestro, Vibrola, and Bigsby.

MUSICAL STYLES Blues and pop-rock.

SOUNDS Nasal, fat, and mellow or hard and raunchy – think of "When Love Comes To Town" by U2 with B.B. King.

ARTISTS B.B. King (who now plays Lucille model variant), Noel Gallagher.

"I like to get all the highs and lows and with stereo you can run one amp set for treble and one for bass and you can get the best of both. The Varitone is good for getting different tones. I leave my toggle switch in the middle and the Varitone at twelve o'clock; then I can get as much bass or as much treble as I want ..." B.B. King

Chuck Berry was a big Gibson fan, and the great rock and roll guitarist was seen with almost every model in the ES-300 range. His powerful style harked back to bluesman T-Bone Walker, but his own influence can be heard in Keith Richards and Angus Young.

Eric Clapton adored the Gibson semi, and this love almost certainly stemmed from its use by Freddie and B.B. King. Gibson's Custom Shop has faithfully recreated Clapton's Cream-era cherry-red 1964 model for a special limited-edition run.

Bill Nelson was an astounding guitarist and front man of intelligent British rock band Be Bop Deluxe. His flowing legato lines were reminiscent of other Yorkshire-bred players Allan Holdsworth and cult hero Ollie Halsall of the group Patto.

Johnny Guitar Watson played many different instruments, but like many other blues players was always drawn back to the ES-300 range. In this picture, the flamboyant guitarist is using a slide and a capo at the eighth fret of a sunburst ES-335.

Bob Weir was historically overshadowed in Grateful Dead by American guitar legend Jerry Garcia, but his contribution to the band was considerable. Here he is in 1972 playing a cherry-red ES-345 stereo.

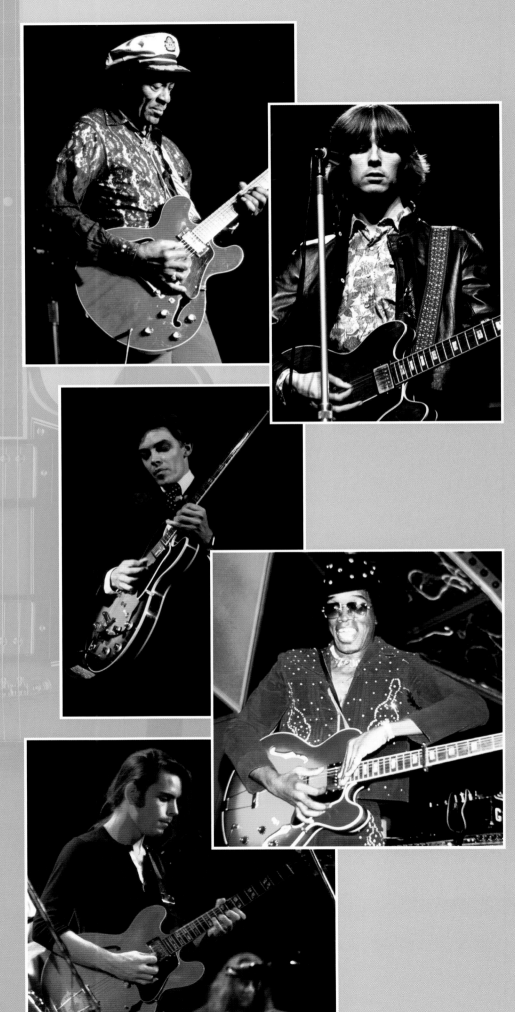

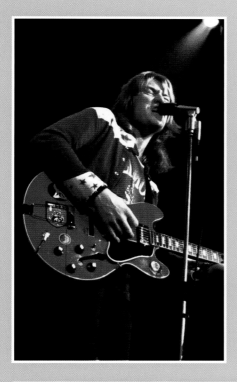

Alvin Lee and Ten Years After put in a performance at Woodstock that was one of the festival's surprise highlights. Alvin's lightning-fast rendition of "Going Home" showed the world his cherry ES-335 with "Ban the bomb" sticker and added Strat pickup.

Lou Reed famously reckons that two chords are enough for any pop or rock song – and proved so with his band Velvet Underground. Here he is with a sunburst ES-335 with Bigsby. Even self-confessed "nonguitarists" like Lou love the credibility that this model brings.

Steve Howe of Yes and Asia was one of the earliest guitar collectors, and he is a great fan of Gibsons. As well as his favourite ES-175, he has been seen with an EDS-1275 double-neck and the rare model The Les Paul, and here is using an ES-345 with nonoriginal tailpiece.

Johnny Marr is one of the most influential modern guitarists. He created multilayered soundscapes for The Smiths using walls of guitar tracks. Although preferring Telecasters and Rickenbackers in the studio, live he will often opt for an ES-355.

Romeo Stodart and The Magic Numbers hark back to the harmony style of late 1960s San Francisco, although they hail from London (Romeo via Trinidad and New York). He delivers his melodic guitar lines using a "dot inlaid" cherry ES-335 reissue.

Gibson Explorer

Number three in Gibson's fabled "Korina trio" was an angular, asymmetrical instrument that looked as though it had been attached to grappling hooks at opposite corners and subjected to a tug of war between teams of cart horses.

When U2 and Paul McCartney opened 2005's Live8 with "Sergeant Pepper's Lonely Heart's Club Band", few of the millions watching the concert could have imagined that The Edge's crazy-looking guitar had been designed the year after schoolboy McCartney met schoolboy Lennon at Woolton fete in Liverpool. So, on its release in 1958 the Explorer must have looked like something from another planet.

Emerging in that golden 12-month period that saw the appearance of the Les Paul Standard, the ES-335, and the Flying V, and at a time when talk of space travel was on everyone's lips, the Explorer was the perfect foil for the symmetrically styled Flying V. Its ludicrously distorted body was hewn from two pieces of Korina, and it featured a neck of the same material and a narrow, scythelike, six-a-side headstock (a few early examples were shipped with a large cleft peghead with raised plastic Gibson logo as fitted to its sister guitar).

On the Explorer, Gibson employed an identical electrics set-up to that of the Flying V – twin humbuckers, separate volume for each pickup, and a master tone control – and the strings were attached in traditional fashion to a stud or "stop-bar" tailpiece. In essence, however, it was exactly the same guitar – just a strikingly different shape.

Right and opposite Original Explorers from 1958 can fetch the price of a house! They are so valuable and rare that originals are almost never seen in the flesh – even multimillionaire guitarist The Edge of U2 plays a 1976 reissue.

> "I'm drawn back to the Explorer. It has this unique tone." The Edge

SUMMARY

CONSTRUCTION Solid two-piece Korina (African limba wood) body and glued-in neck; rosewood fingerboard with pearloid dots.

FEATURES Asymmetrical body design, twin humbuckers with dual volume and master tone control, clear cellulose finish. Later versions with mahogany body.

MUSICAL STYLES Blues, classic rock, and modern rock.

SOUNDS Powerful and biting, with singing sustain.

ARTISTS Eric Clapton, The Edge (U2), Billy Gibbons (ZZ Top), Johnny Winter, Dave Keuning (The Killers).

Left Over the decades, many vintage guitars are modified or customized – often to the real detriment of their value. Eric Clapton's Explorer has had its top horn shortened and rear end rounded off. Ironically, his provenance will bring its value up again.

According to Gibson's sketchy records, a mere 38 Explorers were shipped before production ended although, just like the Flying V, more were released during the early 1960s. In 1976, Gibson produced the first of several official Explorer reissues, this time built from mahogany but in other respects a faithful recreation. In the early 1980s, the entire Korina trio (including the mythical Moderne) was made again in Korina, and in the absence of affordable originals these are already fetching premium prices.

Today the Explorer shape is used as the basis for various manufacturers' guitars, including Gibson and sister brand Epiphone, and also the ESPs played by Metallica and the Dean model used by the late Dimebag Darrell of Pantera and Damageplan. As well as The Edge, players such as Eric Clapton and ZZ Top's Billy Gibbons occasionally like to parade their vintage Explorers in front of incredulous crowds, while Dave Keuning, The Killers' guitarist, regularly sports one of the reissues.

Gibson Flying V

Perhaps the best known of all the weird-shaped solid-bodies, the Gibson Flying V has been used by many guitarists to make a visual and musical statement.

As so often has been the case throughout Gibson's more than century-long existence, its staid and traditional image has masked bouts of innovation that put any of its rivals to shame. From employee Lloyd Loar's superb arch-top instruments of the 1920s – including the unrivalled L-5 and giant Super 400 – and his own experiments with amplifying guitars in the same decade, up to the invention of the adjustable truss rod and the thinline semi-acoustic ES-300 series, invention has been at the heart of the company's ethos. Yet, by the 1950,s this situation had been subverted by Leo Fender's incredible instruments: he seemed to have leapfrogged Gibson, making their achievements look old-fashioned, even pedestrian.

The brilliant Ted McCarty – among whose glories could already be numbered the Les Paul and ES-335, the tune-o-matic bridge and stud tailpiece – could not let this situation prevail. So McCarty and his team invited other designers to come up with ideas for a set of "modernistic" guitars that would put Fender in the shade. Legend has it that, of 100 or so candidates, the selection was whittled down to just three, one of which – the Moderne – was probably never made, although drawings of it exist. The second is the subject of this book's next section and the third is one of the most recognizable guitars ever produced.

Only eight years after Fender's radical but distinctly guitar-shaped Telecaster hit the shops, it had become apparent that a solid-body electric need take no heed of conventional outlines in

Above Based on the 1967 design, this V Factor has a white scratchplate and dot-inlaid fingerboard, but open-topped humbucking pickups.

SUMMARY

CONSTRUCTION Solid two-piece Korina (African limba wood) body and glued-in neck; rosewood fingerboard with pearloid dots.

FEATURES Arrow-shaped body with stringing from the back through delta-shaped metal plate; twin humbuckers with dual volume and master tone control; clear cellulose finish; ridged rubber strip along lower rim for nonslip playing sitting down. Later versions with mahogany body and pickups mounted on large scratchplate.

MUSICAL STYLES Blues and classic rock.

SOUNDS Powerful and biting, with singing sustain – think of "Blind Eye" by Wishbone Ash.

ARTISTS Jimi Hendrix, bluesman Albert King, rocker Andy Powell (Wishbone Ash), Texan tornados Johnny Winter and Billy Gibbons (ZZ Top), glam rockers Marc Bolan and Lenny Kravitz.

Opposite One of the most exciting guitar shapes ever, the Flying V has been the weapon of choice for guitarists, including Jimi Hendrix, The Kinks' Dave Davies, Andy Powell of Wishbone Ash, and bluesman extraordinaire, Johnny Winter.

Right Although blues giant Albert King used to play an original Gibson Flying V, for his 65th birthday ZZ Top's Billy Gibbons had Texan luthier Tom Holmes build the guitar for which he is best known: the bound-bodied V with "Albert King" emblazoned on its fingerboard.

"**Nobody could play like Albert King. His tuning was a secret and Albert made me swear never to reveal it.**" Gary Moore

Next page Although Metallica's Kirk Hammett and James Hetfield often play Explorer and V-shaped guitars by Japanese maker ESP, in their early days they both used Gibson Flying V models. Here a very young James is playing a white one, while Kirk's is in black.

order to fulfil its job description. Indeed, this was the rock and roll era and image was everything. The Flying V came off the drawing board in 1958 and has had several incarnations since its birth. It was built from African limba wood, sold under the trade name Korina. A relative of mahogany, it was lighter in colour and when finished in clear cellulose lacquer turned a warm gingerbread colour. Sonically, it was sharper than mahogany, too, and the V's large mass of the timber complemented the humbucking pickups for an aggressive tone that suited blues and, later on, rock.

Early Vs were strung from behind, the strings emerging from a delta-shaped plate, over a tune-o-matic bridge, along a dotted rosewood fingerboard, and onto an arrowhead-style peghead. Along the body's lower rim a ridged rubber strip provided grip on the player's leg when sitting down, and the instrument's symmetry and balance made it a surprisingly practical choice. As so often has happened, though, the Flying V was mocked on its release and only a handful were made before production ceased. Some leftover parts were put together and sold by Gibson in the early 1960s, before a new design of V emerged in 1967. This was of mahogany construction with droopier shoulders and a large scratchplate onto which the pickups were mounted. It also bore the regular Gibson bridge and tailpiece arrangement. Two of these models found their way into the hands of Jimi Hendrix – one a standard issue, which Jimi painted in psychedelic oils, and the other specially built for him by Gibson in black, with ebony fingerboard and arrowhead inlays. Some experts say that it was his psychedelic Flying V on which he played "All Along The Watchtower" and perhaps even "Voodoo Chile (Slight Return)".

The ultimate irony is that, owing to the distaste that greeted the poor V on its emergence and poor sales, today it is one of the most-prized vintage guitars. An original 1958 example can fetch an astronomic price!

Right Today Gibson produces highly accurate remakes of its original Firebird models, including the Firebird V (near right) with all-chrome mini humbucking pickups. The Firebird Studio (far right) is a cheaper and more purposeful option, and with its full-size humbuckers it is built to rock.

Gibson Firebird

With its radical motor vehicle styling, Gibson's fabulous Firebird should have been an instant hit. Yet it took over a decade for guitarists to see the beauty in the beast.

The year was 1963. The Beatles scored their first British number one with "She Loves You"; John F. Kennedy got in the way of Lee Harvey Oswald's bullet in Dallas; and over in Kalamazoo, Michigan, Gibson decided that enough was enough – those pesky Californians at Fender needed teaching a lesson! It was also a great year for American car design; automobiles such as Chevrolet's two-toned pastel-coloured Impala, with its lashings of chrome and tail fins at least a mile wide, had set the standard for opulence and flash. So Gibson figured that a Detroit motor designer might just be the answer to their needs.

Ray Dietrich had worked for Chrysler but made his name with LeBaron coachbuilders, designing classic Lincoln and Packard models before retiring to Kalamazoo – Gibson's home until the mid-1970s. Dietrich took the modernistic lines of the ill-fated Explorer and pulled in and rounded off its extremities, but capitalized on its upside-down look with a reverse Fender-style headstock. Using rear-facing Kluson banjo tuners and nonadjustable mini-humbucking pickups – plus a white scratchplate that took up the guitar's entire protruding lower horn – Dietrich's Firebird looked enticingly new, but still distinctly Gibson.

Ray wanted a three-dimensional look to the guitar but without using Gibson's traditional arched or carved top method. So the Firebird was built using the through-neck design pioneered by Rickenbacker, where the neck and the body's raised centre section were a single construction – in this case a 9-piece laminate of mahogany and walnut – with mahogany "wings" glued either side. While elegant in the extreme, this made the Firebird both costly to build and prohibitively expensive to repair.

Originally the Firebird came in four guises, from the single-pickup Firebird I right up to the gold-plated, pearl-inlaid, triple-pickup Firebird VII. The "standard" model was the Firebird V with two chrome-covered pickups and Les Paul style "crown" inlays on its rosewood fingerboard

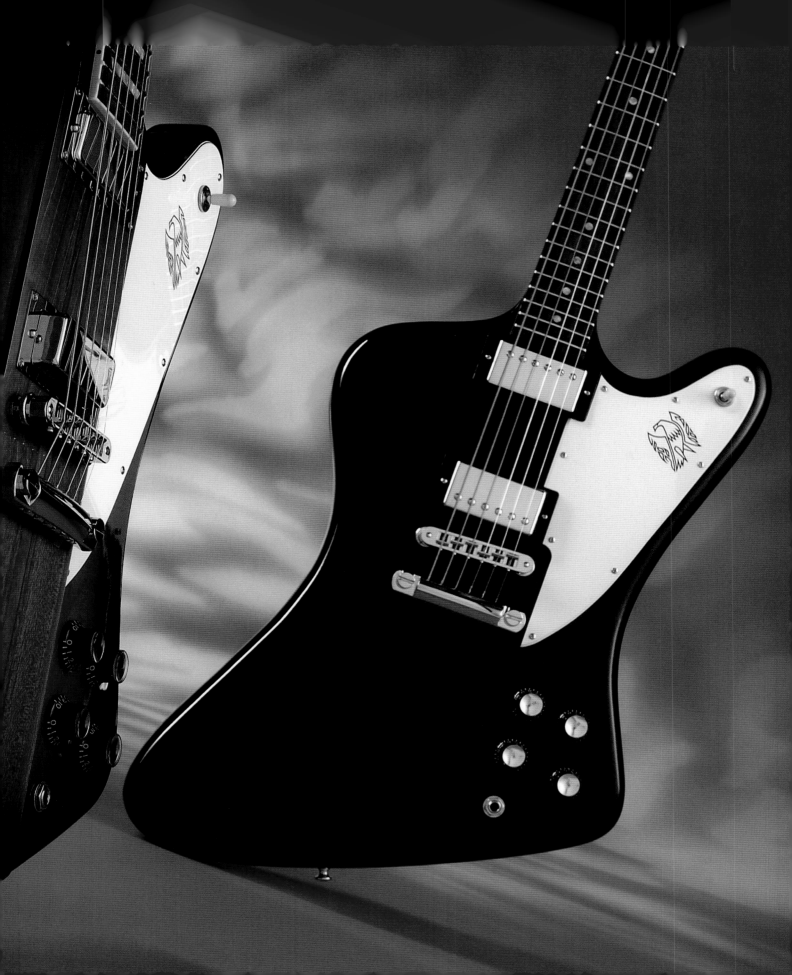

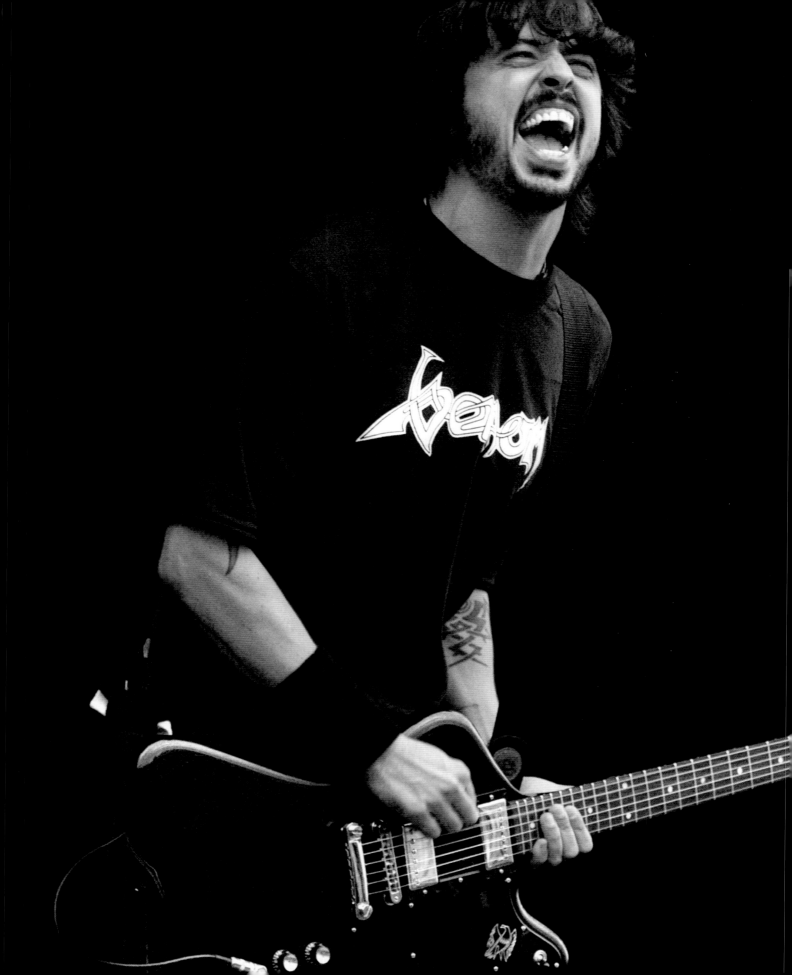

Although Dietrich's design certainly got noticed – Fender felt it was a little too close for comfort – it missed the mark with the guitar-buying public and so was replaced just two years later by what became known as the "nonreverse" Firebird. This much more conventional-looking instrument followed familiar form – its top horn being longer than the bottom – and featured a conventional glued-in neck and a large Fender-style scratchplate onto which the pickups were mounted. While a range of custom colours was made available, including fabulous metallics, even the revamp proved a flop and it was not until a decade later that the Firebird's value as a design was appreciated, and players such as blues maestro Johnny Winter and Roxy Music's Phil Manzanera began using them.

Sonically the instrument was an interesting mix of Gibson and Fender; its mini-humbuckers and unique construction produced a tight, almost brittle sound that perfectly suited Winter's power blues and Manzanera's strong single-note lines.

Firebird models are still made by Gibson, including faithful reissues of Ray Dietrich's original designs, plus the excellent Firebird Studio with full-size humbucking pickups and standard glued-in neck, as played by The Foo Fighters' Dave Grohl. Dietrich died in 1982.

Opposite The Foo Fighters' Dave Grohl was one of the first serious guitar players to pick up on Gibson's Firebird Studio.

Above The Rolling Stones were one of the first groups to get into guitars seriously. Keith Richards and Brian Jones sought out all the great American models even before Clapton, Page, and company. Here is Jones with a sunburst Firebird VII.

SUMMARY

CONSTRUCTION Raised mahogany and walnut centre section with glued-on mahogany "wings"; reverse Fender-style headstock with Kluson banjo tuners.

FEATURES Variety of pickup options, including mini-humbuckers (one on Firebird I, two on Firebirds III and V, and three on Firebird VII); bridges and tailpieces include wrapover combination and Maestro Vibrola.

MUSICAL STYLES Heavy blues, musical pop, and tight rock.

SOUNDS Hard, metallic, articulate – think of "Love Is The Drug" by Roxy Music.

ARTISTS Blues-rocker Johnny Winter has been seen with almost all reverse-style variants, while Roxy Music's Phil Manzanera's pillar-box red Firebird VII is his trademark. Dave Grohl of The Foo Fighters plays the new Firebird Studio.

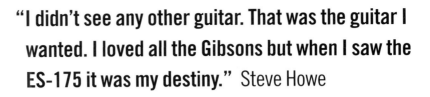

Gibson ES-175

Dating back to 1949, the ES-175 was Gibson's first modern guitar to feature a pointed "Florentine" cutaway and, while used by many jazz guitar greats, it also manages to transcend musical genres.

A result of natural evolution within its stable, the ES-175 can be traced back to earlier Gibson instruments such as the ES-150 – the world's first true production electric and the guitar immortalized by the great jazz musician Charlie Christian. These "Electric Spanish" instruments sprang from even earlier nonelectric models, but by the late 1940s guitars with built-in pickups – designed from the outset to be amplified – were proliferating. The laminated maple style of construction had been around for a while too, notably on the ES-300 of 1940, as it was stiffer than carved spruce and found to be less susceptible to feedback. It also produced the warmer, more rounded tone that jazz players demanded. These instruments usually carried a single pickup, mounted near the fingerboard. This was the case with the ES-175 on its release.

In order to mark it out as an instrument of the new era, Gibson took a radical turn with the guitar, giving it a sharp "Florentine" horn on its single cutaway, rather than the rounded and more gentle-looking "Venetian" version on previous models. It also bore the ES-300's double parallelogram position markers on a rosewood fingerboard. The pickup was Gibson's ubiquitous P-90 and early models featured a typical wooden "jazz"-style bridge and trapeze tailpiece. By 1953, the prayers of tone-hungry guitarists were answered when Gibson introduced the ES-175D (the D stood for "Double" pickup).

Four years later, Seth Lover and Walter Fuller's groundbreaking humbucker debuted. Showing which instrument Gibson felt was commercially its

Left The early ES-175 featured a single P-90 single-coil pickup mounted toward the neck for a mellow tone. In 1957, it was the first Gibson model to receive a pair of Seth Lover's humbucking pickups.

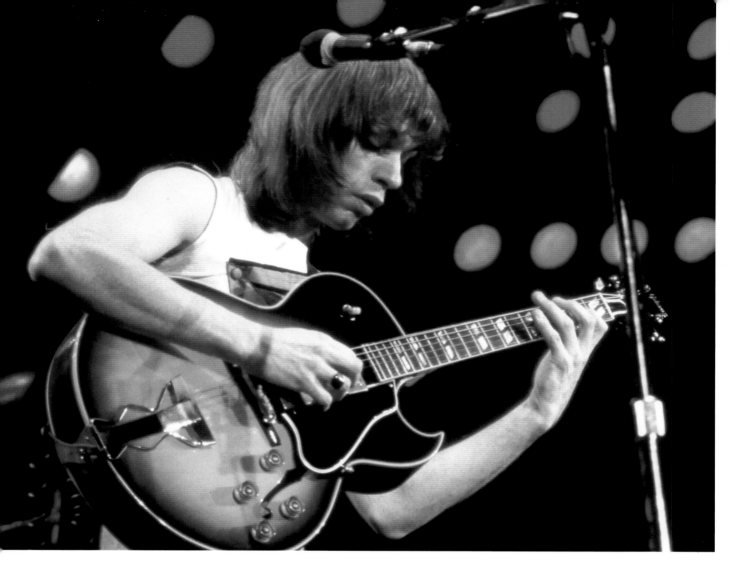

most important at this time, the ES-175D was the first in the catalogue to receive it. By this time, the tailpiece had become a more ornate affair and the three-way pickup selector was mounted on a black rubber grommet. This style of ES-175, from 1957 to the early 1960s, is the most valuable and sought-after today, especially in the scarcer natural finish – ES-175DN.

A massive hit from the outset, the ES-175 became the choice of many famous jazz players, including Herb Ellis (Ella Fitzgerald), Jim Hall, and notably Joe Pass. In the late 1960s, however, a new breed of music emerged called progressive rock, which was soon shortened to "prog". The first and most influential prog band was Yes, featuring a talented young guitarist called Steve Howe. Howe had purchased a Gibson ES-175 in London and the guitar's range of tones – from piercing treble to warm and flutey – was to pervade the group's recordings on albums such as *The Yes Album*, *Close To The Edge*, and *Tales From Topographic Oceans*.

Another influential and talented modern guitarist is Pat Metheny. This U.S. jazz and fusion maestro popularized the use of the chorus effect in his recordings. His articulate playing and sophisticated compositions mark him out as a true master of his art, for which the voice of the Gibson ES-175 has been an indispensable asset.

Above While the ES-175 remains top choice for many jazz greats, in rock its main proponent is Steve Howe. He bought his guitar in London in 1964 and has used it ever since – it has its own seat when Steve travels!

SUMMARY

CONSTRUCTION Laminated full-depth body; mahogany neck and rosewood fingerboard with double parallelogram inlays.

FEATURES Early models had one P-90, then two, before swapping to Patent Applied For humbuckers; jazz-style bridge and various design trapeze tailpieces; toggle selector switch mounted on black rubber grommet; two volumes, two tones.

MUSICAL STYLES Jazz and progressive rock.

SOUNDS Cutting treble pickup and warm mellow neck pickup.

ARTISTS Jazz guitarists Herb Ellis, Tal Farlow, and Joe Pass have all used ES-175s, as have prog rocker Steve Howe (Yes) and modern jazz and fusion exponent Pat Metheny.

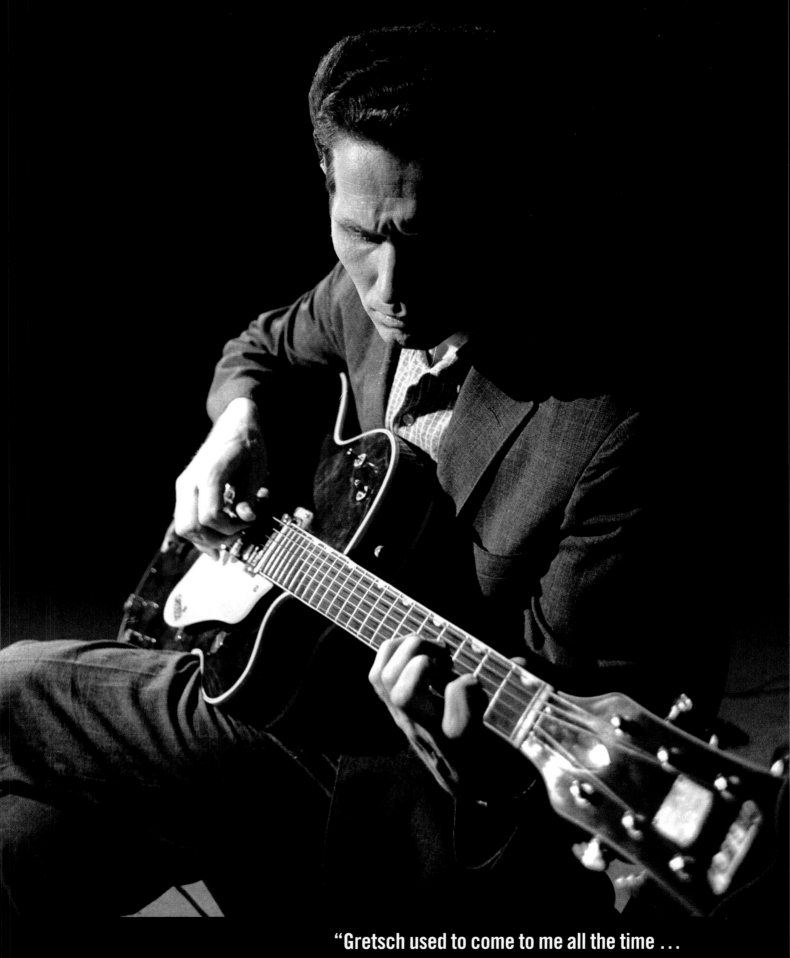

"Gretsch used to come to me all the time . . . I said: 'Well why don't you let me design you a guitar?' And that became the 6120." Chet Atkins

Gretsch 6120 Chet Atkins/Nashville

A true classic, the Nashville – aka Chet Atkins model – is recognized as one of the most important guitars in pop, rock, and country. It is also one of the best lookers ever!

Founded in Brooklyn in 1883 by German immigrant Friedrich Gretsch to make and market mainly percussion instruments and banjos, this most illustrious brand did not really take hold until the 1950s. Today, these models typify Gretsch's unique position in the world of electric guitars, and the 6120 Chet Atkins model, or Nashville, typifies its look and sound. Top country picker and studio producer Chet Atkins was a huge catch for Gretsch, and it is impossible to overstate his influence among the players of the day. Although Chet was happy to put his name to this range of Gretsch guitars, his design input was minimal – this would come with the twin-cutaway Country Gentleman of 1957 (see page 120).

So much changed with Gretsch's models throughout the 1950s and 60s that confusion is rife. On its introduction in 1954, though, this country-inspired guitar sported western scenes etched in its pearl fingerboard inlays, bound f-holes, a longhorn steer headstock decal, and a huge "G" branded into the body. DeArmond single-coil pickups were the order of the day and the instrument's 7.5cm (3in) thick hollow body carried a single Venetian (rounded) cutaway. A Bigsby vibrato unit was standard, as were gold plate and either amber red or the famous Gretsch orange finish. Over the ensuing years the fingerboard inlays changed to plain pearl blocks, then to hump-top pearl blocks and "thumbnail" markers along the fingerboard's edge. In 1958, pickups switched from DeArmond to Gretsch's own FilterTron humbuckers and the following year a zero fret was added – one of Atkins' few stipulations.

Complicated controls and general ergonomics have always been at the heart of Gretsch's inability to capture the mainstream player. While the original 6120's individual pickup volumes with master volume on the body horn, plus single pickup selector switch and tone

Left Fifties rock and roll star Eddie Cochran replaced the DeArmond pickup in the neck position on his 1956 Gretsch 6120 for a Gibson "dog-ear" P-90. This gave Eddie more power for rocking riffs and cool solos.

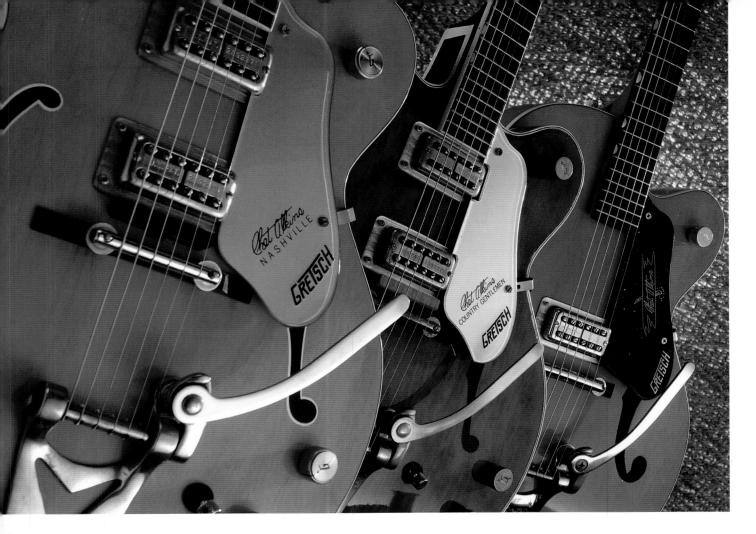

knob, lacked the intuitive element so crucial to the success of Gibson and Fender, when the rotary tone pot was replaced by a preset tone switch alongside the pickup selector it all became too much. Such complications suited some players, however, and rocker Eddie Cochran adopted the 6120, as did Mr Twang himself, Duane Eddy.

In the 1960s, the Chet Atkins' body lost 13mm (½in) in depth but gained a second cutaway, also forsaking real f-holes for painted-on transfers to combat the feedback that dogged early instruments. At around this time, Gretsch added such "luxury" appointments as leather or vinyl back-pads and string mutes, further alienating "serious" guitarists from the model and the brand.

When the Baldwin Piano Company bought Gretsch in 1967, the writing was on the wall for the 6120 – a guitar so different from when it was first introduced that it was virtually unrecognizable. Chet Atkins withdrew his approval when Baldwin added further ravages to the model and in 1980 Gretsch ceased production.

Today Gretsch guitars, including the 6120 Nashville, are built to superlative standards in Japan (and cheaper ranges in other parts of east Asia). The company is now owned by Fender Musical Instruments and, while today's 6120 undoubtedly lacks the character of its 1954 ancestor, it is without doubt a better guitar.

Above Here are three gorgeous vintage Gretsch Chet Atkins models: an orange Cochran-style Nashville; a fabulous George Harrison-vibed Country Gentleman; and an unusual single-pickup Tennessean from 1958.

SUMMARY

CONSTRUCTION All-hollow laminated maple body and solid, two-piece maple neck; early models had Brazilian rosewood fingerboard later switched to ebony.

FEATURES Introduction model had DeArmond single-coils before the change to Gretsch FilterTron humbucking pickups; western features gave way to more standard ornamentation and by the early 1960s leather or vinyl back-pads and string mutes had arrived, as had double-cutaways and a slimmer body; Bigsby vibrato unit as standard from launch.

MUSICAL STYLES Country, rock and roll, instrumental, British beat boom, and rockabilly.

SOUNDS Twangy and bright, often nasal.

ARTISTS Brian Setzer (The Stray Cats), Eddie Cochran, Pete Townshend, Duane Eddy, Bono.

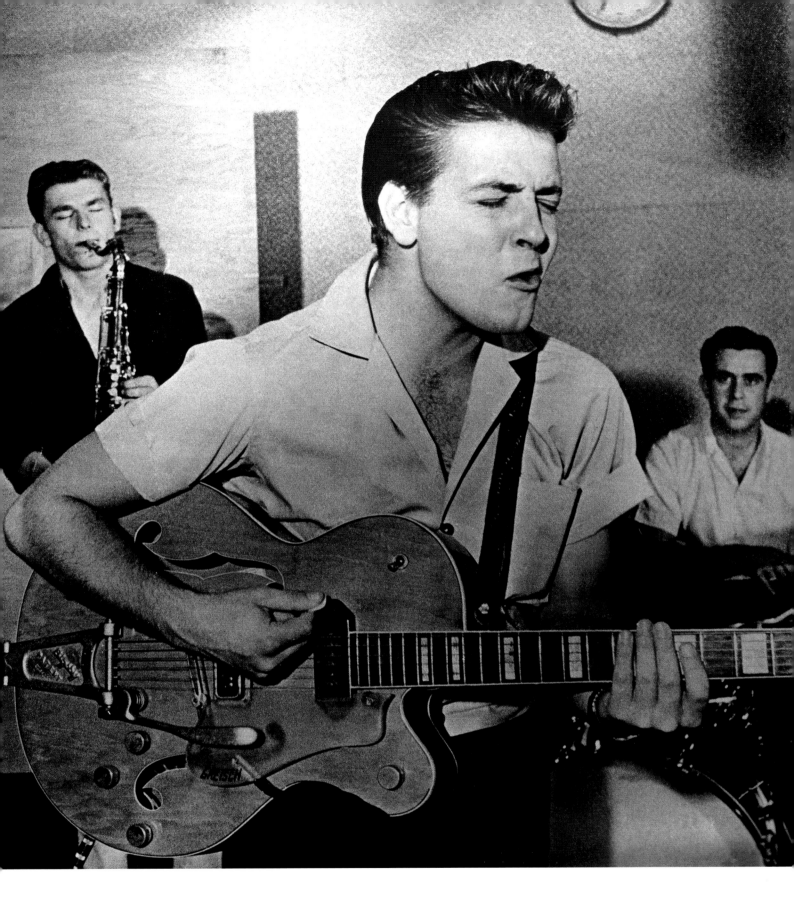

Above Rock and roll legend Eddie
Cochran's use of the Gretsch 6120
inspired countless players who
came after him, including The
Stray Cats' Brian Setzer. Cochran
had many hits including
"Summertime Blues".

Gretsch 6122 Chet Atkins Country Gentleman

How cool is a guitar that was played on stage by none other than The Beatles' George Harrison and the king of rock and roll himself, Elvis Presley?

While country picker Chet Atkins had lent his name to a whole line of Gretsch guitars, he had little real input to many of their features. With the Country Gentleman, however, all that changed. Chet had wanted a slimmer body on his instrument and, ideally, a solid centre section like the Gibson ES-335. Although this never quite came to be, the Country Gent did get an internal block that went some way to appeasing its master's requests.

First introduced in 1957 as a single-cutaway guitar, the Country Gent featured Chet's slimline body with painted-on f-holes, thumbnail position markers on its ebony fingerboard, dual FilterTron pickups, twin tone switches and individual volume controls for each pickup, and the standard master volume knob mounted on the cutaway horn. It also bore a headstock nameplate declaring its model designation and serial number.

It was a cool guitar, but the later, double-cutaway version hit the big time when George Harrison played on the *Ed Sullivan Show* on 9 February 1964. George's double-cut Country Gent (a 1962 model, although this style of 6122 emerged the previous year) was finished in the standard brown mahogany with stud-fastened back-pad concealing the entry to the guitar's innards, and mufflers that brought pads up to the strings in front of the bridge to mute their vibration. The Beatles' appearance on American television caused such a stir that Gretsch could not keep up with demand. Production went up from under 100 units a year to over 2,000, but quality suffered. This did not prevent other 1960s acts jumping on the Gretsch bandwagon, and The Monkees eventually had their own Gretsch model.

SUMMARY

CONSTRUCTION Hollow slimline maple body with partial centre block; two-piece maple neck; ebony fingerboard with thumbnail position markers (later models had rosewood fingerboard).

FEATURES Twin FilterTron humbucking pickups (1964 version had neck position SuperTron); two tone switches, master volume and individual pickup volumes, Bigsby vibrato tailpiece later changed to Gretsch-badged "V" Bigsby; padded back and string mutes.

MUSICAL STYLES Country and British pop.

SOUNDS Bright and wiry, or warm and nasal.

ARTISTS George Harrison, Elvis Presley.

> "Carl Perkins was a sweet fellow... I did a TV special with him and I used the Gretsch for that, the one I like to call the Eddie Cochran/ Duane Eddy model. You have to understand how radical that sound was at the time."
> George Harrison

Right George Harrison had two Country Gentleman guitars, both acquired in 1963. His first documented performance with it was on 23 June 1963, miming their first number one U.K. single, "From Me To You", on the British television show *Thank Your Lucky Stars*.

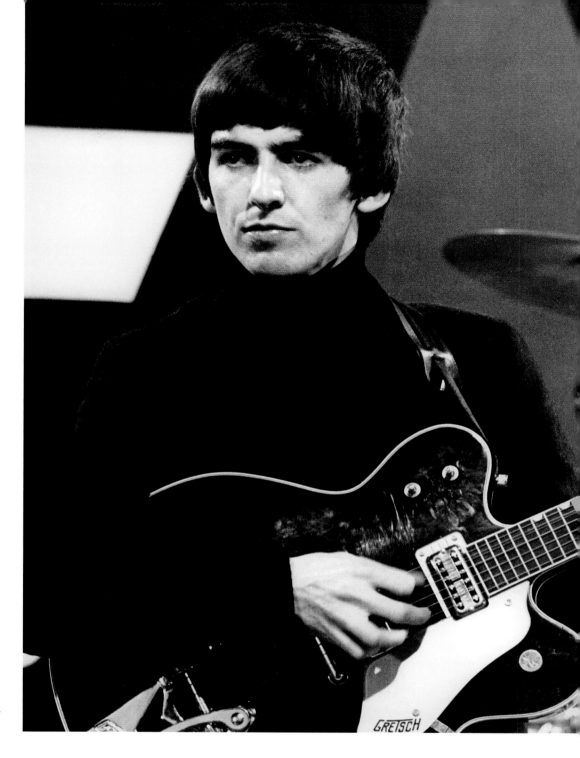

Opposite This Country Gentleman is more like George's second one; note the two flip-up string mutes, one either side of the long Bigsby vibrato.

The Country Gent ran the gamut of sounds from trebly twang to moody blues and pervaded most Beatles recordings, until George's fell off the back of the band's vehicle. In the early 1970s, Elvis Presley purchased one – his 1964 version featured one FilterTron and one SuperTron pickup (no visible pole-pieces), as well as single-lever string mute and kidney-style Grover tuners. It also displayed the Gretsch "V" Bigsby vibrato tailpiece and simple bar bridge always associated with this model.

Even with such patronage, the Country Gent's life was cut short. After Baldwin's 1967 acquisition of the brand, Gretsch sales plummeted. Atkins joined forces with Gibson, taking his brand names. The Country Gentleman became the Country Squire and eventually the Southern Belle, before production fizzled out in the 1980s. Gretsch again builds the 6122 Country Gent under its new owners, Fender – it is now called the Country Classic.

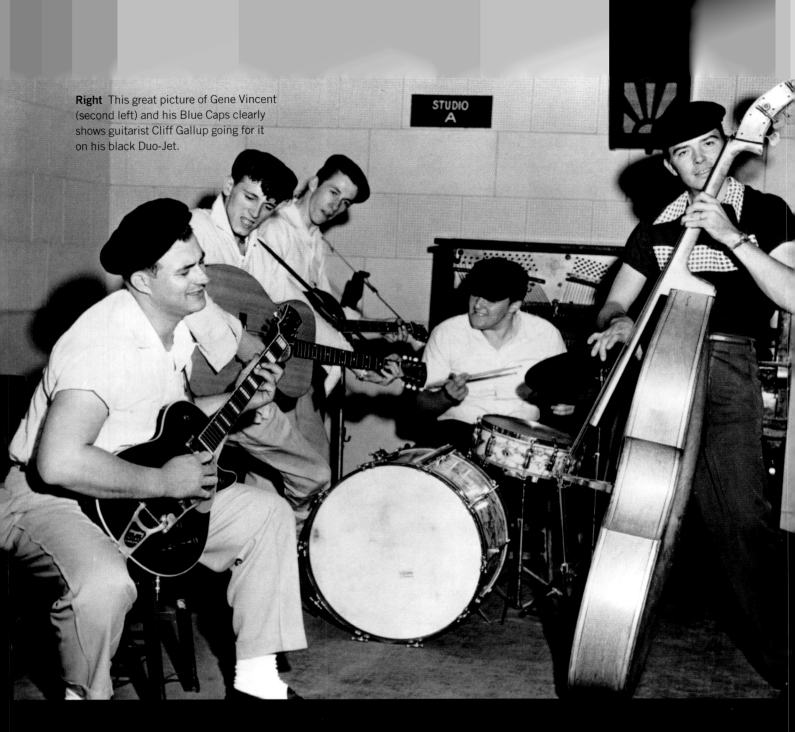

Right This great picture of Gene Vincent (second left) and his Blue Caps clearly shows guitarist Cliff Gallup going for it on his black Duo-Jet.

"I saw an ad in the paper in Liverpool and there was a guy selling his Gretsch Duo-Jet. He had bought it in America and brought it back. It was my first real American guitar and I'll tell you, it was second-hand but I polished that thing. I was so proud to own that." George Harrison

SUMMARY

CONSTRUCTION Semisolid mahogany and mahogany neck; rosewood fingerboard and 22 frets.

FEATURES Early models had two DeArmond pickups, later versions FilterTron humbuckers; early models with block inlays, replaced by humps by 1957, and later versions with thumbnail markers; some models with Bigsby and others with "G cut" tailpiece.

MUSICAL STYLES Rock and roll and Merseybeat.

SOUNDS Twangy, cutting bridge pickup, but warm, rich neck pickup.

ARTISTS Cliff Gallup with Gene Vincent, George Harrison in The Beatles' early years, Jeff Beck on his tribute to Cliff Gallup album *Crazy Legs*.

Gretsch Duo-Jet

Another guitar that was made famous by a Beatle was already a mini-icon in its own right, thanks to a self-deprecating rock and roller from Norfolk, Virginia.

Cliff Gallup's career in the spotlight was short but sweet. Drafted in to join Gene Vincent's Blue Caps by the singer's manager Sheriff Tex Davis, "Galloping" Cliff played on the leather-clad rocker's biggest hit, "Be Bop A Lula", and other tracks. But Gallup was already in his late 20s and married, and did not fancy life on the road. His black Duo-Jet, a Les Paul-sized semi-hollow electric first introduced into the Gretsch line in 1953/4, made an impression on a young George Harrison, who paid £75 for it in 1961.

Although the Duo-Jet looks solid, it is partly hollow, its mahogany body bearing chambers to reduce weight and add some of the tonal dynamics lacking in the all-solid Les Paul. With two DeArmond single-coil pickups it was a sweet-sounding, resonant guitar that suited rock and roll perfectly. Its small, lightweight body and slender neck made the guitar a comfortable handful to play. The Harrison Duo-Jet is a 1957 model and by that time certain things had changed. Early models had the adjustable Melita bridge, "G" tailpiece, and block fingerboard inlays. George's had hump inlays, a Bigsby vibrato tailpiece, and simpler bar bridge. The following year the spec changed again, introducing FilterTron humbucking pickups and thumbprint or "neo-classical" inlays along the top edge of the fingerboard. Another switch was added, providing tone change as well as pickup selection, and the guitar lost a tone pot from its original cluster. In 1959, a zero fret was added. Most Duo-Jets were black but a few came in rare Cadillac Green; the Silver Jet boasted a silver sparkle finish while the Jet Firebird was bright red. An upmarket version, the White Penguin, was also available. Jeff Beck recorded his 1993 album *Crazy Legs* in tribute to Cliff Gallup, using a black Duo-Jet to recreate his hero's tones. Up to his death in Virginia on 9 October 1988, Cliff Gallup was still playing guitar in a local band.

Left This Duo-Jet is similar to George Harrison's 1957 model, with its DeArmond pickups, Bigsby vibrato, and "hump" inlays – notice that Cliff Gallup's earlier model (opposite) has block inlays.

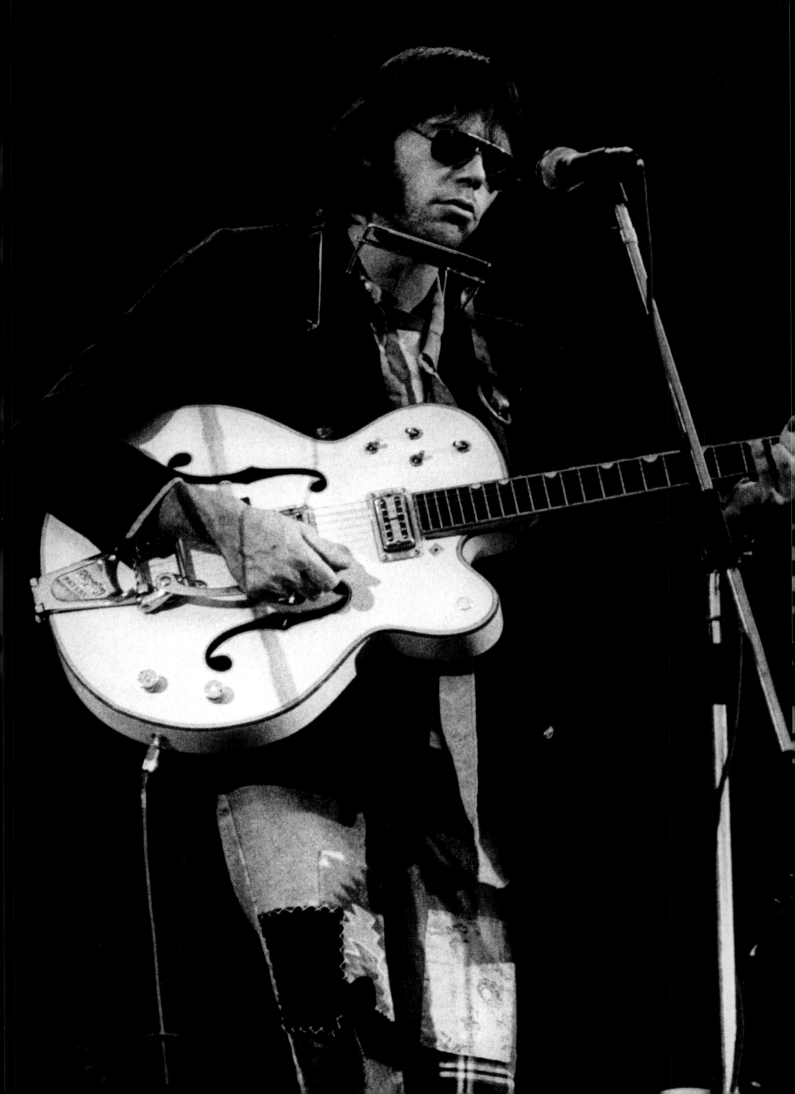

"Neil and I are going to Gretsch in the next couple of weeks. They were amazed at the White Falcons we had because they were kind of old. They offered to let us design one and there's no new design man – just build the old one!"
Stephen Stills, speaking in 1970

Gretsch 6136 White Falcon

Costing a staggering $600 on its release in 1955, the White Falcon was one of the most impressive-looking guitars ever made. But its high price and complexity would be its undoing.

Unlike most guitar builders, Gretsch's background as a drum manufacturer gave the company plenty of useful insight into unusual and visually impressive materials. These included the sparkly plastic drum-shell covering that could be cut into strips and used as body binding or inlay material – and that found its way onto the company's flagship instrument, the glorious White Falcon. So, while Gibson had cornered the market for important-looking, handsome guitars, and Fender continued to dominate the sleek and sexy end of the market, Gretsch found its own niche, where flash met country kitsch.

The company certainly pulled out all the stops when it came to the White Falcon – and so they should have, considering that a new Nash Rambler family automobile from the same year cost just $1,000 more! Although their top guitar was based on the same width of body as the Country Gentleman and employed broadly similar hardware and electrics, Gretsch made sure that the White Falcon boasted everything from 24-carat gold plating to an engraved falcon scratchplate, wings etched into the pearl fingerboard inlays, and a glorious gold Cadillac "G" tailpiece. All this was topped off with a giant cleft headstock, with gold sparkle logo running down the centre and gold-plated Grover Imperial tuners – themselves worth two weeks' wages at the time! The entire instrument, including its milk-white cellulose finish, was a statement of intent, namely that Gretsch was moving in with the big players.

Left Harmony-driven American folk-rock group Crosby, Stills, Nash & Young brought the Gretsch White Falcon out of obscurity when both Stephen Stills and Neil Young began to use it. Young still plays his today.

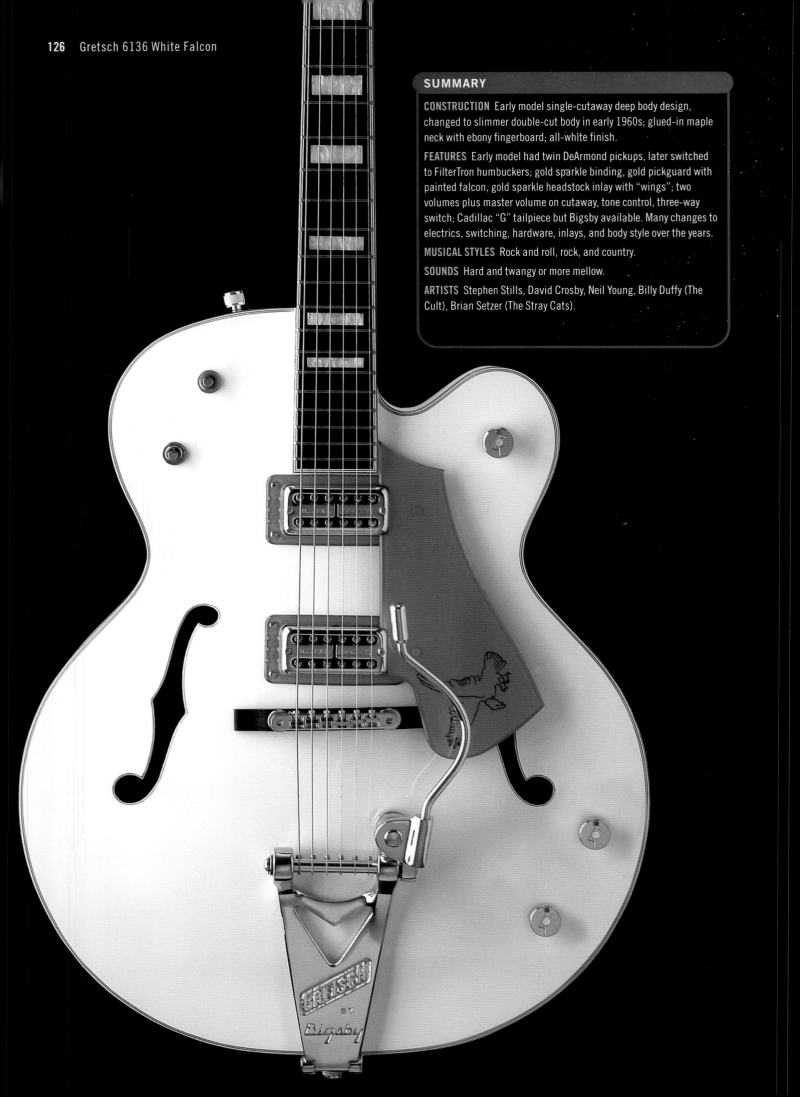

SUMMARY

CONSTRUCTION Early model single-cutaway deep body design, changed to slimmer double-cut body in early 1960s; glued-in maple neck with ebony fingerboard; all-white finish.

FEATURES Early model had twin DeArmond pickups, later switched to FilterTron humbuckers; gold sparkle binding, gold pickguard with painted falcon, gold sparkle headstock inlay with "wings"; two volumes plus master volume on cutaway, tone control, three-way switch; Cadillac "G" tailpiece but Bigsby available. Many changes to electrics, switching, hardware, inlays, and body style over the years.

MUSICAL STYLES Rock and roll, rock, and country.

SOUNDS Hard and twangy or more mellow.

ARTISTS Stephen Stills, David Crosby, Neil Young, Billy Duffy (The Cult), Brian Setzer (The Stray Cats).

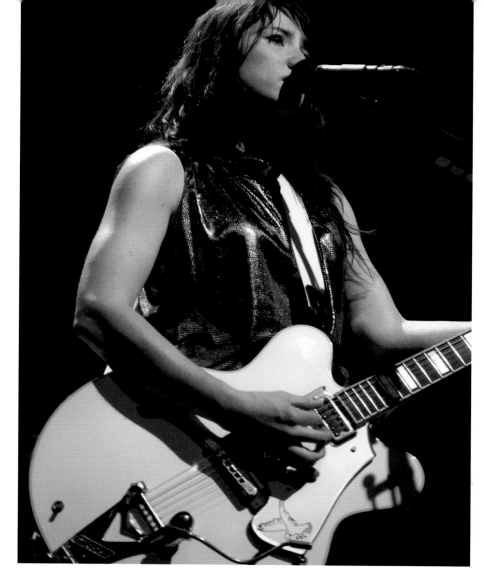

Left So many styles of White Falcon have appeared over the years – single-cutaway, double-cutaway, block, hump, or thumbnail inlays, and different headstocks and binding – that dating them can be a matter of considerable detective work.

Right Scottish rock singer, songwriter, and guitarist KT Tunstall has made waves over both sides of the Atlantic. Here is Tunstall with her recently acquired double-cut White Falcon.

Like the majority of the company's models, the White Falcon was not exempt from changes to almost every facet of its design over the next two decades. So, by the 1960s, the DeArmond-equipped single-cutaway deep body design had become a slimline double-cut model with FilterTrons, standard pearl headstock logo, string mutes, thumbnail markers, and the compulsory back-pad. A stereo version was also available and by the mid-60s the instrument's control layout was so complex as to be almost unusable. The White Falcon's price, complexity, and styling limited the instrument's appeal and so only small quantities were ever produced. By the time that Hendrix and Clapton had made Fender and Gibson the choice for serious players, and even The Beatles had forsaken their quirky Gretsches and Rickenbackers for Teles, Strats, Les Pauls, and SGs, the White Falcon was one expensive anachronism too far.

Yet, when Crosby, Stills, Nash & Young appeared on stage during the early 1970s, their electrics of choice were often early single-cutaway Falcons. Since that time, whenever a true visual statement needs to be made on stage or on video, guitarists from all walks of life turn to the White Falcon. Players from The Cult's Billy Duffy to AC/DC's Malcolm Young have made the Falcon musically credible, too. Now that it is being made again in many of its most interesting guises under the patronage of Fender, one of the most important electric six-strings of the past 50 years should be back to stay.

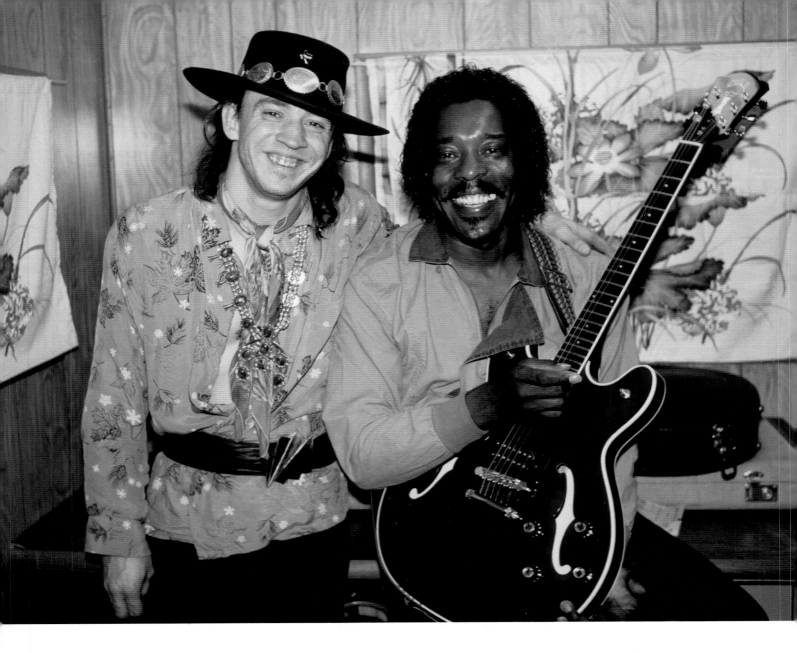

Guild Starfire

This attractive guitar was a thorn in Gibson's side throughout the 1960s and 70s, its attractive single- and later double-cutaway design stealing sales from their own thinline semis.

A relatively young company by American guitar standards, Guild opened its doors two years after Fender had launched the Telecaster. Yet Guild smacked of old-school guitar design; this was because of its first boss and the fact that part of the workforce had migrated from Epiphone.

In 1952, Epiphone – at this time Gibson's major competitor in the jazz guitar market – was having "labour difficulties". Things became so bad that the firm closed its doors for some months and in the same year Alfred Dronge of the Sonola Accordion Company and George Mann, late of Epiphone, got together and opened Guild Guitars. Various ex-Epiphone employees joined Dronge and Mann at their small New York factory and

Below Early Starfires were hollow, single-cutaway instruments, but later models more closely followed Gibson's ES-335 with solid centre block and double horns. This one has the later 18-fret neck joint.

the first instruments were sophisticated full-bodied jazz-style guitars. Move on to 1960 and Mann was gone. Al Dronge's son Mark was working at the firm and Guild already had thinline models such as the Capri and Slim Jim in its range. But they wanted something a little sexier to compete with Gibson. Enter the cherry-finished Starfire I (single pickup), Starfire II (twin pickups), and Starfire III (twin pickups and Bibsby vibrato). These single-cutaway guitars actually looked more like their rival's ES-125 – a thinner version of the ES-175. They were similar in construction, too, since they featured all-hollow bodies without the ES-335's solid centre block. Still, made from laminated sapele mahogany or maple, they looked great and their DeArmond pickups – the same as used on early Gretsch semis but white rather than black – offered a modern sound somewhere between that of Gibson and Fender. Available in see-through red, green, black, and amber, the guitars had a Gibson-meets-Gretsch appearance, but their simple and intuitive control layout lent them a familiar air from the start, offering an edge over the complex switching systems found on many Gretsch instruments.

The Starfire proved popular in single-cutaway form, but by 1963 Guild decided to go the whole hog and give their guitar the double-cut treatment with Gibson-style solid centre section. But the company retained the 16th-fret neck join of the single-cutaway version and the new Starfires – IV, V, and VI, as well as a Starfire XII 12-string version – could not compete with the ES-335, the entire neck of which was presented to the player. Guild switched to an 18-fret, humbucking version in 1967, but by this time it was too late for the model to gain the popularity it deserved.

Nevertheless, several high-profile players adopted Starfires – notably blues men Buddy Guy and Lightnin' Hopkins in the United States, and Alexis Korner (father of British blues guitar) and Jim Armstrong of Van Morrison's band Them in Britain. Today the Starfire can also be seen in the hands of British bad-boy Pete Doherty of Babyshambles.

Guild is now under the ownership of Fender Musical Instrument Corporation and currently produces no electric models.

SUMMARY

CONSTRUCTION Usually sapele mahogany or maple body; neck joined body at 16th fret on single-cut and early double-cut before being changed to 18th fret in 1967.

FEATURES The many Starfire models offered different pickup and tailpiece options – DeArmond on early models and Hagstrom humbuckers later; Bigsby vibrato or "harp"-style trapeze tailpiece; two volumes, two tones, and three-way toggle selector switch.

MUSICAL STYLES Blues and pop-rock.

SOUNDS Early models twangy and Gretschlike, later models fatter and more powerful.

ARTISTS Buddy Guy, Robert Lockwood Jr, Lightnin' Hopkins, Jim Armstrong (Them), Dave Davies (The Kinks), Bert Weedon, Tom Fogerty (Creedence Clearwater Revival).

Hamer Standard

When Jol Dantzig and Paul Hamer opened a Chicago guitar shop in 1973, little did they know that their collaboration would lead to the United States' first "boutique" brand – guitars that strived to be better than the best.

In the early 1970s, some of the top American guitar brands were in the doldrums. Quality and esteem were at an all-time low and the vintage market was kicking in. Dantzig's and Hamer's store specialized in renovating old guitars and selling them on. Their expertise – Dantzig big on ideas and Hamer the optimistic salesman – soon led to them building a guitar of their own. Their first electric six-string was based around Gibson's angular Explorer, but their stroke of genius was adding Les Paul Standard-type appointments to what was, other than its shape, a very plain guitar. Having decided on the Hamer name (it had a more guitarlike ring than Dantzig), Paul and Jol built their instrument from Honduran mahogany, adding a figured maple and cream-bound top and finishing it in cherry sunburst. The back and neck were cherry, just like a 1959 Les Paul, and these simple changes transformed the Explorer into a desirable instrument.

Below One of the United States most influential rock guitarists, Paul Stanley of KISS was often seen wielding his black Hamer Standard.

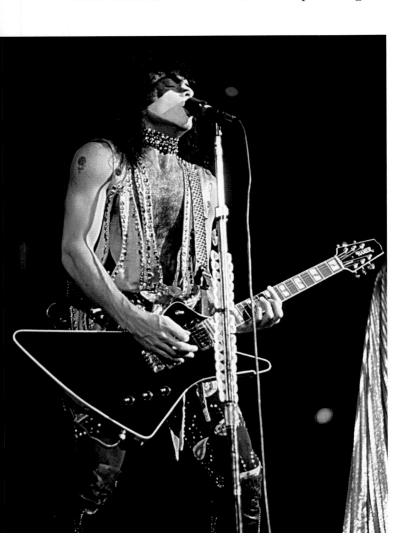

Early models used Gibson humbuckers, but soon the help of a young pickup designer named Larry DiMarzio was enlisted. At Paul's and Jol's request, Larry gave their neck pickup slightly less output than the bridge unit. Gibsons usually had louder neck (rhythm) pickups than bridge (lead) pickups, due to greater string vibration further away from the bridge, so this proved a canny move. The first guitars had black bridge and cream neck pickups, but soon cream was switched to "zebra" (one cream coil and one black). Controls aped the Gibson original with two volumes and a tone set

SUMMARY

CONSTRUCTION Solid mahogany body base and glued-in neck; two-piece maple cap bound in cream; bound rosewood fingerboard with pearloid "crown" position markers and 22 frets.

FEATURES Early models used Gibson pickups but later instruments featured specially designed DiMarzios – eventually named Slammers; two volumes and one tone control; fine-tune bridge and stud tailpiece.

MUSICAL STYLES Classic American and British rock.

SOUNDS Typical Gibson – fat and smooth neck pickup, harder-edged bridge humbucker.

ARTISTS Paul Stanley (Kiss), Keith Richards, Ronnie Wood, Martin Barre (Jethro Tull), Brad Whitford (Aerosmith), Mick Ralphs (Bad Company), Jan Akkerman (Focus), Roy Buchanan.

Above Taking Gibson's Explorer design but adding luxury appointments such as bound flamed maple tops in vintage sunburst finish put Hamer in an instantly superior position.

in line, with a three-way selector toggle on the lower horn. Unlike the original, which carried a plastic scratchplate, on Hamer's guitar the controls were mounted from the rear, leaving the figured maple free of visual encumbrance. Another masterstroke was the use of a Les Paul-style fingerboard with that model's famous "crown" inlays.

The first Standard was built in 1974, but it was another two years before Dantzig, Hamer, and their shop's two guitar repairers formed the partnership that became Hamer Guitars. Frank Untermeyer joined as partner in 1978, injecting cash into the firm, allowing them to relocate to larger premises. Artists such as Jethro Tull's Martin Barre, Ted Turner of Wishbone Ash, and Cheap Trick's Rick Nielson were early converts. The Standard set the scene for every manufacturer of "improved" Gibson and Fender designs. Boutique makers Schecter, Suhr, Anderson, Grosh, Tyler, and Paul Reed Smith all owe a little of their success to Hamer.

Hamer Sunburst

Hamer's second model stuck with the Gibson theme. Paul Hamer and Jol Dantzig gave the boutique treatment to one of the company's most basic models ... and its success took everyone by surprise.

Although essentially a small handbuilding operation, Hamer decided from the start to exhibit at the United States' principal trade show, run by the National Association of Music Merchants (NAMM). This gave their instruments great exposure, aided by their use by high-profile bands such as Jethro Tull, Cheap Trick, and Wishbone Ash. So, when the company's second model was ready for production, it was greeted with open arms by a guitar-playing public unhappy with Gibson quality but unwilling – or unable – to pay spiralling vintage prices.

The Sunburst was a more traditional-looking guitar than its Explorer-shaped sister. Based around Gibson's 1959 double-cutaway Les Paul Junior shape, the Sunburst followed the lead already set by the Standard and gave the instrument a cream-bound, flamed maple top and open-topped DiMarzio pickups – bridge black, neck zebra. Although the basic model came with dot position markers, it was also available with Les Paul-style crown inlays, and it is this version that cuts the real dash.

Hamer retained the Explorer's three-in-a-line control layout of two volumes and a tone, and mounted the pickup selector behind the bridge. This was a Strat-style nonvibrato unit with the strings threaded through Telecaster-style and located in six ferrules on the guitar's back. Early models used a standard Strat replacement bridge mounted on a rosewood block, but this was soon switched to a purpose-made brass "sustain block" bridge, the thicker base of which made the rosewood shim redundant. As well as the deliberately weaker DiMarzio neck pickup, Hamer also chose to

Below Hamer's Sunburst was essentially a double-cutaway Les Paul design. Hamer still make some of the finest electric guitars that are available.

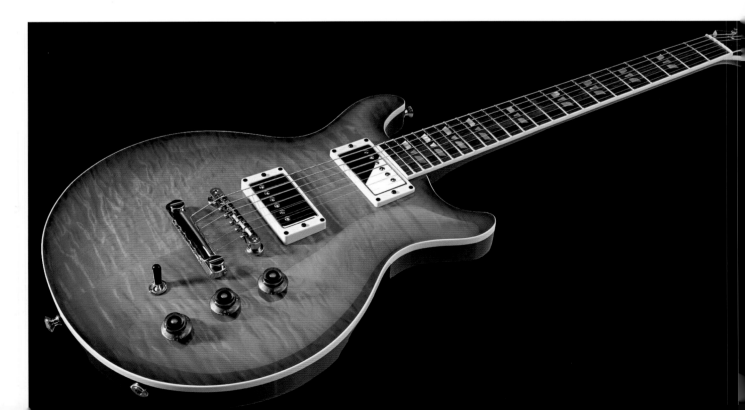

wire the Sunburst so its two pickups were out of phase with each other. This was unnoticeable when each humbucker was selected on its own but, with both pickups on, the sound produced was hollow and nasal – as on "Need Your Love So Bad" by Fleetwood Mac. This was played by Peter Green whose Les Paul had been accidentally wired this way during a repair.

Above One of the earliest converts to the Hamer stable was British guitarist Martin Barre of progressive folk-rock band Jethro Tull, here playing a Hamer Sunburst.

Hamer's original Sunburst users and new converts flocked to buy Sunbursts, and soon they could be seen in the hands of not only Martin Barre of Jethro Tull, but also The Eagles' Joe Walsh, Elliot Easton of The Cars, The Police's Andy Summers, and even Johnny Ramone and The Sex Pistols' Steve Jones.

In 1987, after several differences of opinion on the company's direction – Hamer wanted higher-volume, lower-cost guitars while Dantzig favoured the firm's already established boutique approach – the two co-founders parted company. The following year the Kaman Music Corporation bought the company. Today Hamer is still making some of the finest electric guitars in the world, the company having moved from Illinois to Kaman's premises in Connecticut.

SUMMARY

CONSTRUCTION Solid mahogany body base and glued-in neck; two-piece maple cap bound in cream; bound rosewood fingerboard with pearloid "crown" position markers and 22 frets.

FEATURES Early models used Gibson pickups but later instruments featured specially designed DiMarzios – eventually named Slammers – wired out of phase; two volumes and one tone control; fixed Strat-style bridge with through-body stringing.

MUSICAL STYLES Classic American and British rock.

SOUNDS Typical Gibson – fat and smooth neck pickup, harder-edged bridge humbucker.

ARTISTS Andy Summers (The Police), Pete Townshend, Martin Barre (Jethro Tull), John Belushi (The Blues Brothers), Rick Nielsen (Cheap Trick), Joe Walsh (The Eagles), Steve Jones (The Sex Pistols).

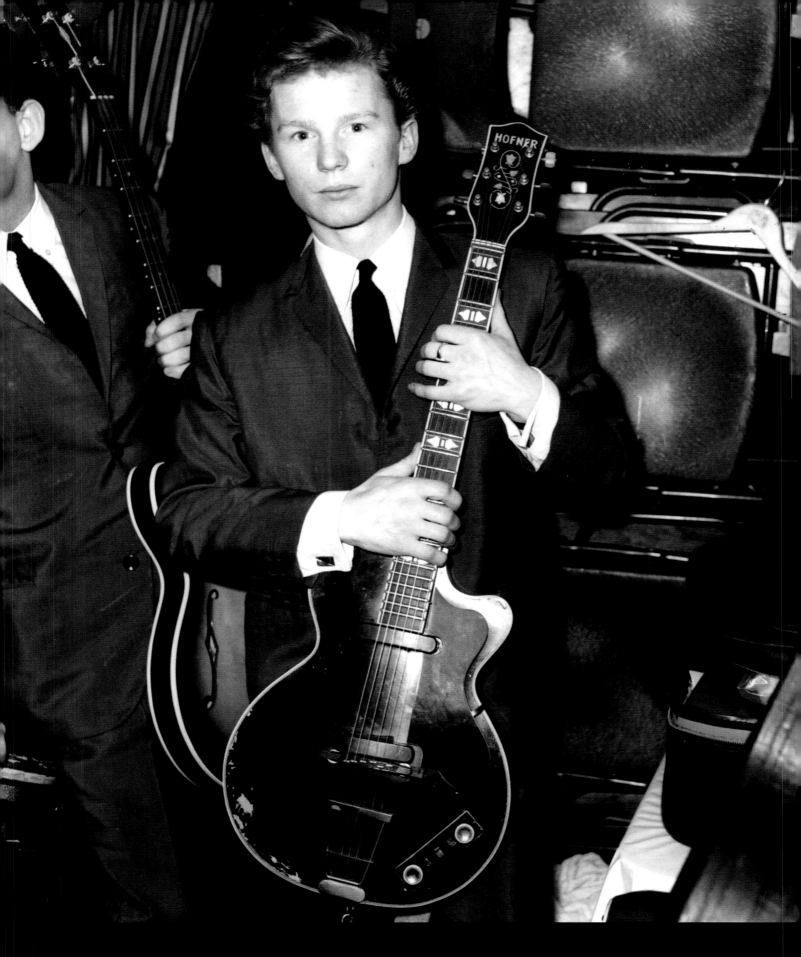

Above A young John McNally of Liverpool band The Searchers proudly holds his Hofner Club 60 with a well-worn black paint job.

Opposite The Club 60 could be distinguished from its lesser siblings, the Club 50 and 40, by complex and elegant pearl inlays on an ebony fingerboard.

Hofner Club Series

In Britain in the late 1950s and early 60s, American guitars were both scarce and expensive. German company Hofner happily filled the void for early Beatles, Moody Blues, and Pink Floyd guitarists.

When Britain was recovering from the expense and social upheaval of World War II, the government of the time imposed an embargo on imported "luxury" goods from the United States. Electric guitars fell into this category and so, just when every aspiring musician wanted a Fender, Gibson, or Gretsch, it was denied him. Imports from Europe were not affected and musical instrument distributor Selmer's of London imported guitars made by an old family firm in Bubenreuth, Germany.

Hofner can be traced back to the late 1800s, when Karl Hofner opened a factory building tops and backs for violins and other stringed instruments. After World War I, Karl's sons Walter and Josef joined the firm and Hofner began exporting musical instruments around the world, including the United States. During World War II, Walter's wife Wanda kept the company going, and when the men returned guitar production began near Erlangen. Hofner's success soon meant the Erlangen factory was too small and so the business uprooted to Bubenreuth near the Czech border, where production started in the early 1950s.

By the middle of the decade the skiffle phenomenon was ablaze in Britain and every kid on the block wanted a guitar to emulate stars such as Lonnie Donegan and early rockers such as Tommy Steele. The Clubs were launched in 1957 and young pretenders, including David Gilmour and Justin Hayward, became interested in playing guitar, with Hofner the best name around.

The Club Series initially comprised three models: the single-pickup Club 40, the double-pickup Club 50 – both with simple dot-inlaid rosewood fingerboards and plain wood bodies – and the more ostentatious and upmarket Club 60, boasting flamed

"I really wanted a Gibson Les Paul, but couldn't afford one. I tried the Hofner Club 60 and liked it – Paul McCartney had one, too – so I had it sprayed black to look like the Les Paul. I couldn't afford to have it resprayed by a proper guitar restorer, so I had it done by a friend who was a car mechanic. But the volume was good, it was light, and it stayed in tune well." John McNally

maple back and sides, ebony fingerboard with fancy pearl position markers, and deluxe headstock, overlaid in ebony and exquisitely decorated in pearl and brass "vine leaf" motif. A Club 70 was introduced later in the 1960s, but few were made and the model was not a success.

Totally hollow and made from laminated maple with an arched spruce top, the Club Series' petite body looked modern and attractive, while its big neck was a multilaminate of maple, mahogany, and beech. Early guitars featured simple black single-coil pickups. The earliest of these had wooden cases with the coil and magnets buried in Plasticine (synthetic modelling clay) but later versions were cast in Bakelite. Switching was crude by Gibson and Fender standards, consisting of a volume control and on/off slider switch for each pickup and another slider for rhythm/solo. The ebony bridge used small lengths of fret-wire as saddles and these could be moved between four different slots to enable basic intonation adjustment.

All three guitar-playing Beatles owned Clubs and of course Paul McCartney made the

Above This later Club 50 has the chrome "toaster top" pickups. Notice the raised finger-rest and grain of the arched spruce top.

SUMMARY

CONSTRUCTION Laminated maple back and sides (plain on Club 40 and 50, flamed on Club 60) on hollow body; laminated maple, mahogany, and beech neck; dotted rosewood fingerboard (Club 40 and 50) and pearl-inlaid ebony on Club 60.

FEATURES Early examples (1957) had small oval control plate changed to rectangular one with two volumes, pickup on/off and rhythm/solo switch; ebony bridge with "fret" saddles and nickel trapeze tailpiece; one or two black Hofner single-coil pickups, later changed to "toaster top" and then Hofner humbuckers.

MUSICAL STYLES Early British rock and roll and Merseybeat.

SOUNDS Sweet but bright.

ARTISTS Dave Gilmour's first good guitar was a Club; John Lennon, Paul McCartney, and George Harrison owned them, as did Justin Hayward (later of The Moody Blues) and Roy Wood (The Move).

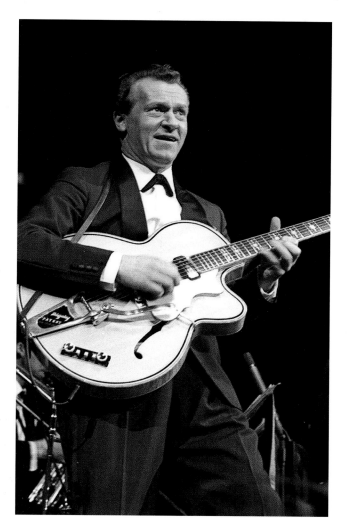

Hofner 500/1 Violin bass the most famous instrument in the world. Perhaps the most enduring Hofner user, however, was The Searchers' John McNally, whose beautiful rhythm playing is so evident on tracks such as "Needles And Pins" and "Don't Throw Your Love Away". John had his Club 60 refinished in black and this guitar's sweet but trebly tones can be heard on all the group's early hits.

Walter Hofner's daughter Gerhilde joined the company in 1957 and her husband Christian Benker in 1963. The Benkers oversaw Hofner's glory years of The Beatles and Merseybeat. But Hofner suffered a blow when cheap Japanese imports began flooding Britain in the 1960s, just as the U.S. embargo was lifted, allowing Fenders, Gibsons, Rickenbackers, and Gretsches into the country, sweeping the brand that had done so much for British music aside.

Left Bert Weedon, the first British musician with a U.S. hit, was on the "committee" that designed the instrument for Hofner importer Henri Selmer.

Committee and Golden

In the late 1950s and early 60s, guitars did not fall into musical categories, but as a rule the more successful the musician the flashier the instrument they played. Rockers Bill Haley and Chuck Berry in the U.S. chose Gibson, while in Britain, Tommy Steele and Marty Wilde used Hofner. The biggest, flashiest Hofners were the Committee and the costlier Golden. At 45cm (18in) across, the Golden was bigger by 13mm (½in). The Committee came in natural maple or sunburst and the Golden in warm blonde. Both featured outlandish bird's-eye maple timbers for the back and sides, plus tight-grained carved spruce on the carved top. The Golden's hardware was gold, and the "lowlier" Committee's chrome. Pearl and pearloid abounded on fingerboard and giant headstock, and finger-rests were clear plastic to emphasize the top's timber and carving. Both came in acoustic or electric, and regular or thinline forms. The Committee had a simple lyre tailpiece but the Golden's was an elaborate engraved affair. Users included Bert Weedon, Lonnie Donegan's guitarist Denny Wright, and Ernie Shear, who played the intro to Cliff Richard's "Move It".

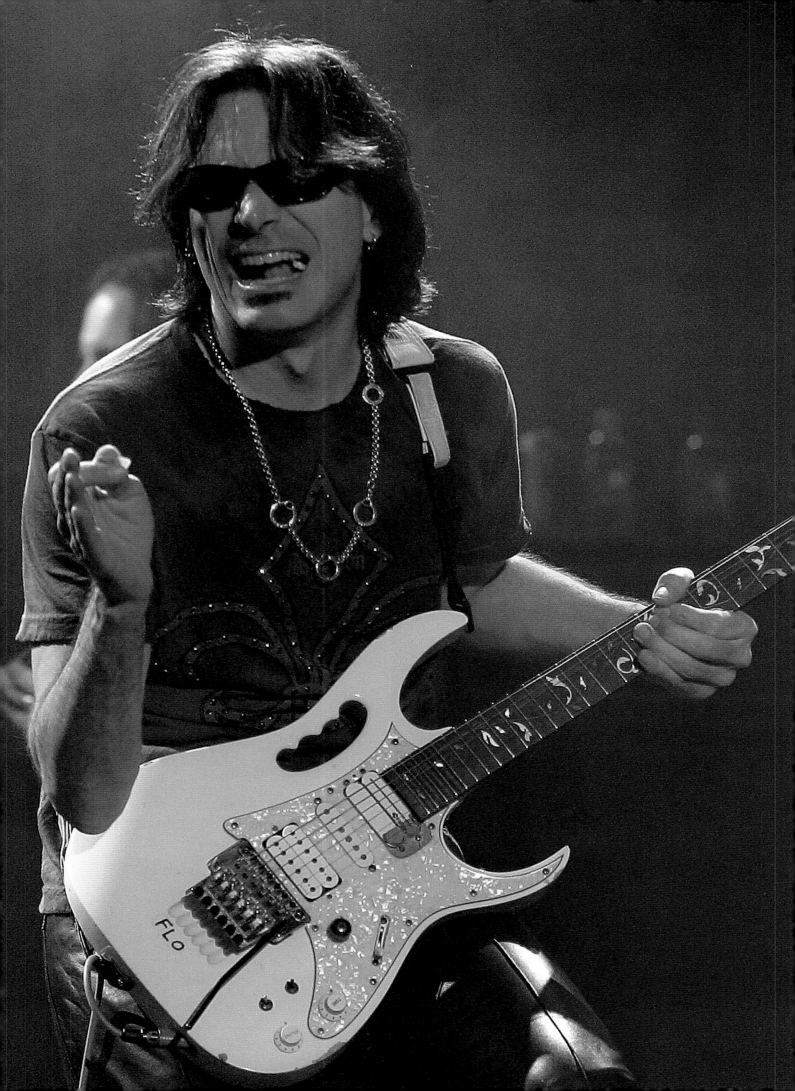

"I handed them my prototype and said 'Here's the guitar I want – make me one exactly like it.' And I got a guitar back in three weeks that was just great ... duplicating the one guitar I really like." Steve Vai

Ibanez JEM

The collaboration of instrumental rock giant Steve Vai and Japanese manufacturer Ibanez sent the latter's fortunes skyward. Today Ibanez is the epitome of the modern rock guitar and the JEM its pinnacle.

Although Ibanez is a relatively new name in the popular guitar world, its parent company Hoshino Gakki dates back to 1908 when it became a musical instrument sales arm of the Hoshino Shoten bookstore in Nagoya, Japan. In 1935, the company began making its own musical instruments and, by the early 1960s, it was building electric guitars and amplifiers. Harry Rosenbloom of Elger Guitars in Ardmore, Pennsylvania, had been distributing Hoshino's guitars in America since the mid-1960s. Rosenbloom realized that a more western-sounding name would benefit sales and credibility, so Ibanez was chosen since Hoshino owned a small Spanish guitar company of that name and it seemed an appropriate choice. Hoshino later bought out Elger and used the company as its American headquarters.

In the 1970s, Ibanez instruments were typical Japanese fare for the time – copies of more famous American models, usually from Gibson, Fender, and Rickenbacker. The copies undercut the originals' prices considerably, but although unoriginal in design Ibanez guitars played well and sounded good, in some cases better than "real" ones. In 1977, Gibson's owners Norlin Music successfully sued Hoshino for breach of its designs, setting the company on the road to producing its own original guitars. One of the first of these was the aggressively shaped Iceman, which

Opposite One of Steve Vai's stage JEM models is "Flo". This white Ibanez is fitted with a Fernandes Sustainer pickup at the neck and has compensated frets on second and third strings to aid intonation.

Left The Ibanez JEM symbolizes instrumental rock guitar at its best, and with Steve Vai at the controls is as evocative a sight as Hendrix with a Fender Strat.

took the fancy of Kiss front man Paul Stanley. By the 1980s, Ibanez was actively looking for modern, influential guitarists to begin an endorsement programme and move the brand up a notch. By the middle of the decade, ex-Frank Zappa and David Lee Roth guitarist Steve Vai was himself in search of a company who could make the guitar of his dreams.

Vai had some strong ideas about what he wanted, and was already using instruments built by Performance Guitar, Charvel, Jackson, and Tom Anderson. When Ibanez approached him, he simply gave them his main instrument – put together by Joe Despagni of JEM Guitars – and told them to make its equal. The guitar arrived in time for Christmas 1986 and was good enough to inspire Steve to begin talking in earnest with Ibanez. He wanted bodies made of lighter basswood than the maple of the prototype, demanded DiMarzio pickups, "scalloping" of the 21st fret up, and the use of rosewood instead of maple for the fingerboard. The JEM777, as it became known, also had to retain the trademark "monkey grip" of the prototype, a locking vibrato system that pulled up as well as pushed down, and came in a range of lurid colours, including Desert Sun Yellow, Shocking Pink, Loch Ness Green, and a Floral Pattern based around some of Steve's own material. The JEM made its debut in summer 1987.

Vai never wanted a "signature" model. Instead he simply craved a guitar that matched his extraordinary technique and that was produced with quality and consistency. A range of JEM models has been made over the ensuing 20 years, including the JEM7, JEM77, JEM777, JEM555, and the seven-string Universe. In 2000, the JEM2KDNA was released, containing Steve's own blood (hence the "DNA" suffix) mixed into its paint finish, while 2007 sees the 20th-anniversary model with three-dimensional multicolour resin body and pearl and abalone "vine" inlay.

Opposite As well as producing a truly great rock guitar, floral designs, outlandish colour schemes, and exotic fingerboard inlays were always part of Vai's vision for the JEM.

Iceman

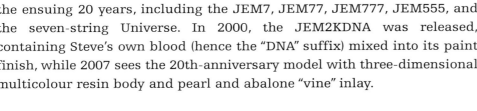

The Iceman was Ibanez's attempt to get out of the copy business and into making original designs. Although the shape we all know arrived around 1975, the guitar fell under Ibanez's "Artist" umbrella until someone decided on the name a year or so later. Early Artist Iceman guitars came in three styles: with two regular humbucking pickups; sporting a single giant three-coil humbucker; and with a triple-coil that slid back and forth on rails to provide all manner of tones. Dan Armstrong had used this idea before and Gibson later aped it with their Grabber bass, but neither caught on; the Iceman fared no better, so the sliding pickup idea was dropped. Check out the Iceman's headstock, though, and you will see that it is not far off the design the company uses on its rock guitars today. With its "Explorer meets Rickenbacker" styling, the Iceman drew the attention of many famous players, notably Paul Stanley of Kiss and Steve Miller of The Steve Miller Band. Modern players such as Daron Malakian of System Of A Down are also fans. Although the original Iceman had melted away by 1983, today Ibanez produces a variety of models in this great 1970s design.

SUMMARY

CONSTRUCTION Solid basswood body (later models alder); maple neck with 24-fret rosewood fingerboard ("scalloped" from 21st fret up).

FEATURES Two humbucking and one single-coil (centre) DiMarzio pickup – various types on different models; Edge Pro locking vibrato; monkey grip on body.

MUSICAL STYLES High-octane instrumental rock.

SOUNDS From hard-edged to rich and thick, usually with bags of distortion.

ARTISTS Steve Vai.

Ibanez JS Radius

Perhaps the most highly regarded of all the instrumental rockers who came to prominence in the late 1980s, Joe Satriani is a fine ambassador for Ibanez guitars.

In the late 1980s, a new style of rock music was born, spurred on largely by the wizardry of Eddie Van Halen and his highly technical playing. This included death-defying speed with new techniques such as two-handed fretboard tapping, advanced vibrato (whammy bar!) use, and harmonic squeals and other exciting effects. A spate of instrumental rock albums was released and a whole new breed of player emerged, having taken even Van Halen's techniques to new heights.

Among the first were Steve Vai, a young Swede named Yngwie Malmsteen, Paul Gilbert of the U.S. band Racer X, and a guitar teacher from Long Island named Joe Satriani. "Satch" had the lot as a player: great touch, amazing technique and a compositional flair that set him apart from most of his contemporaries. He was also Steve Vai's tutor. It was Vai, however, who gained success first, having played with Frank

Above Its rounded edges and more traditional look separate Joe Satriani's signature guitar from the more overtly "rock" instruments in the Ibanez stable.

SUMMARY

CONSTRUCTION All JS models feature wedge-shaped basswood bodies with bolt-on maple necks – standard on JS100, Prestige on JS1000 and JS1200; six-a-side Ibanez "pointed" headstock.

FEATURES Top model 1200 has Joe's own choice Fred and Joe Pro pickups by DiMarzio, 100 features Fred and PAF Pro, 100 has Ibanez Axis humbuckers; Edge Pro locking vibrato system on 1220 and 1000 and Edge II on 100; volume, tone and three-way selector switch on all models.

MUSICAL STYLES Instrumental; all forms of advanced rock and metal.

SOUNDS Thick and sustaining; sweet neck pickup and aggressive, more trebly bridge humbuckers.

ARTISTS Joe Satriani.

"**I like the feel of a vintage Fender neck. I like small frets and I like the tremolo sunk into the body so the strings run low over the body.**" Joe Satriani

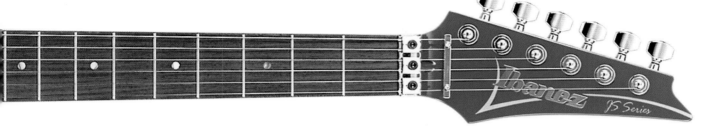

Zappa and ex-Van Halen singer Dave Lee Roth, and now making his own albums. Vai championed his pal and paved the way for Joe's own success. As well as his own record deal, he also gained his own Ibanez model guitar. The 540 Radius had first appeared in 1987 and featured an offset vaguely Strat-shaped body in basswood that became dramatically slimmer at its edges. A slim bolt-on maple "speed" neck, two single-coils and a humbucker at the bridge – an Edge vibrato system with locking nut – lent the Radius its "superstrat" tag and made it an extremely versatile instrument.

Before long, the 540 was available with twin humbucking pickups, and this version found favour with Satriani. Satch has been using the model ever since, and it is now known as the JS, after its illustrious pioneer. Today's Japanese JS models include the JS1200 and JS1000. The JS1000 features a slim Prestige neck screwed to a basswood body. Pickups are a DiMarzio PAF Pro at the neck and Joe's own choice "Fred", also by DiMarzio, at the bridge – upgraded to the locking Edge Pro that so ably handles Satch's occasional abusive whammy bar antics. The fingerboard is abalone-dotted rosewood and the pointed headstock – one of the most recognizable in rock – features a locking nut and chrome string guide. Joe's JS1200 has a neck modelled after that of his own favourite instrument and the neck pickup is his signature DiMarzio "PAF Joe" humbucker. One of Ibanez's most enduring rock guitars is also available as a cheaper JS100 made in Korea, with Edge III vibrato and Ibanez's own Axis humbucking pickups.

Below Joe Satriani helped Ibanez to become one of today's best-endorsed guitar companies among the instrumental rock community.

Next page In 1996, Joe Satriani instigated the first of the now regular G3 concerts where he, Steve Vai, and one other rock virtuoso – such as Eric Johnson or John Petrucci – tour the world.

Ibanez RG

Ibanez's most successful electric guitar range of all time has been in continuous production since it was launched two decades ago. Hail the Rock Guitar!

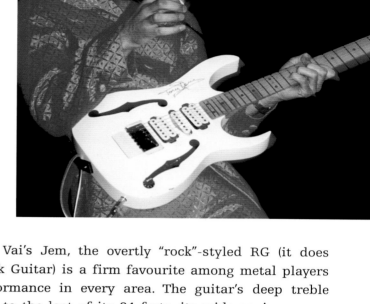

Right Paul Gilbert made the RG550 famous while using it in his 1980s band Racer X. Gilbert's technique and personality earned him his own Ibanez signature model based around the RG – note the painted-on f-holes.

> "We use Ibanez for all the seven-string stuff ... "
> Marten Hagstrom

Sister model to Steve Vai's Jem, the overtly "rock"-styled RG (it does actually stand for Rock Guitar) is a firm favourite among metal players looking for high performance in every area. The guitar's deep treble cutaway allows access to the last of its 24 frets, its wide sonic range – often using two humbucking pickups and a single-coil in the middle – provides a wealth of tones, and the locking vibrato system on most models gives access to the wildest whammy techniques imaginable.

The RG series comes in distinct ranges. At the top is the mainly Japanese-built Prestige line boasting every desirable Ibanez feature, including super-slim Wizard necks, precision double-locking Edge Pro vibrato bridges, and pickups in HH and HSH format from top manufacturers, including Seymour Duncan, DiMarzio, EMG, and Ibanez. RGA models also have arched tops. Next down is the Tremolo series, which uses mainly Ibanez or Designed By EMG pickups, Edge III vibrato, and Wizard II, slightly fatter necks. This range also features the impressive-looking shark-tooth fingerboard inlays. The RG Fixed series offers guitarists all the RG's usual features but without vibrato unit – players such as Paul Gilbert (Racer X, Mr Big, solo) began demanding this style of instrument since it is said to increase sustain and overall stability. Ibanez, one of the most customer-oriented guitar companies around, was happy to oblige. As well as the fixed-bridge option, seven-string RGs are available, too. Featuring an incredible array of construction materials, there is an RG for every taste and ability, including the short-scale Mikro for those with smaller hands.

Paul Gilbert was an early RG proponent; his use of the RG550 gave it superstar status. Paul has designed his own model based on the RG, with fixed bridge, upturned headstock, and painted-on f-holes. During the nu-metal boom of the late 1990s, the RG series was in its element. Now metal is back with a vengeance, and the RG remains modern rock's weapon of choice.

SUMMARY

CONSTRUCTION Basswood, mahogany, or maple-capped bodies – certain models with arched tops; bolt-on maple or maple/walnut Wizard necks, rosewood fingerboards with dot or shark tooth inlays; regular or reverse headstocks and seven-string options.

FEATURES Twin humbucker or HSH pickup configuration using Ibanez, EMG, DiMarzio, or Seymour Duncan pickups. Edge vibratos on most models but fixed bridge available; volume and tone controls plus three or five-way pickup selector (two or three-pickup models).

MUSICAL STYLES Rock and heavy metal.

SOUNDS Built for high-gain rock, so expect thick distorted treble tones, fat "flutey" leads, or Fenderish clean tones (HSH models).

ARTISTS Paul Gilbert, Munky and Head (Korn), Mick Thompson (Slipknot; signature variant), Marten Hagstrom and Fredrik Thordendal (Meshuggah), Wes Borland (ex-Limp Bizkit), Dexter Holland (The Offspring), Matt Roberts (3 Doors Down).

Ibanez George Benson

The association between Ibanez and the world's most famous living jazz player goes back a staggering 30 years; in fact Benson beat both Vai and Satriani to the punch.

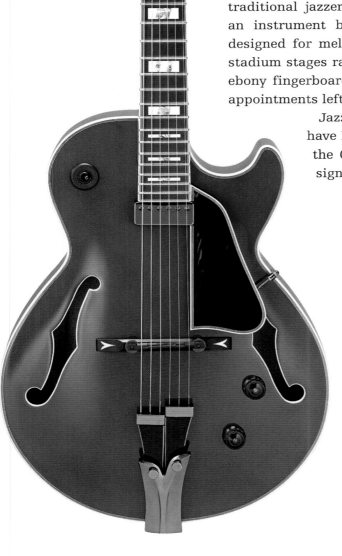

Although today primarily known as purveyors of sleek vibrato-equipped guitars to the instrumental rock fraternity, Ibanez has long been associated with jazz guitarist George Benson. The GB10 was the company's first "signature" model way back in 1977, and Benson has steadfastly remained with the company. Ibanez have traditionally offered two Benson guitar styles: the full-bodied GB20 (now the GB200) and the smaller GB10 (with the single-pickup GB15 also available and the GB15TR offering a coil-tap function for more modern single-coil tones – suitable for George's funkier moments). The GB10 was a modernized version of traditional arch-top jazz guitars as pioneered by Gibson. It was considerably smaller all round, which helped reduce feedback problems at the louder volume required for the kind of big band and stadium-sized gigs Benson was playing.

With back, sides, and neck of maple and a thicker-than-usual spruce front, the guitar looked more like a bloated Les Paul than a scaled-down traditional jazzer, and this lent considerable sex appeal, which suited an instrument being played by a megastar. The GB's pickups were designed for mellow jazz tone but to be played unusually loudly – on stadium stages rather than smoky clubs – but the guitar's abalone-inlaid ebony fingerboard, ebony- and gold-plated bridge, and generally deluxe appointments left one in no doubt that this was a jazz guitar of true class.

Jazz and fusion greats Pat Metheny and John Scofield also have Ibanez signature models. Ironically, just two years after the GB's release, Gibson brought out its own small-bodied signature jazz guitar, the Howard Roberts Fusion.

SUMMARY

CONSTRUCTION Small body with maple back and sides on 83mm (3¼in) deep body; thick spruce top with glued-in Prestige neck and pearl and abalone-inlaid ebony fingerboard; three-a-side headstock. GB20 (GB200) has full-size body.

FEATURES Two "floating" mini-humbucking pickups (one on GB15 and also coil-tap on GB15TR) to prevent interruption of top's vibrations; ebony "foot"-style jazz bridge; floating bound finger-rest; two volume and tone controls with shoulder-mounted three-way selector on padded grommet; gold-plated parts, including ebony and gold split tailpiece; pearloid-button tuners. Full-size GB200 has two Super 58 large humbuckers, split parallelogram inlays, maple finger-rest, and wooden knobs.

MUSICAL STYLES Jazz and R&B/funk.

SOUNDS Lighter than usual jazz tones; mellow but not woolly.

ARTISTS George Benson.

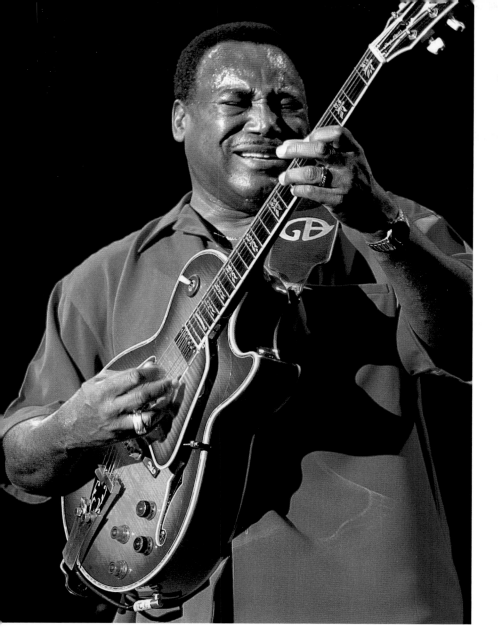

"The GB10's smaller body doesn't have a lot of resonance, but it has a lot of articulation. The notes don't melt together like on softer guitars. It maintains the tone while articulating each note. No other guitar gets that sound." George Benson

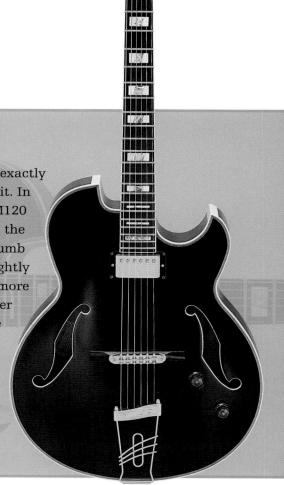

Pat Metheny Signature

A very particular guitarist, jazz virtuoso Pat Metheny knows exactly what he wants in a guitar and he will go to great lengths to get it. In a nod to his well-worn Gibson ES-175, the PM100 and PM120 signature models both feature a Florentine (sharp) cutaway on the treble side. Another small top cutaway – in fact, it is more of a "thumb notch" – helps improve access to the upper frets. The PM100 is slightly slimmer than traditional archtop guitars, and the PM120 is more slender still, the idea being to eliminate feedback and offer greater midrange kick. Bound ebony fingerboards with pearl and abalone inlays and 21 medium frets sit on top of Ibanez Prestige necks.

Both guitars are all-maple construction and use Ibanez's Silent 50 humbucking pickups, again specifically chosen to fight the archtop enemy – feedback. A tune-o-matic style bridge and trapeze tailpiece complete the picture. All the hardware is gold.

Ibanez John Scofield

One of the world's foremost jazz-fusion guitarists, John Scofield followed George Benson in gaining his own Ibanez signature guitar – the semi-acoustic JSM100.

"Ibanez took my original guitar that I'd been using for ages and measured every little detail, neck dimensions and everything. That became the JSM model."

John Scofield

Opposite One of modern jazz's most heralded performers and composers, John Scofield melds blues and rock influences into his jazz grooves and harmonies – all performed on his signature Ibanez guitar.

John Scofield comes from Connecticut and as a youngster got into pop music: "I loved The Beatles and that's when I started to play guitar." He also became a big fan of the blues. Scofield loved the sound of everyone from Albert and B.B. King to Jimi Hendrix and Eric Clapton. Serious about his music, Scofield enrolled at Berklee College in Boston to study jazz, where he met a young Pat Metheny: "He was two years younger than me but already teaching there because he was so good so young." Immersing himself in the music that would become his life, the naturally musical Scofield gained great feel and technique and was invited to play and record with several jazz greats, including Gerry Mulligan, Charlie Mingus, and Miles Davis.

Scofield had been playing the long-running Ibanez AS200 for years and had become so heavily associated with it (people already thought it was the John Scofield model) that the company decided to fly the guitarist to its L.A. headquarters and have him design his ideal instrument. Using the AS100 as the basis for this guitar, Scofield retained features he liked from his own instrument and others he had used over the years, and added new ones, including a compound radius fingerboard – it gets flatter toward the higher frets for better string bending – and a pair of Super 58 humbucking pickups, and the surface-mounted jack socket was moved to the guitar's rim to keep the plug out of the way and to avoid damage.

Adopting the idea of Gibson's semis such as the ES-335, 345, and 355 with their slimline, f-holed bodies made more rigid by a solid maple centre section, the JSM also features upmarket appointments such as gold hardware, flame maple veneered top, multiple body binding, and pearl and abalone inlays on the jumbo-fretted ebony fingerboard. Scofield opted for Ibanez's more traditional Artist headstock shape to maintain his model's vintage character, but decided on 1980s-style brass and bone nut and cream pickup surrounds.

Where the JSM differs from Gibson is in the shape of the body horns. Where the vintage ES-335 had what was termed "Mickey Mouse ear" horns for obvious reasons, Ibanez has made upper-fret playing more appealing by slimming down the horns for slightly better access. This, allied to the instrument's flatter fingerboard and bigger frets, lends a "rock" playing experience to an otherwise jazzy-looking guitar.

SUMMARY

CONSTRUCTION Double-cutaway slimline semi-acoustic body in laminated maple with solid centre block and f-holes (43mm/1¾in depth at tailpiece); multiple cream and black binding; mahogany JSM Prestige neck with compound radius ebony fingerboard and pearl/abalone block inlays; Artist headstock with three-per-side tuners.

FEATURES Pair of Ibanez Super 58 pickups in cream surrounds; two volumes, two tones, and three-way selector; G510BN tune-o-matic style adjustable bridge with quick-change stud tailpiece; all gold hardware.

MUSICAL STYLES Jazz, blues, and fusion.

SOUNDS Vintage sounds from Super 58 pickups with greater dynamics from semisolid body – warm and woody to fat treble typifies the model, with "spanky" tones for those funkier moments.

ARTISTS John Scofield.

> **"Grover Jackson made me a Soloist with Jackson pickups and Kahler tremolo and I fell in love with the thing."** Phil Collen

Jackson Soloist

One of the earliest manufacturers to amalgamate Fender-style looks and Gibson-type tones into the best of both worlds – and add a little bit extra here and there – was Grover Jackson.

For years, luthiers have tried to put the best of Gibson and Fender together, and PRS has achieved the most commercial success in this quest. In the early 1980s, when Paul Reed Smith was developing his designs in Maryland, Grover Jackson and Wayne Charvel were on a different route to achieving similar goals in San Dimas, California. Instead of the "furniture-style" instruments of PRS, their guitars were rock personified. Mating a streamlined Strat-shape body with a Gibson Explorer-style neck and headstock design, then adding a Gibsonlike humbucker at the bridge and two Strat-type single-coils (or stacked humbuckers that looked like single-coils) in the neck and middle position, their "Custom Strat" was a cracker.

Whereas PRS had his own special floating vibrato system, Jackson and Charvel opted for off-the-shelf locking systems by Kahler and Floyd Rose. These were designed for extreme pitch shifting, with the strings locked at both bridge and nut to eradicate tuning problems. The neck and

SUMMARY

CONSTRUCTION Maple through-neck design with generally poplar or alder body "wings"; some models made in mahogany; Explorer-style headstock on neck with bound ebony or unbound rosewood fingerboards; shark-fin inlays on Custom, dots on Student model.

FEATURES Usually humbucking pickup at bridge and two single-coils in neck and middle positions; all makes available on original guitars; some twin-humbucker versions available; Floyd Rose or Kahler vibratos, some nonvibrato with through-body stringing.

MUSICAL STYLES Rock – think of "Animal" by Def Leppard.

SOUNDS Composite of fat treble (Gibson) and spanky hollow tones (Fender) make Soloist a versatile guitar; rock use means high gain with distortion pedals and/or high-gain amps added.

ARTISTS Phil Collen (Def Leppard), Richie Sambora (Bon Jovi).

Left One of Jackson's strengths was its use of lurid graphics to show that his guitars were for one thing only – rock!

entire centre section of the body was a single plank of maple with "wings" of poplar or alder glued on. Although not Charvel's and Jackson's own idea, this was the first "through-neck" modern rock guitar.

The Soloist, as it became known in 1984 after Jackson had bought out Charvel, was the first so-called "Superstrat" and set the benchmark for a new breed of guitar for a new style of music. Not only did it play and sound right for rock, but its look matched the flamboyant dress and hairstyles of the mid-1980s. Two models were available – Custom and Student. Early Soloists were custom-built guitars and were available with Floyd or Kahler vibratos, almost any make of pickup, and many other options. In the 1990s, custom graphic finishes became the rave and Jackson's Custom Shop created some of the most elaborate guitar art yet seen. Various models have been made, including American archtops and the Performer and Professional range built in Japan. Today, Jackson is in the hands of Fender Musical Instrument Corporation and the Soloist is still in demand.

Above Bon Jovi's flamboyant guitarist Richie Sambora quickly latched onto the Jackson Soloist with its speedy neck, Floyd Rose vibrato, and plenty of rock attitude.

Jackson Randy Rhoads

One of rock's most tragic losses, the super-talented guitarist with Ozzy Osbourne's legacy lives on in the guitar Randy Rhoads designed with Jackson.

Randy Rhoads was widely seen as one of the most promising and naturally gifted guitarists of his generation. His playing style mixed blues-rock licks with lightning fast classical runs to create what has become known as the neo-classical style adopted by Yngwie Malmsteen, Jason Becker, Jake E. Lee, and others. He did not take drugs, drank in moderation, and was passionate about furthering his knowledge and technique. Randy died on 19 March 1982 when the band's tour bus driver took him for a flight in a light aircraft. The plane's wing clipped the bus while trying to buzz it. Randy and the other occupants of the plane perished. Just prior to the tragedy, Randy had been working with Jackson guitars to come up with a futuristic model loosely based on the Gibson Flying V. Randy was already playing a V-shaped Jackson now known as the "Pinstripe V". He wanted to move the design away from Gibson and so he came up with the elongated horn; he also suggested the headstock look like the nose cone of the supersonic aircraft Concorde, and so the droopy, pointed headstock was born.

The Concorde, now called the RR1, was Jackson's first production guitar and was immediately popular. Using the company's maple through-neck design, the Rhoads model had alder wings, two Seymour Duncan humbucking pickups, and Floyd Rose locking vibrato. The fingerboard was bound ebony with shark-fin pearl inlays and jumbo frets that aided Randy's deft string bending and heavy finger vibrato. Under ownership of Fender Musical Instrument Corporation, a range of Randy Rhoads models is produced at every price point, from American Select models and quality midrange Pro and JS instruments to the east Asian budget X series.

SUMMARY

CONSTRUCTION Maple through-neck design with asymmetrical alder body "wings"; Concorde-style headstock; bound ebony fingerboards with shark-fin inlays.

FEATURES U.S.-made RR1 features Seymour Duncan JB humbucker at the bridge and Jazz at the neck; other ranges use Duncan Design or EMG pickups; Flord Rose locking vibrato and strings-through-body fixed bridge options available; Kevin Bond signature model has single Duncan Iommi pickup, pentagram inlays and fine-tune Schaller tailpiece.

MUSICAL STYLES Rock and metal.

SOUNDS Generally Gibson-style tones – fat treble and warm neck pickup – but usually more overdriven or distorted.

ARTISTS Randy Rhoads.

Right Randy Rhoads bought his first custom V-shaped guitar from luthier Karl Sandoval. This polka-dot instrument became Randy's main instrument in Quiet Riot and in early Ozzy shows. It was probably the inspiration for his Jackson models.

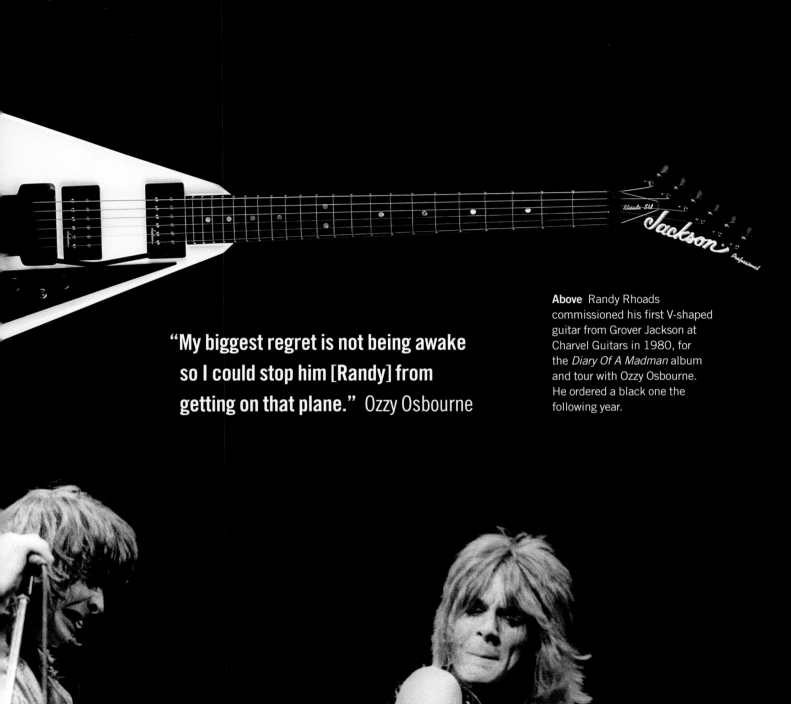

"My biggest regret is not being awake so I could stop him [Randy] from getting on that plane." Ozzy Osbourne

Above Randy Rhoads commissioned his first V-shaped guitar from Grover Jackson at Charvel Guitars in 1980, for the *Diary Of A Madman* album and tour with Ozzy Osbourne. He ordered a black one the following year.

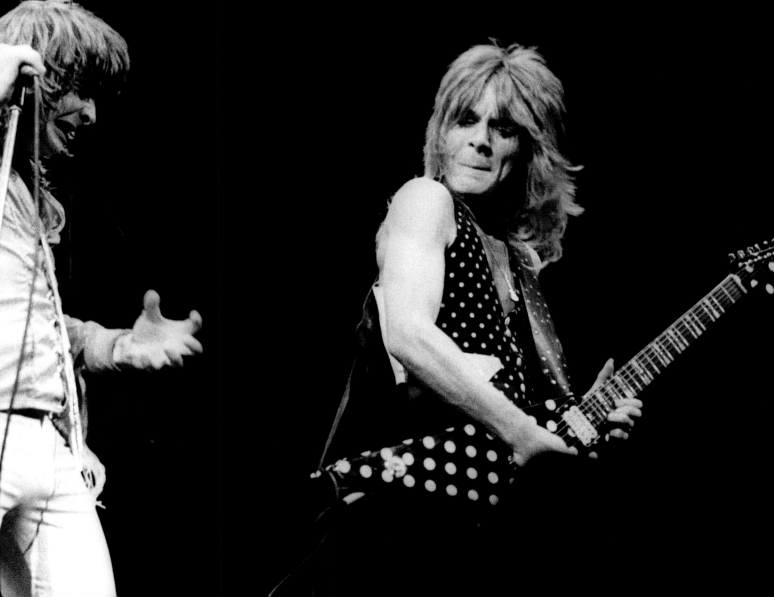

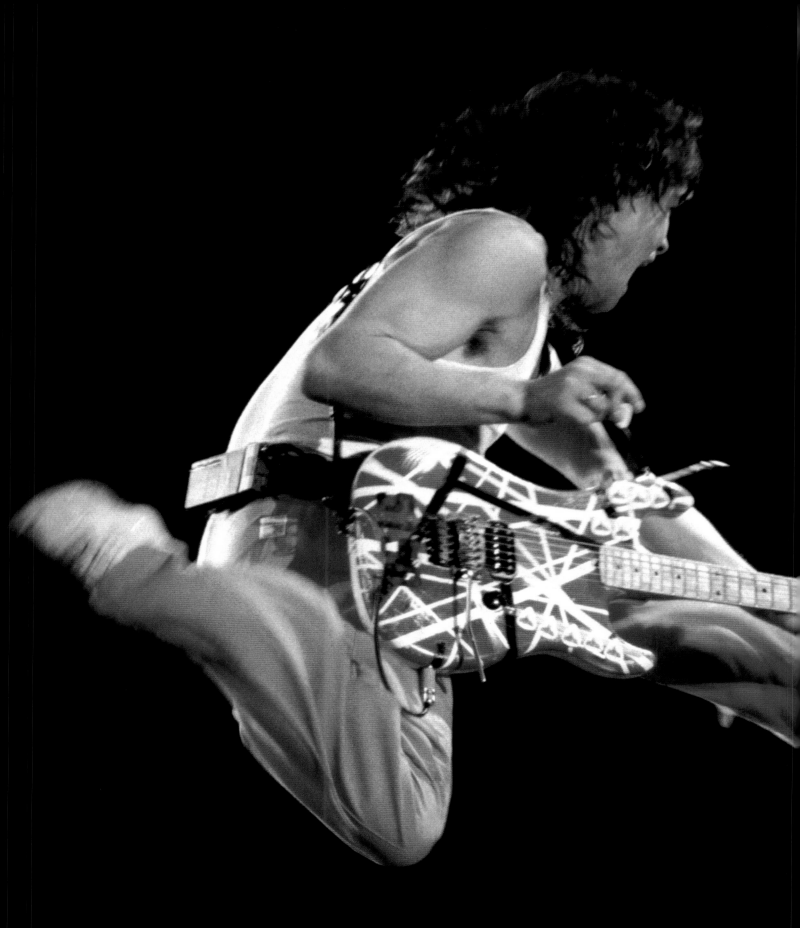

"It's very simply the best guitar you can buy today."
Eddie Van Halen (in mid-1980s Kramer promo)

Kramer Baretta

The Baretta was not the Eddie Van Halen model, but without his input it might never have happened; it was one of the closest designs to Eddie's Kramer 5150.

When Gary Kramer, Dennis Berardi, and associates started Kramer Guitars in New Jersey in 1976, it was to build instruments that featured aluminium necks with "pitchfork" headstocks and wooden inserts along the back. But the guitars were heavy and many players did not like their "cold" feel. So, by 1981, Kramer and company realized that wooden guitars offered a better route to success. When Berardi met Eddie Van Halen's manager, who spoke of his charge's desire for a guitar that could cope with extreme techniques more ably than his homemade one, the marriage was made. Eddie wanted his Kramer to be a faithful reproduction of the homemade instrument with which he had made his name. Despite the guitarist's huge success, at the time it was deemed unrealistic to release the model, so Kramer introduced its own "cleaned-up" version of the guitar with a slightly different body shape, and named it the Baretta.

The 1983 instrument's most striking feature was a droopy "banana" headstock on its Japanese ESP neck. Based around the Ibanez Destroyer design, it did not pitch back like a Gibson but was parallel to the plane of the fingerboard, like a Fender. The angled pickup was Schaller's Golden 50 with cream and black "zebra" coils but set in traditional surround. The Baretta model changed over the ensuing years with the headstock becoming pointy, back-angled, and more Jacksonlike, Seymour Duncan pickups replacing Schaller, and different models entering the fold – some built in east Asia. But instruments built in 1983–84 with the original specifications are considered the Holy Grail, and are among rock's most influential guitars. Kramer closed in 1991 and Gibson/Epiphone now owns the brand.

Left Although Van Halen's input was largely responsible for the Baretta's creation – his 5150 guitar was its inspiration – he never used this actual model in anger.

SUMMARY

CONSTRUCTION Alder body with bolt-on maple neck (oiled finish) built by ESP with banana headstock design. Early models had flat headstocks, later instruments were back-angled. Banana design changed to pointy style c.1986; various body style changes, including cutaway scoop and change to "Dinky"-style body on Baretta II model.

FEATURES Floyd Rose locking vibrato with hex wrench holder at rear of headstock; early models with Schaller Golden 50 pickup, later switching to Seymour Duncan JB; single Fender Jazz bass-style volume control; early models used Gotoh tuners, switching to Schaller c.1986. All hardware black.

MUSICAL STYLES Rock.

SOUNDS Fat Gibson-style treble.

ARTISTS Eddie Van Halen (5150 and various Baretta-style guitars); Mick Mars (Motley Crue), Richie Sambora, George Lynch.

"The Variax reinvents the way we will access all the classic
tones from vintage electric and acoustic collectables from
one single guitar." Steve Howe

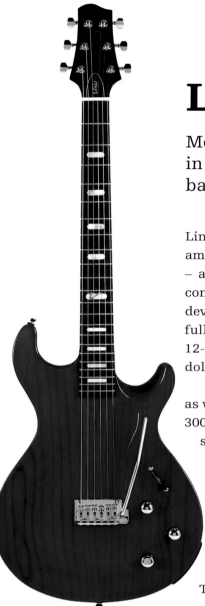

Line 6 Variax

Most of today's favourite electric guitars were designed in the 1950s and 60s. Line 6 has brought the instrument bang up to date using space-age "modelling" technology.

Line 6 is a Californian company that made its name developing guitar amplifiers and recording interfaces that "modelled" – or digitally recreated – a store full of classic amp tones. In 2003, the company extended the concept to guitars. Instead of a single amplifier or desktop recording device loaded with great amp sounds, Variax was an electric guitar packed full of vintage Strats, Les Pauls, Gretsches, Telecasters, Rickenbacker 12-strings, acoustics, and even a sitar and banjo! It was literally a million dollars' worth of sounds in a single instrument.

Line 6 decided to build the technology into its own guitar and so far – as well as bass and acoustic models – there are four ranges on offer: Variax 300, 500, 600, and 700. Each range is built in east Asia, has a 65cm (25½in) scale length and the same palette of guitar models, but Line 6 has ensured that the styling, colours, construction materials, and playability of the various instruments cater to most tastes. No pickups are visible, giving the Variax models a slightly unusual look. Instead, six separate transducers – one for each string – are mounted beneath the bridge saddle. These pick up the strings' vibrations and digitally convert them into the modelled guitars' complex frequency spectra to provide the different characteristics inherent in each one. T-Model offers the user 1960 and 1968 Telecaster tones, while Spank is a 1959 Strat. There are great Gretsches, Gibsons, and many more. Chime is the Rickenbacker sound and includes six and 12-string models. The acoustic selections are convincing, too, and if you are feeling creative the Coral electric sitar, Gibson banjo, and National resonator selections offer bags of musical opportunity.

Line 6 has made Variax a guitarist-friendly experience. As well as standard volume and tone knobs, a separate control selects your chosen guitar, and then the modelled pickup combinations are accessed via the Strat-style selector. A Custom setting allows you to save 10 of your favourite sounds and call them up using this five-way switch. While in its relative infancy, guitar modelling has made a big impact, and Line 6 looks set to build on these impressive beginnings. Although Variax might look like the ideal way for new players to get expensive tone, some world-class acts also enjoy the experience.

SUMMARY

CONSTRUCTION Solid mahogany/ash/basswood/agathis on various models; maple neck with maple or rosewood fingerboard and 22 medium frets; various fingerboard radii on different models.

FEATURES Six individual pickups hidden beneath bridge saddle; variety of modelled sounds from a range of famous classic and modern instrument,s including Gibson Les Paul, ES-335, Super 400, Fender Strat, Tele, Gretsch 6120, Rickenbacker six- and 12-string models, acoustic, banjo, resonator, and electric sitar; standard jack, plus digital outputs for connecting to other Line 6 products; XLR output for feeding acoustic sounds to separate amp or PA (not Variax 300).

MUSICAL STYLES As Variax models all styles of guitar, any style of music is available to it.

SOUNDS Almost any classic guitar tone is available.

ARTISTS Ed O'Brien (Radiohead), Babydaddy (The Scissor Sisters), and Andy Taylor (Duran Duran) are just three Variax users.

Brian May Red Special

Occupying an exclusive position among rock's elite, Brian May not only has a unique musical voice but has also made that voice heard on an instrument designed and built in 1963 with his father Harold.

With a tone and style that are so distinctive that even the sound of a single chord, string bend, or vibrato will give its perpetrator away, Brian May has become a rock-guitar legend. Although his use of modified Vox AC30 amplifiers, treble boosters, and the famous "Deacy" amp – a homemade transistor amplifier built into a bookshelf hi-fi speaker by Queen bassist John Deacon – go a very long way toward creating his unique sound, the prime components are his fingers and, of course, his beloved Red Special guitar.

In the early 1960s, a teenage Brian May could not afford a large sum to buy an electric guitar, so his electronics draughtsman father Harold cleared a room in the family house and stepped up to the challenge of building one. Back then, guitar spares were all but impossible to obtain; no replacement bodies or necks existed, and parts from any of the major manufacturers such as Fender and Gibson were like gold dust.

So, using a piece of mahogany rescued from an old fireplace surround as the neck, and lumps of oak for the fingerboard and as a base for the pickups and bridge, the Mays finished the body of the guitar using blockboard and mahogany veneers. The neck and fingerboard were painted black, the body was stained red, and the whole instrument was finished by hand in Rustin's Plastic Coating. The fingerboard dot markers were pearl buttons and the vibrato bar knob was a piece of knitting needle.

Hardware was always going to be difficult, and in this area the Mays' ingenuity was tested to the full. In the end, Brian came up with a knife-edge vibrato system that relied on motorcycle valve springs to counter string tension and bring the instrument back into pitch. "It's better than everyone else's system", says Brian, "because the milled steel plate pivots against a case-hardened knife edge. I also came up with a roller bridge so there's very little friction in the system and it returns to pitch remarkably well."

Pickups were originally of Harold's and Brian's own invention, but owing to an error in magnet polarity they did not work too well and were replaced by Burns Tri-Sonic single-coils. These were wired in series, rather than the more common parallel wiring found in most electric guitars. This meant that, when used in combination with each other, one pickup added to the sound of the other(s) for extremely fat and powerful tones.

Right One of the most iconic instruments of modern rock was conceived and created by a father and son in a suburban house in 1963. The Red Special has appeared on every Queen album and stage show since Brian helped to form the band in 1970.

SUMMARY

CONSTRUCTION Oak centre section with blockboard wings and veneered in mahogany; mahogany neck; painted oak fingerboard.

FEATURES Three Burns Tri-Sonic pickups wired in series; handmade vibrato system using motorcycle valve spring and knitting needle knob! Finished in Rustin's Plastic Coating.

MUSICAL STYLES Queen.

SOUNDS Heavy and fat or more trebly, sometimes warm and bassy – think of "Killer Queen" by Queen.

ARTISTS Brian May.

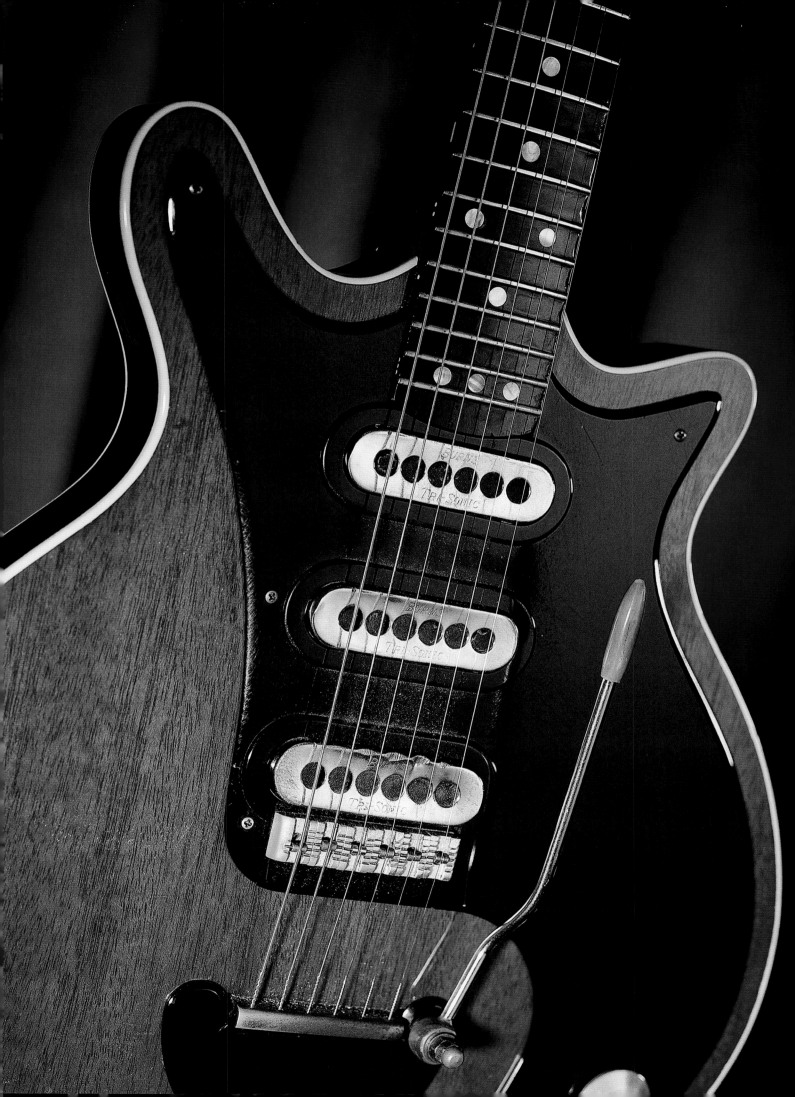

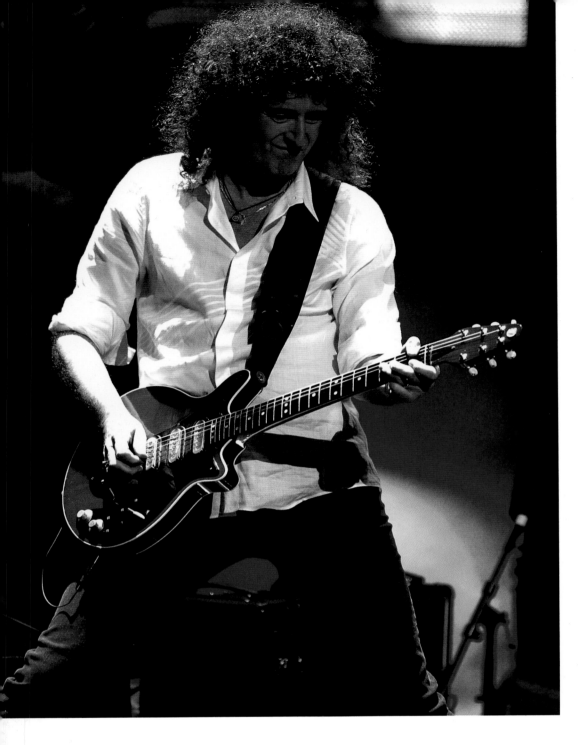

"I'm quite stunned that it's lasted this long really, but nothing else has quite come up to it for that warm, sustaining sound. A combination of design and luck I suppose." Brian May

The Mays' Red Special was a triumph in design over adversity, so much so that, over 40 years later, Brian still plays it as his number one guitar. He has had replicas made by English builder John Birch (he smashed this in frustration), American manufacturer Guild, and more recently Australian luthier Greg Fryer and English craftsman Andrew Guyton have recreated the closest ever versions of this historical instrument. To satisfy a longstanding wish for an affordable Red Special, in 2001 Brian sanctioned a Korean-made copy of the guitar to be built by Burns, and this is called the Brian May Signature.

National Airline Map

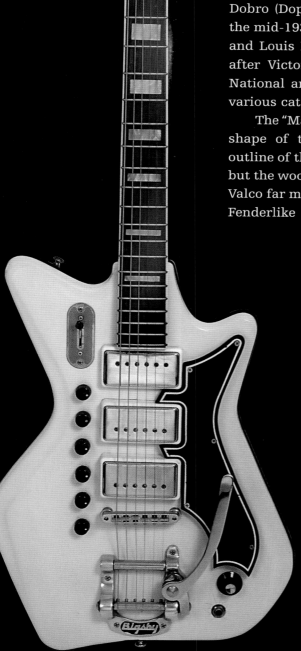

Once consigned to the six-string bargain basement, due to the patronage of one of rock's most exciting modern players National's Airline "map" guitar is now a rising star among vintage electrics.

The National Airline story is as complicated as the range of guitars it produced, and as convoluted as each one's controls and layout. National had come to prominence in the 1930s building multicone metal-bodied resonator guitars – as seen on the cover of Dire Straits' *Brothers In Arms* album. Brothers John, Ed, and Rudy Dopyera set up the company when they emigrated from what was then Czechoslovakia to L.A. in the 1920s. They later broke away from National and formed Dobro (Dopyera brothers) to build wooden single-cone resonators. In the mid-1930s, the two businesses merged; then Victor Smith, Al Frost, and Louis Dopyera bought the company in 1942, renaming it Valco – after Victor, Al, and Louis. Valco made electric guitars under the National and Supro brands, as well as producing Airline models for various catalogue companies.

The "Map" range of National electrics gained its nickname from the shape of the instruments' bodies, which vaguely represented the outline of the U.S. Of the nine models in the range, launched in 1962, all but the wooden Westwood were made of fibreglass – or "Res-O-Glas" as Valco far more evocatively titled it. Two preformed halves, in a range of Fenderlike colours impregnated into the synthetic material, were

SUMMARY

CONSTRUCTION Two-piece self-coloured fibreglass (Res-O-Glas) shell over wooden centre block, joined around perimeter with seam hidden by cream vinyl; wooden neck with rosewood fingerboard and a variety of inlay designs.

FEATURES Single or twin Vista Power humbucking pickups, plus some models with built-in Silver Sound acoustic simulation pickup mounted in rosewood bridge; variety of simple and complex controls included Glenwood with three volumes, three tones, master volume, and pickup selector.

MUSICAL STYLES Rock, pop, and blues.

SOUNDS Big, fat, and distorted when played through an overdriven valve amp – mushy neck pickup and more biting bridge sound.

ARTISTS Jack White (The White Stripes) is the Airline Map's most famous player; others are David Bowie, The Cure, and Joey Burns (Calexico).

Left Check out this National's amazing array of controls on its three pickups and Bigsby-equipped "Res-O-Glas" body.

joined together over a wooden centre block, with a strip of cream vinyl used to hide the seam. A painted wooden neck was bolted to the body and the 20-fret rosewood fingerboards displayed a variety of inlays, from simple quarter-moons to elaborate split diamonds.

Single or twin Vista Power pickups were often augmented by another innovative National feature: a Silver Sound contact pickup buried in the rosewood bridge provided pseudo acoustic sounds and predated Parker's Fly and the Taylor T-5 by decades.

The Nationals' mode of construction allowed the guitars to look like nothing else on the market and their vibrant colours – sea foam green, white, red, or black, with the wooden-bodied Westwood 75 in sunburst – certainly caught the eye. But the guitars' controls were often complex; take the Glenwood's three volumes and three tones lined up above the pickups and fingerboard, plus master volume and selector switch down by the jack socket. Fibreglass is also a time-consuming medium with which to work, so the Nationals' almost throwaway vibe was not matched by prices that made the more practical Fender Strat and Tele look cheap, and east Asian imports even cheaper. So Valco closed its doors in 1968.

Today original Nationals are expensive, hard to find, and often tricky to play – their necks, while reinforced, had no truss rods. Yet various reissues are available that look the part, play and sound great, and are built in a more conventional manner. Eastwood Guitars of Ontario, Canada, offer perhaps the most exciting and affordable option to these wacky and lovable misfits from the past.

Right National's desire to come up with radical guitar concepts extended to this three-quarter scale student instrument and case with built-in amp and manually operated tremolo circuit.

"If we had five people on the stage, a 300-track studio, or a brand-new Les Paul, the creativity would be dead."
Jack White

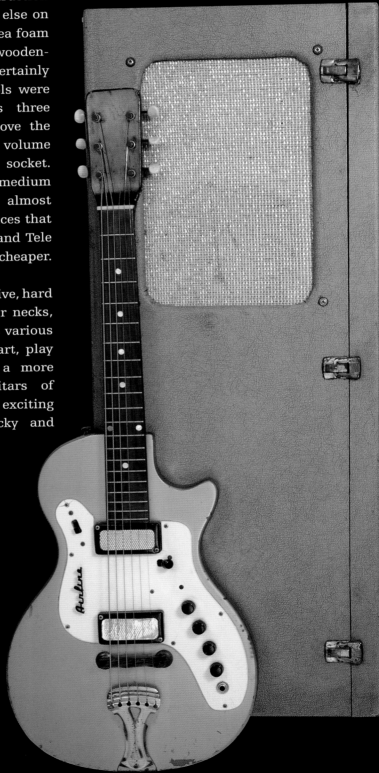

Opposite Jack White has changed the tuning pegs and removed the nonworking neck pickup on his 1964 JB Hutto Montgomery Airline guitar.

"My Parker has taken a hell of beating and is still going strong." Reeves Gabrels

Opposite Parker's instruments combine the beauty and resonance of traditional guitar-building materials such as alder, spruce, basswood, and mahogany (right) with carbon and glass fibre to create guitars of timeless beauty.

Parker Fly

Ken Parker's ingenious Fly range flaunts almost every guitar-building convention going, but his lateral thinking created possibly the most advanced electric guitar in the world.

Parker Guitars, the result of a collaboration between luthier Ken Parker and acoustic pickup guru Larry Fishman, began in the early 1990s, and the Fly debuted in July 1993.

Parker maintained that traditional materials and construction techniques conspire against great guitar tone, inhibiting the strings' vibration and dulling the transference of tone through the pickups. So, beginning from scratch, he looked at what he felt was wrong and what was needed to rectify the problems. Fishman's role was to devise a system that allowed Parker's instruments to provide realistic acoustic sounds alongside the electric tones of its twin humbucking pickups. Guitarists would not only be able to switch between modes at will, but could also mix acoustic and electric sounds in a manner previously unavailable.

Almost everything about the Fly is different and the first radical departure was in the instrument's general construction. A Fly uses much less wood than any conventional solid-body electric. Its eccentric twin-horned body is just 13mm (½in) at its thinnest and only 38mm (1½in) at its thickest point, compared to a Fender Telecaster that is almost 50mm (2in) all over. The neck is joined to the body using a heelless system that provides unhindered access to the top frets, and a space-age carbon and glass fibre truss rod weighs just a sixth of conventional systems.

Next, the rear of the neck and body are bonded to a wafer-thin exoskeleton of glass and carbon fibre, resulting in a lightweight but immensely strong and resonant platform for hardware, electrics, and strings. The fingerboard is also carbon and glass fibre and its 24 stainless steel frets are glued to the surface, rather than hammered in and held by the traditional barbed "tang".

Larry Fishman's piezo transducers are buried in the bridge's six saddles so that each string is picked up separately for added clarity of tone. An "intelligent" jack socket senses stereo or mono cables and routes

the electric and acoustic signals accordingly, while a mixer circuit allows precise balance of both sounds. The advanced vibrato system can be free-floating, downward motion only, or completely locked. There is virtually nothing about the Fly that is commonplace. Pickups are DiMarzio or Seymour Duncan humbuckers and these are joined to the body using the pole-piece screws, eliminating the need for scratchplates (on all but the NiteFly) or cumbersome pickup mounting rings.

Since the Fly's inception, the company has introduced many variants, including the bolt-on neck, 22-fret mahogany NiteFly, the nylon-string Spanish Fly, the mahogany-bodied Classic, the poplar Deluxe, and the recent all-mahogany Fly Mojo and Mojo Singlecut with Seymour Duncan pickups and optional flamed maple tops. There is even a Fly Mojo Snakeskin – with genuine reptile coat bonded to the front! While its looks and build are like those of no other guitar, the Fly is a true player's instrument – feather-light, sonically versatile, and tonally top drawer. It is also strangely organic, given its high-tech pedigree.

Ken Parker recently sold his company to the owners of Washburn and is now producing radical archtop guitars that look set to challenge jazz preconceptions – just as his Fly caught the rock world off guard.

SUMMARY

CONSTRUCTION Various woods (poplar, spruce, mahogany, basswood) are used on different models; necks are basswood or mahogany; most feature multifinger heelless neck joint; carbon and glass fibre fingerboard with bonded stainless steel frets; micro-thin carbon and glass-fibre exoskeleton bonded to back of body and neck.

FEATURES Twin coil-tapped Di Marzio or Seymour Duncan humbucking pickups (humbucker and two single-coils on NiteFly); aluminium vibrato bridge with stainless steel piezo-loaded saddles offers floating, locked, and down-only movement; switchable or mixable with magnetic pickups; Sperzel locking tuners.

MUSICAL STYLES Pop, rock, folk, and jazz.

SOUNDS Range of humbucking and single-coil tones as well as authentic acoustic sounds that can be mixed together.

ARTISTS Reeves Gabrels (Tin Machine), Joni Mitchell, Phil Campbell (Motörhead), Phil Keaggy, Nashville session player Dann Huff, Joe Walsh (The Eagles), Merle Haggard, Adrian Belew.

Below Ken Parker's radical range of lightweight wood and carbon-graphite composite guitars includes such gems as the now discontinued Spanish Fly, which is still available through the Parker Custom Shop.

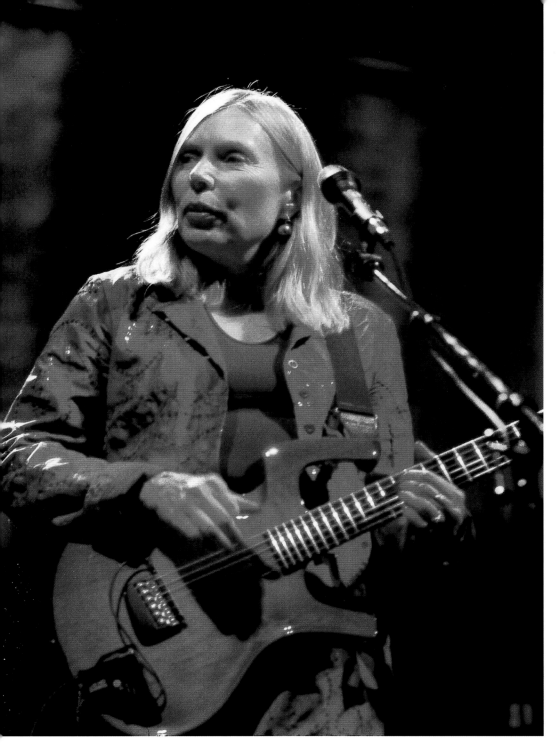

Left Artists such as the brilliant singer, songwriter, and guitarist Joni Mitchell use the Fly because of its light weight and sonic versatility, offering electric and acoustic tones at the flick of a switch. Joni's previous use of Ibanez George Benson and Martin acoustic models is now combined into a single instrument.

"My NiteFly is gutsy enough for Motörhead and versatile enough to play just about everything else." Phil Campbell

Peavey Wolfgang/HP Special

When rock virtuoso Eddie Van Halen parted company with Ernie Ball Music Man he switched allegiance to Mississippi-based Peavey for his new model, the Wolfgang.

Named after his son, Eddie Van Halen's Wolfgang shares many design traits with his previous signature guitar, the Music Man that bore his name and that has since transmuted into the Axis range. When Eddie fell out with Music Man, the move to Peavey was an obvious choice since the company already made his signature amp, the 5150.

At first look, there is little to separate the original Wolfgang Standard Deluxe from its Music Man predecessor. Both share a deep cutaway and stubby top horn on an offset body faced with highly figured maple. But look closer and you will notice it has an arched top, unlike the Music Man's flat front, and a six-a-side tuner arrangement as opposed to the earlier guitar's four-plus-two layout. You will also spot a second control knob – for tone – and see that the three-way pickup selector switch has been moved from the lower to the upper horn. What is not so easy to spot is the slightly wider fingerboard and Eddie's patented D-Tuna device that allows the guitar's low E string to be instantly dropped a tone to D, despite the instrument's locking Floyd Rose vibrato. The Wolfgang Special Deluxe, introduced after the Standard Deluxe, features a flat top and no tone control, while the

SUMMARY

CONSTRUCTION Wolfgang Standard Deluxe has basswood body with arched maple cap; Special Deluxe has flat maple top; Standard and Special both feature all-basswood construction; bolt-on maple neck in oiled finish with shape copied from EVH's Frankenstrat; maple fingerboard with 22 jumbo frets.

FEATURES Floyd Rose locking vibrato, volume and tone control with coil-tap facility (some models with just volume); three-a-side headstock with D-Tuna fitted; Van Halen/Peavey designed low-output humbucking pickups.

MUSICAL STYLE Rock.

SOUNDS Fat Gibson-style treble; coil tap offers Fenderlike tones.

ARTISTS Eddie Van Halen.

Special (flat top) and Standard (archtop) feature solid basswood bodies without maple tops. These come in solid colours such as gold, black, and ivory. For the first year's Wolfgang Standard Deluxe, Peavey used quilted maple tops, but this was changed to regular flamed (stripy) maple when the preferred choice became prohibitively expensive. Van Halen used his Wolfgang guitars, built in the company's American Custom Shop, until late 2004 when relationships between guitarist and company soured.

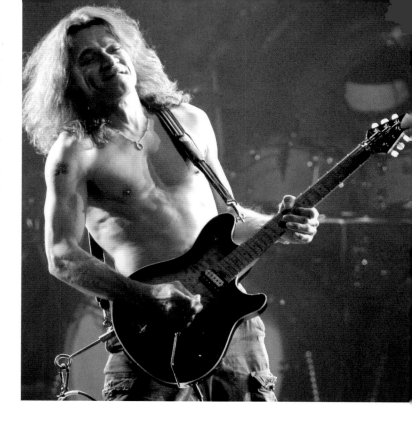

As Ernie Ball did with the EVH model – made small but significant alterations and changed its name to Axis – so Peavey has done with the Wolfgang. Now produced as the HP Special, the guitar has a slightly more Stratlike look with slimmer horns on either arched or flat-topped bodies. Highly figured flamed maple is used on transparent finishes and a range of solid colours is available. Unlike the Wolfgang, the HP's two humbuckers have a split coil option for additional Fender-type tones; its Floyd Rose vibrato system can raise or lower the strings' pitch, whereas on Van Halen's instruments the upward option is not available.

Although the loss of the Van Halen association could be seen as a blow to Peavey, so well have these new "improved" instruments been received – there is a budget EX version, too – that the company's reputation as a builder of quality American guitars seems assured.

Peavey T-60

Hartley Peavey reasoned that, if computers could help build cars and other products, surely they could help build guitars. In 1976, Hartley and engineer Chip Todd devised the scheme together – the T in T-60 stands for Todd. Peavey equipped his Mississippi factory with computer-driven milling machines and routers that slashed build time and cost, but increased consistency and accuracy. It was a revolution that the guitar industry was not ready for. Just as other companies criticized Leo Fender for presuming he knew better than the establishment, they scoffed at Peavey's nerve at bringing "robots" to their industry. Now even one-man operations use CNC routers and it is a rare guitar manufacturer that does not hand over much of the shaping work to machines that can turn out identical components 24 hours a day. The T-60 offered innovative features, such as a tone control that put the pickups in humbucking mode as it was turned down and single-coil as it was wound up, and lasted until 1987. While it did not inspire players, it prompted the biggest change in guitar production since Leo Fender.

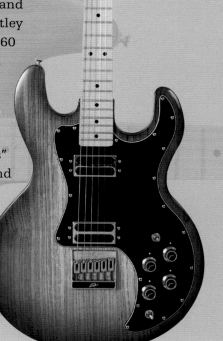

PRS

"The ideas are gifts … I just have a strong vision about what a guitar can be. I've had a few brilliant ideas!" Paul Reed Smith

PRS Custom 22/24

Gibson and Fender can both thank Paul Reed Smith for bringing care and quality back to the electric guitar industry – they would not be making such good instruments today if it were not for PRS.

Paul Reed Smith started out repairing and handbuilding guitars from his bedroom in Bowie, Maryland, and now runs a multimillion dollar guitar business that has helped to shape today's electric guitar. His instruments are the benchmark for quality and he proved that there was life beyond the Les Paul and Stratocaster.

While Smith acknowledges the problems associated in trying to combine two of the world's favourite electric guitars – "It's ugly and it doesn't work" – his Custom from 1985 achieved the impossible, though that was never his stated aim. "I don't know if the goal was to make a better guitar, but just to make a design that worked", says Smith. "I did know that at the time people were playing Fenders for rhythm and using Gibsons for the solos – the joke was, wouldn't it be great if you could change guitars midtune. I also knew that Fenders were being shipped with file marks on the fingerboards; there were finishes with too much polyester, neck angles and fret levels weren't right. And you couldn't give away Les Pauls!"

Smith came up with a compromise scale length – 13mm (½in) shorter than Fender and 6mm (¼in) longer than Gibson. This he felt would be comfortable for players in both camps. He also made his guitar slimmer than a Les Paul but built with mahogany and curly maple like a Gibson. The Custom featured a twin-horned body design that echoed the elegance of a Stratocaster and, although Gibson-style humbucking pickups were fitted, Smith cleverly wired them – using a five-way rotary selector switch – to split the coils for some pretty convincing Fender tones. He also created a virtually friction-free floating vibrato system with quick-change tuners – it returned

Left The most commercially successful of all Gibson-meets-Fender designs, the PRS Custom has been the company's mainline instrument for over 20 years, in 22- and 24-fret guise.

the guitar to pitch perfectly. You no longer needed to change guitars midnumber.

Quality of both Gibson and Fender products had dipped to an all-time low around the mid-1980s. CBS had recently sold Fender to its management team after making changes to its most famous models that players simply would not wear. Gibson, too, was in a state of flux and the attitude seemed to be: "Whatever we make and however poorly we make it, the players will buy it on the back of past glories." To a degree that was true, but when guitar magazines began writing about a new instrument that combined the best of both makers with attention to detail on another level, the playing public took note. They also loved PRS's unique touches, like 10 tops (after Bo Derek's perfection in the Dudley Moore film *10*), and beautiful bird inlays that seemed to dance their way up dark Brazilian rosewood fingerboards with their perfectly polished frets. A range of see-through colours complemented the guitars' gorgeous timbers, and by the late 1980s, a PRS was the instrument to which many serious players aspired. In 2006, PRS Guitars celebrated its 20th anniversary crafting fine electric guitars – and today Gibson and Fender build their best instruments for decades!

SUMMARY

CONSTRUCTION Solid mahogany with figured maple carved top; glued-in mahogany neck and rosewood fingerboard.

FEATURES Two PRS pickups, tone and volume control plus five-way rotary pickup selector; "sweet" switch (for Santana "nasal" tone); pearl dot markers with abalone "moon" cut-outs, or PRS "bird" inlays; floating PRS vibrato with Teflon nut and locking tuners.

SOUNDS Lighter Les Paul tones and thicker Strat ones.

ARTISTS Mike Shinoda (Linkin Park), Dave Navarro (Jane's Addiction), Mike Oldfield, Alex Lifeson (Rush).

Below The use of exquisite curly maple, fine South American mahogany, and PRS's most famous trademark, abalone bird inlays, has set Paul Reed Smith's instruments a cut above the rest.

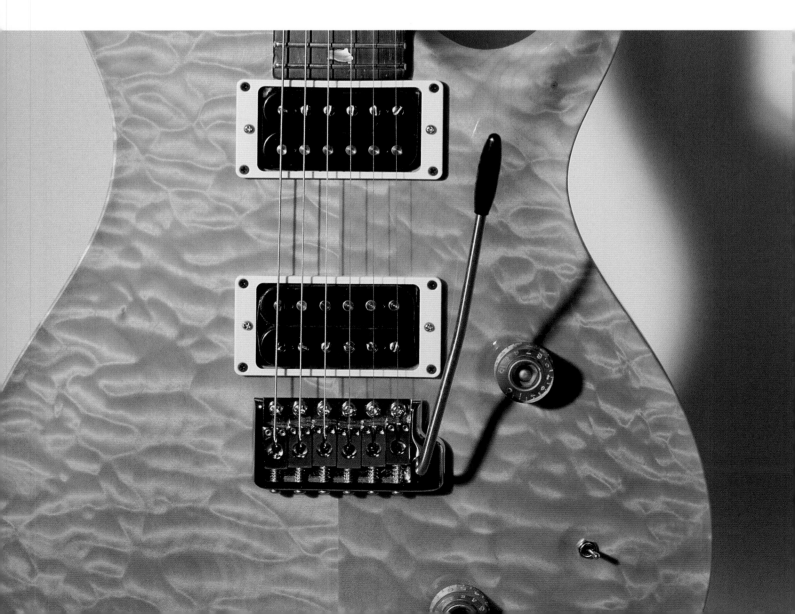

"Where did the birds come from?
My mother was a bird watcher;
I grabbed a bird-watching
guide and stole the pictures
out of it." Paul Reed Smith

Next page Jane's Addiction's Dave Navarro is an avid PRS user. Here he is alongside JA's singer Penny Farrell, playing his indispensable white signature model based on the Custom 24.

PRS Standard and CE Models

Paul Reed Smith's guitars have always been perceived as high-end instruments for high-end players. But away from his bird inlays and curly maple tops Smith always liked the idea of the "working man's guitar" – after all, he based his earliest instruments on Gibson's lowly Les Paul Junior. Smith had been making all-mahogany guitars in the now familiar "archtop Strat" outline since day one, but then it was known simply as the "PRS Guitar". To differentiate it from the more popular Custom, in 1987 Smith took a leaf Gibson's Les Paul model nomenclature and re-named it the Standard. A big and raw sounding tone machine, the Standard was a blues-rock guitar par excellence and yet people still flocked to buy the "furniture style" Custom that pervaded the company's literature and which the world's guitar magazines sought to review.

The following year PRS launched one of its best guitars ever – again, with the cost-conscious guitarist in mind. Still based on the Custom/Standard outline and with similar hardware, electrics, and 24-fret fingerboard, the CE (Classic Electric) featured a bolt-on maple neck and alder body, with abalone-dotted maple fingerboard. One of the company's best guitars ever, it captured the Fender-style simplicity and vibrant tone that the other models – which were deliberately aimed at the Gibson sound – failed to capture.

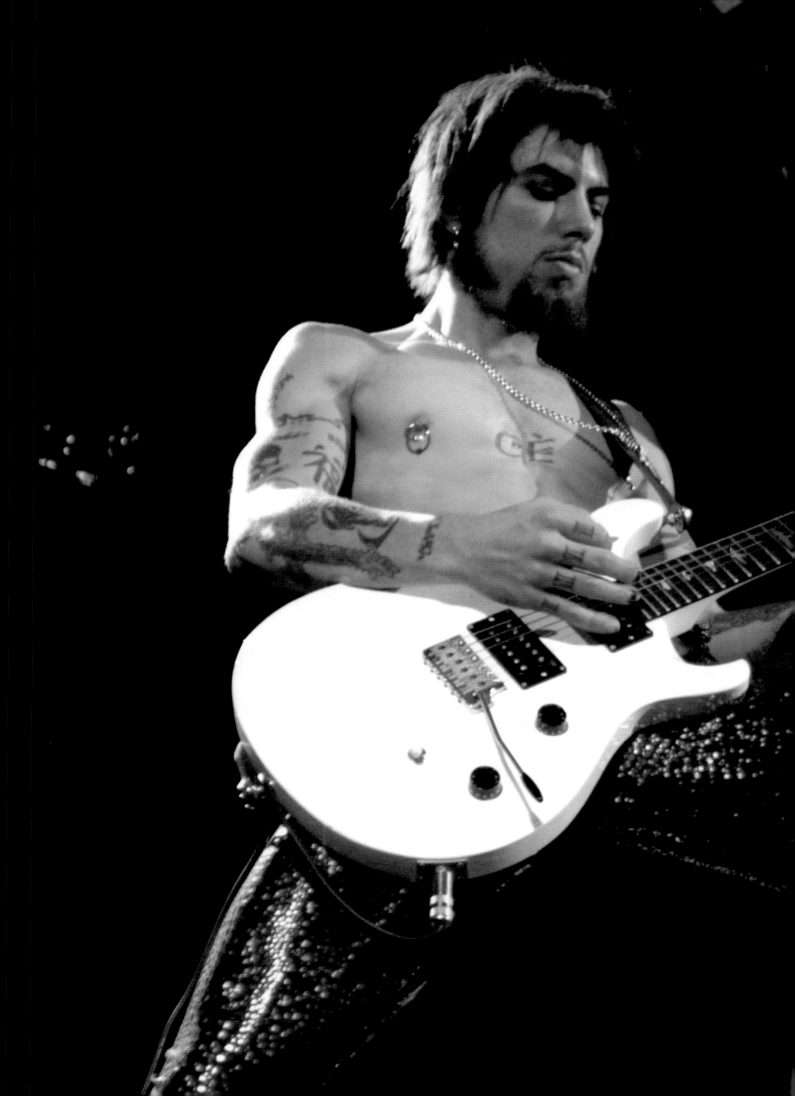

PRS McCarty

Paul Reed Smith's admiration of Gibson drew him to one of the company's leading figures, the man who had overseen its golden era of the 1950s and 60s – Theodore "Ted" McCarty.

Ted McCarty had been the brain behind so many great Gibson innovations during his tenure as President of the company between 1950 and 1966. Paul Smith had come across McCarty's name while seeking out old guitar patents and noticed it alongside many Gibson models and designs. Smith sought out the retired company boss and the two became friends. As hired consultant to PRS Guitars, Ted happily imparted knowledge about pickups, glues, timber, famous models such as the Les Paul, and much more. The first fruit of their friendship and the things Smith learned from his mentor was the McCarty Model of 1994.

Using a fixed "wrapover" bridge with built-in staggered "saddles", plus an extended heel on a wide-fat neck and lighter-weight tuners – a modern take on the tulip-buttoned Klusons of old Les Pauls – the McCarty was a simpler guitar than the Custom. It also used red maple for the top – again as employed on 1950s Les Pauls – and covered humbucking pickups. The model had simple volume and tone controls and a three-way Gibson style selector (a push-pull pot would be introduced two years later, providing three extra split-coil tones). The body was also thicker and the headstock thinner – all deliberate attempts to emulate the tone of a vintage Les Paul.

SUMMARY

CONSTRUCTION Solid mahogany body with red "Michigan" maple cap; glued-in mahogany neck with rosewood fingerboard.

FEATURES PRS wrapover one-piece bridge; McCarty treble and bass pickups with covers (P-90 style on McCarty Soapbar); PRS "moon" or "bird" inlays.

MUSICAL STYLES Heavy blues, and all styles of rock except heavy metal.

SOUNDS Smooth and thick.

ARTISTS Al Di Meola, Dave Grissom, Mark Tremonti.

Left The McCarty model with its thicker body, stiffer neck, and heftier heel brought huge tone to the PRS line; its combination bridge/tailpiece is precompensated for correct intonation.

The McCarty was a classic, elegant guitar designed to pay homage to a man who prized form, function, and quality. Although offered with bird inlays, gold hardware, and other more flashy accoutrements, the McCarty looks best in simple form, with mildly flamed "Michigan" maple, nickel parts, and "moon" inlays. With a tone darker and "browner" than previous PRS guitars, the McCarty was the one that David Grissom, guitarist with Joe Ely and John Mellencamp, had been asking Smith for since the early 1990s. This fabulous blues guitarist has used McCarty models ever since. An all-mahogany McCarty Standard is also available, as is a P-90-equipped McCarty Soapbar – named after the look of these simple cream single-coils.

Ted McCarty died in 2001, but his legacy lives on, both in his Gibson innovations and in this range of enthralling modern-era guitars.

Right Many modern rock acts have embraced the PRS brand, using McCarty, Singlecut, and Custom models. Here's Linkin Park's Mike Shinoda with a Custom 24.

PRS Hollowbody

Ted McCarty's design of Gibson's ES-335 of 1958 and his mentorship of Paul Reed Smith were bound to result in a semi-acoustic model. The Hollowbody appeared in 1998 along with its sister, the fatter and less successful Archtop. Where the ES-335 employed relatively traditional guitar-building techniques, the Hollowbody took advantage of radical new computer technology. Solid maple tops and backs of either mahogany or maple are carved into their elegant shapes by computer-driven machines, achieving perfection at a fraction of the cost of hand labour. The machines carved out large hollow areas leaving the block and rims behind, onto which the top was glued. The bridge assembly and pickups were then set into the retained middle section and the f-holes cut out of the top, creating the classic "cello guitar" appearance. PRS master builder Joe Knaggs was responsible for the Hollowbody and Archtop models, made as part of the company's "Guitar Of The Month" programme, from which many of its major innovations have sprung. McCarty pickups were specially voiced to take advantage of the new models' construction; the result is a versatile instrument at home playing jazz, fusion, blues, rock, pop, and even country. Build quality is high and, now that a piezo bridge is available, adding believable acoustic tones, the Hollowbody is one of the most desirable electric guitars.

> **"It's a dream come true. It's an 'I'm not worthy' moment. PRS wanted to work with us and I got lucky to have my own signature model."**
> Mark Tremonti

PRS Singlecut

This controversial instrument came, went, and is back again with a vengeance as the centrepiece of one of PRS's most popular and mould-breaking ranges.

Above PRS approached Creed when they were a little-known act, believing they could make it big. The Tremonti model is based on the Singlecut, with pearl-inlaid ebony truss rod cover and Tremonti 12th-fret inlay.

Opposite Unlike the Gibson Les Paul, on which the pickup selector switch is located on the top shoulder, the Singlecut's is down by the guitar's controls; the cutaway is also relieved for better top-fret access. "Bird" inlays are an optional extra.

The PRS Singlecut guitar became the subject of an American court case when Gibson declared that it was a little too close to their Les Paul model for comfort. Paul Reed Smith had always stated that his instrument was no copy: "Lay one on top of the other and the shape is different, the headstock is different, the switch and controls are in a different place, and even the bridge is not the same." Although the initial hearing found in favour of Gibson, and Singlecut production was forced to cease, PRS appealed against the ruling. On appeal, the decision was overturned and now the company is free to produce this excellent guitar.

While no one could deny that the Gibson Les Paul was the Singlecut's inspiration, Smith is indeed right – it is different enough in every respect not to be deemed a copy. The result of a 1999 prototype, the Singlecut made its debut in 2000. If the quintessential PRS design, the Custom, is essentially a cross between the Les Paul and the Stratocaster, then in reality the Singlecut is a hybrid of Smith's original production instrument and the one Gibson so strongly guards. Using classic mahogany and maple construction – the body being thicker than regular PRS guitars but thinner than a Les Paul – all the usual PRS trademarks are here. Note the marked "dishing" around the body perimeter, the carved-out cutaway, the unbound

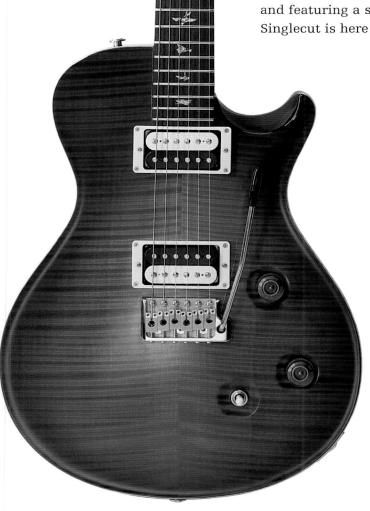

neck and faux-bound body – where the edge of the maple top is masked off to reveal the plain wood colour – the now classic PRS headstock design, and the company's clever take on the wrapover bridge. The whole is not quite as perfect a design as Kalamazoo's quinquagenarian model, but as a modern guitar it hangs together supremely well.

A much more accessible instrument to play, the Singlecut's heel features an ingenious design whereby the neck is dovetailed into the body, not unlike a Fender's design but longer and glued in place rather than screwed, allowing considerably freer playing at the upper frets. Sonically, too, the guitar is different. With freshly designed pickups – PRS "7" humbuckers – the Singlecut is the perfect marriage of sweet vintage and powerful modern.

Its looks and sound attracted the Singlecut to Creed's guitarist Mark Tremonti. So impressed was Tremonti that a signature PRS based very closely on the instrument was in production the following year, available in black and platinum finishes. Mark stipulated his own sound, too – like the Singlecut but with a more powerful treble tone. Other differences include a "Mark Tremonti" 12th-fret inlay and white-edged truss rod cover.

As well as a budget Tremonti SE version made in Korea and a brand new vibrato-equipped, American-made Tremonti, other models based around the Singlecut are becoming available. These include the three-pickup Chris Henderson model, the SC250 with beefed-up pickups and new mini-locking tuners, and the SC245, a vintage-vibed offering with scuffed pickup covers and old-style tuners. Interesting, too, is the SE1, a "junior" all-mahogany instrument made in east Asia and featuring a single P-90 pickup. It would seem as though the PRS Singlecut is here to stay!

Left and opposite Gibson took issue with PRS's Singlecut, saying it infringed its own designs/trademarks. Local courts initially sided with Gibson and Singlecut production was put on hold. Finally, a superior court ruled in PRS's favour and today the Singlecut is once again being built.

SUMMARY

CONSTRUCTION Solid mahogany body with figured maple cap and glued-in rosewood fingerboard.

FEATURES Single-cutaway body with scooped out cutaway; PRS Hardtail bridge (or PRS nonlocking vibrato on Single-cut Trem model); PRS "7" treble and bass pickups; "moon" or "bird" inlays.

MUSICAL STYLES Heavy blues, and modern rock styles – think of "Open Your Eyes" by Alter Bridge.

SOUNDS High-octane, powerful and rich treble, fat bass.

ARTISTS Mark Tremonti (signature model based on Singlecut), Chris Henderson (3 Doors Down), Alex Lifeson (Rush).

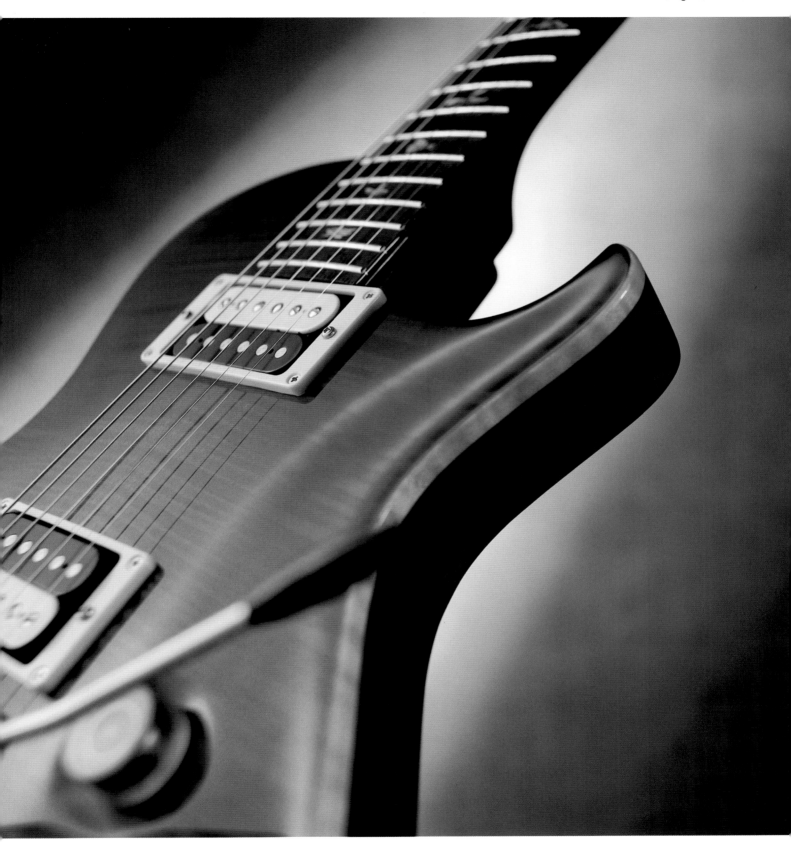

"I think being picky was the reason I got my signature model. Finally, about a year later, we had it all done and you have the guitar we've got now." Mark Tremonti

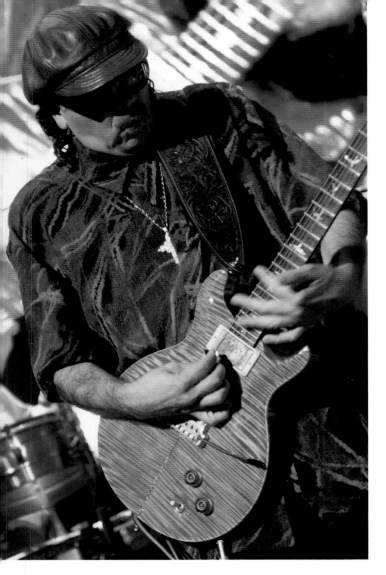

PRS Santana

Carlos Santana so loved this guitar, which was the first "signature" instrument made by PRS, that he ordered another, and then another.

Guitarist Carlos Santana had been a big hero of a young Paul Reed Smith (himself a fine player) and it was always his goal to get one of his instruments into the hands of the man who had played "Samba Pa Ti", "Black Magic Woman", and "Oye Como Va". Smith's early guitars were completely handbuilt; he began using fine-quality timbers such as curly maple and spent years honing every facet of the guitar-maker's art into his instruments. He would show up backstage to gigs and demonstrate his wares. "I'd sell them a guitar and if they didn't love it, I would offer to give them their money back." One such meeting was with Santana. "You mean, if I don't love it, I don't have to pay for it?" he exclaimed. In fact, the instrument played so well that Carlos called it an "act of God".

The Santana was similar to a guitar Smith had already built for Heart's guitarist Howard Leese and

Above The original guitars that Paul Reed Smith made for Santana were based on a double-cutaway Les Paul design, but when PRS went into production with the Custom in 1985 it was a different instrument altogether. It took 10 years and many requests for Smith to relent and produce an actual Santana model.

one of his earliest with a curly maple top. These and other pre-production guitars bore an inlaid eagle motif in the centre of the headstock; bird inlays became a trademark of PRS guitars and influenced many modern makers to adopt similar ideas – leaping dolphins and falling leaves featuring on the fingerboards of various "boutique" instruments. Carlos' original model also boasted an early version of the PRS "in-tune" vibrato system – Smith never liked the idea of locking tremolos and so came up with a low-friction alternative of his own, initially with a roller nut (as on Carlos' guitar) and eventually switching to one made of Teflon-impregnated plastic. Other components in this groundbreaking system were a knife-edge vibrato base-plate and quick-change locking tuners.

In 1995, after dozens of requests to build the guitar that Carlos played, Smith bowed to demand. By this time the standard PRS shape had changed to that of the Custom, so Smith used the company's new computer-aided routers to recreate the Santana. Now fully up to date with all of PRS's usual appointments, it also featured twin mini pickup switches (later changed to the more conventional three-way toggle) and abalone body stripes. An abalone "om" symbol was inlaid into the rosewood truss rod cover and the guitar featured the transitional headstock design – it employed straight string pull to aid tuning, and was shaped somewhere between the handmade originals and the Custom. Sonically darker and more aggressive than other PRS models, the Santana (changed to Santana II in 1999) has been the guitarist's instrument of choice ever since.

SUMMARY

CONSTRUCTION Mahogany body and neck; 24-fret Brazilian rosewood fingerboard with bird inlays and eagle motif on headstock; carved maple top with abalone inlays.

FEATURES Two zebra-coil Santana Treble and Bass pickups; volume, tone, and three-way selector (early model had two pickup mini switches); PRS vibrato; nickel hardware.

MUSICAL STYLES Rock and blues-rock.

SOUNDS Fat and powerful, overdriving and almost synthlike at times — think of "Smooth" by Santana.

ARTISTS Carlos Santana, Howard Leese (Heart).

"Paul Reed Smith said: 'Hey Carlos, I want to send you this guitar and if you don't like it, send it back. If you do like it, then call me.' And since I played that guitar I can't go back to anything else."
Carlos Santana

Left Ironically, the Santana model, although based on a guitar completely handbuilt for Carlos, was the first in the PRS line to be made using the company's new CNC computerized machinery.

Alex Lifeson is one of the most renowned of prog rock guitarists. His work with Canadian outfit Rush is packed with great technique and musicality. A long-time Gibson ES-345 user, recently Alex has rarely been seen without his PRS Custom 24.

Martin Barre is a guitarist of immense ability. Since the late 1960s, his playing with Jethro Tull has brimmed with inventiveness and high technique, but always with great taste and tone. Known for his use of Gibson and Hamer guitars, Martin is another PRS convert.

Paul Allender plays guitar in Cradle Of Filth, Britain's most successful heavy metal band since Iron Maiden. He joined the group in 1992, left in 1996, then was asked back in 2000. Cradle Of Filth's brand of extreme metal needs a guitar that can handle all excesses – Paul chooses PRS!

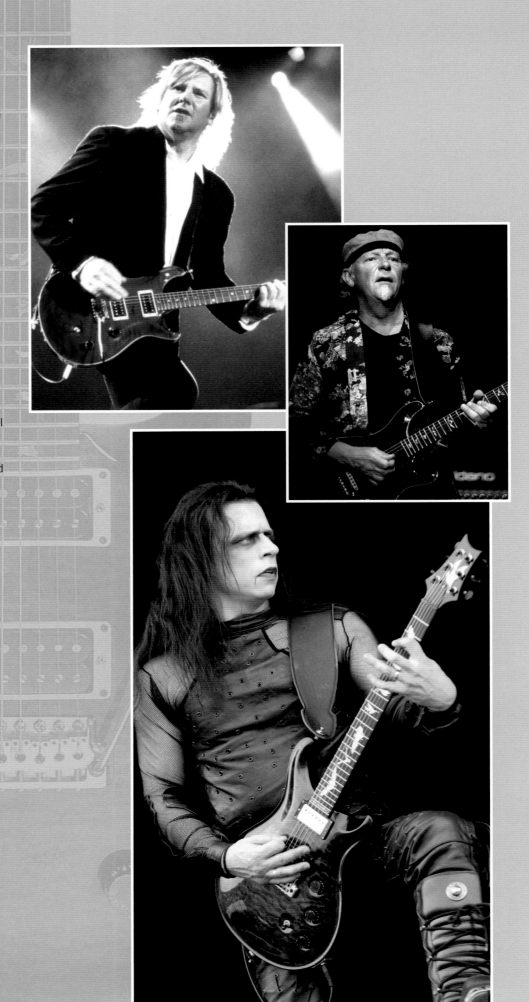

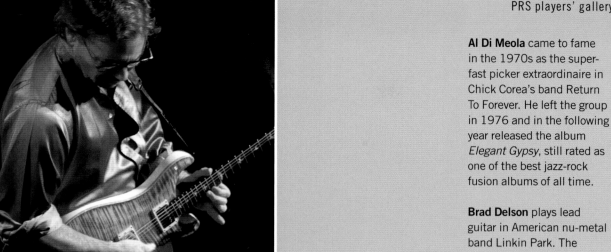

Al Di Meola came to fame in the 1970s as the super-fast picker extraordinaire in Chick Corea's band Return To Forever. He left the group in 1976 and in the following year released the album *Elegant Gypsy*, still rated as one of the best jazz-rock fusion albums of all time.

Brad Delson plays lead guitar in American nu-metal band Linkin Park. The group's debut album *Hybrid Theory* caught the imagination of the U.S.' disenfranchized youth and sold a staggering 18,000,000 copies. Brad and LP cohort Mike Shinoda both play PRS.

Mike Lewis plays rhythm guitar in Welsh alternative rock band Lostprophets. Although they began on Britain's "toilet circuit", the group's 2006 album *Liberation Transmission* topped the album charts. Mike plays various PRS Singlecut guitars.

Johnny Hiland is blind and learned guitar while growing up in Maine. An astounding technician, he plays super-hot country, blues, and rock equally well. He switched from Fender to PRS and now has a signature model based on the bolt-on neck CE.

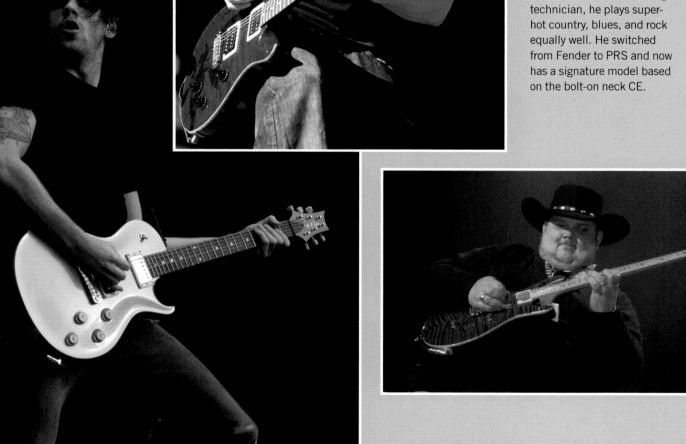

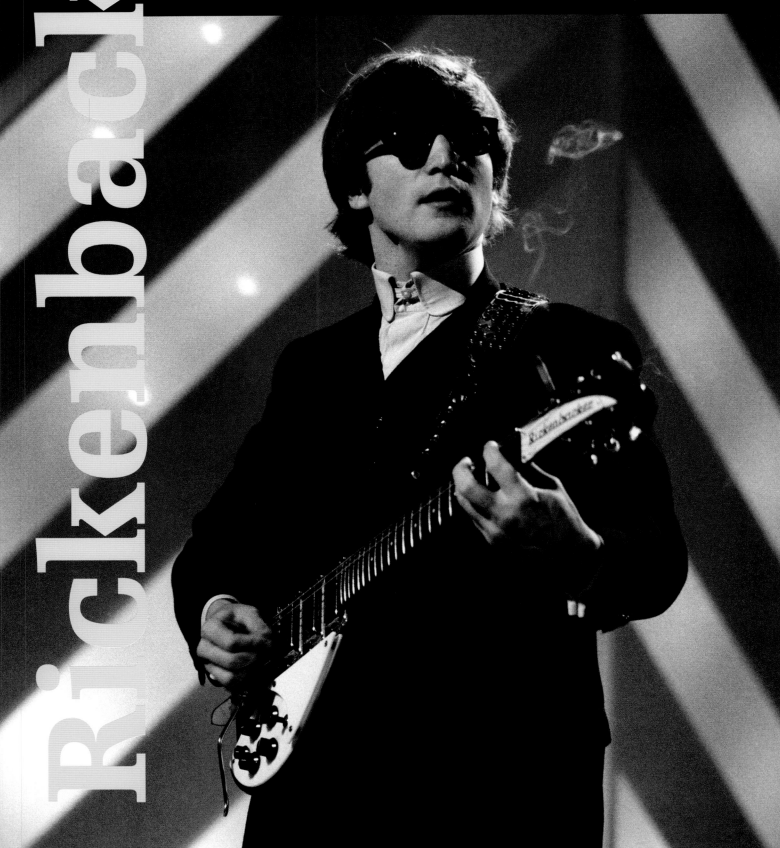

Rickenbacker

"We went into this shop in Hamburg and John bought that little Rickenbacker with a scaled-down neck. He'd seen an album by Jean Thielemans, who used to be the guitar player in the George Shearing Quintet, and had to have one of those Rickenbackers." George Harrison

Rickenbacker 325

In 1964, when American audiences saw The Beatles playing Rickenbacker, this respected but low-volume manufacturer was sent into hyperdrive becoming, for a time, more famous than Fender.

When The Beatles appeared on the *Ed Sullivan Show* in February 1964, John Lennon was playing a guitar that relatively few people recognized. It was a three-quarter-size, short-scale Rickenbacker 325. Originally part of the so-called Capri range designed in the late 1950s, the 325 and other hollow-body models with this attractive double-cutaway design had become the 300 series. It included the 360/12 as played by fellow Beatle George Harrison and Roger McGuinn of The Byrds, and the 330 made infamous by The Who's Pete Townshend.

Rickenbacker had been making electric guitars since the 1930s. Its "Frying Pan" was the first production solid-body – almost 20 years before Fender made the idea more practical with his workhorse Telecaster. George Beauchamp had pioneered the resonator-style acoustic guitar with National – as seen on Dire Straits' *Brothers In Arms* album cover – and developed his own design guitar pickups as early as the 1920s. Adolph Rickenbacker was a shareholder in National and a talented engineer whose company made the metal bodies for Beauchamp. The two formed Electro String (later to become Rickenbacker), along with ex-National man Paul Barth and set up shop in Los Angeles.

In 1946, F.C. Hall entered the picture. Hall distributed both Fender and Rickenbacker through his company Radio Tel; Adolph sold

Left This Rickenbacker 325 is in the popular Fireglo finish, but John Lennon had his originally natural maple guitar refinished in black by Jim Burns of Burns Guitars.

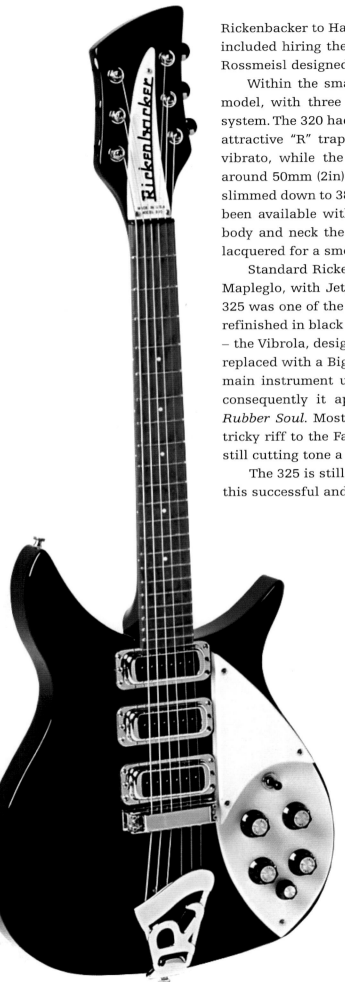

Rickenbacker to Hall and he embarked on a modernization process that included hiring the talented German guitar designer Roger Rossmeisl. Rossmeisl designed the 300 series guitars in the late 1950s.

Within the smaller of the range's two styles the 325 was the top model, with three Rickenbacker "toaster top" pickups and a vibrato system. The 320 had three pickups and no vibrato, instead featuring the attractive "R" trapeze-style tailpiece; the 315 had two pickups and vibrato, while the 310 had two pickups and no vibrato. Originally around 50mm (2in) deep and with no f-hole, the hollow body was soon slimmed down to 38mm (1½in), but throughout the model's history it has been available with or without non-f-hole tops. Using alder for both body and neck the fingerboard was a thick slab of African rosewood, lacquered for a smooth and shiny feel.

Standard Rickenbacker colours were Fireglo – pink sunburst – and Mapleglo, with Jetglo black an extra cost option. John Lennon's 1958 325 was one of the very first. Originally Mapleglo (natural), John had it refinished in black by Burns of London; he also had the original vibrato – the Vibrola, designed by Doc Kauffman who went on to join Fender – replaced with a Bigsby while in Hamburg. John's Rickenbacker was his main instrument until he obtained his Epiphone Casino in 1966 and consequently it appeared on most recordings up to and including *Rubber Soul*. Most famously, its short neck allowed John to play the tricky riff to the Fab Four's 1965 chart-topper "I Feel Fine", its rich but still cutting tone a trademark of the model.

The 325 is still made today and F.C. Hall's son John now looks after this successful and much-loved brand.

Left and opposite top With Rickenbacker's model numbering system, the suffix "5" means the guitar has vibrato. So this small-bodied Lennon-ish guitar is actually a 320. Notice, too, its black High Gain pickups as opposed to the 325's "toaster tops".

Opposite bottom The Who's Pete Townshend has smashed dozens of Rickenbackers. Pete has said that he agreed to a signature model partly out of guilt, and that some of the older factory workers were less than happy about the tie-in.

SUMMARY

CONSTRUCTION Hollow alder body with alder neck and lacquered African rosewood fingerboard.

FEATURES Early models had the Kauffman vibrato and later versions featured the Accent vibrato; three Rickenbacker "toaster top" pickups, two volumes, and two tone controls (earliest had just one of each and later a pickup mix control was added); gold Lucite or white double-tier scratchplate; Rickenbacker logo on plastic dagger-style headstock plate; Sta-Tite tuners.

MUSICAL STYLES Pop.

SOUNDS Single-coil twang but with a fat centre.

ARTISTS John Lennon, Suzannah Hoffs (The Bangles), Bob Berryhill (The Surfaris), Marie Frederiksson (Roxette).

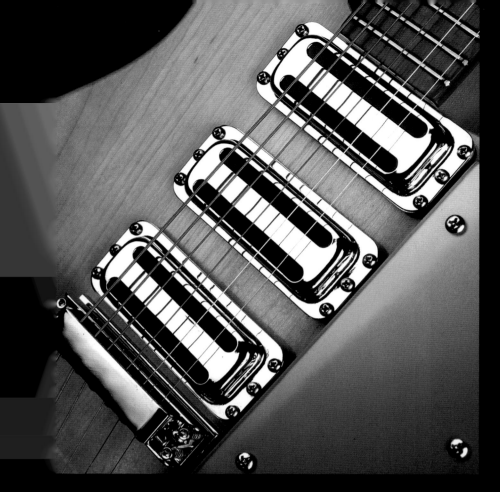

"The delicate body shape[] the lightness of the woodwork, the carefully constructed craftsman[] neck all contribute to a guitar that is utterly different in every way f[] all other makes. I often that Rickenbackers are like violins rather than guitars." Pete Townshe[]

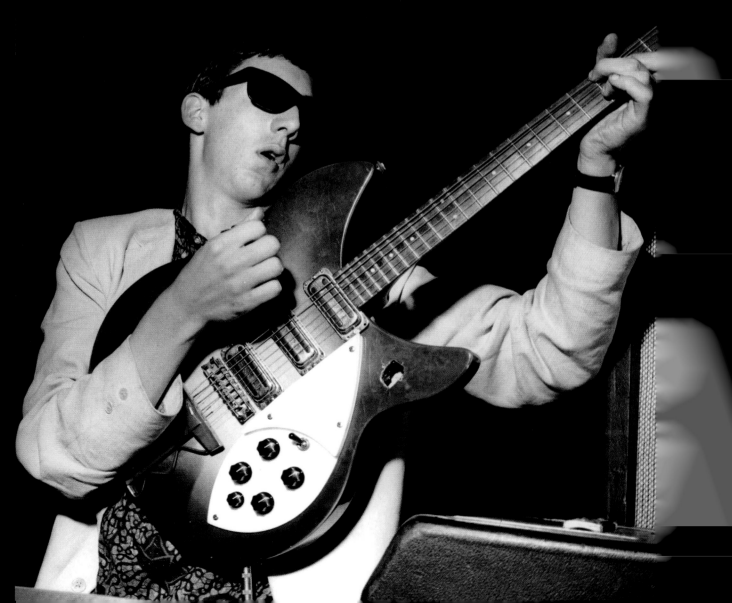

Rickenbacker 330

While the small-bodied 325 drew its fame from John Lennon, the full-sized 330 gained notoriety in the musical but often destructive hands of Pete Townshend.

A Rickenbacker 330's wonderfully clean, crashing tones created the backdrop to many hits by The Who, including "My Generation", "I'm A Boy", and "Anyway, Anyhow, Anywhere". The model also unwittingly contributed to the band's violent stage shows. Many a 330 ended its life in splinters (Townshend modestly suggests around eight), its complex construction making a convincing repair of the shattered carcass almost impossible.

Below Rickenbacker's styling and method of construction set them apart from any other brand, and make the company's instruments instantly recognizable. Note the multilaminate neck, "cat's-eye" sound-hole, and two-tier scratchplate of this modern 330 with two High Gain pickups.

Using the same double-cutaway design and hollow body wings as its little brother, the 300 often gets sidelined when discussing early semi-solid guitars in favour of Gibson's own ES-300 series – even though the two ranges debuted in 1958. This is perhaps due to the Gibson's all-round nature – it is at home in blues, jazz, and rock – whereas the Rickenbacker's purpose is distinctly singular. It is a purveyor of power pop par excellence but cannot compete against the Gibson's might in other areas.

As with the Lennon-style 325, the 330 starts life as a solid slab of wood, in the 330's case maple. Hollow chambers are then routed out of it, as are the single "cat's-eye" sound hole and space for the guitar's five control knobs and selector switch. The multilaminate neck is set into its deep socket and the instrument's back glued on. This construction method is ingenious and elegant but it does make repairs – such as those required after pile-driving the instrument into a stage or the front of a speaker cabinet – very costly and difficult.

Townshend has said that he was attracted to Rickenbacker because of The Beatles, but his guitar was different from the Ricks used by both Lennon and Harrison. While Lennon's small-bodied 325 sat in the middle of its model range, the 330 languished at the bottom of the larger-bodied line (top dog being the 345 with three pickups and vibrato). Just two pickups, no vibrato, and simple dot inlays marked it out as the junior model.

Yet in hindsight these factors were the 330's making. Historically, the simpler models are the

SUMMARY

CONSTRUCTION Maple semihollow body carved out from the rear with neck glued in and back glued on; neck is multilaminate of maple and mahogany with red-coloured African rosewood fingerboard; twin truss rods accessible under "scimitar" cover.

FEATURES Two High Gain single-coil pickups; two volumes, two tones, pickup blend knob, and three-way pickup selector; two-tier scratchplate layout of finger-rest and control plate; 335 has vibrato tailpiece and 340 comes with three pickups.

MUSICAL STYLES Pop and pop-rock.

SOUNDS The Rickenbacker jangle is legendary and has proved the sonic backdrop to dozens of classic pop songs.

ARTISTS Pete Townshend, Paul Weller (The Jam), Noel Gallagher (Oasis), Jeff Buckley, Johnny Marr (The Smiths), Darius Rucker (Hootie And The Blowfish).

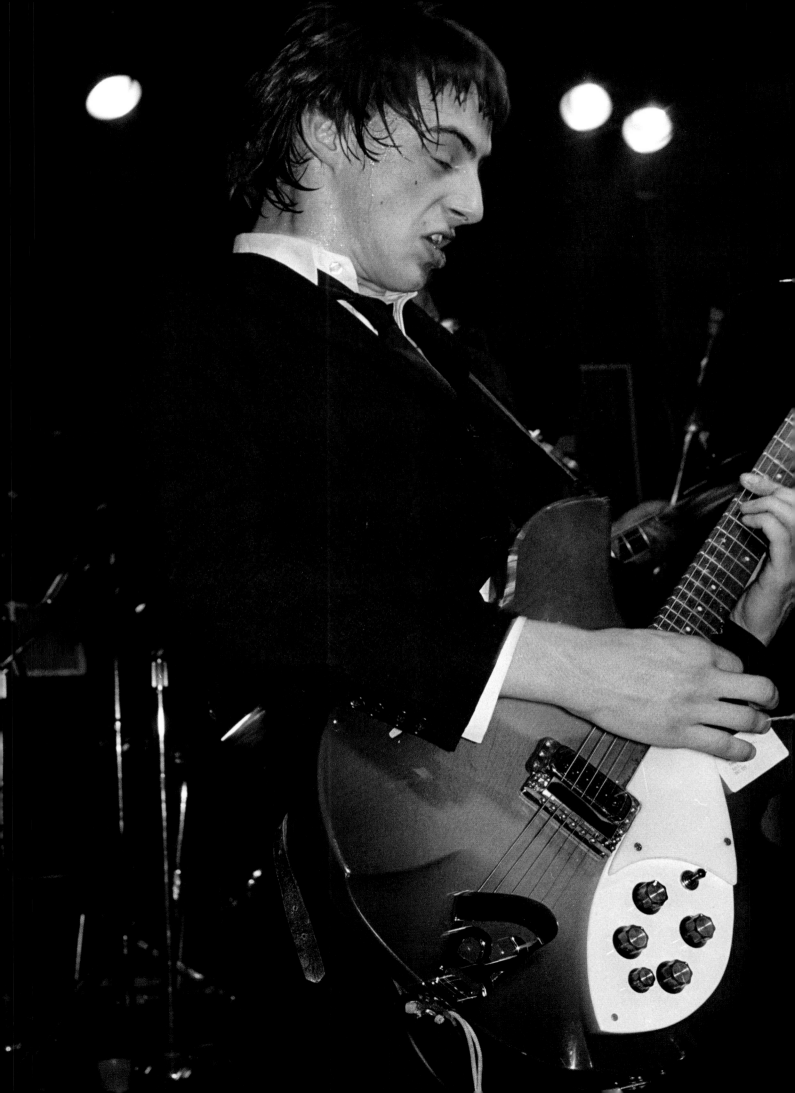

ones preferred by players, and the 330 did its job impeccably. With its swept-back cutaways and cat's-eye sound-hole, it is a remarkably modern-looking instrument. In its most popular Fireglo finish with regulation lacquered rosewood fingerboard, it just looked "right".

Early instruments had fatter bodies and these were slimmed down to 38mm (1½in) thickness in 1961. They also featured four TV or "stove" type knobs and these were later changed to the circular knurled type that became the norm – the smaller fifth mix knob was also added later. While some early instruments had single scratchplates, the 330 is best known for its two-tier arrangement with lower control plate and upper, raised finger-rest. Of course it also featured the dramatic sabrelike truss rod cover plate with underlined Rickenbacker logo, which was designed by the wife of boss Francis C. Hall. Bright and chiming, shimmering and majestic are adjectives that all describe the 330's tone. Pete Townshend knew exactly how to use the 330 to punctuate tracks with vicious chord stabs, to write catchy riffs that sounded almost acoustic guitarlike, or to play powerful solos like the manic workout in "Substitute".

The 330's success as an instrument is highlighted by the fact that it is the only model in its part of the 300 range that has remained in production since its birth. It is the guitar of the mods, those notorious British sticklers for taste and aesthetics, and alternative American rock culture. As such, it has been the weapon of choice for both The Jam's Paul Weller and John Fogerty of Creedence Clearwater Revival. The Rickenbacker 330 – a visual and sonic icon of the swinging sixties!

Opposite The British "mod" movement of the mid-1960s, with groups such as The Small Faces, Creation, and The Who, was a big influence on The Jam's Paul Weller, whose dress sense and choice of Rickenbacker 330 both echo the times.

Rickenbacker 360

Due to the huge Beatles-driven success of its 12-string sibling (page 196), Rickenbacker's delightful 360 model took a back seat, even to the lowlier and vibrato-equipped 330 as used and abused by The Who's Pete Townshend. The 360 entered service in 1958 with the old-style thick body, square-edged and bound top and bottom, the bound rosewood fingerboard looking ultra cool with shark-fin inlays and the four-knob scratchplate resplendent in gold acrylic. By 1960, the stereo "Rick-O-Sound" was available, and as The Beatles topped the U.K. charts for the first time the fifth "blend" control and "R" tailpiece were added. In 1964, major visual change occurred when the 360's front edges were rounded off to provide a more comfortable playing experience, losing the front edge binding in the process. At the same time the gold scratchplate gave way to white and the old "TV" style knobs became the smaller black ones of today.

If you wanted a Rickenbacker six-string and 12-string all in one, a Convertible version was available on certain models from 1966. A unique "comb" system grabbed a preset number of strings and pulled them down out of the pick or fingers' way. It was a great idea, but was seen as more of a gimmick than a serious playing advantage.

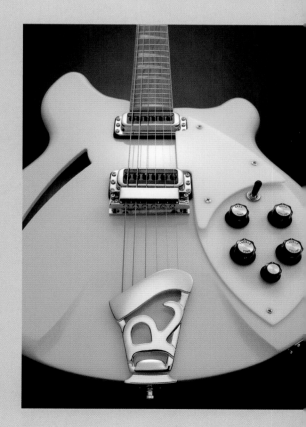

Rickenbacker 360/12

From "A Hard Day's Night" to "Mr Tambourine Man" and "Smiley Happy People", Rickenbacker's 12-string chimed its way into pop history in the hands of George Harrison, Roger McGuinn, and Peter Buck.

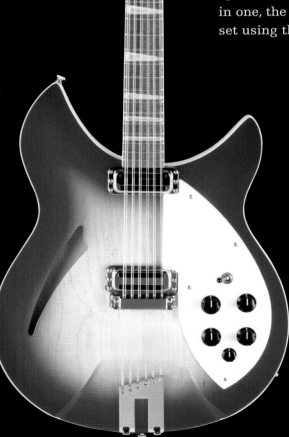

When the Fab Four first visited the United States in 1964, Rickenbacker boss Francis Hall had been doing his homework. He knew that John Lennon already played a Rickenbacker 325 and that George Harrison had bought a solid-body 425 while visiting his sister in Miami the previous year. So Hall arranged a meeting with the group to present a range of instruments for their perusal. As well as a left-handed bass for Paul McCartney and a new, updated 325 for John, a brand new model was shown to George Harrison – the 360/12. This Rickenbacker guitar would go on to shape the music not only of The Beatles, but also of American folk-rock legends The Byrds and 1980s rock sensations R.E.M.

George's 360/12 was only the second ever built. It was also the first with a revolutionary new tuning system. In order to retain a standard-sized headstock and guard against neck-heaviness, the dozen tuners were cleverly arranged. Six were attached in the usual way – mounted on the back of the headstock with the winding posts protruding through the front – but the second set faced backward, as on a classical guitar, using the Spanish-style slotted headstock design. It was essentially two headstocks in one, the main strings using the "standard" tuners and the higher-octave set using the backward-facing six.

Left One of the most iconic electric guitars, the 360-12 almost defined an era, but modern groups have also made the Ricky 12 "their" sound.

SUMMARY

CONSTRUCTION Maple semihollow body carved out from the rear with neck glued in and back glued on; early models had square edges bound top and bottom – after 1964 the top became rounded; "shark-fin" inlays on bound rosewood fingerboard.

FEATURES Two "toaster top" pickups; early models had four controls (two volumes and two tones) but later the fifth "blend" knob was added.

MUSICAL STYLES Pop and pop-rock.

SOUNDS The extra jangle of a 12-string adds personality to any pop number. Look out for two octaves chiming at once – think of "Mr Tambourine Man" by The Byrds.

ARTISTS George Harrison, Roger McGuinn (The Byrds), Peter Buck (R.E.M.), Tom Petty, Pete Townshend (The Who), The Edge (U2).

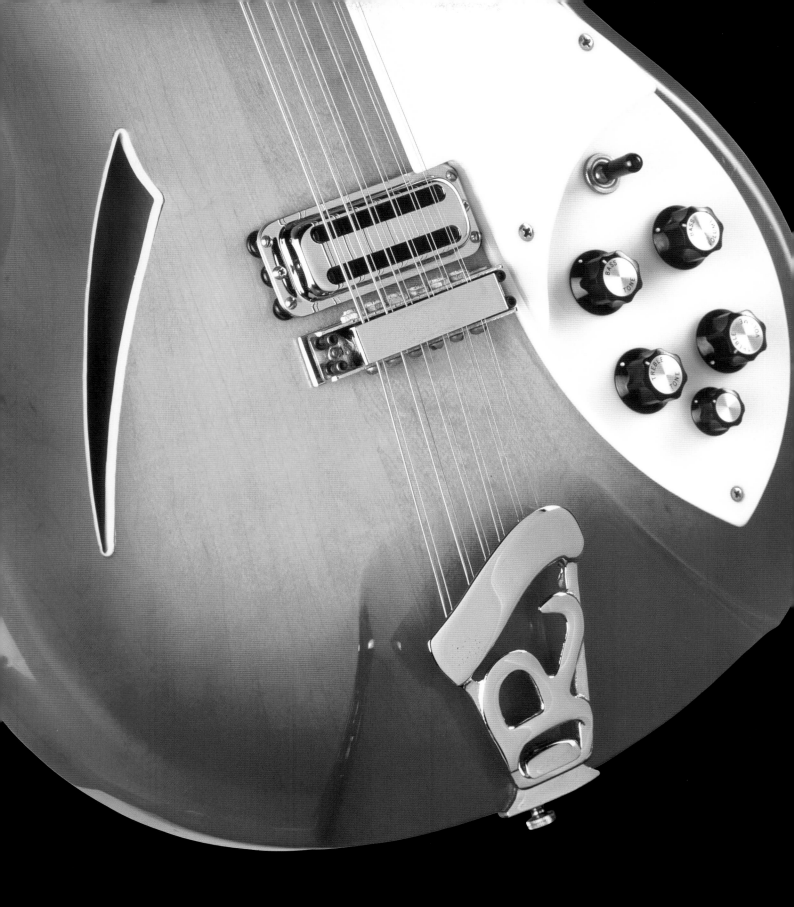

"I've used my black 360 Rick on every record we've ever done. It's my main guitar. I bought it new, beat it up, splattered blood on it, and now it's my guitar. You play a guitar for 10 years and it's almost a part of you." Peter Buck

"The whole group went to see *A Hard Day's Night*. George was playing a

Twelve-string guitars employ two sets of strings run together in pairs, or courses. One set is in standard tuning – E A D G B E – while the other is also in standard tuning but with the top two pairs (B and E) in unison and the rest an octave higher. It is this arrangement that gives 12-strings their signature jangly sound. Rickenbacker's method of fitting the two string sets differs to other manufacturers, however. While the usual arrangement is for the octave strings to sit above the standard-tuned set – so that a downward strum would hit the higher of each pair first – on the 360/12 this was reversed. The result was a slightly different tone, with the high strings less overpowering than on other makes.

George Harrison's first 360/12 was the prototype design with square edges, binding around both top and back, and triangle or "shark-tooth" position markers on its lacquered rosewood fingerboard. This later became known as OS or "old style", as Rickenbacker soon began changing the guitar by rounding the top edges and retaining only the back binding. The simple trapeze-style tailpiece was also switched to the attractive new "R" design. Toaster top pickups remained the order of the day, as did a white two-tier scratchplate with four main control knobs, three-way switch, and smaller mixer pot.

Although the 360 model was also available in six-string form (see page 195), it is the 12-string version so beloved of Beatle George Harrison that is perhaps Rickenbacker's most famous guitar of all.

Opposite Several songs included on The Beatles' album *A Hard Day's Night* feature the Rickenbacker 360/12, including the opener and title track, the intro chord of which has been the subject of much debate. As this was actually doubled by bass, piano, and possibly another guitar, the best solo rendition is probably Fadd9/G or perhaps Fadd9/dropD.

"Cresting wave" models

Any fan of Tom Petty And The Heartbreakers, The Bangles, and even those who have delved a little deeper into the history of The Beatles will recognize the slim and attractive "cresting wave" solid-body design. It first appeared in 1958 on the unbound-bodied twin pickup 450. While visiting his sister in Florida in 1963, George Harrison picked up the more lowly one-pickup 425, which he used on at least one television appearance. The considerably upmarket 460, introduced in 1961 and pictured here, had a bound body and neck, with shark-fin inlays ands two "toaster top" pickups. One of the company's most loyal supporters is Tom Petty. Twelve-string lover Petty has owned and played the 660-12 for years and Rickenbacker has proudly made a Tom Petty signature model based on this most elegant guitar. With chequered body binding on its figured maple body plus two-tier gold scratchplate and matching truss rod cover nameplate, the 660-12 is one of the company's premier instruments. Petty's guitarist Mike Campbell is often seen with the 625-12, while Suzannah Hoffs, singer-guitarist with The Bangles, prefers the even simpler 620-12 with "R" tailpiece, plain maple body, and black High Gain pickups. Other models in the cresting wave 600 series include the 650D Dakota and 650S Sierra with maple through-necks on fixed-bridge and oiled American walnut bodies. The more affordable 650C Colorado has a lacquered finish. Other cresting wave models have come and gone, including the three-quarter size 950 and a range of models sold under the Electro label.

Roger McGuinn created the sound of The Byrds using his 360-12 model bought after seeing the Beatles' film *A Hard Day's Night*. McGuinn's Rickenbacker pervaded all The Byrds' 1960s hits, including "Mr Tambourine Man", "All I Really Wanna Do", "Turn! Turn! Turn!", and "Eight Miles High".

Peter Buck of R.E.M. is an avowed Rickenbacker 12-string fan. The group had several huge-selling albums from the 1980s until the present day such as *Green*, *Out Of Time*, *Automatic For The People*, *New Adventures In Hi-Fi*, and *Around The Sun*. For years, his main instrument was a black 360-12.

Tom Petty & the Heartbreakers, heavily influenced by The Beatles and The Byrds, have become synonymous with Rickenbacker 12-strings. Petty even had his own limited-edition signature model, and guitarist Mike Campbell is regularly seen with a 625/12.

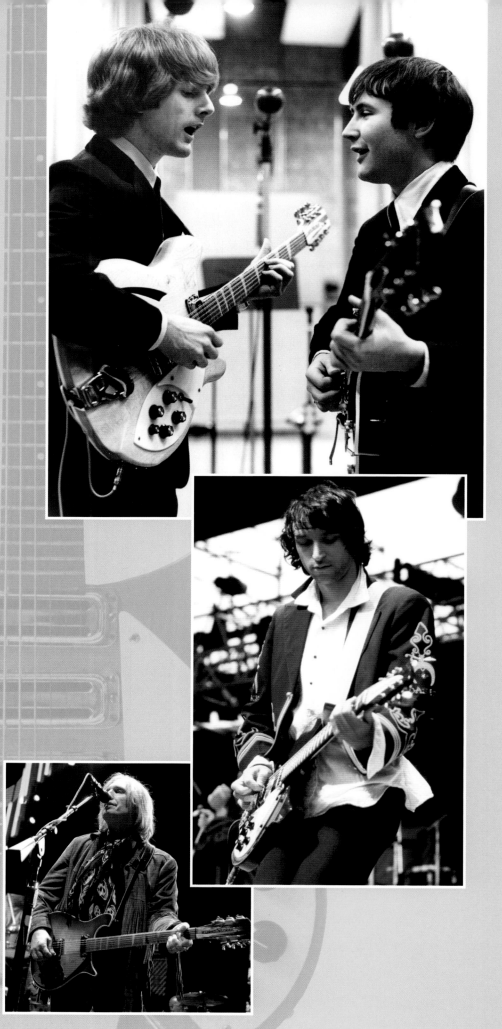

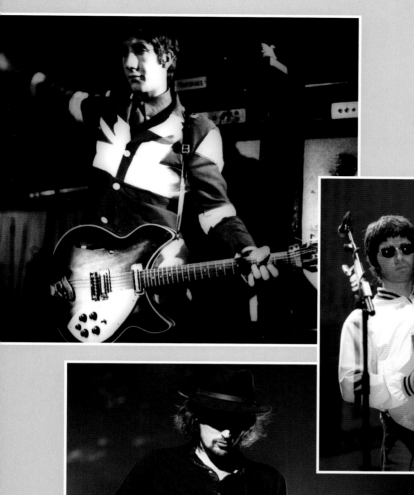

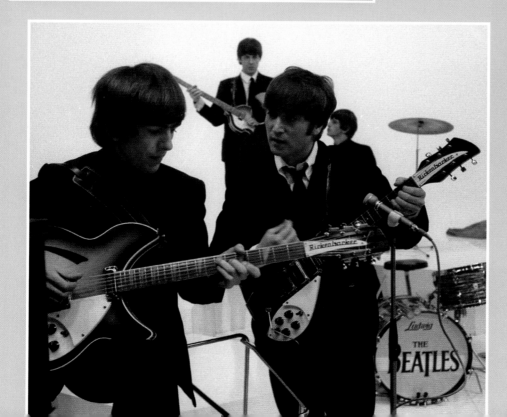

Pete Townshend made his reputation smashing up great guitars, many of them Rickenbackers. The band's early- to mid-1960s "mod" sound was fuelled by the Rickenbacker on tracks including "Can't Explain", "I'm A Boy", "Happy Jack", and "My Generation".

Noel Gallagher penned dozens of rock anthems while his band Oasis ruled the Britrock boom of 1990s Britain. Gallagher and vocalist brother Liam are huge fans of 1960s pop and pals with Paul Weller, so Noel's occasional use of a Rickenbacker 330 is hardly surprising.

Sergio Pizzorno plays guitar in one of Britain's top new bands Kasabian (named after Linda Kasabian of Charles Manson's gruesome "family"). Pizzorno's main instrument is the unusual Rickenbacker 481, modelled after the 4001 bass and with slanted frets designed to aid chord playing.

George Harrison could claim much responsibility for Rickenbacker's success. Company boss F. C. Hall saw the potential in the group's patronage in his products and sought them out to play his instruments, beating Fender to the punch. He could not have imagined The Beatles' effect on Rickenbacker sales.

Steinberger GL series

Ned Steinberger's GL "stick" was one of the earliest departures from traditional electric guitar design, using a futuristic headless neck, man-made body, and active electronics.

First shown in 1982, Ned Steinberger's GL guitar succeeded the L2 headless bass he launched in 1979. Steinberger's experience as a freelance industrial designer had led to his creation of the groundbreaking Spector NS bass, so it was not surprising that his company's first product would have four strings. As well as its tiny body and futuristic construction, the L2's other obvious difference was its headlessness. A headless design had worked with the bass guitar and the next logical step was a six-string.

Steinberger's GL guitar was a wood-free zone, with hollow body and neck made from a high-tech graphite and fibreglass blend. The fingerboard was phenolic resin and the entire instrument was black, lending a purposeful and space-age look to the guitar. The specially made double ball-end strings attached to slots behind the fingerboard's zero fret and at the back of the fixed bridge; a set of high-ratio thumb-wheel tuners brought them to pitch and offered quick and easy fine tuning. A vibrato bridge was soon introduced. Pickups were by EMG and controls were volume, tone, and three-way pickup selector. In 1984, Steinberger introduced the radical TransTrem. This vibrato system allowed all the

Above Available exclusively online is the all-wood Korean-made Spirit range, which is available with EMG Select pickups in HSH or SSH format and foldout leg rest.

SUMMARY

CONSTRUCTION Original GLs used graphite and fibreglass body and neck construction with screwed-on front faceplate. Today's GLs use a one-piece graphite and fibreglass neck bolted to a maple body; headless design with double ball-end strings locating behind the first fret and in the tailpiece or vibrato system.

FEATURES Twin active or passive EMG pickups with volume, tone, and three-way selector; floating vibrato or optional TransTrem; Synapse TransScale model with rolling capo offers baritone to regular guitar pitch; foldout leg rest; Spirit series with either HSH or SSH pickup layout by EMG Select.

MUSICAL STYLES Rock, experimental rock, and fusion.

SOUNDS Clean natural tones with a lot of sustain.

ARTISTS David Rhodes (Peter Gabriel), Allan Holdsworth, Reeves Gabrels (David Bowie's Tin Machine), David Bowie.

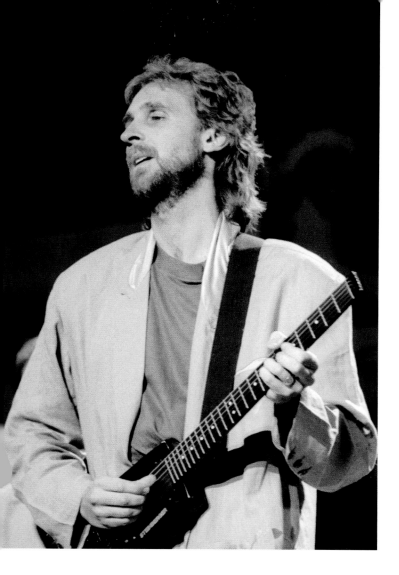

guitar's strings to change pitch in parallel – usually the bass strings drop in pitch significantly more than the treble – so that full chords could be raised or lowered in tune. It could also be locked into five extra keys: G, F#, D, C, B. Players such as Allan Holdsworth made the TransTrem part of their musical palette.

Despite the GL's technical success, only certain forward-thinking players took it up, and Steinberger was forced to make instruments with wooden bodies to satisfy the more conventional market. In the late 1990s, production ceased, but the following year the all-wood Spirit range was introduced and sold through an Internet retailer. Today Steinberger (now owned by Gibson) offers a full range of American and east Asian guitars, including GL and GM models, as well as the hybrid Synapse and Synapse TransScale with integrated rolling capo taking it from baritone to regular guitar pitch.

Left While Genesis bass player and guitarist Mike Rutherford's first Steinberger guitar was the original "cricket bat" (pictured), he found the guitar too small and so, along with British luthier Roger Giffin, came up with a new design that, with Ned Steinberger's blessing, became the GM model.

GM model

Genesis guitarist and bass player Mike Rutherford was an early Steinberger convert but found the "stick" design just too small for his lanky frame. He asked Ned Steinberger if the factory could build him a larger GL, but Ned told him this would be impossible. Not to be defeated, Mike laid his GL on a piece of paper, drew a more guitar-like double-cutaway shape around it, and commissioned top British luthier Roger Giffin to refine his idea and build it. The factory sent over a neck, pickups, and hardware – including Rutherford's preferred TransTrem vibrato – and Giffin went to work. The job done, Rutherford began using the new guitar live. On the U.S. leg of Genesis' Invisible Touch tour, it attracted the attention of Steinberger's Artist Relations representative Rich Briere. So bowled over was Briere with it that he called Ned Steinberger, who flew over to take a look at the instrument. Equally impressed, he went to work on a new model that became the GM. Today a range of GM guitars is made in America and east Asia.

Taylor T5

A leading light in the acoustic guitar world, Taylor has entered the electric guitar fray with a stylish instrument that aims to give its players the best of both worlds.

Bob Taylor has been building fine acoustic guitars in California for over 30 years. Like Paul Reed Smith on the electric side, Taylor and business partner Kurt Listug realized that many of the top acoustic manufacturers had been sitting on their laurels. Quality had taken a back seat and Taylor, like PRS, exploited this to his advantage; before long, the name Taylor was a synonym for all that was good in acoustic guitar build, tone, and playability. Bob Taylor is also a champion for the guitar industry, sharing production ideas, machinery, and technology even with his competitors.

Over the years, the Taylor range has grown and now encompasses every style of acoustic guitar imaginable. Many artist models feature fabulous finishes and exotic inlays, while the Presentation Series represents the pinnacle of modern acoustic guitar design with its fancy timbers and outrageous inlay work. It is not surprising, then, that Bob decided that he could design and build a quality electric guitar and, while he was at it, incorporate some great acoustic sounds as well.

Enter the T5, which debuted in 2005. Available in Standard and Custom livery, it is a hollow-body thinline made from routed-out sapele mahogany

with spruce, maple, or exotic wood top and stylized f-holes. It has one metal-covered electric pickup redolent of the Telecaster's neck single-coil but which is in fact a stacked humbucker – two coils one on top of the other, unlike the Gibson norm that sets them side by side. An acoustic body sensor is located under the T5's top and another acoustic pickup is buried in the neck block for a range of electric, acoustic, and "mixed" tones. A five-way selector chooses pickups and pickup combinations, while a pair of soft-grip tone knobs and a volume control offer fine-tuning.

On the Standard, hardware is chrome and on the Custom it is gold, with the Standard offering microdot pearl position markers and the Custom "artist" inlays. While the top of the Standard is made of spruce or maple, exotic timber tops such as Hawaiian koa, cocobolo, or walnut are optional on the Custom. A variety of see-through finishes, or solid and metallic colours, are also available.

Sonically, the T5 offers a range of convincing acoustic and electric tones in a simple-to-operate and elegant package, while Taylor's continuing innovation in production techniques, such as super-fast ultraviolet finish curing and the use of lasers to cut logos and inlays, means that the T5's striking good looks are matched by extraordinary attention to detail in construction, finish, and playability.

Left American singer, songwriter, and guitarist Jason Mraz was one of the first professional recording artists to embrace Taylor's elegant "electric meets acoustic" model, the T5.

SUMMARY

CONSTRUCTION Sapele mahogany body routed out to produce semisolid construction with top of spruce, maple, koa, cocobolo, or walnut glued on; stylized bound f-holes.

FEATURES Two acoustic sensors in neck block and inside body; magnetic "electric" pickup set into top; two soft-grip tone controls and one volume are mated to a five-way tone selector switch.

MUSICAL STYLES Apart from heavy rock, the T5 will handle almost anything electric or acoustic.

SOUNDS Fender-ish electric tones and believable acoustic sounds.

ARTISTS A relatively new guitar, the T5 has not yet made it into the hands of many top guitarists, but it is already being used by session players needing quality acoustic and electric sounds in a top-notch package. Welsh rock and roll guitarist Dave Edmunds is also already using one on stage and in the studio.

Trussart Steelcaster and Steeldeville

James Trussart crafts his guitars from steel, using a variety of unique ageing techniques to produce instruments of incredible beauty that also play and sound like fine vintage pieces.

James Trussart was a professional fiddle player in a Cajun band before devoting his life to building musical instruments – in metal. His first efforts were understandably violins, but he quickly realized that there was more potential in electric guitars – higher-profile instruments that evoked even more passion than their classical relatives. He now operates from Los Angeles and has built up an impressive client base.

Trussart bases his two most popular models, the Steelcaster and the Steeldeville, around the shapes of the Fender Telecaster and the Gibson Les Paul. He crafts vintage-style necks out of traditional materials and uses pickups from the most-respected specialist manufacturers, but that is where any similarities end. Trussart's bodies are constructed from hollow steel and then subjected to an array of finishing processes that include rusting, drilling holes, or even overlaying the steel body with alligator leather, immersing in water, and allowing the skin's pattern to transfer onto the metal. The treated body is then rust-treated, sanded, and satin-lacquered. Other decorations on the body, scratchplate, or headstock can include tribal art, delightful roses, or disturbing skulls. Hardware is similarly aged. Not all of Trussart's instruments are old and rusty-looking; there are also shiny or satin nickel, gold, or copper finishes. Neck material is primarily maple on both models, often stained to match rusty bodywork or other decoration, with fingerboards of rosewood. Koa wood is a neck option, as are ebony fingerboards.

The Deluxe Steelcaster is an f-hole version while the Steeltop is more traditional mahogany and maple build with a steel plate attached to the top. One striking option is the holey front or back feature, where the steel sheet is drilled with numerous round holes to look almost like metallic speaker fret. The headstock's steel plate is more than decorative, adding sustain to the vibrant, earthy tones. Trussart certainly thinks laterally when it comes to designing guitars, but his products are far more than just quirky.

Opposite and above This holey front Steelcaster shows the detail and craftsmanship inherent in every one of James Trussart's quirky but eminently musical designs. The metal headplate (above) is said to improve tone and increase sustain.

SUMMARY

CONSTRUCTION Hollow steel bodies with various effects, including rose or skull graphics, holey front or back, heavy rusting, shiny or satin nickel, gold, or copper; metal headstock plate for decoration and sustain; necks maple or optional Koa.

FEATURES A range of pickups, including Seymour Duncan Antiquities, TV Jones, Tom Holmes, or ARCANE; volume and tone (Steelcaster); two volumes and two tones (Steeldeville); three-way selector switch.

MUSICAL STYLES Rock and blues.

SOUNDS Classic Telecaster or Les Paul with a little more bite.

ARTISTS Billy F. Gibbons, Eric Clapton, Tom Morello, Metallica.

Vox Phantom and Teardrop

In mid-1960s Britain, the top groups of the day were just as happy to be seen with Italian-made coffin- and lute-shaped electrics as they were with Rickenbackers and Gretsches from the U.S.

> "I never really liked the Rickenbacker 12-string. I tried it but couldn't get on with it. The neck was too narrow and I always preferred the sound and feel of the Vox."
>
> Tony Hicks

Vox was the U.K.'s first and in some ways most influential guitar amplifier brand, providing amps for The Beatles, The Hollies, The Dave Clark Five, The Yardbirds, The Kinks, The Rolling Stones, Brian May, Bryan Adams, and a host of others. For a brief period in the 1960s, it looked as if the company's electric guitars might prove just as influential. Although this was not to be, the Phantom and Teardrop created a lasting image of a time when music was on the verge of changing the world.

Tom Jennings was an accordion player who, in 1945, began trading in second-hand musical instruments and accordions imported from Italy, before opening a factory making electric organs. After the success of the company's amps (designed by his long-time friend Dick Denney) Jennings opened a shop in London selling imported accordions, Vox organs, and his own range of amps. The Shadows had created huge demand for electric guitars; by 1961, Tom already had a couple of British-built Fender-alikes on sale, but with the start of the British pop boom in 1962 he needed something original. So together with the Design Centre in London he came up with the Phantom. With three single-coils that looked like squared-off

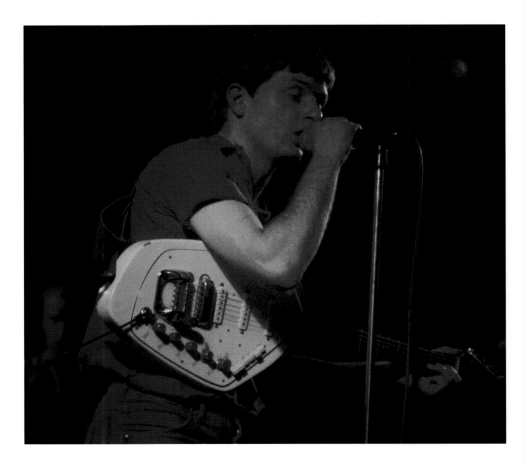

Right Ian Curtis, singer of influential British band Joy Division, used several Vox guitars during the band's brief existence, including Teardrops and this Phantom with built-in effects. Curtis committed suicide in May 1980, and Joy Division became New Order.

Right Rolling Stones founder and guitarist Brian Jones was a champion of Vox guitars, using both models. Jones received the prototype of the Teardrop that had a Stratocaster bridge, different control layout, and slightly elongated body.

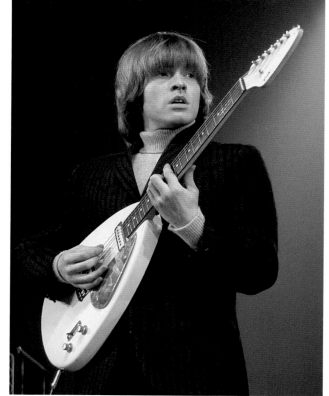

Far right With three single-coil pickups, vibrato, and simple and intuitive controls, the Teardrop was a far cry from many Vox guitars of the period and was an obvious attempt to emulate the success of Fender.

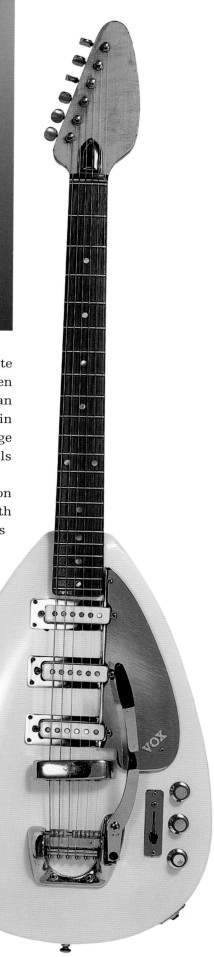

Strat pickups, a Bigsby-style vibrato tailpiece, and a large scratchplate that virtually covered the body, it made a fantastic visual statement. Then came the Mark series that quickly became known as the Teardrop. Brian Jones was given the prototype, which differed from subsequent versions in having a longer body and just two pickups. Without the Phantom's huge front plate, these were mounted in Gibson-style surrounds. Both models came in six- and 12-string format.

By the mid-1960s, Jennings needed a more reliable source of production and so he commissioned Italian guitar maker EKO to build them. Soon both models were available with optional built-in effect circuits. The infamous Organ Guitar, based on the Phantom design, was the culmination of these efforts. The idea was ahead of its time, but the technology was incapable of supporting it, and the Organ Guitar was a flop. In 1969, Vox ceased production. Several attempts have been made to recreate these guitars, including some great Vox reissues and some fine instruments from Phantom Guitar Works of Oregon.

SUMMARY

CONSTRUCTION Coffin- and teardrop-shaped bodies with bolt-on mahogany bodies; bolt-on maple necks with "spearhead" headstock design and rosewood fingerboards.

FEATURES Both models had three single-coil pickups, Bigsby-style tailpiece; two volumes and one tone control with three-way pickup selector; effects-laden models offered as variety of specific controls.

MUSICAL STYLES Pop and R&B.

SOUND Fenderlike single-coil tones.

ARTISTS Brian Jones (The Rolling Stones), Sterling Morrison (The Velvet Underground), Lenny Davidson (The Dave Clark Five), Chris Martin (Coldplay), Ian Curtis (Joy Division).

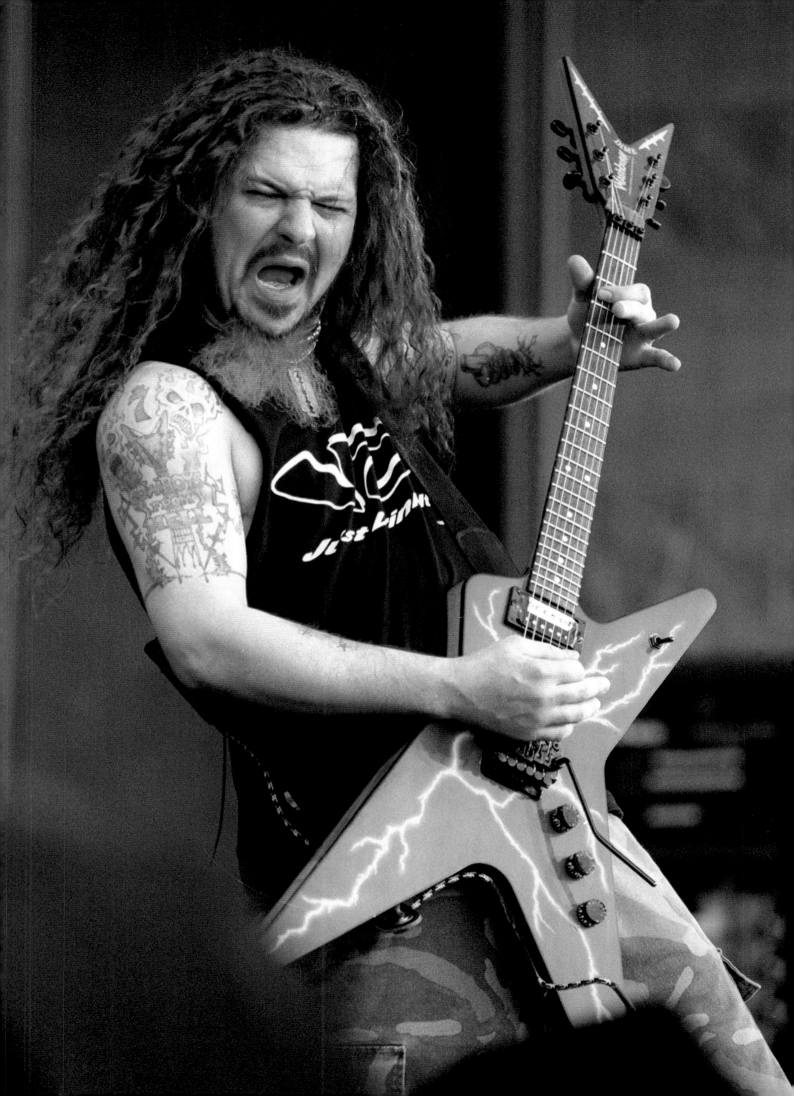

Washburn Dime

One of metal's most charismatic figures and talented guitarists had an on/off relationship with Washburn that ended just before his untimely death in 2004.

Opposite and above
Washburn made several models for Pantera/ Damageplan guitarist Dimebag Darrell, including the metal-fronted Stealth, the DimeBolt model (opposite), and various V-shaped instruments (above).

Darrell Abbott, also known as "Dimebag" or "Dime", was the lead guitarist of metal band Pantera. His lightning-fast playing gained him legions of devoted fans. The group, which also contained Abbott's brother Vinnie Paul on drums, split up in 2003. The brothers reconvened to form Damageplan in 2004, the year that Dimebag was shot and killed in Columbus, Ohio, while on stage, 24 years to the day that John Lennon was gunned down.

Dimebag left Dean Guitars when his friend Dean Zelinsky sold the company in 1986. Washburn offered the guitarist an endorsement deal, and a variety of Dime models were produced over the next decade. Darrell's first good guitar had been the Dean ML; his main Washburn model was based on the ML design, although several Dimebag guitars were available. The Dime 333 featured a solid alder body with flamed maple cap, glued mahogany neck, and rosewood fingerboard with 22 jumbo frets. He was often pictured with the DimeBolt version in blue sunburst with "lightning bolt" graphic, but the 333 also came in green and yellow DimeSlime sunburst. The famous forked headstock on Dime's Washburns carries Grover tuners, signature logo, and "barbed wire" graphic.

In the mid-1990s, Armadillo Enterprises opened a new Dean factory and Dean Zelinsky returned to oversee production. When Darrell formed Damageplan, Dean invited him back, and he left Washburn. No Dime models are currently available, but a second-hand market thrives.

SUMMARY

CONSTRUCTION Alder body with flamed maple top on Dime 333 in DimeBolt and DimeSlime finishes; glued-in mahogany neck with distinctive forked headstock and 40cm (15¾in) radius rosewood fingerboard with 22 jumbo frets; many Custom Shop graphic finishes. Stealth is more dinky version; diamond steel truck ramp finish available; Pro V arrowhead body design; variety of graphics.

FEATURES Floyd Rose locking vibrato; Seymour Duncan pickups on American versions, including Dimebucker at bridge, Washburn on imported models; nonvibrato 332 with through-body stringing; Grover tuners; two volumes, tone, and three-way selector switch.

MUSICAL STYLES Metal.

SOUNDS Fat, distorted bridge pickup tones and surprisingly clean and warm neck sounds for quieter rhythm or picked passages.

ARTISTS Dimebag Darrell.

Yamaha Pacifica

Although always renowned for quality and value, Yamaha's Pacifica 112 would change the world's expectations in entry-level electric guitar with its untouchable balance of features and price.

By the late 1980s, the technique-driven instrumental rock of players such as Steve Vai and Joe Satriani had caused guitar makers to re-evaluate what was required. Unmodified Les Pauls and Stratocasters simply were not equipped to handle the kind of fretboard fireworks and over-the-top whammy bar (vibrato arm) antics displayed by these virtuoso players.

Van Halen had built his "Frankenstrat" with a humbucking pickup at the bridge and locking vibrato. Kramer had formalized it with the Baretta model and manufacturers such as Ibanez and Jackson were already in production with their JEM and Soloist models. Such double-cutaway, bolt-on-neck guitars with six-a-side tuner arrangement, and humbucker and single-coil pickup combinations, had started to be dubbed "superstrats" – although only Fender had the right to use the terms Strat or Stratocaster. Pro players and aspiring youngsters alike were now seeking out this style of guitar and models were in demand at both ends of the price spectrum.

"They copied the guitar that I've been using, which is a kind of a custom Tele style. The one that they made me was very close to it and they're selling that as a Mike Stern model, which I was of course thrilled about." Mike Stern

The Pacifica programme began in Yamaha's Guitar Development (YGD) centre in North Hollywood, California, in 1989. The idea was that a team of designers would be at the heart of this new style of music and its players, and develop the kind of instruments that they demanded. Early Pacificas included the all-American USA1 and USA2, the former based loosely on Fender's Telecaster shape and the USA2 vaguely following the Stratocaster's form, albeit in "superstrat" guise with Wilkinson vibrato, the new Sperzel locking tuners, two single-coils, and a bridge humbucker. This pickup configuration would become known as "HSS" – others would adopt the HSH format – and clever switching methods were devised to make the most of the available permutations.

Early top-end Pacificas used necks built by Warmoth, a Californian company specializing in upmarket replacement parts. They featured compound radius fingerboards – where the board is flatter at the top of the neck to eliminate strings "choking off" when bending. Highly figured maple caps were used on bodies of alder, poplar, or basswood. Lower-level Pacifica models included the exclusive 912 and 904, the midrange 812 and 804, and the more affordable 604. But the guitar that would change everything was the Pacifica 112 of 1992. Made from solid timbers with high- quality pickups and hardware, the 112 revolutionized entry-level electric guitars. At a genuine entry-level price, the 112 played and sounded great, stayed in tune, and bred confidence in all who played it. Guitar magazines raved about it and beginners flocked to buy it. Other manufacturers quickly adopted similar tactics, but by this time the Pacifica 112 was the most revered entry-level guitar around. The Pacifica is still a jewel in Yamaha's crown of great electric guitars, but the 112 will forever stand as a milestone in guitar-buying history.

Above One side of the Pacifica range is a direct nod in the direction of Fender's Stratocaster and the other side is more akin to the Telecaster. It was an adaptation of the latter that became the signature model of the renowned jazz-fusion guitarist Mike Stern.

SUMMARY

CONSTRUCTION Solid alder body with forearm contour and belly scoop; maple neck with dotted, 22-fret rosewood fingerboard; a number of coloured finishes and natural, to show solid timbers and not laminates (plywood).

FEATURES Two single-coil pickups (neck and middle position) and humbucker (bridge); vintage-style vibrato bridge/tailpiece; quality sealed tuners.

MUSICAL STYLES Rock, pop, and blues.

SOUNDS Fat bridge pickup, clean and warm neck sounds and hollow "in-between" sounds typical of the Fender Strat – think of "Who Let The Cats Out?" by Mike Stern.

ARTISTS Mike Stern plays the PAC1511MS in the Pacifica range; other Yamaha players include Blues Saraceno and Ritchie Kotzen.

Yamaha SG2000

The SG2000 was the first Japanese guitar to gain international respect and a reputation that rivalled and even beat Gibson during the 1970s. Great design and flawless construction made it a real contender.

Yamaha has been building guitars in Hamamatsu, Japan, since the mid-1940s. Its reputation in the 1960s moved on apace with the FG "folk guitar" range that played well and sounded good. These guitars were also light on the pocket and all but indestructible. Although electric guitar production began at Yamaha in 1965, it was not until the mid-1970s that the company's offerings garnered anything like the same reputation.

It all began with the SG175. This double-cutaway guitar from 1975 had two pointed horns on a Les Paul-size body – it was not a copy of any Gibson model, yet somehow it looked like a distant relative. In 1976 came the guitar that would change everything for Yamaha. Based on the same body outline, the SG2000 was a top-line electric that went head to head with the Les Paul in performance but was way ahead of the American giant in quality and innovation. Prior to the launch of the SG2000, Yamaha had contacted Carlos Santana to see if he would play one of their new electrics. While Carlos was bowled over by its build and playability, he did not like the way it sounded – he needed more sustain – and so suggested Yamaha make the SG thicker and add a block of brass under the tailpiece. This, he reasoned, would have the desired effect. The guitar that eventually became the SG2000 was radical. Rather than traditional construction, its neck – a multilaminate of maple and mahogany – ran the entire length of the body, with "wings" of mahogany either side and a three-piece maple cap ingeniously laid on top. Carlos's brass plate was embedded beneath the tailpiece, whose twin studs screwed directly into it. A typically Gibsonlike set of volume and tone rotaries controlled a pair of Yamaha humbucking pickups, while a three-way toggle switch was positioned on the top horn. The 22-fret ebony fingerboard – Santana stipulated fat frets – was adorned with striking split "arrowhead" inlays for a classy and distinctive look.

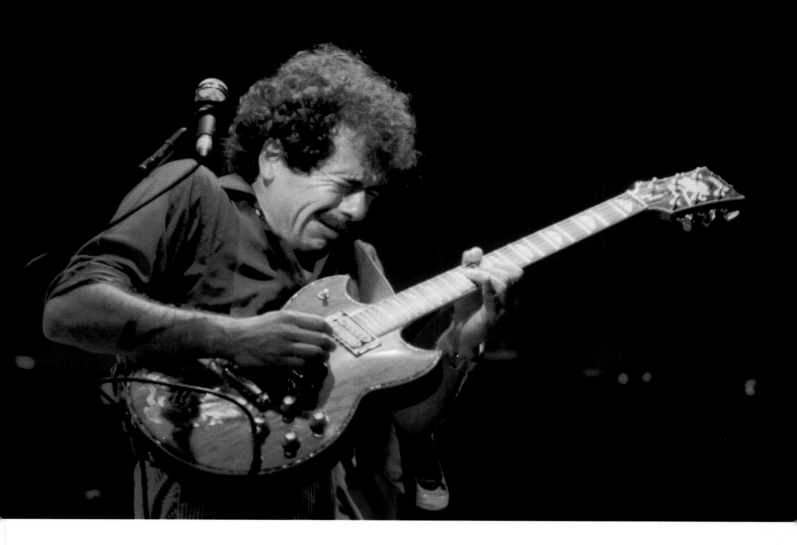

As a player's instrument, the SG2000 easily surpassed the Gibson Les Paul. Those shallow cutaways offered almost total access to the neck, and the instruments arrived so perfectly set up from the factory that guitarists began asking questions about Gibson quality. When Santana – a musician still at the height of his first wave of success – began playing one in earnest and speaking in praise of Yamaha's instruments and ethics, other top players listened and so did the guitar-playing world at large. From that point onward, Yamaha's position as a major electric force in the electric guitar business was assured.

Over the years, a whole range of SG models has followed, including the excellent SG1000, a slightly more affordable but no less playable instrument featuring Yamaha's now legendary push-push pots which coil-tapped the humbuckers for a more twangy, Fenderlike tone.

The SG shape is still used today on a variety of Yamaha models and, since the original was introduced over 30 years ago, Japanese guitar manufacture has gained unprecedented respect. There is no doubt whatsoever that Yamaha's excellent SG guitar paved the way for other Japanese manufacturers such as Ibanez to gain worldwide acceptance.

Above A long-time Gibson player, Santana broke ties with the company and joined Yamaha to become the chief player of the SG range. His custom SGs were pearl- and abalone-inlaid masterpieces.

SUMMARY

CONSTRUCTION Laminated maple and mahogany through-neck construction with mahogany body "wings" and maple cap with brass sustain block under bridge; ebony fingerboard with split arrowhead inlays; bound body, neck, and headstock.

FEATURES Two Yamaha humbucking pickups with coil-taps accessed from push-push pots; wide-travel gold-plated tune-o-matic bridge and gold Grover-style tuners; two volumes and two tones plus three-way selector on top horn.

MUSICAL STYLES Rock, pop, and blues.

SOUNDS Combination of Les Paul-style fat bridge and neck humbucker tones and Telecaster-type single-coil sounds via coil-taps.

ARTISTS Carlos Santana, Bill Nelson (Be Bop Deluxe), Stuart Adamson (Big Country), Robben Ford, Andy Taylor (Duran Duran), Bob Marley, Brian Robertson (Thin Lizzy), Steve Cropper.

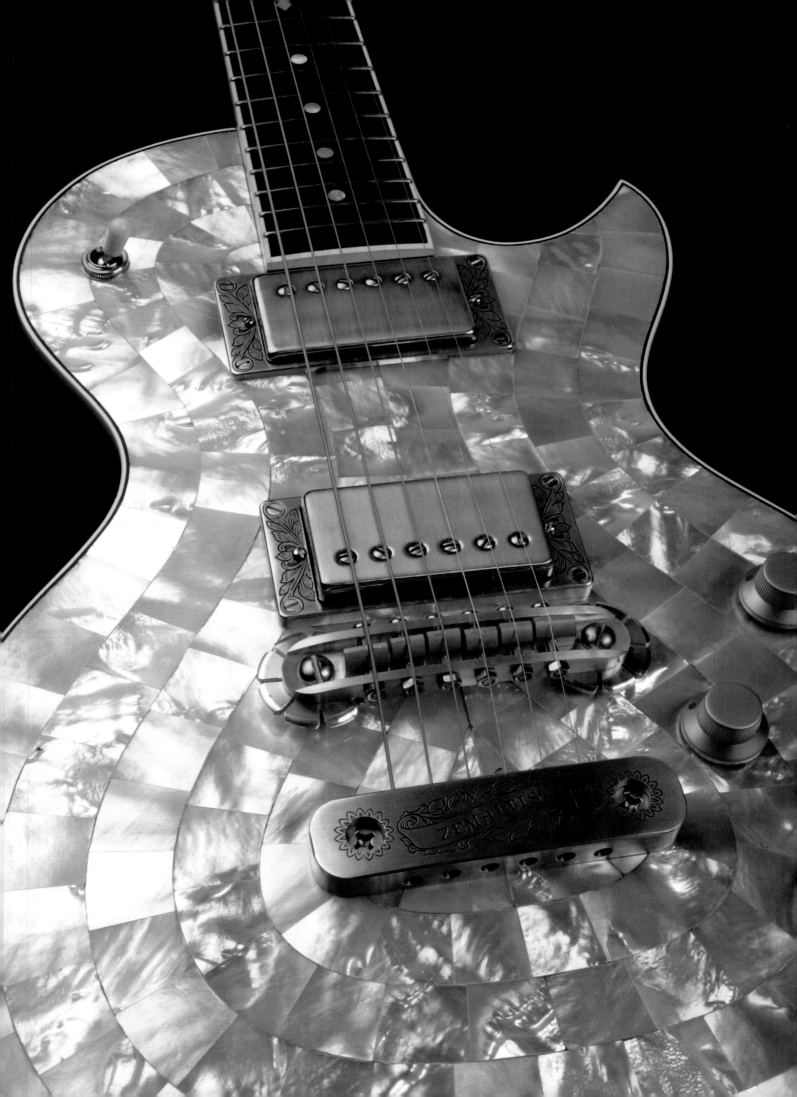

Zemaitis Pearl Front

During the 1970s, Britain's rock elite was seen playing unusual electric guitars that obviously were not Fenders or Rickenbackers, but could have been some extinct Gibson dug up by musical instrument archaeologists.

These unique guitars were handmade in England by a one-man show in Chatham, Kent. The maker was Tony Zemaitis, and Ronnie Wood and Ronnie Lane of The Faces, ex-Beatle George Harrison, Rolling Stone Keith Richards, superstar guitarist Eric Clapton, and glam god Marc Bolan were all playing his guitars.

Although he began making acoustic guitars and became known for his big-bodied 12-strings – including Clapton's legendary "Ivan The Terrible" – Zemaitis soon began building electrics. The design he came up with was an elegant, slim-waisted model that looked vaguely Les Paul-ish but with a more pointed horn on its single cutaway, and a stylized three-a-side headstock. Built using traditional electric guitar timbers such as mahogany with ebony or rosewood fingerboards, what set Tony's guitars apart from all others was how he adorned them, and the most elaborate instruments he made were the legendary Pearl Fronts, as played by Ron Wood and later The Pretenders' young guitarist, James Honeyman-Scott.

The Pearl Front, as its name suggests, utilized mother-of-pearl and abalone to decorate the top surface of the guitar. The shells – the abalone is the darker, more colourful of the two – were arranged in a variety of designs: sometimes pearl was used all over in a "crazy paving" style, and on other instruments there was a border of abalone with the plainer pearl taking up the centre. The first Pearl Front was made for Ron Wood. Ron's high-profile position and his guitar's stunning looks attracted Honeyman-Scott. Already a huge Faces fan, Honeyman-Scott was the perfect candidate for his own Zemaitis instrument and got his Pearl Front in time to record *Pretenders II*, the band's second album. James took advantage of an offshoot Pearl Front model that Zemaitis had brought into the range. This was the TerZetto, a "three-single-coils" version that catered to those guitarists who were more in tune with the twangy Fender sound than the thick tones of Gibson, for which Zemaitis guitars were also renowned.

The 1980s and 90s saw a succession of modern guitarists picking up the Zemaitis baton. These included Rich Robinson of The Black Crowes, Guns N' Roses' Gilby Clark, and Guy Griffin of The Quireboys.

Opposite Blocks of mother-of-pearl are finely cut and laid in intricate patterns on the guitar's mahogany top, and the hardware receives Danny O'Brien's engraving treatment. Almost any level of ornamentation can be specified, dependent only on cost.

SUMMARY

CONSTRUCTION Three-piece mahogany body and neck; pearl, abalone, or a combination of shells in intricate patterns over entire front; Mono-Cut or Duo-Cut body shape; engraved metal truss rod cover and "Z" logo on three-a-side headstock.

FEATURES Twin humbucking pickups or three single-coils on TerZetto models, engraved hardware; Gibson- or Fender-style switching and controls, depending on model.

MUSICAL STYLES Rock, pop, and blues.

SOUNDS Typical Gibson or Fender tones but less girthsome humbucker sounds due to smaller body and lack of maple cap; less twangy Fender tones due to mahogany and set-neck construction.

ARTISTS Ron Wood and Ronnie Lane (The Faces), Keith Richards, James Honeyman-Scott (The Pretenders), Rich Robinson (The Black Crowes), Marc Bolan (T-Rex), Gilby Clark (Guns N' Roses).

Zemaitis Metal Front

While seeking a way to shield one of his guitar's electrics from interference, Tony Zemaitis used a metal plate to cover the instrument's top, and the Metal Front was born.

Opposite This highly ornamented Metal Front has Gibson-style plastic pickup surrounds and control knobs – note the flathead screws around the top's perimeter, holding the metal plate to the mahogany body.

Below Rod Stewart and The Faces performing live; Ron Wood plays a Zemaitis Metal Front with pearl inlays on an ebony fingerboard. Ronnie Lane is playing a Zemaitis bass.

Tony Zemaitis asked Danny O'Brien, skilled in the art of engraving shotguns' metal parts, to embellish the metal plates with intricate designs, and thus came up with an instantly recognizable guitar. Soon the handmade stud tailpieces were also engraved, as were the metal pickup surrounds, headstock logo, and truss rod cover. Metal Fronts, like all of Zemaitis's guitars, were custom orders, so each instrument had as plain or fancy appointments as the owner wished for, or could afford. Zemaitis bridges with their large adjustment wheels were another design statement, while simple dotted rosewood or elaborately inlaid ebony fingerboards were used, depending on the level of ornamentation. Most Zemaitis guitars were double-humbucker models with mahogany "Mono-Cut" bodies and three-piece mahogany necks (always glued in) with standard Gibson control layout of two volume controls, two tones, and three-way selector switch. But Metal Fronts were also available with the more Telecaster-esque Duo-Cut – never quite as successful a design and therefore less commonly seen.

As "special order only" instruments, Zemaitis guitars were expensive, and this made them available to a select few. The marque became so legendary in Japan that models starting changing hands for many times more than their original cost. Today they are among the most collectable of all electric guitars. Zemaitis died in 2002, but his guitars are being made by a new company with the blessing of his family, to keep the tradition going and the Zemaitis name alive.

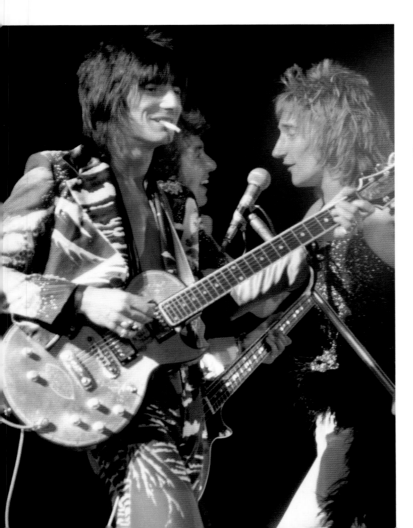

SUMMARY

CONSTRUCTION Three-piece mahogany body and three-piece mahogany neck; engraved metal plate covers most of the guitar's front; engraved metal truss rod cover and "Z" logo on three-a-side headstock.

FEATURES Most Zemaitis Metal Fronts used the Mono-Cut body (single cutaway) and two humbucking pickups – often Gibson but other makes could be stipulated – with two volumes, two tones, and a three-way selector. The Telecaster-ish Duo-Cut was also available, as were other pickup configurations; Grover or Schaller tuners were commonly used.

MUSICAL STYLES Classic British and American rock.

SOUNDS Typical Gibson tones but slightly lighter than a Les Paul.

ARTISTS Ron Wood and Ronnie Lane (The Faces), Keith Richards, Rich Robinson (The Black Crowes), Marc Bolan (T-Rex), James Honeyman-Scott, Gilby Clarke (Guns N' Roses), The Quire Boys.

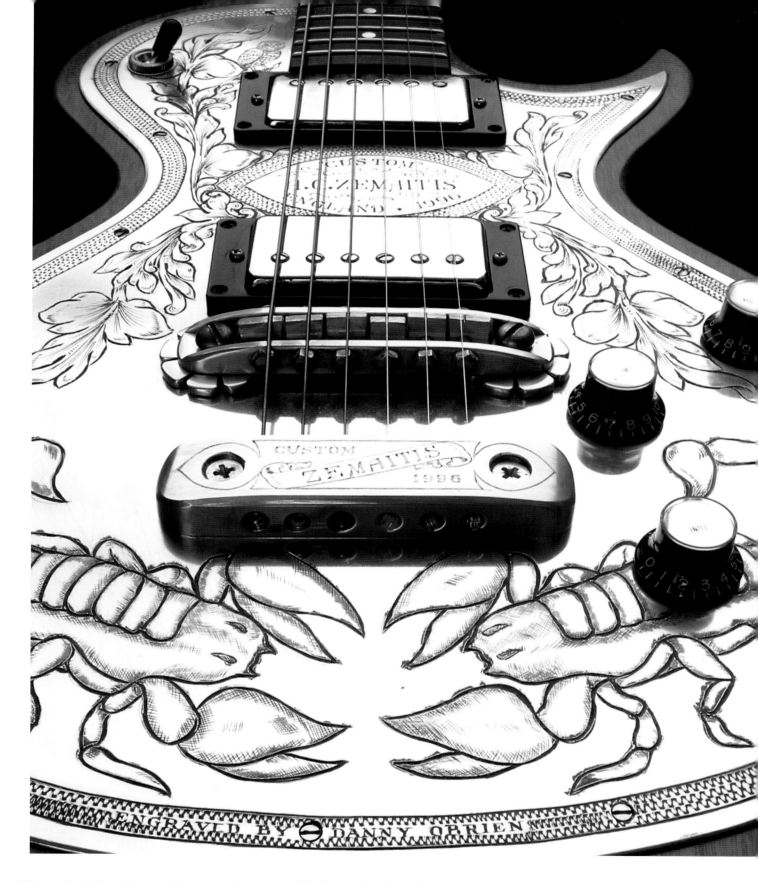

"Ronnie Wood used to use them and I thought they looked beautiful. I have two made of engraved metal with Gibson humbuckers and ebony fingerboards. One is a 22-fret guitar; the other has 24 frets. I've also got another 24-fret one, but the front is crushed mother-of-pearl. A Zemaitis definitely makes me play a bit more like Ron Wood." James Honeyman-Scott

Index

Acknowledgements

Although much of the information in *Guitar Heaven* came from the artist interviews, research, and guitar review writing I have carried out over the years, I also consulted dozens of books and magazines on the subject written by some of the world's great guitar journalists. These include: Andy Babiuk, Tony Bacon, Rick Batey, Simon Bradley, Dave Burrluck, Walter Carter, Paul Day, André Duchossoir, Tom Erlewine, Tom and Mary Ann Evans, Dan Forte, George Gruhn, Jeff Hudson, Dave Hunter, Adrian Ingram, Michael Leonard, David Mead, Don Menn, Ed Mitchell, Michael Molenda, Hans Moust, Tom Mulhern, Michael Naglav, Roger Newell, Tom Nolan, Jas Obrecht, Richard Smith, Mick Taylor, Brad Tolinski, Chris Vinnicombe, Tom Wheeler, and too many others to mention. Thanks to all!

I'd like to extend special thanks to Brian May for his fantastic foreword to the UK edition, and to Les Paul for doing the same for the US edition of the book.

Picture Credits

Mitchell Beazley would like to acknowledge and thank the following for providing images for use in this book. Particular thanks go to Future Publishing.

Key: a above, b below, c centre, l left, r right

Alamy Backbeat/Lebrecht Music & Arts Library 139; gkphotography 201ac; Piotr & Irena Kolasa 187a; Craig Lovell/Eagle Visions Photography 95; Odile Noel/Lebrecht Music & Arts Photo Library 133; Pictorial Press 100cr, 115; **Christie's Images** 21, 39b, 71, 96, 114, 135; **Corbis** Stephane Cardinale/People Avenue 102; Contographer 186c; Rune Hellestad 83bl; Karl Larsen/Zuma 176–7; Ethan Miller 171a; Tim Mosenfelder 127, 187c, 200b; Neal Preston 23, 52, 76–7, 83br, 92–3, 203a; Jaume Sellart/epa 149a; Derick A Thomas/Dat's Jazz 172; **DK Images** 137b, 171b, 174; **Future Publishing/Guitarist** 25, 28, 30, 45, 50, 53, 62, 64a & b, 72, 73, 74l & cl, 78, 158, 159, 167, 178, 182, 183, 195, 204–5; James Cumpsty 34–5, 216, 219; Neil Godwin 21a, 180; Simon Lees 173, 175a; Simon Lees & Katharine Lane Sims 46; Joby Sessions 16, 17, 19, 110–11, 118, 146, 161, 163, 164; Amanda Thomas 38, 65l & r; **Getty** 9r, 29; Brad Barket 179a; Sandy Caspers 49br; Robert Cianflone 138; Debi Doss 49ar; Frank Driggs Collection 57al; Jim Dyson 61; Simon Frederick 47a; Jo Hale 44, 48ar; Paul Hawthorne 56bl; Dave Hogan 162; Paul Kane 143; Paul McConnell 106; Ethan Miller 49cr; Tim Mosenfelder 33a, 49al, 51, 57ar, 81, 89ar, 100al, 184; Ralph Notaro 181; Michael Ochs Archives 116, 130; Robin Platzer 82cra; Paul J Richards 83cr; Karl Walter 60, 165; Robert Whitaker 88l; Louise Wilson 57bl; Graham Wiltshire 54–5; Vaughn Youtz 210; courtesy **Donald Greenwald** 202a & b; **Lebrecht Music & Arts Photo Library** Private collection 33b, 36, 189; **Redferns** Richard E Aaron 87, 215; Jorgen Angel 32; Dick Barnatt 22; BBC Photo Library 48al; Janet Beckman 58; Paul Bergen 15r, 68–9; Louise Broom 192; Mike Burnell 101b, 201bc; Carey Brandon 39a; Mike Cameron 200c; Steve Catlin 67r, 102r, 140, 141, 154a, 186, 196, 197, 203b; David Corio 83al, 88r; Fin Costello 101cr, 154b; Nigel Crane 70; Pete Cronin 101cl, 108–9; Grant Davis 91; Ian Dickson 49bl, 100cl; James Dittiger 150; David Warner Ellis Photography 124–5, 218; David Farrell 121; Tabatha Fireman 63; Jeremy Fletcher 134; Colin Fuller 82bl, 89cr; Charlie Gillett Archive 56ar; Ross Gilmore 112; Harry Herd 48c, Mick Hutson 49cl, 75; John Lynn Kirk 49bl, Robert Knight 40–1, 48br, 56al, 56cl, 169, 187br; Hayley Madden 83ar, 147, 187bl; Susie MacDonald 100ar; Chris Mills 208; Chris Morphet 201a; Keith Morris 82ar, 82crb, 98; Ilpo Musto 104; Michael Ochs Archives 82al, 101ar, 113, 119, 122; K & K Ulf Kruger Ohg 2; Don Paulsen 84, 89al; Jan Persson 82br, 89b, 97, 100b, 101al; Martin Philbey 144–5; Christina Radish 57br; David Redfern 4, 11, 56cr, 107, 188, 198, 208; Redferns 186b; Lorne Resnick 156; Ebet Roberts 56br, 57c, 66r, 128, 153, 186a, 194; Max Scheler 201b; Richard Upper 83cl; Rob Verhorst 54–5; Alexei Zaikin 37; **Bent Rej** 18; **Rex Features** Dezo Hoffmann 12r, 20, 137a, 193b; Brian Rasic 7, 31a; Marc Sharratt 12l; Sipa Press 15l; Webb 9l; **TopFoto.co.uk** Ian Dickson/ArenaPAL 82cl; Image Works 89cl.

Thanks also to the following manufacturers for their kind help with this book.
Tom Anderson Guitarworks 14; Fender 47, 59, 117, 123, 126; Gibson 28, 31b, 32, 74r & cr, 79, 80, 85, 86, 90, 94, 105; Hamer courtesy Jol Dantzig 130, 132; Hofner 136; Ibanez courtesy of Headstock Distribution 142–3, 148, 149b; Jackson 152; Parker courtesy US Music Corp 168–9; Peavey 170; Paul Reed Smith Guitars 175b, 179b; Rickenbacker 190, 191a, 199; Taylor Guitars 205a; James Trussart 206, 207; Washburn 211; Yamaha 212–3, 214.